International acclaim for Lawrence Weschler's

VERMEER IN BOSNIA

"Lively and provocative. . . . Wonderfully illuminating. . . . A surprising smorgasbord of delights. . . . [Weschler is] an erudite, enthusiastic observer of life." —*Los Angeles Times*

"Absorbing. . . . Weschler . . . has an unbeatable eye—and heart and writerly panache—for human oddity and invention." —*Entertainment Weekly*

"Luminous. . . . Exquisite. . . . Weschler is a master of the short form. . . . [He] pokes around in odd corners but always finds great stories of human experience. . . . [He] finds the 'edge' and freezes it for us in finely-sharpened prose." —*The Oregonian*

"Weschler is a national treasure . . . that rare cultural commentator whose keenly off-center perspectives and interests bring new meaning to the idea of 'the pleasure of the text.'" —*The Bloomsbury Review*

"Like a postmodern Scheherazade . . . Weschler spins yarns about everything under the sun. . . . [He has] a keen eye for connecting the dots we mere mortals can't, or won't, see . . . and writes generous prose that allows the reader to share in the author's serendipitous discoveries." —*The Austin Chronicle*

"Inspiring. . . . With his densely textured consciousness, coupled with a curiosity that can only be called protean, [Weschler] may be the most civilized staff writer *The New Yorker* ever lost. . . . Most consistently winning of all is that *echt* capacity of the literate soul: the ability to juggle incongruities without twitching."

—*The New York Observer*

"Rich. . . . Enchanting. . . . A smart melding of thought and feeling. . . . Weschler shows great mind-eye coordination. He sees and he thinks, and what he thinks is revelatory."

—*Detroit Free Press*

"Off-the-charts, happy/sad feeling, dark in the winter brilliant in the springtime crazy book! Big Polish ears and shaky furniture, are you joy today? Suntory time."

—Mark Salzman, author of *Lying Awake*

"Weschler [is] one of the best writers in the country. . . . He puts his own soulful stamp on anything that beckons him, and something moves me in almost everything he does. . . . What sets Weschler apart is the utterly fresh and unexpected connections he makes as he digs ever deeper into a subject."

—Pamela Feinsilber, *San Francisco* magazine

LAWRENCE WESCHLER

VERMEER IN BOSNIA

Lawrence Weschler is the author of more than ten books, including *Mr. Wilson's Cabinet of Wonder,* which was short-listed for both the Pulitzer Prize and the National Book Critics Circle Award. He was a staff writer at *The New Yorker* for more than twenty years and is a regular contributor to *McSweeney's.* Since 2001 he has been the director of the New York Institute for the Humanities at New York University. He lives in Westchester County, New York, with his wife and daughter.

VERMEER
IN BOSNIA

VERMEER IN BOSNIA

SELECTED WRITINGS

LAWRENCE WESCHLER

VINTAGE BOOKS
A Division of Random House, Inc.
New York

A BALKAN TRIPTYCH

PRELUDE:
THE DIKES OF HOLLAND

Justice may be many things these days at the Yugoslav War Crimes Tribunal in The Hague, but one thing it decidedly is not is swift. At times the pace of the proceedings in the court's main hearing chamber—a gleaming, light-filled, technologically almost-futuristic cubicle encapsulated behind a wall of bulletproof glass—can seem positively Dickensian. The proceedings tend to lurch forward and then become bogged down in a thicket of minute-seeming legalistic distinctions, and there are mornings when even the most attentive mind can wander.

One such morning a while back, I found my own attention wandering into a book of history I'd brought along just in case—though of Holland, as it happened, not of Yugoslavia. I was reading about the earliest stages of human habitation of the Netherlands in the lowland marshes and swamp-fields north of the Rhine River delta, terrain much of whose elevation is pitched so low that it was regularly subject to catastrophic flooding. It was not all that surprising, therefore, to learn that through many centuries this muddy floodplain went largely uninhabited and that it wasn't until around the year 800 that the first tentative forays at serious colonization were undertaken as tiny communities pitched precarious clusters of hovels atop artificially piled mounds, known as terps.

With the passing generations, some of these terps were in turn joined together by painstakingly raised landbridges, which served both as connecting paths and as protective dikes. Any given triangle, say, of such dikes, joining together three outlying terps, incidentally proved capable of shield-

ing the terrain it enclosed from outside flooding, but that only led to a new problem: what to do with all the rain and groundwater trapped and festering within the enclosure. Initial attempts at draining these patches of pestilential marshland, the so-called polders, have been documented as far back as 1150, but the real breakthrough came with the introduction of windmills in the fifteenth and especially the sixteenth centuries. Eventually "gangs" of dozens of coordinated windmills were being deployed, each in turn raising the stagnant marshwaters a few inches up and up and over the dikes and into a surrounding network of irrigation and navigation canals. Polder after polder was thus reclaimed—hundreds, thousands, and presently hundreds of thousands of acres of uncommonly fertile land—in a process that continues to this day.

Half-listening to the drone of the ongoing trial, I suddenly realized how in a sense the judges and prosecutors and investigators there in The Hague had set themselves a remarkably similar sort of reclamatory challenge. The tribunal's founding judges and officers have all repeatedly cast their work in terms of an attempt to stem the historic cycle of floodtides of ethnic bloodletting that recurrently afflict places like the former Yugoslavia, or Rwanda, the other principal locus of the tribunal's mandate. And in this context, it occurred to me that each of these individual prosecutions was like a single mound, a terp cast out upon the moral swampland of the war's aftermath—and the entire tribunal enterprise a system of interconnected dikes and sluices and pumps and windmills and canals designed to reclaim for each of the regions the possibility of fertile regeneration.

But the tribunals weren't merely attempting to reclaim such a possibility for Yugoslavia and Rwanda alone. Sitting there in the spectator's gallery at the tribunal, I recalled that old jurists' saw to the effect that if international law exists at the vanishing point of law, the law of war exists, even more emphatically, at the vanishing point of international law; and it occurred to me how there, on the infinite marshy borderland, these jurists and lawyers and investigators, and the diplomats who'd carved out the immediate occasion for their labors, and the human rights monitors

and (yes) the journalists who'd painstakingly (and often at great risk) gathered up the initial shards and planks required for their effort, were all engaged—fact by fact, testimony by testimony, case by case—in the latest instance of a decades-long, at times maddeningly halting, vexed, and compromised effort to expand the territory of law itself.

(1999)

VERMEER IN BOSNIA

I happened to be in The Hague a while back, sitting in on the prelimi-
nary hearings of the Yugoslav War Crimes Tribunal—specifically, those
related to the case of Dusko Tadic, the only one of more than forty accused
war criminals whom the Tribunal had actually been able to get its hands
on up to that point. While there, I had occasion to talk with some of the
principal figures involved in this unprecedented judicial undertaking.

At one point, for instance, I was having lunch with Antonio Cassese, a
distinguished Italian jurist who has been serving for the past two years as
the president of the court (the head of its international panel of eleven
judges). He'd been rehearsing for me some of the more gruesome stories
that have crossed his desk—maybe not the most gruesome but just the
sort of thing he has to contend with every day and which perhaps accounts
for the sense of urgency he brings to his mission. The story, for instance, of
a soccer player. As Cassese recounted, "Famous guy, a Muslim. When he
was captured, they said, 'Aren't you So-and-So?' He admitted he was. So
they broke both his legs, handcuffed him to a radiator, and forced him to
watch as they repeatedly raped his wife and two daughters and then slit
their throats. After that, he begged to be killed himself, but his tormentors
must have realized that the cruelest thing they could possibly do to him
now would simply be to set him free, which they did. Somehow, this man
was able to make his way to some U.N. investigators, and told them about
his ordeal—a few days after which, he committed suicide." Or, for instance,
as Cassese went on, "some of the tales about Tadic himself, how, in addi-
tion to the various rapes and murders he's accused of, he is alleged to have

supervised the torture and torments of a particular group of Muslim prisoners, at one point forcing one of his charges to emasculate another—*with his teeth*. The one fellow died, and the guy who bit him went mad."

Stories like that: one judge's daily fare. And, at one point, I asked Judge Cassese how, regularly obliged to gaze into such an appalling abyss, he had kept from going mad himself. His face brightened. "Ah," he said with a smile. "You see, as often as possible I make my way over to the Mauritshuis museum, in the center of town, so as to spend a little time with the Vermeers."

Sitting there over lunch with Cassese, I'd been struck by the perfect aptness of his impulse. I, too, had been spending time with the Vermeers at the Mauritshuis, and at the Rijksmuseum, in Amsterdam, as well. For Vermeer's paintings, almost uniquely in the history of art, radiate "a centeredness, a peacefulness, a serenity" (as Cassese put it), a sufficiency, a sense of perfectly equipoised grace. In his exquisite *Study of Vermeer,* Edward Snow has deployed as epigraph a line from Andrew Forge's essay "Painting and the Struggle for the Whole Self," which reads, "In ways that I do not pretend to understand fully, painting deals with the only issues that seem to me to count in our benighted time—freedom, autonomy, fairness, love." And I've often found myself agreeing with Snow's implication that somehow these issues may be more richly and fully addressed in Vermeer than anywhere else.

But that afternoon with Cassese I had a sudden further intuition as to the true extent of Vermeer's achievement—something I hadn't fully grasped before. For, of course, when Vermeer was painting those images, which for us have become the very emblem of peacefulness and serenity, *all Europe was Bosnia* (or had only just recently ceased to be): awash in incredibly vicious wars of religious persecution and proto-nationalist formation, wars of an at-that-time unprecedented violence and cruelty, replete with sieges and famines and massacres and mass rapes, unspeakable tortures and wholesale devastation. To be sure, the sense of Holland

during Vermeer's lifetime which we are usually given—that of the country's so-called Golden Age—is one of becalmed, burgherlike efficiency; but that Holland, to the extent that it ever existed, was of relatively recent provenance, and even then under a continual threat of being overwhelmed once again.

Jan Vermeer was born in 1632, sixteen years before the end of the Thirty Years' War, which virtually shredded neighboring Germany and repeatedly tore into the Netherlands as well. Between 1652 and 1674, England and the United Provinces of the Netherlands went to war three times, and though most of the fighting was confined to sea battles, the wars were not without their consequences for the Dutch mainland: Vermeer's Delft, in particular, suffered terrible devastation in 1654, when some eighty thousand pounds of gunpowder in the town's arsenal accidentally exploded, killing hundreds, including Vermeer's great contemporary, the painter Carel Fabritius. (By the conclusion of those wars, the Dutch had ended up ceding New Amsterdam to the British, who quickly changed its name to New York.) These were years of terrible religious conflict throughout Europe—the climaxes of both the Reformation and the Counter-Reformation and their various splintering progeny. And though the Dutch achieved an enviable atmosphere of tolerance during this period, Holland was regularly overrun with refugees from religious conflicts elsewhere. (Vermeer himself, incidentally, was a convert to Catholicism, which was a distinctly minority creed in the Dutch context.) Finally, in 1672, the Dutch fell under the murderous assault of France's Louis XIV and were subjected to a series of campaigns that lasted until 1678. In fact, the ensuing devastation of the Dutch economy and Vermeer's own resulting bankruptcy may have constituted a proximate cause of the painter's early death, by stroke, in 1675: he was only forty-two.

Another preliminary session of the Tribunal was scheduled for late in the afternoon of the day I had lunch with Judge Cassese, and, following our conversation, I decided to spend the intervening hours at the Mauritshuis.

On the taxi ride out, as I looked through a Vermeer catalogue, I began to realize that, in fact, the pressure of all that violence (remembered, imagined, foreseen) is what those paintings are all about. Of course, not directly—in fact, quite the opposite: the literary critic Harry Berger, in his essays on Vermeer, frequently invokes the notion of the "conspicuous exclusion" of themes that are saturatingly present but only as *felt absence*—themes that are being held at bay, but conspicuously so. It's almost as if Vermeer can be seen, amid the horrors of his age, to have been asserting or *inventing* the very idea of peace. But Hobbes's state of nature, or state of war (Hobbes: 1588–1679; Vermeer: 1632–75), is everywhere adumbrated around the edges of Vermeer's achievement. That's what the roaring lions carved into the chair posts are all about—those and also the maps on the wall. The maps generally portray the Netherlands, but the whole point is that during Vermeer's lifetime the political and geographic dispensation of the Netherlands, the distribution of its Protestants and Catholics, the grim legacy of its only just recently departed Spanish overlords, and the still current threats posed by its English and French neighbors—all these matters were still actively, and sometimes bloodily, being contested. When soldiers visit young girls in Vermeer's paintings, where does one think they have been off soldiering—and why, one wonders, does the country need all those civic guards? When pregnant young women are standing still, bathed in the window light, intently reading those letters, where is one invited to imagine the letters are coming from?

Or consider the magisterial *View of Delft*—as I now did, having arrived at the Mauritshuis and taken a seat before the magnificent canvas up on the second floor. It is an image of unalloyed civic peace and quiet. But it is also the image of a town only just emerging from a downpour, the earth in the foreground still saturated with moisture, the walls of the town bejeweled with wet, the dark clouds breaking up at last, and the sunlight breaking through, though not just anywhere: a shaft of fresh, clean light gets lavished on one spire in particular, that of the radiantly blond Nieuwe Kerk, in whose interior, as any contemporary of Vermeer's would doubtless have known, stands the mausoleum of William the Silent, one of the

heroes of the wars of Dutch independence, assassinated in Delft at the end of the previous century by a French Catholic fanatic.

I found myself being reminded of a moment in my own life, over twenty-five years ago. I was in college and Nixon had just invaded Cambodia and we were, of course, all up in arms; the college had convened as a committee of the whole in the dining commons—the students, the professors, the administrators—what were we going to do? How were we going to respond? Our distinguished American history professor got up and declared this moment *the* crisis of American history. Not to be outdone, our eminent new-age classicist got up and declared it the crisis of *universal* history. And we all nodded our fervent concurrence. But then our visiting religious historian from England—a tall, lanky lay-Catholic theologian, as it happened, with something of the physical bearing of Abraham Lincoln—got up and suggested mildly, "We really ought to have a little modesty in our crises. I suspect," he went on, "that the people during the Black Plague must have thought they were in for a bit of a scrape."

Having momentarily lanced our fervor, he went on to allegorize, deploying the story of Jesus on the Waters (from Matthew 8:23–27). "Jesus," he reminded us, "needed to get across the Sea of Galilee with his disciples, so they all boarded a small boat, whereupon Jesus quickly fell into a nap. Presently a storm kicked up, and the disciples, increasingly edgy, finally woke Jesus up. He told them not to worry, everything would be all right, whereupon he fell back into his nap. The storm meanwhile grew more and more intense, winds slashing the ever-higher waves. The increasingly anxious disciples woke Jesus once again, who once again told them not to worry and again fell back asleep. And still the storm worsened, now tossing the little boat violently all to and fro. The disciples, beside themselves with terror, awoke Jesus one more time, who now said, 'Oh ye of little faith'—that's where that phrase comes from—and then proceeded to pronounce, 'Peace!' Whereupon the storm instantaneously subsided and calm returned to the water." Our historian waited a few moments as we endeavored to worry out the glancing relevance of this story. "It seems to me," he finally concluded, "that what that story is trying to tell us is sim-

ply that in times of storm, we mustn't allow the storm to enter ourselves; rather we have to find peace inside ourselves and then breathe it out."

And it now seemed to me, sitting among the Vermeers that afternoon at the Mauritshuis, that that was precisely what the Master of Delft had been about in his life's work: at a tremendously turbulent juncture in the history of his continent, he had been finding—and, yes, inventing—a zone filled with peace, a small room, an intimate vision . . . and then breathing it out.

It's one of the great things about great works of art that they can bear— and, indeed, that they invite—a superplenitude of possible readings, some of them contradictory. One of the most idiosyncratic responses to Vermeer I have ever encountered was that of the Afrikaner poet and painter Breyten Breytenbach during a walk we took one morning through the galleries of New York's Metropolitan Museum. Breytenbach, who was a clandestine antiapartheid activist, had only recently emerged from seven years of incarceration in the monochrome dungeons of the apartheid regime, and most of his comments that morning had to do with the lusciousness of all the colors in the paintings we were passing. For the most part, though, we were silent, moving at a fairly even pace from room to room— that is, until we came to Vermeer's painting of the young girl in the deep-blue skirt standing by a window, her hand poised on a silver pitcher, the window light spreading evenly across a map on the wall behind her. Here Breytenbach stopped cold for many moments, utterly absorbed. "Huh," he said finally, pointing to the gallery's caption giving the date of the painting: circa 1664–65. "It's hard to believe how from all that serenity emerge the *Boere.* Look." He jabbed a finger at the little boats delicately daubed on the painted map's painted coastline. *"That's them leaving right now!"* (And, indeed, Cape Town had been founded by the Dutch East India Company only a decade earlier, and would soon start filling up with some of the Huguenots who had flooded into Holland following a fresh upsurge of repression back in France.)

Edward Snow, for his part, makes quite a convincing case that Vermeer's art is above all about sexuality and as such provides one of the most profound explorations of the wellsprings of the erotic in the entire Western tradition. It is about female reserve and autonomy and self-sufficiency in the face of the male gaze, Snow suggests, or even in the seeming absence of such a gaze.

In this context, the pièce de résistance in his argument is a brilliantly sustained twenty-page close reading of Vermeer's magnificent (though uncannily diminutive) *Head of a Young Girl*—sometimes referred to, alternatively, as *The Girl in a Turban* or *The Girl with a Pearl* (at the Mauritshuis, it happens to face *The View of Delft*, just across the room). Snow's approach to this overexposed and by now almost depleted image is to ask, Has the girl just turned toward us or is she just about to turn away? Looked at with this question in mind, it does seem that such immanence, one way or the other, is of its essence. As Snow points out, if we momentarily blot out the face itself, everything else conspires to make us expect a simple profile of a head—so that afterward, as we allow ourselves to look again on the face unobstructed, the girl does seem to have only just now turned to face us. But if we look for a moment at the pendant of cloth cascading down from the knot at the top of her turban, it seems at first as if that pendant ought to fall behind her far shoulder; in fact it falls far forward, provoking a visual torsion precisely opposite to that of the one we'd surmised earlier: no, on second thought, she seems to be pulling away. The answer is that she's actually doing both. This is a woman who has just turned toward us and is already about to look away: and the melancholy of the moment, with its impending sense of loss, is transferred from her eyes to the tearlike pearl dangling from her ear. *It's an entire movie in a single frozen image.* (One is in turn reminded of the obverse instance of Chris Marker's ravishing short film from 1962, *La Jetée*, a Vermeer-saturated romance made up entirely of still shots unfurling evenly, hypnotically, one after the next, with the sole exception of a single moving-picture sequence: the woman asleep in bed, her eyes closed, her eyes opening to gaze up at us, and then closing

once again. A sequence that passes so quickly—in the blink, we say, of an eye—that it's only moments later that we even register its having been a moving-picture sequence at all.)

The girl's lips are parted in a sudden intake of breath—much, we suddenly notice, as are our own as we gaze back upon her. And in fact an astonishing transmutation has occurred. In the moment of painting, it was Vermeer who'd been looking at the girl and registering the imminent turning-away of her attention (the speculation among some critics that Vermeer's model for this image may have been his daughter renders the conceit all the more poignant); subsequently, it was, of course, the painted image that would stay frozen in time, eternally attentive, while it was he as artist who'd eventually be the one turning away; and, still later, it would be Vermeer himself who, through the girl's gaze, would remain faithful, whereas it would be we viewers, casually wandering through the museum and tarrying before the image for a few, breath-inheld moments, who would be the ones eventually turning away. *The Head of a Young Girl* thus becomes a picture about presence and eternity, or, at any rate, posterity.

But this is only because it is first and foremost a painting about intersubjectivity: about the autonomy, the independent agency, dignity, and self-sufficiency of the Other, in whose eyes we in turn are likewise autonomous, self-sufficient, suffuse with individual dignity and potential agency. And here is where we come full circle: because if Vermeer's work can be said to be one extended invention—or assertion—of a certain concept of peace-filledness, this is precisely how he's doing it, by imagining or asserting the possibility of such an autonomous, inhabited sense of selfhood.

The scale of Vermeer's achievement becomes even clearer if, like me, you have a chance to walk among some of the genre pieces by Vermeer's Dutch contemporaries, also scattered about the Mauritshuis (it was getting late now and I wanted to make it back for the final session of the preliminary Tadic hearing, but I did tarry for a few minutes longer in some of the museum's adjoining rooms).

For many years, Vermeer's works were themselves seen primarily as instances of these sorts of moralizing genre images. The Metropolitan's *Girl Asleep* was thus cast as yet another castigating allegory of feminine sloth and drunkenness, while Berlin's *Woman Putting on Pearls* was folded into the tradition of vanity motifs. The Frick's *Officer and Laughing Girl* was assigned to the tradition of vaguely unsavory prostitution images (as, naturally, was Dresden's *Procuress,* from earlier in Vermeer's career); conversely, the Louvre's *Lacemaker* was seen in the context of more positively tinged illustrations of industriousness, and the Rijksmuseum's *Milkmaid* was cast as yet another prototypically Dutch celebration of the domestic virtues. All of which misses the essential point, because in each of these instances and in virtually every other one of his paintings, Vermeer deploys the conventional iconography precisely so as to upend it. No, his paintings all but cry out, this person is not to be seen as merely a type, a trope, an allegory. If she is standing in for anything, she is standing in for the condition of being a unique individual human being, worthy of our own unique individual response. (Which is more than can be said, generally, for the men in Vermeer's paintings, who do seem, hovering there beside the women, to stand in for the condition of being somewhat oafishly de trop.)

Or so, anyway, I found myself thinking in the taxi as I returned to the Tribunal—of that and of the way in which the entire Yugoslavian debacle has been taking place in a context wherein the Other, even one's own neighbor, is suddenly being experienced no longer as a subject like oneself but as an instance, a type, a vile expletive: a Serb, a Croat, a Turk, and, as such, preordained for an ages-old, inevitable fate. (Note that such a construction has to be as assiduously "invented" as its obverse: people who've been living in relative peace for decades have to be goaded into seeing one another, once again, in this manner.) No wonder that Cassese flees to Vermeer for surcease.

A Dutch journalist named Alfred van Cleef recently published a re-

markable book, *De Verloren Wereld van de Familie Berberovic* (*The Lost World of the Berberovic Family*), in which he traces the downward spiral of the last five years in Yugoslavia through the shattered prism of one Bosnian family's experience. Early in his narrative, he recounts how the war came to the Berberovic family's village, how for many months its members had been picking up the increasingly strident harangues welling out from the Belgrade and Zagreb television stations but hadn't worried because theirs was a peaceful village, where Serbs and Croats and Muslims lived equably together, with a high degree of intermarriage, and so forth. Then the war was just two valleys over, but still they didn't worry, and then it was in the very next valley, but, even so, no one could imagine its actually intruding into their quiet lives. But one day a car suddenly careered into the village's central square, four young men in militia uniforms leaping out, purposefully crossing the square, seeming to single out a particular house and cornering its occupant, whereupon the leader of the militiamen calmly leveled a gun at the young man and blew him away. The militiamen hustled back to their car and sped off. As van Cleef subsequently recounted the incident for me, "They left behind them a village almost evenly divided. Those under fifty years of age had been horrified by the seeming randomness of the act, while those over fifty realized, with perhaps even greater horror, that the young man who'd just been killed was the son of a man who, back during the partisan struggles of the Second World War, happened to have killed the uncle of the kid who'd just done the killing. And the older villagers immediately realized, with absolute clarity, that if this was now possible everything was going to be possible."

David Rieff tells a story about visiting a recent battlefield at one point during the war in the company of a small band of fellow journalists: Muslim corpses strewn across the muddy meadow, a Serb soldier grimly standing guard. " 'So,' we asked the soldier, this young kid," Rieff recalls, " 'What happened here?' At which point the soldier took a drag on his cigarette and began, 'Well, in 1385 . . .' "

Yugoslavia today has been turned back into one of those places where people not only seem incapable of forgetting the past but barely seem

capable of thinking about anything else: the Serbs and Croats and Muslims now appear to be so deeply mired in a poisonous legacy of grievances, extending back fifty years, two hundred years—indeed, all the way back to the fourteenth century—that it's almost as if the living had been transformed into pale, wraithlike shades haunting the ghosts of the long-dead rather than the other way around.

Which is to say that we're back in the moral universe of epic poetry: the Iliad, Beowulf, the Chanson de Roland, the Mahabharata, and, of course, *Finnegans Wake*—a modernist recasting of the entire epic tradition, composed during the thirties by James Joyce, who once characterized history as "two bloody Irishmen in a bloody fight over bloody nothing." Not so much over bloody nothing, perhaps, as vengeance for vengeance for vengeance for who-any-longer-knows-what? That's the heart of the epic tradition: those twinned themes of the relentless maw of vengeance and the ludicrous incommensurability of its first causes recur time and again, from one culture to the next. It's worth remembering how, also during the thirties, when the great Harvard classicist Milman Parry was trying to crack the Homeric code—to determine just how the ancient Greek bards were able to improvise such incredibly long poems, and what mnemonic devices they had devised to assist them—he scoured the world for places where such oral epic traditions were still alive, and the place he finally settled on as perfect for his purposes was Yugoslavia (see his disciple Albert Lord's seminal account in *The Singer of Tales*).

Vermeer was not a painter in the epic tradition: on the contrary, his life's work can be seen, within its historical moment, as a heroic, extended attempt to steer his (and his viewers') way clear of such a depersonalizing approach to experiencing one's fellow human beings. It was a project, I now realized, as I took my seat in the visitors' gallery facing the Tribunal's glassed-in hearing room, not all that dissimilar from that of the Tribunal itself.

The day before, I'd spoken with Richard Goldstone, the eminent South African jurist who has been serving as the Yugoslav Tribunal's lead prosecutor. (He is serving the same role on the Tribunal that has been estab-

lished to prosecute the war criminals in Rwanda.) I'd asked him how he envisioned the mission of the Tribunal, and he'd described it as nothing less than a breaking of the historic cycle of vengeance-inspired ethnic mayhem. He does not believe in the inevitability of such violence. "For the great majority of their histories, the Croats and Serbs and Muslims, and the Tutsis and Hutus, have lived in relative peace with one another—and they were all doing that relatively nicely once again until just recently," he told me. "Such interethnic violence usually gets stoked by specific individuals intent on immediate political or material advantage, who then call forth the legacies of earlier and previously unaddressed grievances. But the guilt for the violence that results does not adhere to the entire group. Specific individuals bear the major share of the responsibility, and it is they, not the group as a whole, who need to be held to account, through a fair and meticulously detailed presentation and evaluation of evidence, precisely so that the next time around no one will be able to claim that all Serbs did this, or all Croats or all Hutus—so that people are able to see how it is specific individuals in their communities who are continually endeavoring to manipulate them in that fashion. I really believe that this is the only way the cycle can be broken."

The preliminary hearings now resumed. Tadic was seated in a sort of aquarium of bulletproof glass, a panoply of high-tech gadgetry arrayed all around him and around the various lawyers and judges: instantaneous-translation devices, video cameras and monitors, computerized evidence screens, and so forth.

Inventing peace: I found myself thinking of Vermeer with his camera obscura—an empty box fronted by a lens through which the chaos of the world might be drawn in and tamed back to a kind of sublime order. And I found myself thinking of these people here with their legal chamber, the improbably calm site for a similar effort at transmutation.

I looked up at the TV monitor: the automated camera was evidently scanning the room. It caught the prosecutors in their flowing robes shuffling papers, the judges, the defense table, and now Tadic himself. The camera lingered on him—a handsome young man, improbably dapper in

a navy-blue jacket and a gleaming white open-collared dress shirt—and
then zeroed in for a closer shot of his face.

There he was, not some symbol or trope or a stand-in for anybody other
than himself: a quite specific individual, in all his sublime self-sufficiency;
a man of whom, as it happened, terrible, terrible allegations had been
made, and who was now going to have to face those allegations, stripped of
any rationales except his own autonomous free agency.

For a startling split second, he looked up at the camera. And then he
looked away.

(1995)

POSTSCRIPT

The Tadic trial dragged on for many more months, evidence for the depravity of the defendant's alleged crimes vying against equally compelling evidence of the relative insignificance of his role in the wider conflict: he had, after all, merely been a guard at the camp in question, and some felt that he was being singled out at that early stage of the Tribunal's proceedings primarily because he'd had the bad luck to get caught while much more significant malefactors had so far eluded arrest, and the Tribunal had to be seen to be doing *something.* In the end, he was found guilty on eleven counts, not guilty on nine others (for which there was found to be insufficient evidence of his specific involvement) and sentenced to twenty years in prison (a sentence which, after both sides appealed the verdict, was presently lengthened to twenty-five years).

With the passing years, the Tribunal did begin netting more—and more significant—suspects. By the end of 2003, ninety-two individuals had been brought before it, with forty-two already tried, their cases disposed. Several of these were "big fish" indeed—Biljana Plavsic, one of the highest civilian authorities among the Bosnian Serbs, for example, pled guilty in advance of her trial—though two of the most significant, the Bosnian Serb civilian and military commanders Radovan Karadzic and Ratko Mladic, had thus far managed to elude arrest.

HENRY V AT SREBRENICA

At the climax of the legendary victory that King Henry V's hopelessly outnumbered English troops wrested from their French counterparts on the fields of Agincourt, in 1415, there occurred an atrocity on a scale and of a horror almost unimaginable, even by contemporary standards. When Shakespeare came around to treating the famous triumph in *Henry V,* composed almost two centuries after the fact, he did not shy away from confronting the scene; indeed, it may constitute the defining moment of his staging of the battle. But just as, in the centuries since, the incident itself gradually receded from public consciousness—as the name *Agincourt* grew increasingly synonymous with an unalloyed sense of national pride—so Shakespeare's treatment of the scene began to fall out of productions of the play. Neither Laurence Olivier nor Kenneth Branagh, for instance, included the slightest allusion to it in their film versions, of 1944 and 1989, respectively: perhaps it seemed too starkly upending of the generally rising tone of celebration and pageantry—the sickening thud you might momentarily experience while on a breezy midnight drive through country lanes. (What was *that*? A branch? A deer? Something worse? Never mind, it's late, nothing to be done, just keep going and try not to think about it.)

The director Douglas Hughes and his star, Andre Braugher, however, have decided to put the incident, with its relevant adjacent scenes, back into the middle of their coming production of *Henry V,* previewing next week as this summer's first installment of the New York Shakespeare

Festival's Central Park season. In an effort to find out why—and how—I recently sat in on some rehearsals.

"My own first experience of the play was with the Olivier and Branagh films," Braugher commented the other morning, as the production's company was gradually filing into their rehearsal space downtown at the Public Theater. At thirty-three, Braugher is a powerful presence—a forceful, uncannily poised black man, given to expansive self-mockery (he'd often cut the tension of rehearsals by breaking into hip-hoppy Elizabethan-mock-Motown riffs—"King Harry and the Pips," as he'd boyishly josh). "But the more Douglas and I burrowed into the play and its literature," he went on, "the more I realized that it's not just a national anthem in five acts, and Henry's not some oversize grad with a giant 'H' on his chest—the conquering frat boy. The play's rather about the journey taken by this prideful, strutting boy, at the outset playacting at being the King, with all that title's lavish trappings, till at the end he's a humbled man who *is* King and knows he will one day—and, in fact, as it happens, quite soon—be meeting his Maker, armed only with his self." (The actual historic Henry V died just a few years after the action depicted in this play—at the age of thirty-five.) Most renditions of the play have tended to assume that whatever growing is to be done has already occurred in the two prior plays, when the determinedly delinquent Prince Harry, or Hal, as he's affectionately known to his rascally sidekicks—Falstaff and Pistol and Bardolph and all the rest—renounces that life in assuming his father's mantle at the conclusion of *Henry IV, Part II.* "But that's nonsense," Braugher now insisted. "If the journey had ended there, there'd have been no play here."

"We didn't want a Henry who was some kind of military superman," Hughes concurred as he came over to join us. Braugher excused himself and went to consult with the fight choreographer. "The Henry in the text is, rather, somebody who's by no means completely sure of himself. And, in fact, the whole middle portion of the play—the scenes within France

leading up to and through the battle—are for him like some extended performance-anxiety nightmare. He's riddled with doubts: Am I worthy? What am I doing here? Far from being certain of his claim to the crown of France, he's not even sure of his right to the crown of England, what with his usurping father Bolingbroke, who, as you'll recall, set the whole train of events in motion in the first play by unseating Richard II and then having him killed." It occurred to me, as Hughes said this, that with this production he and Braugher might be at similarly hinge moments in their own rapidly vaulting careers.

"It was clear there was a lot more going on under the surface of the play than is sometimes thought," Hughes went on. "But the deeper one dug into it, the more confusing it seemed to become—in part because of the density of fairly arcane historical reference. Which is where your Professor Meron's book proved so extravagantly helpful."

Professor Theodor Meron, that is, of the N.Y.U. School of Law—a leading scholar of international humanitarian law and, specifically, the evolution and application of the laws of war. And *my* Professor Meron because, as it happened, it was through him that I'd heard about this production in the first place.

I'd come to know Ted Meron over the last year, while I was covering the Yugoslav War Crimes Tribunal, in The Hague, where he has been advising the chief prosecutor. The author of such books as *Human Rights Lawmaking in the United Nations* and *Human Rights and Humanitarian Norms as Customary Law,* Meron had been inordinately helpful to me in providing background on some of the finer points of jurisdiction and proper procedure as they pertained to the work currently under way there, but what he *really* liked to talk about was Shakespeare—a relatively recent rapture in his extended career, and the subject of his 1993 book, *Henry's Wars and Shakespeare's Laws: Perspectives on the Law of War in the Later Middle Ages* (Oxford University Press), which Hughes in turn first heard about through his lawyer girlfriend.

I suppose that to the extent I had thought about it at all, it hadn't particularly occurred to me that there was *any* law of war in the later Middle Ages. What with the various Hague and Geneva conventions, the Nuremberg proscription of crimes against humanity, and the subsequent conventions against genocide, torture, and the like, I figured that such attempts to limit human violence by imposing a system of legal accountability, halting though they may be, were a relatively recent achievement in human history and, conversely, that anything before, say, the mid-nineteenth century must have been pure, unmediated mayhem. This last, in particular, was a notion that Meron used to enjoy disabusing me of during breaks at the Tribunal in The Hague.

"Actually, during the Middle Ages there was an extremely rich normative system of military law, enforced across boundaries and often honored far more than anything we have today," he told me. Meron, at sixty-six, is a survivor of the Holocaust (he was nine years old and living in western Poland when Hitler's armies came pouring over the border; somehow he made it through six years of ghettos and labor camps, though he lost both his mother and a brother who perished as one of the leaders of the Treblinka uprising), whose daily work now forces him to spend hours gazing upon some of the most vile manifestations of the human spirit. Yet he could become positively spry as he turned his mind to things medieval. He went on to enumerate the whole range of conventions that nowadays fall under the general rubric of the chivalric codes. These rules were customary, which is to say that they were largely unwritten, but they were occasionally enshrined in official ordinances, such as the ones that Henry himself decreed during the French campaigns. They articulated, for the most part, what constituted fair and honorable combat between Christian knights; indeed, they involved obligations incurred between individuals rather than between armies or states—both between combatants, that is, and between vassals and their lords. There were elaborate articulations about the types of individuals—women, children, churchmen—who were generally to be considered hors de combat, and how they were to be treated.

Not that such strictures were always observed—far from it—but they

were there as guideposts, and the question of honor was taken very seriously. There were, for instance, strict protocols dealing with the granting of quarter—how one knight was to accept the surrender, when offered, of another; and how the surrendering knight could expect, and even demand, decent treatment and protection, while the vanquishing knight could, in turn, expect a substantial ransom. In fact, elaborate conventions on ransom-giving and -taking were at the heart of the whole system, much more so, probably, than any qualms of mercy.

Of course, ransom and plunder were the medieval soldier's principal incentives in going to war in the first place—but the point is that, for all its violence, medieval war-making was still channeled to a remarkable degree. There were even chivalric courts, whose principal sanction—a very effective one, as it turned out—was ritual dishonor, the upending of a warrior's coat of arms, a mortifying prospect to any Christian knight.

Gradually, however, the system began to break down—for two principal reasons, according to Meron. First, because of technological advances—initially, as at Agincourt, archery, but later artillery and gunfire—that led to a decline in face-to-face combat, and, with it, a decline in the possibility of capture and ransom. And then because of the breakup of the unified Christian culture in Europe; the same knights had completely ignored such rules on the Crusades, for example, during their often quite brutal engagements with the infidel Arabs, and when they began seeing one another as infidels, in the wake of the Reformation, they began ignoring those rules in their own internecine religious conflicts as well.

But all the while these chivalric codes were generating quite a remarkable literature of supple, scholarly commentary. In fact, the more the observance of the chivalric norms seemed to fall away, the richer the literature about them seemed to become, almost as if in desperation. "And it's against that backdrop that Shakespeare himself enters the scene, in the late fifteen-hundreds and early sixteen-hundreds," Meron said, resuming his Tribunal-break tutorials one afternoon there in The Hague. "If you happen to approach him from the point of view of a historian of international law, you find that he can provide a quite unparalleled optic.

"For example, in *Henry V* Shakespeare affords a vast retrospective panorama of attitudes toward chivalric norms—among the various characters, but especially within the character of the King himself, whom Shakespeare portrays as an ambivalent and very complex personality. For instance, in one scene you have him concur in the hanging of one of his own soldiers—and not just any soldier but his old tavern companion Bardolph, from back in his days with Falstaff—for the crime of stealing a small ritual box from a church. Whereupon he makes that hanging an example in the speech to his soldiers that follows."

> We would have all such offenders so cut off; and we give express charge
> that in our marches through the country there be nothing compell'd from
> the villages; nothing taken but paid for; none of the French upbraided or
> abus'd in disdainful language; for when lenity and cruelty play for a king-
> dom, the gentler gamester is the soonest winner. (III, vi, 112ff.)

As Meron pointed out, this speech, which he had clearly committed to memory, could be uttered *in so many words* at just about any contemporary military academy: "That's the rationale professional soldiers urge on one another whenever they try to inculcate humanitarian norms.

"And yet, in another scene—Henry before the walls of Harfleur, near the end of that town's terrible siege—Shakespeare has the same King mouth a series of threats that read like— Well, I mean, listen." Meron pulled a tattered copy of the play out of his coat pocket and flipped to the passage. "He is warning the town's elders, gathered on the ramparts above, to surrender now—while, as he puts it, he still retains control of his seething troops."

> If not—why, in a moment look to see
> The blind and bloody soldier with foul hand
> Defile the locks of your shrill-shriking daughters;
> Your fathers taken by the silver beards,
> And their most reverend heads dash'd to the walls;

Your naked infants spitted upon pikes,
Whiles the mad mothers with their howls confus'd
Do break the clouds, as did the wives of Jewry
At Herod's bloody-hunting slaughtermen.
What say you? Will you yield, and this avoid?
Or guilty in defense, be thus destroy'd?

 (III, iii, 85ff.)

"I mean, this reads like a veritable catalogue of egregious war crimes, the sorts of horrors we're having to cope with every day here at the Tribunal—none of which, as it happened, Henry had to carry through on, since in the event Harfleur's leaders surrendered their town at the very prospect."

Meron paused for a moment. "However," he noted, "later in the play, there is that bloodcurdling incident at the climax of the Battle of Agincourt—and that threat he *did* carry through on."

It was this scene that Hughes and Braugher and their company were getting set to rehearse that morning. Which is why I had come, and why Meron, now likewise back in New York, would soon be here as well.

When the professor arrived, Hughes immediately engaged him in a fresh piece of interpretative speculation. "I've been thinking some more about that terrifying speech Henry gives at the walls of Harfleur," Hughes said. (Clearly, the two men had been in touch with each other for some time now.) "And the more I think about it, the more it seems to me a kind of bluff on Henry's part. I mean, the siege has proved a fiasco. The English launched their campaign late to begin with—in September—and this first siege, which they'd thought would take just a few days, has stretched into weeks. The English forces are stranded in the pestilential marshes outside the town, on hostile territory. Everything's going wrong. So that Henry just tries to bluff his way out of it through the sheer force of his terrifying oratory. And it works."

"I think there's much to commend that line of interpretation," Meron concurred. "The siege *was* proving a fiasco. The chronicles describe in considerable detail how the English, in their desperation, had taken to trying to undermine the town's ramparts—that is, to tunnel beneath them—and had been met by countermines: intercepting tunnels dug by the town's defenders. Can you imagine the horror of such hand-to-hand battles in those dark, swampy tunnels? It must have been unspeakable."

"But that in turn casts a whole new light on the rest of the campaign," Hughes amplified his point, "because after Harfleur it's as if Henry lost his stomach for more fighting. He just wants to get the hell out of there. He can't simply return to England: that would be too humiliating. So he launches out on a sort of aggressive retreat. Instead of marching east, toward Paris, he heads north, toward the English outpost at Calais, after which he figures he'll be able to sail home, having at least traversed a respectable swath of his newly claimed territory."

"Yes, yes," Meron concurred. "Again I think you're absolutely right."

"And it's in that context that Henry and his exhausted, depleted, plague-infested men stumble into the French trap at Agincourt."

With that, Hughes led us to a little table off to the side of the stage area and excused himself to go over to confer with his stage manager and other members of his troop. "Of course," Meron now continued, "that backdrop is essential for understanding the shape of the battle—both the miracle and the horror of what ensued. For the roughly five thousand Englishmen who then straggled into the valley field at Agincourt were vastly outnumbered by the much better equipped, rested, armored, and mounted French force"—something like five to one. "Ludicrous, virtually insurmountable odds."

It's during the night before that battle that Shakespeare has Henry take his anonymous midnight stroll among his troops, and it's the next morning that he has him make that incomparably rousing Crispin's day speech.

> And gentlemen in England, now abed,
> Shall think themselves accursed they were not here;

And hold their manhoods cheap whiles any speaks
That fought with us upon Saint Crispin's day
(IV, iii, 64 ff.)

John Keegan, one of the battle's more recent chroniclers, provides a masterly evocation of what then happened in his 1976 book *The Face of Battle,* the outlines of which Branagh followed in his film: how Henry had his men set up a hedgerow of spikes, sharpened at both ends and planted diagonally, across the pastures running the breadth of the valley. The archers stood among the spikes as they let loose their volleys, so that as the heavily armored French knights made their charge any horses that managed to get through the arrow storm impaled themselves on the spikes. Again, a horrible scene, compounded by the fact that wave after wave of overconfident French horsemen continued pouring into the melee from behind: the French almost defeated themselves. At any rate, the much more lightly armed Englishmen proved far better suited to this type of battle, especially on that rainy morning in those freshly plowed and mud-sogged fields. With astonishing swiftness, the English not only routed the French but managed to capture thousands of their fighters as well, for the most part in keeping with the requisite chivalric norms: the request for and granting of safe quarter in exchange for the promise of a hefty ransom.

A few of the retreating French veered off, probably in a panic, behind the English lines and, along with local villagers, entered the King's camp, killed some of the attendants, and made off with a certain amount of plunder. Meanwhile, Henry suddenly noticed how some of the other retreating French forces seemed to be gathering for a renewed assault. His own forces were so depleted—or so it would subsequently be argued in his defense—and his lines were so thin that he felt he couldn't afford to keep diverting any of his men to the rear of the field to guard the prisoners. Furthermore, he worried that the vast mass of prisoners might somehow retrieve their weapons and open an assault from his rear.

"So, in blatant contravention of all basic chivalric norms, he ordered his

men to kill their prisoners," Meron recounted. "The men couldn't believe their ears—honor and avarice froze them in their tracks. Again he ordered them, this time on pain of death, to kill their prisoners—and, still, apparently, they hesitated. In the end, he had to call in a band of two hundred archers—yeomen, not bound by the chivalric code—to do the job. He turned toward the utterly appalled regathering French forces and sent a herald to inform them that if they didn't give up the field not only would he continue the massacre of their confederates but he would treat them the same way in the coming battle—no quarter granted. This threat did the trick: the French dispersed in short order, and the battle was won."

Over the next few hundred years, commentators regularly debated the validity of Henry's order. Some excused it on the ground of the King's proper outrage over the raid on his camp; although, as other commentators pointed out, even if that raid had constituted a violation of the rules of war—a debatable proposition—wreaking communal vengeance on members of the same army who happened to be prisoners and were hence hors de combat could hardly be justified. More commonly, the King was excused on the ground of military necessity, but that, too, seemed to some—as it does to Meron—highly questionable. The captured French knights were still in their heavy armor—upward of sixty or seventy pounds' worth—for only their helmets and their weapons had been removed. Dismounted, defenseless, dazed, and demoralized, squatting in the mud and barely able to move, they could hardly have been regarded as constituting any sort of threat to the English troops.

"It was like killing turtles," Meron now insisted passionately. "One should at least try to visualize what was involved in carrying out that order. Look at Holinshed's version." Meron pulled out a copy of the sixteenth-century chronicler's famous account of the battle and speared the relevant passage.

Contrarie to his accustomed gentlenes, [the King] commanded by sound of trumpet, that everie man (upon paine of death) should incontinently slaie his prisoner. When this dolorous decree, and pitifull proclamation

was pronounced, pitie it was to see how some Frenchmen were suddenlie sticked with daggers, some were brained with pollaxes, some slaine with malls, other had their throats cut, and some their bellies panched, so that in effect, having respect to the great number, few prisoners were saved.

When this lamentable slaughter had ended . . .

And so forth, as Meron now summarized, on through the triumph and subsequent campaigns—Shakespeare compresses events significantly here—leading to the Treaty of Troyes, in 1420, with which the play concludes: Henry's achievement of the French King's daughter in marriage, and his being named heir to the French throne, for whatever that was going to be worth. For as Shakespeare himself notes in his epilogue, Henry would be dead within a few years, and his son's regents would quickly lose everything he'd gained in France (after Joan of Arc rallied the French in 1429) and would presently be plunging their own country into that terrible civil war of succession, the Wars of the Roses.

"Okay, gentlemen," Hughes said. He had now ambled back to us to deliver the morning's order of battle. "We're going to be working on two scenes this morning, and we'll begin with Act IV, Scene 4, the one with Pistol and his prisoner—the one that sets up the killing of the prisoners two scenes later." He pointed out that this scene was regularly left out of most productions, and noted, "That's especially striking because it's the only scene in the entire text in which Shakespeare actually has a Frenchman and an Englishman onstage fighting each other. I mean, in other scenes there are all sorts of accounts of such action offstage, and every director has felt free to scatter his own wordless, mimed swordplay choreography throughout. But in Shakespeare's actual text this scene *is* the Battle of Agincourt."

It is indeed—and with an audacity that perhaps Shakespeare alone, of all writers, would have dared to muster, it's played for a romp. At this most dramatic and tension-fraught moment in the play (for the outcome of the battle is still far from assured), Shakespeare turns to bald farce.

Pistol, who was Prince Hal's and Falstaff's mock-ruffian sidekick in earlier plays, bursts onto the stage, flanked by his considerably more sensible boy attendant, in mad pursuit of a French knight who has already lost his sword. In no time, Pistol has the knight pinioned to the ground, his sword wedged into the hollow of the poor fellow's throat—"Yield, cur!"—and the knight is blubbering away desperately: "*Je pense que vous êtes le gentilhomme de bonne qualité.*" Desperately, but to little avail, for Pistol understands barely a word of French: "Qualtitie! Calen o custure me!" Pistol barks back, grabbing the man's leg and sliding his blade menacingly along the knight's femoral artery: "Art thou a gentleman? What is thy name? Discuss." In other words, are you worth anything? Can I get a ransom for you, or should I just up and off you right here and now? (Pistol, incidentally, is a mere ensign. No knight, he's nevertheless happy to be mistaken for one if it qualifies him for knightly ransom in the Frenchman's eyes.) "*O, Seigneur Dieu!*" the frantic Frenchman implores God. "Signieur Dew," Pistol repeats, figuring that he has ascertained the fellow's name, and he proceeds to lay out for Mr. Dew the facts of his situation—how he'd better be prepared to pay up or else.

Through all this, Hughes was being wonderfully well served by his players. Jeff Weiss was a grizzled, coarse, would-be terrifying Pistol, and David Costabile was a baby-faced Pillsbury Doughboy of a knight, all bubbly with frantic Gallic charm: a winsome and utterly winning clown. When Pistol calls on his French-speaking boy, played with preternatural calm by Torquil Campbell, to translate, the boy quickly establishes that the Frenchman's actual name is Monsieur le Fer. "Master Fer?" Pistol says. "I'll fer him, and firk him, and ferret him! Discuss the same in French unto him." Across much linguistic confusion, the boy gives Master Fer to understand that short of some hefty ransom, his friend here is prepared to cut his throat—"*couper votre gorge.*" Pistol, who can barely contain his excitement, chimes in menacingly, "Owy, cuppele gorge, permafoy," at which point the knight throws himself on Pistol's mercy and promises a ransom of two hundred crowns. Pistol can barely believe his good fortune: a salacious grin momentarily flashes across his face until he regains his compo-

sure. An agreement between the warriors is quickly struck, by way of the boy, and the Frenchman bounds gratefully into Pistol's arms—a veritable human puppy. They exit arm in arm, full of merry bonhomie ("As I suck blood, I will some mercy show!" Pistol declares expansively), to the boy's ironic bemusement.

Throughout several run-throughs of the scene, Hughes kept pushing his players to goose the comedy higher and higher, broader and broader: he laughed loudly and encouragingly at each jape and pratfall—as a one-man stand-in for the entire eventual audience.

Satisfied with the final run-through, Hughes called a break while his assistants prepared for the next scene, and came over to talk with us. "It's wonderful the way Shakespeare with this scene so perfectly humanizes and individualizes both the French knight and the boy," he said, "thereby setting up the massacre of the former in the upcoming killing-the-prisoners scene and of the latter in the scene immediately thereafter, for, as you know, the boy will prove to be one of the attendants killed by the French troops marauding through the King's camp—a revelation that will to some degree undercut the stark shamefulness of the King's order."

"Not really," Meron disagreed. "One of the things that is so striking is how Shakespeare refuses to mitigate the King's responsibility in issuing that order to kill the prisoners. Interestingly, the actual, historical Henry's own court chronicler, an eyewitness to the battle, tried to do just that: in his account of Agincourt the English knights almost seem to start slaying their prisoners of their own accord, with no order from the King whatsoever. Mistakes were made. In other Shakespeare plays, his kings regularly try to evade blame through resort to a kind of deniability. In *Richard II,* Henry's own father, Bolingbroke, Henry IV, distinctly gives one of his courtiers, Exton, the impression that he'd like to see his predecessor dead, but then, when Exton goes ahead and murders Richard, Henry IV insists that he'd never meant anything of the kind. Something similar happens in *King John.* This strategy of deniability seems uncannily modern. Think, for instance, of Milosevic in Belgrade. But Shakespeare's Henry V does nothing of the sort."

Hughes, as if on cue, laid his script of the King's speech from the scene he was about to direct on the table before us:

> But hark, what new alarum is this same?
> The French have reinforc'd their scatter'd men.
> Then every soldier kill his prisoners,
> Give the word through.

"See?" Meron continued. "No subterfuge, no deniability. The order, hideous though it is, is admirably clear and direct."

When Hughes went back to huddle with Braugher and the other players, Meron related a new theory of his, about the way this specific issue must have been very much on Shakespeare's mind. "I realized this just a few weeks ago, while I was on vacation with my wife, Monique," he told me. "As we were exploring the cliffs of County Clare, in western Ireland, every once in a while we'd come upon signposts indicating the connection with the Spanish Armada. In September 1588, several vessels of the Spanish Armada were wrecked off the Clare coast. The surviving Catholic sailors were massacred by Irish supporters of the Protestant cause: no quarter, no ransom, no mercy. And all this was just a little over a decade before Shakespeare composed his *Henry V.* In a sense, his implied criticism of Henry's behavior can be read as a sort of rearguard defense of the kinds of chivalric norms that were already fast receding."

As Meron spoke, it occurred to me that Shakespeare was like a man trying to pitch his tent along a steep incline—that, even as he wrote, history was falling away into the unmediated horror of the wars of religion and all the wars that were to follow in the fog-choked valley below. In this sense, Meron and his colleagues at the Tribunal had pitched their camps on the equally precarious slopes of the far side of that valley, where Geneva and The Hague and Nuremberg rose up tentatively out of the mayhem below. Maybe that was why Meron, gazing out across that foggy vale, so readily recognized a fellow spirit in Shakespeare, clinging there on the far slope.

Meron smiled somewhat indulgently at my flight of fancy, but he did note that initial attempts in modern times to reintroduce some sort of internationally recognized law of war—provoked in part by horror at the scale of death in the American Civil War, and, at about the same time in Europe, at the Battle of Solferino, when the Franco-Piedmontese and Austrian armies, between them, managed to kill or wound some thirty-nine thousand soldiers in the space of a single day on June 24, 1859—did quite self-consciously hark back to chivalric principles. Thus the continuing rampages of technology, which had done so much to undercut the face-to-face basis of chivalry in the first place, now ironically played a role in its resurgence. "And, in fact, many of the earliest initiatives, in the mid- and late nineteenth century, had to do with this very issue of the proper treatment of prisoners of war," Meron said. "Subsequently, there has been an attempt to widen the parameters of chivalric rules—to apply them universally not just within but between tribes, religions, and ethnicities. This is where the notion of crimes against humanity comes in. And the furtherance of that kind of jurisprudence is precisely what is at stake today, for instance, at the Yugoslav Tribunal."

Hughes now gathered Braugher and the rest of his players around him before they tried once more to scale a scene that Hughes had earlier described to me as the single most daunting in the play. Addressing his players, he noted that "time and again, the audience is forced to wonder, urgently, What will the King do *now?* And, time and again, Henry rises to the challenge with decisions that audiences will marvel at or else, as in this instance, decisions that will leave them shaken and appalled. As you know, Shakespeare's language here is very spare and direct, and in earlier runthroughs we've tended to race through the sentences. But this time I want to push the resistance to his order—the shock and hesitation.

"Now, as before, Andre, you'll enter from up center, flanked by four sets of Englishmen and their prisoners, with Pistol and his prize among them.

Suddenly, in the middle of the scene, the trumpets will sound. As we agreed earlier, you'll look up in frank alarm, as if momentarily overwhelmed: *But hark, what new alarum is this same? The French have reinforced their scatter'd men!* Almost a moment of panic there, but quickly you steady yourself, you size up the situation, and your resolve is almost immediate: *Then every soldier kill his prisoners!* And that's where I want to see the hesitation. The knights freeze, thunderstruck; they stare at one another, dumbfounded. Five, maybe ten seconds. Andre, you're already rushing ahead, seeing to the next things, when you come to realize that the order hasn't been carried out. Let's maybe even ad-lib a little here—have you repeat the order: *Then every soldier kill his prisoners!* Still nothing. Your eyes lock on your senior commander on the field, Warwick: *Give . . . the . . . word . . . through.* And still more hesitation, until, finally, Warwick slays his charge and—one . . . two . . . three—the others do so as well and the prisoners start collapsing to the ground, with last, and obviously most powerful of all, Pistol: '*Coup' la gorge!*' "

"*Coup' la gorge!*" If this whole scene often fails to find its way into modern productions of *Henry V,* Pistol's final exclamation is hardly ever included. The phrase *couple gorge,* attributed to Pistol, was included in the first so-called bad Quarto, a quickie edition printed in 1600, only a year after the play's first production, probably based on actors' notes and recollections, and containing only sixteen hundred lines, compared with the more authoritative 1623 First Folio's close to three thousand lines, among which, however, Pistol's exclamation had notably dropped out. Almost all modern editions of the play follow the Folio's lead, and the scene ends with the King's "Give the word through." Andrew Gurr, the editor of the New Cambridge edition, typically dismisses the Pistol interpolation with a tart footnote: "Pistol's added 'Couple gorge' in [the Quarto] is a comic catchphrase [from the prior scene] which would lose all its comedy if immediately enacted with blood on stage." Perhaps. But the Oxford edition, edited by Gary Taylor, includes Pistol's scene-ending "*Coup' la gorge!*" in optional brackets, and Hughes is trying to figure out some way to include it.

The cast ran through the scene two or three times, each time with more prolonged and excruciating hesitations, most excruciating of all being Pistol's, as he registers with pained disbelief the sudden slipping away of his momentary good fortune.

But something was still not quite right. Hughes paced for a few moments and then lit on a fresh solution. Tentatively at first but with growing conviction, he suggested, "Instead of having Pistol's '*Coup*' *la gorge*' as the last of the series, why not have it be first? Warwick, a knight, can't bring himself to do it, locked in Henry's angry gaze though he is. But then Ensign Pistol steps forward, as if trying to recapture his old friend's attention one last time: *I'll do it! I'll fucking do it.* He sees a chance to reconnect. In fact, maybe he even cries out 'Henry!'—or, rather, 'Harry!'—or, no, '*Hal!*' What are they going to do, throw us in Shakespeare Jail if we slip in that single word *Hal*? '*Hal!*' he cries, and then '*Coup*' *la gorge!*' Him, a lowly ensign, issuing orders. And then the bloodlust rises. Maybe he even goes over and slashes the throat of Warwick's prisoner as well. And now the others follow suit: one, two, three. And we're out of here, on to the next scene. Let's try it that way."

They do, and, yes, it does work, almost too unnervingly. "Hal!" Pistol cries, and then, "*Coup*' *la gorge!*" He slashes Master Fer's throat, and the clown staggers forward, disbelieving, a look of astonishment spread across his draining face as he crumples to the floor with a sickening thud. A whole world is ending.

(1996)

POSTSCRIPT

The Hughes/Braugher production of *Henry V* in New York in the summer of 1996, of course, transpired in the immediate wake of the slaughter of the eight thousand Muslim men and boys of the Bosnian enclave of Srebrenica by their Bosnian Serb captors, during the prior summer of 1995, the most appalling massacre in Europe since the end of the Second World War. It is

interesting to speculate in this context on the similarities in the situations of the Bosnian Serb military commander at Srebrenica, Ratko Mladic, with that of Henry V at Agincourt.

At the outset of the Bosnian War, the Bosnian Serbs, inheritors of the massive firepower of the crumbling Yugoslav Army, had easily been able to overwhelm their largely unarmed Muslim and Croat neighbors (hence the sorts of depredations documented at the Tadic trial in The Hague). Only one-third of the province's population, the Serbs had nevertheless managed to capture over two-thirds of the province's territory, terrorizing and evicting the former Muslim and Croat residents en masse and laying siege to the capital of Sarajevo. Had they been able quickly to break their opponents' will and spirit, as by all rights it might have appeared they were destined to do, the war would have been a short one and their victory complete. Instead, somehow the Muslims and Croats fought on, and with the passage of time (as they in turn began bulking up their forces and securing armaments of their own), the overextended situation of the Serbs (with one-third of the population attempting to retain that two-thirds of the territory) became more and more precarious.

The two-thirds of the territory in question in fact constituted two bulging expanses conjoined by a disconcertingly narrow landbridge, around the crucial strategic town of Brcko, to the central-north of the former province (visualize an outspread butterfly, say, or an hourglass set on its side). And in the summer of 1995, Bosnian Serb and Muslim armies were converging on that spit of land for what was shaping up to be the decisive battle of the war (were the Muslims able to sever the artery, the divided Serb territories would immediately have fallen into terrible jeopardy). It was against this backdrop that Mladic resolved to rid himself of the side-annoyance of the ongoing existence of the safe haven at Srebrenica, in the middle of the eastern bulge of the Bosnian Serb territory—an outcome he secured with a lightning strike in June of 1995.

Having captured the defenseless Srebrenica Muslims, however, and with the battle for Brcko rapidly taking shape, General Mladic faced a daunting challenge: what to do with his eight thousand male prisoners.

Arguably, he couldn't just release them (and risk their joining the Muslim army massing near Brcko); nor could he spare the troops necessary to guard such a large contingent of prisoners—he was going to need every soldier he could muster. Hence, it has been argued, his Henry-like decision to launch the horrendous massacre.

Which is in no way to excuse the horror. Generals are regularly going to find themselves faced with such savage predicaments—which is precisely why the laws of war have evolved, to guide and constrain them at such terrible junctures (and which is why they are often championed most fervently by the militaries themselves). In the event, Mladic's gruesome tactic failed: NATO, shamed at last by its horrible inaction in the face of such barbarism, finally joined the battle in a serious way, bombing Serb positions for several weeks, which in turn opened the way for a lightning counteroffensive on the part of the Croats across the western Serb flanks, culminating in a cease-fire on the eve of the battle for Brcko, which in fairly short order led to the Dayton Accords ending the war—and to General Mladic and his civilian counterpart Radovan Karadzic getting indicted for war crimes at The Hague (though as of the winter of 2004, they have yet to be apprehended).

Incidentally, the Shakespearean Theodor Meron has in the meantime been appointed to the position formerly held by that Italian Vermeerlover, Antonio Casesse, as the chief justice, the president, of the International Criminal Court for the Former Yugoslavia in The Hague.

ARISTOTLE IN BELGRADE

By the time the Belgrade students, bottled up behind police cordons on the forty-ninth day of their protests, had taken to lecturing their helmeted interlocutors, over bullhorns, on the finer nuances of Aristotle's Nicomachean Ethics, you just knew that "The Situation," as everyone had taken to calling it, had to be coming to some sort of head.

Of course, in Belgrade these past many years, there have been situations and there have been situations. To begin with, there was the situation of a fractious country, survivor of a horrendous siege of internecine bloodletting during the last World War, which had never really come to terms with any of the particulars of that bloodletting since its Maximum Leader (the leading partisan general emerging from that war) chose instead to smother all nationalist intimations in a treacly communist ideology of "Brotherhood and Unity"—a strategy that worked well enough, perhaps, while he was alive but clearly failed to survive his passing. (As regards the legacy of Josip Broz Tito, there are those in Belgrade today who credit him with having forestalled the eventual disaster for as long as he did. There are others who instead put the blame for that disaster squarely on his autocratic shoulders, arguing that his refusal to allow the blossoming of independent liberalizing tendencies of any sort—tendencies which often took the form of mild nationalist and regionalist heresies, which he in turn regularly and mercilessly purged—meant that the only political figures still left standing after his death tended to be cynical, mediocre, opportunistic types who then indeed proceeded to tear the country apart in an orgy of calculated self-interest. And then there are others who, in the words of

Aleksa Djilas, an independent political analyst and himself the son of one of the greatest of the purged dissidents, point out that "the single most important thing to say about Tito at this point, in the winter of 1996, is that he's been dead for over sixteen years and at a certain point people have to start taking responsibility for what's happening on themselves.")

There was the situation, about ten years ago, of a part of that country, the Serbian lands that claim Belgrade itself as their capital, whose people suddenly and quite improbably fell under the spell of a midlevel Communist apparatchik who, sensing the fading of that once reigning ideology in the face of a looming economic crisis, instead recast himself as the fervent and almost messianic Savior of his people, to rapturously adoring response, which in turn had the effect of stampeding all the other peoples in the region into their own nationalistic seizures and the entire dissolving country into another horrendous war. There was the evolving situation of the Serbs across that war—at first blazingly triumphant but soon manifestly overextended, simultaneously sapped by international sanctions and homegrown gangster profiteers, most notably successful among the latter being the Savior himself, who now suddenly shed his warlord trappings and recast himself as a man of peace (in the process abandoning hundreds of thousands of his once adoring followers in the outlying Serbian districts to rout and ruin and a future as pathetically forlorn refugees).

By the middle of last year, the situation of Serbia was well-nigh dire—its economy cratered, its towns swollen with those aimless refugees, its industrial base virtually paralyzed—and yet the situation of the Savior himself, Slobodan Milosevic, seemed eerily unaffected by the calamities all about him. As the Tribune of Dayton, he'd managed to mesmerize the rest of the world's leaders—including Bill Clinton in the midst of his own reelection campaign—almost all of whom seemed willing to buy into his self-characterization as The Indispensable Man. Internally, he continued to hold sway over a remarkably lean dictatorial system: as long as he continued to exercise absolute control over the security forces (in particular the police) and the national media (especially state television), he didn't really much care what anybody else said or did or thought. (Visitors to Belgrade

six months ago, for example, were astonished to see prominent posters advertising showings of the new film version of *Richard III*, in which Ian McKellen reinterprets the hunchbacked villain as a modern fascist dictator. It was as if Milosevic were reveling in the comparison, virtually taunting his subjects: "Yeah—yeah—so, what are you going to do about it?") Even the pervasive economic devastation seemed to work in his favor, rendering his subjects, surly and disaffected though they might be, too frantically preoccupied with the requirements of their own immediate survival (and the fear that they might jeopardize whatever tiny portion they still retained) to consider any serious political engagement.

Milosevic's horizon was not entirely clear: there was the fact, for instance, that he was going to be constitutionally barred from seeking a third term as Serbia's president in November 1997. But such impediments hardly seemed insurmountable: the elections could be forestalled; the constitution revised; office descriptions jimmied and rejiggered. And in the meantime, he could count on the likelihood that his opposition—whose continuously hapless fractiousness had all along constituted a virtual bulwark of his own regime—would fail once again to mount any significant challenge in the upcoming two rounds of parliamentary and local elections, scheduled for early November.

Instead, however, things began going oddly. The opposition, improbably, did manage to unite behind three leaders (Vesna Pesic of the minuscule cosmopolitan Civic Alliance party; the romantic nationalist Vuk Draskovic of the Serb Renewal Movement; and the slick young Western-style politician Zoran Djindjic, head of the free market–liberal Democratic Party) who up till then had been at each other's throat, but now, suddenly, joined forces under the rubric Zajedno ("Together"), variously shredding their own respective parties in the process (factions of each of which recoiled in revulsion), but somehow managing to stick together throughout the electoral campaign, right through the runoffs on Sunday, November 17. Notwithstanding the virtually complete news blackout bedeviling the

Zajedno coalition's final campaign, they emerged from that Sunday night's tallies the upset winners, by decisive margins, in fourteen of the country's sixteen biggest cities, notably including Belgrade and the Socialist Party's onetime stronghold of Nis (the country's second-largest city). Or so anyway things appeared until State Television mysteriously suspended its reports—and the various local electoral committees (all dominated by the ruling coalition) began spewing all sorts of patently bogus claims about alleged voting irregularities as a rationale for upending the manifest results.

By Wednesday, Zajedno was crying foul, accusing the regime of having "stolen" the election (a peculiar locution in Serbo-Croat—"*ukrasti*," the word for "stealing," in lieu of the more traditional "*prevara*," or "cheating"—but one which proved highly effective since it seemed to line up with people's barely suppressed rage over all the other sorts of thefts and stealings and depredations to which the authorities and their minions had routinely been subjecting people for years). Improvising wildly, the three Zajedno leaders converged on the Parliament building, where they announced an occupation strike, or a hunger strike, or something—it wasn't entirely clear. No less taken by surprise, Milosevic likewise began improvising, evicting the Zajedno leaders from the Parliament, for starters, allegedly on grounds that the entire building had to be temporarily closed for fumigation!

Meanwhile, down the street, to everyone's surprise, the students at the University of Belgrade had occupied their faculties in protest over electoral developments. This was the generation, after all, that had grown up most completely exposed to Milosevic's saturation propaganda campaigns—they'd known nothing else—where had they come up with the notion that things might ever be any different? ("I know, I know," one of their professors subsequently replied when I asked him the question. "*That's* the miracle.") Terrified that their party overlords might take umbrage at this breach of ideological rigor, the university administrators likewise evicted the students from the premises.

These two evictions—from the Parliament and now from the university as well—were to have terrible unintended consequences for the regime.

For now, in separate, distinct, but parallel manifestations, the Zajedno followers and the students took to the streets in earnest. The students tended to gather around noon each day in Plato Square, in the pedestrian mall outside the Faculty of Philosophy, listen to speakers and music, and then head out on marches around town. Zajedno's followers, for their part, would gather around three in the nearby Plaza of the Republic under the equestrian statue of King Mihalo (the Serbian monarch during whose mid-nineteenth-century reign the Turks finally surrendered their centuries-long control over the Serbian lands) and then head off toward the Parliament building, the State Television complex (which they liberally pelted with eggs) and then back toward the Democratic Party headquarters on Terazije (literally, "the balancing scales") Street, from whose fifth-story window ledge the coalition's leaders would address the assembled throng. (Vuk Draskovic was given to climbing out on the ledge itself, theatrically, heart-stoppingly, one hand clutching the microphone, the other scrunched up against the balcony outcropping above, like some big hoary caryatid.)

The marches generally began with ten or twenty thousand participants but picked up tens of thousands more as they went along. Citizens who initially might have hesitated before hazarding attendance at an actual rally were swept along in the antic rush. The marchers in turn were cheered along by other citizens leaning out from their balcony windows (one in particular, an old lady who regularly took to waving a vast Serbian flag from her overhanging balcony, was dubbed "Grandma Olga," and today her buoyant image features mascotlike atop one of the most popular new year's calendars). State Television covered the events hardly at all, and when it deigned to do so, buried coverage late in its 7:30 newscast, featuring images taken on the scraggly edge of the crowd and narration that claimed that the marchers were limited to a few hundred spoilsports and the occasional "accidental passerby." Such coverage only served to inflame the mass of Belgraders, further adding to their rage over the electoral shenanigans. Within days, thousands were walking around sporting buttons pegging themselves as yet another "Accidental Passerby." ("Accidental,

maybe," commented one citizen, "but this city sure is accident-prone.")
Placards taunted the authorities with increasing verve and imagination.
Everyone's favorite was the sign carried by two striking young blondes:
"Even blondes get it!" Everyone's second favorite was the one carried the
next day by a decidedly more schlumpy, middle-aged gentleman: "Even
dentists get it!"

The rallies vied with each other for sheer noise. At first, the crowds jan-
gled little bells (the Civic Alliance's liberty-bell-like symbol was now dou-
bling as the clanger of an alarm clock, the subtext being "Time's up!"). A
student handball referee claims credit for having been the first to blow a
whistle, though soon small entrepreneurial fortunes were being made sup-
plying the throng with cheap, multicolored plastic mouthpieces and more
elaborate soccer-match horns and banging clangers of all sorts. Whenever
someone at the microphone would mention the name Milosevic, the
crowd would lash itself into a frenzy of madcap vituperation—louder,
louder, and louder still—for minutes and, presently, half hours at a time.
The proceedings were broadcast throughout the city over the weak signal
of the town's one independent station, Radio B-92 (early on, Milosevic's
minions tried to shut the station down, but soon relented under fierce
international pressure), and neighborhoods throughout town would join
in with their own noise-revels.

This tendency was formalized within a few weeks when it was decreed
from the podium at the foot of King Mihalo's horse that the entire town
should endeavor to drown out the noxious bleatings of the State Televi-
sion's evening newscast, and indeed, night after night thereafter from 7:30
to 8:00 all Belgrade seemed to let loose full-throttle (who knows what an
uninformed casual tourist would have made of the eruption). In the out-
lying districts, I'm told, where the fear of neighbor-informants was still
more pronounced, the first night you might only have heard the muffled
tapping of a few casserole lids from behind closed shutters, the second
maybe a few more, but by the third night, the entire district would have
come heedlessly alive with the lusty bashing of pots and pans and all man-
ner of improvised contraptions (my favorite being a tuba yoked to a vac-

uum cleaner). Radio B-92 monitored the relative decibel achievements of the different city blocks through round-robin phone-ins, and the winners were heartily praised at the next day's rallies. The State Television covered not a hint of any of it.

Surely, Milosevic must have been thinking, this couldn't go on forever; surely the marchers were going to tire and he could just passively filibuster his way, as it were, out of the crisis. The advantage of presiding over an entirely flattened economy was that nobody could really shut it down, and it was unlikely that all the disruptions (there were similar uprisings in Nis and many of the other large cities) were having that noticeable an effect on the already prostrate GNP. (Furthermore, the working class was less likely to come surging out of the factories in support of the marchers if the vast majority of them had already been sacked for economic reasons and the few who remained cowered in fear of losing what little livelihoods remained.) As infuriating as State Television's derisive obliviousness may have been to the marchers themselves, it did constitute the image the vast majority of the rest of the country was continuing to receive of the Belgrade events (which is to say hardly any at all). Winter was coming on: nothing here that a good snowstorm wasn't going to be able to stopper. Except that a good snowstorm came roaring through and the crowds, if anything, only increased in giddy delight at the muffled winter wonderland. Tens and often hundreds of thousands continued to demonstrate literally on a daily basis. Milosevic was said to be surrounded by hard-liners—notably including his wife—who were demanding some sort of more concerted response, which was probably the origin of the idea for the regime's big Belgrade counterrally on December 24.

The rally, dubbed "For Serbia" and as massively touted by the state media as the other demonstrations were ignored, was scheduled for the very time and place on Terazije Street ("the Scales," indeed) where those other demonstrations daily converged—a circumstance virtually precision-engineered to heighten tensions. That morning, busloads of Milosevic's supporters—or rather, of workers given the day off and ordered to attend—converged from all over the country. State Television

that night crowed over a throng of nearly half a million; more jaundiced observers put the figure at closer to one hundred thousand and pointed out that in any case the opposition managed to post twice as many participants for their near-simultaneous counter-counterrally. The two crowds jostled one against the other—one almost pities the guests from the provinces who'd arrived, assured that they were coming to rout a paltry fascist rabble. The buses were roundly booed, various fistfights erupted on both sides, as well as several quite serious incidents in which beefy plainclothes thugs boiled out from amid the regime's demonstrators and severely beat randomly passing protesters (by evening, over fifty individuals required hospitalization, including one man shot in the head).

Meanwhile, over on Terazije Street, Milosevic himself ascended to the podium—his first address before a public crowd in Belgrade since 1989 (uncomfortable before crowds and never particularly charismatic, he much preferred to wield power behind the scenes—till recently quite expertly— and to hobnob with the Holbrookes of the world). With growing passion, he lashed into his opponents, decrying "a fifth column" acting in cahoots with "foreign power mongers," rising to a crescendo with his sputtering proclamation that "Citizens have the right not to be at the mercy of . . . of . . . of . . ."—he seemed at a momentary loss—"of *walkers!*" (Predictably, within days, the city had blossomed over with buttons proudly identifying their wearers as yet another "Walker.")

To a considerable extent, the "For Serbia" rally backfired miserably for the regime: that night buses fanned back out throughout the country, filled with previously blinkered provincial Serbs who'd seen for themselves the true dimensions of The Situation in Belgrade and would now be broadcasting that intelligence among family and friends. More to the point, they'd witnessed the degree to which State Television was skewing its evening newscasts. One woman from Pozarevac, Milosevic's own hometown, about a hundred kilometers to the east of Belgrade, had been utterly shocked by what she'd encountered upon arriving in the capital. Approached by roving interviewers for State Television and asked for her evaluation of the evening newscasts, she'd replied, "Shameful, unbeliev-

ably bad. They're all liars!" But the greatest shock of all awaited her when she saw her comments broadcast over that evening's newscast in answer to the supposed question, "What do you think of the government's opponents?" A hard lesson which she now proceeded to convey to all of her neighbors back in Pozarevac.

On the other hand, the regime was able to take advantage of the violence (much of it, admittedly, self-generated) as the basis for a ban on all further marches through the city: demonstrations were hereafter to be confined to the Plaza of the Republic and the adjacent pedestrian malls abutting the university. Busloads of grim, helmeted police arrived to enforce the prohibition with ranked cordons wherever these might prove necessary.

The regime's opponents, however, were not without recourses of their own, many of them increasingly inspired. A small posse of guerrilla oppositionists, for instance, broke out of their confines early the next day, armed only with buckets, mops, bleach bottles, and aerosol canisters, with which they proceeded to ostentatiously "disinfect" the corner of Terazije Street from which Milosevic had delivered his address. Other students proceeded to parade single file in front of the police cordons, in glum circles, like the prisoners they claimed that they considered themselves to have become. One afternoon, a crowd massed on one side of a bridge and the police ranks massed on the other in a grim standoff until a lone dog proceeded to lope out from among the crowd onto the bridge and toward the police, at which point the throng burst into a euphoric chant of "Dog! Dog! Dog!"

Such theatrics couldn't mask the fact, however, that the opposition had been robbed of a highly effective tactic—its swarming presence on the streets of the capital—and that with time, thus marginalized, its campaign might well begin to flag. Its tacticians struggled to fashion a series of effective responses. One evening in early January, the Zajedno leaders, speaking again from their equestrian perch, urged their followers to drive into the town center the next day and then, at an agreed-upon time, for everyone to encounter all manner of engine trouble. The plan worked like a charm: all

of central Belgrade became a vast sea of honking, disabled cars, hoods up and emergency lights blinking, between which, tens of thousands of demonstrators managed to file out once again as before. Zajedno's tacticians liked that stunt so much they announced a reprise for a few days later (Vuk Draskovic, addressing the evening crowd, spoke of the cooperation between his "infantry" and his "motorized divisions"). This time, however, the police cordoned off the entire central district—not letting any traffic in or out of town—at which point the leaders merely deemed the police to have been appropriated as part of their demonstration since, together, they'd all managed to bring the city to the standstill that had been the main idea all along.

The morning of the Serbian Orthodox Christmas (celebrated on January 6) saw the latest installment in what was fast becoming a veritable charm offensive aimed at the police themselves. The three leaders, bottled up once again in the square surrounded by police cordons, announced their intention to move from the horse's hooves right up to the police lines themselves, but only so as to greet the men individually and extend them Christmas wishes. The whole crowd surged along behind, in a merry mood. Draskovic, with his long black hair and flowing beard, looking for all the world like some gilded Orthodox icon, moved down the ranks, blessing the policemen with his microphone. The next day he used the microphone to address them more directly. "I am addressing you," he declaimed from the top of a jeep that had been moved right up to the edge of the cordon. "We don't want anything from you except that you obey and honor the law. Think about the man whose illegal orders you are now serving to implement. Nobody's candle lasts forever. When this is all over, you have to be able to look your son and father in the eye. If I were you, I would come over to our side. You should join with us, join with our nation's history as it is marching forward. Right now you are only guarding the past."

The policemen gazed forward, impassively. It was hard to tell what they were thinking. This, after all, was Milosevic's archenemy, the man against whose sinuous enticements they'd been most fiercely warned during their indoctrinations. Such reserve tended to melt, on the other hand, when

the police—many of them themselves just young kids—were confronted by the students. Perhaps taking cognizance of this fact, the students announced their next gambit. As of the next day, they would march out of the square and into Terazije Street, right up to the police lines. There they would stop and wait it out, as long as it took, all day and all night and all the next day if necessary, until the police relented and let them resume their daily marches. And in the meantime, so as not to waste everyone's time, they'd launch their Police University.

And so it began the next morning: the reading over a bullhorn, for starters, of the entry on "Morality" from a junior encyclopedia. "After all," it was explained, "these are just beginners, we've got to take it slow and easy." From there on to Plato and Aristotle, classes on Serbian history and literature, and so on. The police were aligned in a sort of U-shaped plug, the base of the U facing the throng of students and the legs extending back up either side of the avenue, allowing pedestrian traffic along the sidewalks but preventing anyone's drifting into the center of the road. Clumps of students kept extending their way up the sidewalks, forcing the police to stretch their lines and thereby liberating individual policemen for "intensive private tutorials." By midday, the police were having a hard time keeping a straight face, by midafternoon they weren't even trying. Every few hours the current unit would be marched out ("Class dismissed," the cry went up from the crowd, "Recess!") and a new unit marched in. ("It's better that way," someone commented. "Don't you find that after a few hours the learning curve really begins to drop off?") Class resumed: a reading from Walt Whitman, of all things. Students from the medical faculty detailed the pernicious consequences for spinal alignment of the continuous wearing of bulletproof vests. Followed by more Whitman, and more of the Nicomachean Ethics.

Observing the scene, Milos Vasic, a crusty, wizened independent journalist and longtime student of the police (in fact, himself a former policeman) noted how "Cops are calculating and self-interested, they're figuring—what?—'I'm twenty-eight, with four years of police training behind me and however many years before I can retire with my pension—

do I want to blow it all defending this guy?' Already Milosevic can no longer rely on his Belgrade boys. He keeps on having to bus in guys from outlying districts. But then they too get contaminated. They say the shelf life for a good, regime-loyal cop these days is no more than a week."

Well past midnight and the students were showing no sign of letting up: a good ten thousand of them still crowded toward the base of the U, having a rollicking good party, fraternizing joshingly with the boyish cops. (An old man in his pajamas leaned out forlornly from his fifth-story balcony overlooking the raucous scene: *Who does somebody have to call to put an end to this kind of racket?*)

Four police commanders in the center of the road consulted nervously, edgily eyeing the manifestly deteriorating discipline all around them. And The Situation lurched that much closer to a climax.

It was all quite marvelous and rousing and daft. A veritable carnival, as velvet as velvet could be.

And yet . . . This wasn't Prague, after all, this was Belgrade, where ten and nine and eight years earlier, as the dictator Milosevic had been in the process of consolidating his power, throngs just as lusty and passionate and virtually unanimous had exulted in his bloodcurdling bacchanalias of nationalist renewal, thereby helping to precipitate their country into some of the most horrendous episodes of ethnic carnage in the modern era. Where had all these people been during the decimation of Vukovar, the shelling of Dubrovnik, the siege of Sarajevo, or the massacres at Srebrenica? This was a city with blood on its hands, and it was by no means obvious what the attitude of the people massing in their new throngs was to all that blood, or if, indeed, they had any such attitude at all. Yes, they were demonstrating against Milosevic's theft of an election, but why exactly had they voted against him at all? To the extent that the legacy of the war had factored in their decisions, were they voting against him for having joined the war in the first place, or rather for having abandoned it halfway through? Were they enraged about having fought the war, or

about having lost it? The signals were decidedly mixed—what was one to make of that sea of arms raised in the traditional Serbian three-fingered salute? On-scene reporting tended to refract in all sorts of directions (Chris Hedges in his coverage for the *New York Times* in particular seemed to highlight some of the more disturbingly recidivist nationalistic under-tones at the rallies, even among the students). This was perhaps why all around the world, many of those who'd once so enthusiastically opened their hearts to the marchers in Prague were still tending to hold back, hopeful but decidedly wary, as they observed the unfolding developments in Belgrade.

I know I was, observing developments during November and into December from my office in New York. Both hopeful and wary, I recalled a visit I'd made to Serbia just the previous summer as part of an ongoing project regarding the War Crimes Tribunal in The Hague, and in particular I recalled a conversation I'd had, sitting in a Belgrade café with an opposi-tionist journalist, of whom there were at the time still dismayingly few. She in turn had been recalling her own experience of the late eighties and early nineties there in Yugoslavia. For some reason, she said—and she couldn't really explain why—she hadn't at the time succumbed to Milosevic's rag-ing propaganda campaign. In fact, she elaborated, she'd kept herself almost studiously oblivious to the swelling surge of nationalist hysteria sweeping over her fellow countrymen, there in the Serbian capital—the growing rallies, the thronged marches, the midnight masses of lusty, near-messianic patriotism. "It was all so stupid, so beneath contempt," she said, "this transparent gambit of Milosevic's to cast himself as some kind of Sav-ior of the Serbs, when of course he'd never been the slightest kind of nationalist before. And the response he managed to evoke was mystifying, to be sure, but it too was just too stupid to spend time thinking about. Surely it would pass, and in the meantime I felt justified in ignoring it." She paused. "Then, one night," she recalled, "I was watching the evening news, and they had footage out of Zagreb, the Croatian capital—a huge nation-alist rally there, a shouting throng chanting these bloodcurdling *Croatian* patriotic slogans—and I remember thinking, all at once, "Oh my god, *we're*

driving *them* crazy!" And suddenly I saw it all clearly, how it wasn't just going to pass, and all the horrors that were going to come. And that have."

I was recalling that conversation, as I say, in part hopefully, because it seemed justifiable to hope that if the Serbs in Belgrade were indeed now in the process of driving themselves *sane,* just maybe such a process could once again prove catalytic, helping return a measure of sanity to the entire region. (After all, Croatia's tin-pot dictator, Franjo Tudjman, was known to be in the process of dying of cancer. Who knew how things would tend thereafter in Zagreb—though couldn't a reversion to sanity in Belgrade be expected to contribute to similar tendencies there?)

On the other hand, however, was a reversion to sanity in fact what was going on in Belgrade? On the more wary side, I recalled the sheer extent of the "brain damage," as I'd taken to calling it at the time, that I'd encountered during those Serbian travels six months ago.

For instance, there was the money changer I'd met up with outside a cafe in Pozarevac, Milosevic's old hometown—a strapping, burly fellow with a few days' growth of beard. What did he make of the country's situation? "Well," he began, "what do you expect with a country that's being ruled by a woman?"—a reference, of course, to Milosevic's wife, Mira, who's all along been considerably more despised than he is. I invited the fellow inside for a drink, where it turned out that he was a Serb from Kosovo, the ancestral Serb lands whose ethnic Albanians (who now made up 90 percent of the population) had provided the original occasion for Milosevic's lurch toward hypernationalism back in 1987 (he'd claimed that the Albanians there were persecuting the remaining Serbs). What did the money changer think of those Albanians? "Oh, you know," he said, "unlike a lot of people up here, I was living with them on a day-to-day basis; they were my neighbors and my friends. They're an honorable people. They weren't hurting anybody." And what had he thought of Milosevic's coming to the Kosovo capital Pristina in April 1987 and promising the local Serbs that he wouldn't allow anyone to beat them? "That was great. *That was great!*" Or of the president's return visit, later that year, for the Serbian nationalist celebration of the six hundredth anniversary of the Battle of

Kosovo? "Wonderful, wonderful. I was there. It made me *proud.*" He went on to describe how, fired up with all that pride, he'd volunteered for the army and had therefore been able to take part in, as he put it, "the liberation of Vukovar"—the decisive battle of the first Serbo-Croat phase of the war in which the picturesque town along the Croat-Slavonian side of the Danube River was quite literally leveled. In fact, he'd fought in all sorts of battles—he regaled me with tales—and what really pissed him off these days was the way "that coward Milosevic" had taken all that blood, the blood of Serbian martyrs, and just thrown it all away, abandoning the Krajina and Eastern Slavonia and the graves of all his comrades. Who, I asked him, did he intend to support in the upcoming elections? Without batting an eye, "Milosevic," he replied.

One hesitates to make vast general statements about the mentality of an entire people, but this conversation was entirely typical of the kind I had with dozens of other Serbs as well. (There has, perhaps, been a kind of homogenizing of the Serbian mind, so to speak, under the pressure of the past decade of war and the forty years preceding that of Communist indoctrination, particularly under the pressure of State Television. As one despairing dissident told me, "People around here carry television sets between their shoulder blades in the place of heads.") Tendrils of rationality seem to float in the ether: you'll get thirty seconds of pristine reason, followed by a ten-second free fall through the abyss, followed by another twenty-five seconds of complete common sense. (Was this exploded remnant what a mind looked like after a war, I sometimes found myself wondering, or was it the kind of mind that lent itself to a war project in the first place?)

To put things another way, using a computing metaphor, it was as if there were certain crucial flaws in the Serbian operating system. For instance, the notion that you couldn't believe both A and B, if B had elements in it that were contrary to A. If at first you believed A and then B came along, you'd either have to reject B on the basis of A or else change your mind about A—at any rate, you'd have to *make up your mind.* This simple notion of the incompatibility of opposites—a fundament of stan-

dard logic—didn't seem to perturb many Serbs. (They could simultaneously feel that their neighbors were affording them no threat and exult at a visiting demagogue's promise that he wasn't going to let those neighbors "beat you anymore.") Nor did they seem unduly bound by its corollary, the notion of consequences, the sense that if you in fact come to believe X, this may have implications for how you then have to behave in the world. (They saw no problem in roundly despising a leader and simultaneously planning to vote for him.)

In fairness, there was a certain almost Pavlovian logic behind this turn of mind: it wasn't hard to see where it came from. For decades, state propaganda had blithely spewed forth all manner of contradictory positions simultaneously—most recently the notion that this man of war had in fact been a man of peace all along (a notion with which many of the world's leaders had for that matter been all too willing to play along). As far as this question of consequences went, when in the last fifty years had anything any Serbian subject thought politically had any bearing on what he was then allowed, let alone enabled, to do?

This general turn of mind proved all the more disconcerting when the mind in question was invited to turn to the specific question of the recent war. Six months ago, Belgrade was in the high summertime of Milosevic's peace offensive. "We fought and we lost," as the film director Srdan Drago-jevic parsed the matter, "and now they're doing everything possible to convince us that we didn't fight and we didn't lose." And Belgraders generally seemed all too eager to go along with the conceit.

In the late 1980s, most Belgraders had been caught up in Milosevic's crusade toward a Greater Serbia—the exalted fantasy, that is, of "All Serbs in One Nation," with its attendant requirement of drastic territorial revisions, bloodily achieved if necessary, such that any non-Serbs in outlying districts that included Serbs would either have to leave (voluntarily or by force) or else subject themselves to the Greater Serbian hegemony. At first, the ambition seemed not altogether implausible (after all, the Serbs had inherited the bulk of the equipment from the former Yugoslav Army), but by the beginning of last year, all Milosevic had ended up delivering was

the perverse obverse of that original dream: virtually all Serbs *were* now living in one state, but that was only because those in the outlying areas (with the possibly temporary exception of certain swaths of Bosnia) had been utterly routed and forced back into the narrow confines of the original motherland as abject refugees—a debacle of truly world-historical proportions. Serbs had been living in the Krajina and Eastern Slavonia for centuries—neither the Balkan Wars, early in the century, nor either of the subsequent World Wars had managed to dislodge them—but not anymore. And yet, far from being welcomed or even minimally succored in their receiving motherland, these refugees seemed to be even more despised than the far-off Croats or Muslims, those ostensible blood-enemies of yore—in part, perhaps, because they so vividly incarnated both the war and the fiasco everybody else was attempting so fervently to forget.

There were, of course, exceptions to this general frenzy of obliviousness—for instance, Dragojevic's wrenching film treatment of the Bosnian War, *Pretty Village, Pretty Flame,* which was enjoying a popular run during the weeks I was there. (Trolley cars, entirely covered over with painted smoke and flames to advertise the film, floated eerily about the town.) But even these proved distinctly problematic. Dragojevic's film, for instance, adopted a vividly cynical, catch-22-like posture toward war in general, and though it didn't shy away from suggesting a few Serb-spawned atrocities around the edges of the action, it tended to characterize the war as principally one of mass psychosis—everybody (Serb and Muslim alike) going equivalently crazy—and presently devolved, during the last half of the film, into the story of a hapless band of Serbian irregulars holed up in a dead-end tunnel, pathetically pinned down under a witheringly merciless siege. Though allegedly based on an actual historical incident, this was, to put it mildly, an odd way of encapsulating the Bosnian conflict as a whole, though, even more oddly, it was one to which the Bosnian Serbs themselves often seemed to subscribe. (On countless occasions during my travels through the Republika Srpska last summer, I had Serbian veterans of the siege of Sarajevo—from snipers through government ministers—insisting to me that *they* had been the ones under attack, or, as one official

assured me, that they'd never been the first to fire, only ever doing so when forced to by rampaging Sarajevans coming boiling out of their valley fastnesses, inexplicably hell-bent on breaching their lines. "*What siege?*" the Bosnian Serb vice president had demanded of me adamantly one afternoon in his grungy Pale office. "*We* were the ones who were surrounded. They had us surrounded three hundred and sixty degrees!")

When it came to the question of moral responsibility for the war, Serbs had, as my crusty cop-reporter pal Vasic liked to put it, "a blind spot the size of Bosnia-Herzegovina." Or, as I sometimes came to feel, reverting to my computer analogy, a definite bug in the software. Belgraders didn't want to talk about it at all (what, after all, did any of those barbarian controversies among the "Mountain Serbs" have to do with them?), but if you persisted, it could get to be as if you'd barely finished typing in, say, the word *Srebrenica,* when the screen would spontaneously pox over in a veritable blizzard of frantic rationalizations. "Oh, yeah, but what about . . . ?" What about Cambodia (how come nobody paid any attention to that? Why is it always only the Serbs who get picked on?). What about Vietnam (how come no American presidents ever got hauled to The Hague?). What about the NATO bombing runs on our guys (wasn't that a war crime?). What about the twenty Serb villagers massacred in the environs of Srebrenica in 1992? And what about the Ustasha massacres in 1944? And what about the Turk treachery at the battle of Kosovo in 1389? What about the ten thousand Krajina Serbs who completely disappeared during Operation Storm last year?—a total fabrication but an eminently convenient one, since it so neatly seemed to balance out the eight thousand Muslims still unaccounted for, and presumed dead, in the wake of Srebrenica. And anyway, how come everybody so easily credits that eight thousand figure, simply because it puts Serbs in a bad light? Has anybody actually seen the eight thousand bodies? And how do you know they didn't simply go around executing themselves, just to make the Serbs look bad? (After all, Muslims are famous for that sort of thing.) And anyway, what about the German-Vatican conspiracy against the Serbs? What about the famous Trilateral Commission/Council on Foreign Relations plot?

The information minister in Pale tried that last one out on me. So, I'd asked him as our conversation was winding to a close, seriously, why did all this happen? "You should know," he replied, a Cheshire-cat grin spreading across his face. How so? He proceeded to detail for me elaborate minutes from secret meetings back in the seventies and early eighties in which high-level officials at the Trilateral Commission and the Council had conspired to bring about the dissolution of Yugoslavia and its conversion into a base for American ground forces—precisely the outcome that had in the meantime come to pass: QED. I responded that things were probably much worse than he could possibly imagine, that more likely, during the seventies and eighties, nobody in the United States had been giving the slightest thought to the fate of Yugoslavia—that it was the last thing on anybody's mind. He looked at me pityingly. "Oh yeah," he said, preparing to launch his ultimate salvo. "How come is it, then, that this war ended the minute you guys decided it should end?" But it only ended, I pointed out, because "us guys" had finally bombed you. His Cheshire grin resumed: "Precisely," he said. "How come you didn't do it sooner? You knew that we were destroying ourselves. You *wanted* us to destroy ourselves."

Another time, during a break in the proceedings in the Tribunal's anteroom in The Hague, a Bosnian Serb reporter took me aside and sagely explicated how the one thing I needed to understand was how the primary engine of the past hundred and fifty years of European history was a German-Jewish conspiracy to do in the Serbian nation. A German-Jewish conspiracy? I repeated—I wasn't quite sure I'd heard correctly. He nodded. Okay, I responded tentatively, but where did that put the Holocaust? "Makes you wonder, doesn't it?" came my interlocutor's all-knowing reply.

The evening I went to see Dragojevic's film, I struck up a conversation with the woman the next seat over and we subsequently went out for coffee. She'd clearly been deeply affected by the film. She told me a bit of her life history—she was thirty years old, a kindergarten teacher; she'd been visiting her brothers in the United States during the late eighties when, overcome with homesickness, she'd made what she described as the mis-

take of her life, returning to Belgrade just as the country fell apart; she hated Milosevic but was otherwise somewhat confused politically. She was a good person. (I've often thought somebody should write a book about the Serbs: *When Bad Ideas Happen to Good People*.) I took my time—it takes a while, talking with Belgraders, especially if you're an American, before you can establish your credentials, that you're not some knee-jerk Serb-hater, but I thought I'd done so—and after an hour or so, I hazarded out upon the topic of Srebrenica. "So a couple dozen Muslims were killed," she shot back defensively. "Why does everybody keep beating us over the head with that?" I suggested it was more than a couple dozen. "Okay, so a couple hundred—it was wartime, what do you expect?" No, I persisted, it was more like several thousand. She hesitated: how did I know? where was the evidence? I explained that I'd been at some of the mass gravesites and I'd heard eyewitness testimony from survivors. I described how men were taken off buses by the hundreds, their arms bound behind their backs, paraded to ditches and machine-gunned in cold blood for hour after hour after hour. She was silent for a few moments—authentically shaken, it seemed. Not that she was hearing this for the first time, I don't think, but maybe that she was being forced for the first time truly to listen and to take it in.

She sighed and steadied herself. "Well," she replied at length, "I knew someone in Croatia, a Serbian girl working in a restaurant, and one day these bandits came barging into the place, lined the staff up along a wall, selected one boy at random, killed him, and then told all the others that if they ever so much as breathed a word about it, they'd come back and kill them, too."

I waited for the rest of the story but it gradually became clear that that was it—there was no more. By my expression it must have been evident that I was failing to fully grasp the moral equivalence between the two episodes.

"The point is," the woman elucidated, "the boy at the restaurant—they *stabbed* him."

I still wasn't getting it.

"They stabbed him! Can you imagine? *Stabbed.* I mean, the people in Srebrenica, okay, so there were more of them, but at least there they were machine-gunned, so they all died instantly, mercifully. And each individual can only die once. But try to imagine the agony of that poor Serb boy who was stabbed like that for no reason."

Like I say: Brain damage.

"You never hear of a Serb just dying in battle," as my gruff cop-reporter pal Vasic likes to say. "They're always being 'butchered' or 'slaughtered' or 'massacred.' "

And indeed, Serbian culture is pickled in the brine of the epic, the heroic, the mythomaniac—the endless cycle of mindless atrocity and atrocious retribution. I had found myself thinking, during my few weeks last summer when I was traveling around the country, that what the people of the Balkans generally, and the Serbs in particular, really needed was a transition from the epic to the tragic, from the Homeric to the Sophoclean: Oedipus, the evidence of his own tortuously tangled complicities staring him full in the face the entire time, and yet he just can't see, he can't see, he can't see, until finally, in a great purging moment of cathartic revelation, the scales fall from his eyes and he does see. He sees, he acknowledges, and somehow he goes on. Or Euripides (who even managed to write a play from the point of view of the *Trojan* women!): how in his *Bacchae,* Agave comes staggering home from her Dionysian revels, exultant, triumphant, brandishing in her arms the bloody lion's head she'd earlier managed (in her ecstatic delirium) to tear free with her own bare hands, only gradually (under the gentle prodding of her horrified father) coming to realize ("I do not understand this question—and yet I am somehow becoming in my full senses, changed from my previous state of mind") that this is no lion's head wrenched clean from its roots but rather that of Pentheus, her own beloved son.

That was the sort of great purging cathartic realization and self-recognition that seemed so desperately called for and yet so endlessly fugitive last summer in Belgrade.

Could it be, I found myself wondering, as I sat there before my TV set in New York these past several weeks, transfixed before the newscasts emanating out of Belgrade, that at last it was beginning to occur?

Anyone headed for Belgrade these days seeking evidence of an authentic cathartic transformation is bound to be disappointed—though he may be asking the wrong questions.

And, indeed, initially I, too, was somewhat disappointed. The joy in the streets, such lively inventiveness, the verve of long dormant political engagement—of course, all that was wonderfully engaging. But there was a hollow in the center—the roar of everything that was going on left conspicuously unsaid. (I was reminded of Sartre's critique of Freud's notion of the unconscious in *Being and Nothingness,* composed in the immediate aftermath of World War II—how repressed material, far from being salted away and hidden from consciousness, as Freud posited, surely must have to persist at its very forefront: being virtually all the mind can think about, though of course in the mode of strenuously laboring to avoid even accidentally happening to think of it.) One of the most common placard slogans in Republic Square—the exultant "Belgrade Is the World!"—might at first have seemed an innocuous riff on the "Whole World Is Watching" of Chicago 1968 or the universalist "We Are the World." But there was at the same time something strainingly solipsistic about it. Well, no, actually— you found yourself wanting to say—Sarajevo and Vukovar and Srebrenica and Dubrovnik and Kosovo, for starters, are *also* the World: *what about them?* For they were hardly ever mentioned—either from the podium or in the throng.

In their stead came the lusty, full-throated denunciations of Milosevic and Mira—the half-hour catcall deliriums. There was, as ever in the crowds of Belgrade, this note of righteously plaintive grievance, of all the terrible things that had been done to them, the Serbs, while they'd just been innocently minding their own business, whether it be by the Turks or the Croats or the Germans or the Americans or—as now—by Slobodan

and his evil wife. Of course, such concentrated vilification was yet another way of occluding any inklings of one's own possible co-responsibility. ("It will all be scapegoated onto them," my gruff pal Vasic predicted, "which at one level, of course, is unfair and even self-delusional, though, at another—what the hell, the bastards have it coming!") "Milosevic to The Hague!" a boozy fellow in a tattered trenchcoat boomed forth quite unexpectedly one evening in the Plaza—"Slobo to the Tribunal!" My companion that evening immediately recognized the fellow as an outdoor CD vendor who a few years ago could just as regularly be heard hawking the most bloodcurdlingly virulent anti-Croat cassettes with equally self-satisfied gusto.

Of course, not everyone in Serbia was equally co-responsible for the dismal hypernationalist hysteria that swept over the country in the late eighties. Although it's common nowadays to assume that this was some countryside or lumpen virus that mysteriously overtook the urban elites, in fact what actually transpired was quite the reverse. Many, if not most, of the Belgrade academic and cultural elite (including the president of the Serbian Academy, the novelist Dobrica Cosic, and such colleagues of his as the internationally best-selling novelist Milorad Pavic of *Dictionary of the Khazars* fame and the poet Matija Beckovic) featured among the most fervent incubators of the original Greater Serbia project. As Aleksa Djilas likes to characterize the situation of the country's less exalted subjects during that period, "It would be as if you went to some quack homeopath and he told you you had to amputate your perfectly healthy right arm—of course, you wouldn't do it. But if you went to a top-notch M.D. and he said the same thing, and then to another specialist and he agreed, and then to every other expert in the town and virtually all of them concurred, sooner or later you'd probably submit to the operation." And the point is that many of those same experts are now prominent among the backers of the current uprising as well—addressing rallies, currying favor with the students—in part, no doubt, to launder their prior reputations; but in part, as well, to try and repackage their as-yet-unrepented original ideological project.

I myself paid a call on the students one day—that is, on a group of their

leaders gathered together for one of their famous brainstorming sessions. Nebojsa Popov, the old oppositionist sociology professor who'd earlier described the sudden upwelling in this generation as nothing short of a "miracle" ("How—from where?—could they ever have gotten it into their heads," he marveled, "first of all that elections in Yugoslavia were ever anything to be taken seriously, or secondly, having decided to take them so, that they'd ever be in a position to do anything about them?"), went on to offer a surmise. Perhaps, he suggested, part of the answer lay in the fact that the two principal weapons with which Milosevic lorded it over the rest of the population—fear and shame—had no purchase on these kids: they had the heedless fearlessness of youth everywhere in the world but, more to the point, having been barely pubescent at the time of some of the worst hysteria, they had nothing to feel personally ashamed of.

With this characterization in mind, I allowed myself to imagine that I might encounter some clearer thinking about the past among these students, and at first I was indeed quite heartened. The students voiced particular dismay over the way they'd been characterized in some of Chris Hedges's reporting in the *Times* (they'd clearly been tracking the clippings) as a band of (their characterization of his characterization) maddog Serbian nationalist cryptofascists. And indeed, far to the contrary, they presented themselves as conscientious and levelheaded, simultaneously aware of the immense stakes involved in the struggle upon which they'd embarked and yet unwilling to take themselves overly seriously—an altogether winning combination.

Encouraged, I decided to hazard the Srebrenica question; however, that instantaneously provoked the bug in the software: Which Srebrenica—1995, 1992, 1941? Why not Pol Pot? What about NATO's bombing runs? Every American president since Franklin Roosevelt? And anyway, what about Srebrenica? From what one of the kids understood, there'd never been any eight thousand massacred—this had been *proven*—there'd only been fifteen hundred Muslim soldiers who'd tried to fight their way out of the siege and ended up getting killed in the ensuing battle. (Everyone else nodded in assent.) And so forth.

The kids rejected the notion of collective guilt absolutely—only individuals could be held liable for crimes, whereas the Serb people as a whole had absolutely nothing to be ashamed of. Sure, there had been a few war criminals and these deserved to be tried—but by national courts, and not by that farce in The Hague, which clearly had it in for the Serbian people as a whole. (This last formulation was one I came upon repeatedly, and it was especially ironic, since both Judge Richard Goldstone, the original chief prosecutor in The Hague, and his successor Louise Arbour have repeatedly proclaimed that one of the main rationales behind their entire exercise is the desperate need to establish individual criminal liability for heinous war crimes precisely as a way of breaking the terrible cycle in which otherwise unassigned guilt gets attributed to the entire group, thereby serving as an excuse for subsequent retaliatory rounds of interethnic violence. This is a message which manifestly has not gotten through. Indicted war criminals—and those who fear that they may yet one day be indicted as such—whether in Serbia, the Republika Srpska, or Croatia, have been almost entirely successful in convincing their countrymen that the Tribunal's animus is directed toward all the people as a whole rather than any specific individuals, so that vigilant defiance becomes almost a patriotic imperative.) "You see," one of the more circumspect students now interjected, "we are afraid of the humiliation of our people. The humiliation of a nation is a terrible thing."

To a certain extent dismayed by conversations such as these, I'd gravitate back to the afternoon rallies and feel newly encouraged. For bracketing this question of the past for a moment, what was happening right now in the Plaza and on the streets along the police cordons was deeply impressive: the resolute good humor, the striking commitment (endlessly reasserted) to nonviolence, the sense of purpose and (I suddenly realized) of consequence. It was as if the "operating system" part of the "brain damage" were magically beginning to correct itself right there before one's eyes: these people were thinking consequentially (if one came to feel X,

this meant one would have to *do* Y, and in order to do so effectively, one would have to sort out one's feelings about A, B, and C in a logically coherent manner)—they were making up their minds.

In addition, as Aleksa Djilas pointed out, "Whatever one's misgivings, one has to acknowledge these events for the breakthrough they are. It's been incredibly rare in Serbian history that people have demonstrated like this on behalf of *democracy*. There have, of course, been nationalist demonstrations and monarchist demonstrations and, in 1968, left-wing radical manifestations which lent themselves to manipulation by Tito as a way of repressing party liberals. But here people are on the street, day after day, on behalf of a single focused demand: *they want the results of an election honored*. This is new, surprising, almost unaccountable—a profoundly hopeful development."

"They want to like themselves," the sociologist Popov commented. We were talking about the almost giddy tenor of some of the assertions rising up, especially from the students at their podium: how Belgrade was becoming "the World University for Nonviolent Protest" (people from Sofia to Seoul were aping their tactics); and so forth. "They need something to be proud of," Popov went on, "and all that is to the good. You have to realize the sort of nationalist fog we've been living through the past several years—the bogus, hysterical pride. But if people begin to like themselves as defenders, say, of the right to vote, once they begin to see themselves as defenders of individual human rights on behalf of themselves, this will launch a new sort of discourse and they may begin to see the relevance of those rights as they pertain to others as well. In fact, it's already happening. For me, the single most impressive thing so far happened the other day when Vuk [Draskovic] was at the podium and he suddenly called for a moment of silence on behalf of an Albanian recently killed in police custody in Kosovo. I cringed as he issued the call—tens of thousands of people spread out there in the Plaza: I was just waiting for the inevitable whistles and catcalls. But no: not a sound. It was deeply moving: you see, people want to be better than they are."

I was repeatedly told by longtime oppositionists how my hankering

for instant clarity about the past was unfair and premature. These were agonizingly difficult truths that were going to have to be fleshed out and absorbed. The kind of pride people were beginning to feel was a precondition—necessary though not in itself sufficient—for future self-questioning. The outright contempt people were now expressing for State Television as they watched their own activities so hideously misrepresented over the evening news broadcasts—with time, this might yield retrospective insights as well. (Why did they believe what they believed about the past? Where, after all, had they gotten their information in the first place?) For that matter, once the state's virtual monopoly on the media was at last effectively upended, all sorts of fresh information could be expected to pour in (much of the Serbian fog simply consisted in the lack of availability of hard facts). The Tribunal itself might prove immensely important. Latinka Perovic, a longtime oppositionist historian and one of the few unequivocal advocates on the Tribunal's behalf whom I encountered in Belgrade, noted that "The careful, meticulous establishment of individual criminal guilt may constitute the first step in initiating a process whereby people will be able to engage in reflections on wider moral responsibility." When people come to understand that they are not being held personally liable for what happened in, say, Srebrenica—nor should they be (that those who should be are being held to account)—then they may be able to drop the defenses that currently keep them from considering their more generalized culpability.

But it's going to be a long-term process, I was repeatedly assured. It's not something that can be shouted from the podium. "Catharsis will be individual, capillary, not global," the sociologist Popov predicted. Another longtime oppositionist suggested an analogy to psychotherapy: "These are truths you can't thrust on people—they have to come to them themselves, one at a time, and in their own good time." People often invoked the analogy of Germany, where the process of de-Nazification had taken over a generation.

All of which was fine, as far as it went. The trouble was that the Serbs might not have the luxury of a generation to come to their senses about

the immediate past. For all the analogies I kept hearing to the situation in Germany after World War II, it seemed to me far more likely that Serbs in the years ahead—assuming they're able to rid themselves of Milosevic and his cohorts one way or another—will be facing a situation far more like Germany's after World War I: a fragile, inexperienced, rickety democracy; an utterly devastated economy and a decimated, once-proud middle class; all sorts of resentful, unemployed war veterans milling around convinced (like my money-changer friend in Pozarevac) that they were stabbed in the back, that the victory they'd achieved in battle was squandered at some far-off peace conference.

In fact, as some have been noting nervously, they've already got a poten-tial Hitler in their midst. All the exhilaration over Zajedno's performance in the local elections has tended to cloud over the fact that the Serbian Radical Movement of Vojislav Seselj (pronounced "Scheshel"), one of the most notoriously ruthless of the paramilitary commanders, scored only one hundred thousand total fewer votes. Seselj himself was elected mayor of the Belgrade suburb of Zemun, where his impact has been immediate: he is quite literally making the buses run on time; he is at his desk fifteen hours a day and has let it be known that he expects similar devotion to duty from all the other municipal employees (bureaucratic applications that used to require weeks to course through city hall's sclerotic arteries are now being processed in a matter of minutes). He has also let it be known, in all seriousness, that he considers the solution to the Kosovo problem to be the enforced inoculation of the majority Albanian population with the AIDS virus.

Considering this, an authentic coming to terms with the actual history of the past several years in Serbia may be a matter of some urgency.

In the end, it looked as though it was Aristotle with his Nicomachean Ethics that finally did the trick. Overwhelmed with knowledge, the police broke ranks at 1:30 in the morning, surrendering the streets to the students once again. As the rapturous throng came surging past my hotel window a

few minutes later, I was reminded of lines from Seamus Heaney's wonderful poem "The Cure at Troy," itself a meditation on the transition out of the epic:

> History says, *Don't hope*
> *On this side of the grave.*
> But then, once in a lifetime,
> The longed-for tidal wave
> Of justice can rise up,
> And hope and history rhyme.

Within a few days, Milosevic's regime seemed to give in, announcing that it would be abiding by the municipal election results after all. *Seemed,* of course, turned out to be the operative word, for in no time the government was backtracking, or at any rate having difficulty getting its subordinates to enact the alleged concessions. (Many incumbent local chieftains were simply refusing to cede power.) Even in those towns where the oppositionists were in fact taking over city hall (Belgrade and Nis still notably not yet among them), they were discovering the insubstantiality of their reputed new powers: Milosevic had managed to hoard most functions at the national level (even including control over the local traffic police), and in those instances where local oppositionists tried to enforce the few prerogatives they did have (such as control over local television stations), the Old Guard was refusing to be dislodged, and the local authorities pointedly lacked the police muscle to enforce their edicts. Meanwhile, Milosevic—a master at this sort of short-term tactical jockeying—was slashing the share of state revenues allocated to municipalities while transferring ever more onerous responsibilities (for everything from education to road maintenance) to the suddenly strangulated local governments. Clearly, he was still hoping to stare everybody out.

So the demonstrations continued, day after day after day. The oppositionist leaders enchanted the crowds in Republic Square with the news that they'd "broken every sort of Guinness Record for this sort of upris-

ing." The Velvet Czechs had had to hold out for only thirty-eight days whereas Belgraders had already put in twice that. Who knew how much longer this could last? Nerves were beginning to fray and things could still turn ugly at any moment—as in either Tiananmen or Bucharest. But the point was that as yet they hadn't. Not for nothing had the crowds in Republic Square adopted Vangelis's inspirational theme from "Chariots of Fire" as the anthem with which they launched each new rally. They seemed to know that, no matter what, they were going to be in this struggle for the long haul.*

My last evening in Belgrade I attended an astonishing, free-form modern dance performance of Shakespeare's *Macbeth*, of all things, choreographed by and starring one of the country's foremost theatrical figures, Sonja

*As indeed they proved to be. Astonishingly, Milosevic, the master political escape artist, managed to wrest himself out of even this hopeless morass. Within no time he had the Zajedno victors bickering among themselves, and come the end of 1997 he still bestrode the citadels of power—or, anyway, what passed for power in Belgrade—as he somehow continued to do at the end of 1998 and even the end of 1999. Finally, in September 2000, he tried to steal one election too many, and the Serbs rose up once again, this time finally managing to dislodge their tyrant in a relatively peaceful coup that brought the election's actual victor, a "moderate nationalist" constitutional lawyer named Vojislav Kostunica to power in a prickly alliance with that young and considerably more dynamic Zajedno firebrand, the Westernizing technocrat Zoran Djindjic. Out of power and more or less confined to his villa, Milosevic continued to stir up trouble until June 2001, when, having had enough, Djindjic succeeded in engineering the deposed tyrant's arrest and transfer to The Hague, where Milosevic was finally forced to face the Tribunal's charges against him, representing himself in what rapidly devolved into a marathon all its own. In apparent revenge, Djindjic was himself assassinated in March 2003, and though his political heirs initially responded, at long last, with a vigorous crackdown on the organized ganglord criminals who'd come to dominate what passed for Serb economic life during the Milosevic era, their campaign appeared to peter out in the months that followed, and by year's end Belgrade appeared, once more, to be socked in a miasmic drift, with the hypernationalist Seselj's party achieving the most votes in a fresh round of parliamentary elections.

Vukicevic, in the harrowing role of Lady Macbeth. I say, "of all things," but it quickly became evident that this was the perfect play for this moment. No one in the audience needed a playbill to recognize that what was really being alluded to was the tale of Slobodan and Mira, their surging lunge for power, and its inevitable, terrifying, blood-drenched denouement. That was the easy part, but Vukicevic was up to something far more sophisticated as well. For she'd made the first third of the piece, the exposition of the initial relationship between Macbeth (played by Slobodan Bestic) and his wife incredibly erotic and engrossing, drawing the audience in, inviting it to remember how thrilling and vivifying and involving that initial lunge for power and territory and glory had been for all of them, and thereby implicating them in all the horrors that were to follow. This, it seemed to me, in a stylized, theatrical context, was precisely the sort of cathartic confrontation with their past that Serbs in general needed to be moving toward.

After the performance I said as much to Borka Pavicevic, the dramaturge and chief doyen of this performance space, the Center for Cultural Decontamination, that, as it turned out, had been hosting evenings like this one throughout the darkest days of the hysteria.

I tried out my theory about the transition from the Homeric to the Sophoclean, suggesting somewhat facetiously that maybe the Aristotle the kids really needed to be reading, rather than the *Ethics,* was the *Poetics,* with its careful elucidation of the themes of recognition and catharsis.

Mrs. Pavicevic smiled but then replied, "The thing is, before you could have Sophocles you had to have the *polis*—the possibility, that is, of face-to-face relations between equals. Democracy has to precede catharsis, not the other way around."

<div align="right">(1996–97)</div>

CODA:
THE MARKET ON
THE TUZLA/BRCKO ROAD

It may just be too late to envision any sort of true ethnic reintegration for Bosnia. That's the reluctant conclusion toward which the Belgrade-based political analyst Aleksa Djilas—son of the great dissident Milovan Djilas, and himself an inveterate nonnationalist—has recently found himself tending. "I mean," he suggested hesitantly, "it's a little like a situation where a beautiful woman is walking down the street and a madman dashes up to her and slashes her face with a razor, exultantly screaming, 'Ha ha, Ha ha, you'll never be beautiful again!' Sometime later, the woman goes to a plastic surgeon, and the doctor examines her carefully, tenderly, before sighing, 'Alas, alas, you'll never be beautiful again.' It's the same sentence but with two radically different connotations—the difference between advocacy and diagnosis." He was quiet for a few moments, then added, "And, alas, alas, maybe Bosnia never will be beautiful again."

Maybe. And maybe even worse. For if the Bosnian Serbs, in their continuing thrall to their gangster nationalist warlords, continue obdurately refusing to cooperate in any meaningful way in the peaceful reintegration of the country, at some point NATO may really give up in exasperation and abandon them to their fate.

Then, in all likelihood, the war will resume, and it could be a very short war. The (predominantly Muslim) Federation Army has been steadily

building itself up, and the Serbs can no longer rely on the monopoly of heavy weaponry, upon which they based their spectacular early successes in the last war. In fact, the Bosnian Serb Army is completely demoralized and gutted of effective leadership. The Muslims will be fighting to return to the idealized fantasies of their former homes, while the Serbs will only be defending the wretched wasteland that their leaders have made of their current ones. Their leaders, meanwhile, will very likely have skipped town, their wealth securely socked away in Cypriot bank accounts, their Belgrade villas handsomely outfitted—just as the Serb leaders did in the Croatian Krajina and in western Herzegovina before the outbreak of the final Bosnian-Croat offensive in 1995. The war, then, will be short and brutal, with perhaps a million Bosnian Serbs being forced from the lands their ancestors inhabited for centuries, and relegated to a life of abject desolation as refugees among the Serbs of Belgrade, who will have at last achieved the dark realization of the dream that Milosevic originally sold them on ten years ago: all Serbs in one state, indeed. The metropolitan Serbs will despise these new refugees (just as they despise the current crop) as the persistent mirror of their own onetime folly, and they will make the refugees know it. And that will be that. Except that, of course, it won't be. Those desolate shantytowns will doubtless incubate the next batch of history's aggrieved Serbs, avid for revenge and just itching for the next fascist crusade to come along.

Or, then again, maybe not. There's a field alongside the road between Tuzla and Brcko, near the place where the highway crosses over from the Muslim-Croat Federation into the Republika Srpska. It was once the site of pitched battles, salted with trenches and mines, and, in fact, it marks the place where the war came to an end on the eve of that last mammoth confrontation. Once the Americans arrived, they cleared the minefields and established a frontier checkpoint, and, little by little, merchants from either side of the divide started coming to trade. Nowadays, by eight or so in the morning the place is swarming, with tens of thousands of merchants and customers trading everything from cassette tapes and batteries and

detergents and vegetables to stoves and cars and cattle—everything, they like to say, from pins to locomotives.

There are claptrap bars and outdoor cafés, and at one of those cafés, one afternoon, I happened upon a group of about eight merchants, relaxing after a busy day, ribbing and cracking wise and laughing up a storm. Two of the guys were Serbs, another was a Croat; there were two Muslims, a Montenegrin, and even a Hungarian, from the Vojvodina. I asked if any of them had fought in the war. "Oh, sure," one of the Serbs said, laughing. "In fact, I was stationed right up there." He turned, indicating the hills behind him. "And you were firing at me over there," one of the Muslims chimed in, pointing in the other direction and laughing just as hard. "A pathetic shot!" A waitress brought a round of drinks, and everybody toasted everything. I asked whether it felt strange for them to be gathered together like this after so much killing. The other Serb fixed me with his eyes. "Look," he said, "the thing you have to understand is that for eight hundred years around these parts, going all the way back to the Middle Ages . . ." Oh no, I felt myself deflating. Here it all comes again: the Battle of Kosovo, the massacres during the Second World War, the endless endlessness of it all. "For eight hundred years," he repeated, "people around here have lived with each other *in peace.* Catholics, Muslims, Orthodox, Jews. In peace. No one anywhere else has been able to pull such a thing off. Sure, every once in a while some crooked politicians come along and muck everything up, but eventually they leave, and we're all still here. And people here know how to get along."

(1997)

THREE POLISH
SURVIVOR
STORIES

The Brat's Tale: Roman Polanski

The Troll's Tale: Jerzy Urban

The Son's Tale: Art Spiegelman

THE BRAT'S TALE:
ROMAN POLANSKI

He has at last begun to look his age. Well, no, that's an exaggeration. Roman Polanski looks forty, whereas he is in fact sixty-one. But at least he looks like an adult, which through most of his life he hardly ever has. His features—fetching or ferrety, depending on your point of view—have softened. His focus, though, has sharpened—or has sharpened again, and he has just completed work on one of his most significant films in years, the screen adaptation of the Chilean exile-playwright Ariel Dorfman's *Death and the Maiden.*

"Death and the Maiden" could well have served as an alternative title for well over half of Roman Polanski's movies (for *Knife in the Water,* for instance, or *Repulsion,* for *Chinatown, The Tenant* or *Tess,* for *Frantic* or *Bitter Moon,* maybe even for *Macbeth* or *Rosemary's Baby*), but at first blush, Polanski would hardly have seemed the most obvious candidate to direct Dorfman's deeply and overtly political thriller, perhaps the most widely staged play anywhere in the world over the past several seasons. After all, Polanski has seldom seemed a director even remotely interested, with the possible exception of his *Chinatown,* in any kind of overt politics.

On the other hand, in Dorfman's tight little chamber-play—about a skittish woman who years ago survived a harrowing stint of torture and rape at the hands of a brutal military regime; her husband, an eminent defense attorney and human-rights activist just tapped by their country's newly installed democratic transitional president to head a fact-finding

commission charged with ventilating (but not prosecuting) a tortuously circumscribed fraction of the prior regime's depredations, conspicuously not to include cases such as his wife's own; and a Good Samaritan doctor who, one storm-lashed evening, just happens to stop and assist the lawyer-husband after his car has broken down on a remote stretch of highway along the country's rugged coast and who then volunteers to deliver him back to the weekend cottage where his wife has been anxiously waiting, a man whose voice she in turn instantly recognizes, with absolute and horrifying conviction, as that of the very doctor who supervised her own tortures as she lay strapped and blindfolded across the regime's dank interrogation tables—the political is deeply personal, and with a vengeance.

In fact, in the film version (perhaps Polanski's most compelling cinematic achievement in over a decade, with lacerating performances by all three of its principals: Sigourney Weaver as the wife; Stuart Wilson as the lawyer-husband; and Ben Kingsley as the doctor), the mood of relentlessly intensifying claustrophobia, the sense of three scorpions mortally tangling in an ever-tapering bottle, is so distinctly *Polanskian* that the whole project might well have been dubbed *Knife in the Water II,* in homage to the director's first feature film, a similarly strangulating exercise in dire erotic triangulation.

In fact, forget Polanski's films: Dorfman's play is so evocative of certain aspects of the director's notoriously well-known *life,* that is, it so neatly splays out among its three characters, almost as if prismatically, three of the principal guises by which that life has come to be so publicly known— Polanski the guilt-ridden husband who had to come to terms with the savage brutalities visited upon his own young wife, Sharon Tate, by Charles Manson's gang in 1969; Polanski the man himself accused, eight years after that, of statutory rape, who likewise steadfastly continues to maintain his innocence (or at any rate to insist upon the free, mutual consent involved in a fateful dalliance with a thirteen-year-old girl that culminated in his arrest, incarceration, and eventual flight from Hollywood and his resultant and ongoing exile); and, prior to either of those, Polanski, himself the young Jewish victim of a fascist regime's most brutalizing attentions dur-

ing the Nazi occupation of his native Poland—that at moments it almost
seems as if Dorfman could have had no one *other* than Polanski in mind
(forget Chile!) as he was composing the original play.

 Not that Polanski himself would necessarily go along with any such
autobiographical associations. In fact, for years, with almost every new
release, Polanski has consistently bridled at the psychobiographical read-
ings that his films—perhaps more so than those of any other director—
consistently seem to evoke, both among critics and audiences. And yet, he
keeps on generating films that time and again not only invite but almost
seem to insist upon such (supposed) misreadings. In fact, not only do they
seem to reflect on his own prior life—and what a life! (has any other
world-class director lived a life so overbrimmingly packed with lurid inci-
dent and accident?)—but often they even seem to *anticipate* that life's
more bizarre upcoming turns, to anticipate and at times almost even to
provoke them. This uncanny, clammy interpenetration of the life and the
work is but one of the enduring fascinations of Polanski's oeuvre, right
alongside its technical brilliance and the director's manifestly expansive
passion for the medium.

"But no, no, *no!*" Polanski kept insisting to me, typically, with sputtering
exasperation, one afternoon a few months back as we sat in the sleek, taste-
fully appointed office he keeps just off to the side of the sleek, commodi-
ous apartment overlooking the fashionably elegant Avenue Montaigne
(between the Champs-Élysées and the Place d'Alma on Paris's Right Bank)
that he shares with Emmanuelle Seigner, his young consort of (amaz-
ingly!) ten years and their baby daughter of eighteen months, Morgane. "It
had *nothing* to do with that!"

 I'd just been trying out on him a fairly conventional theory regarding
the ending of *Chinatown*, which Polanski famously changed at the last
possible moment on the very last day of the film's shooting, now over
twenty years ago. The film's original scenarist, the redoubtable Robert
Towne, had originally had the Faye Dunaway character killing her father

(and incestuous tormentor), the creepily smarmy John Huston character, before he could sink his claws into the barely pubescent child (simultaneously her daughter and her sister, simultaneously his granddaughter and his daughter) whom she was so desperately trying to protect. Instead, Polanski had the Faye Dunaway character herself get gruesomely killed right in front of the child, whom the lurid Huston character now enveloped in his oily embrace, leading her away, as Jack Nicholson's detective character looked on, abashedly ineffectual ("Forget it, Jake, that's Chinatown").

So I was trying out the fairly standard notion that maybe one reason Polanski had changed the ending that way was because, as Robert Towne subsequently formulated the matter, "For Roman, that was life: beautiful blondes always die in L.A. Sharon had, just five years earlier." (I hadn't even gotten around to advancing a possibly more intriguing line of speculation, based on a throwaway aside I'd noticed in Polanski's 1984 autobiography in which the director suggested that the reason he'd been drawn to cast Dunaway in that crucial part in the first place was because she exuded "a special brand of 'retro' beauty, the same sort of look I remembered in my mother," a beloved and lovely young woman whose capture by Nazi storm troopers and subsequent murder had cast Roman himself, as a young, young child, suddenly as unprotected as the girl in the film, into the very maw of evil— such that the autobiographical associations being summoned in Polanski's revised ending might be said to have wended their way right past Sharon and all the way back to some of the most primordially evil material of our time: "Forget it, Jake, that's Chinatown." Nor had I yet gotten around to pointing out—not that I was sure that I was even going to try—the eerie way in which the film's revised ending, the dirty old man enveloping the young girl in his prurient embrace, uncannily foreshadowed the maelstrom of public perceptions Polanski himself was going to be subjected to just two years later, when he'd be being accused of the scandalous seduction of a thirteen-year-old of his own.)

But: "No, no, *no*," Roman was already protesting. "That ending had absolutely *nothing* to do with my life. It had everything to do with *movies,*

with all the movies I saw and adored and couldn't get enough of as a child, in the first years after the war back in Krakow. Why do people always imagine that in order to make a tragic film you have to have led a tragic life, that only a deeply sad person could perpetrate a deeply sad ending? It's crazy. *Of Mice and Men,* Carol Reed's incredible *Odd Man Out* (have you ever seen it? *incredible!*), Lawrence Olivier's *Hamlet*—I went to see those films again and again, and *those* were the experiences that shaped me. I remember how *shattered* I was by the death of Lenny at the end of *Of Mice and Men,* and yet, walking out of the theater, even then I realized how a conventionally happy ending would never have given me that same extraordinary combination of pleasure and sorrow together. *That* was the biographical basis for my choices in the ending of *Chinatown,* not any of this other cheap psychological nonsense."

But just look at the movies he'd cited, I now countered, persistent. Earlier in the day we'd been reviewing the harrowing circumstances of his childhood transit through the Polish holocaust: his then-pregnant mother's terrible capture in one of the earliest actions in the Krakow ghetto (and her subsequent extermination, unbeknownst to him at the time, in a nearby death camp); his father's being similarly herded up and led away to who-knew-where during the ghetto's final liquidation action (the very one so vividly evoked, just recently, in Steven Spielberg's *Schindler's List*); Roman himself, barely ten years old, narrowly escaping that action (with his father's help) but then cast out alone onto the continuously peril-barbed streets of occupied Krakow, caroming from one grudging family to the next until he was eventually shunted off to the remote countryside, where he somehow managed to eke out an existence through the end of the war, working for and sharing appallingly primitive quarters with a near-serflike peasant family (pious mother, her brutish dolt of a husband, their three children, at least two of whom were clearly retarded); his eventual return to Krakow after the war, a seeming orphan, receiving word of the death of his mother; his father suddenly surfacing after all, having survived his own terrible camp ordeals, but now accompanied by another woman, who soon let it be known that she had no interest what-

soever in rearing this obviously difficult little street urchin (for, by all accounts, Roman, the headstrong young survivor, had indeed become quite a handful); her ultimatum to Roman's father that it was going to be either the boy or her, so that, on his fourteenth birthday, Roman found himself being installed by his father across town in a small room of his own (in effect, he was never really to enjoy any extended parental supervision after his tenth birthday); and now, in the wake of all that, his both losing and finding himself in those movies. . . .

And what movies in particular was he citing? Is it any wonder, I asked him, that, with a history like that, he'd found himself particularly drawn to Reed's *Odd Man Out* (with James Mason as a lone and compromised Irish nationalist terrorist on the run through the claustrophobic back alleys of Belfast, the object of a relentlessly tightening police manhunt), *Of Mice and Men* (with its final death of the pathetically retarded field hand Lenny) or, for God's sake, *Hamlet* (the story, after all, at least in part, of a grieving son cast out of his own home by an inappropriately interloping stepparent)?

"Well, maybe," Polanski conceded begrudgingly, at length, but he didn't seem all that intrigued by the coincidences, or in any case much interested at all in his past, or at any rate in talking about it. It seems to hold no conscious purchase on him. Except for the fact that it keeps showing up, sometimes almost to the exclusion of anything else, in his movies.

Time and again during my conversations with Polanski over the past several months, and as I reviewed a career's worth of interviews, clippings, and films, I was reminded of the old story about the guy who goes to the psychiatrist. "Doc," he says, "doc, you gotta help me with my problem." Fine, says the doctor, but don't even say another thing; we'll do this test and I'll be able to tell you what your problem is without your even telling me. At which point he takes out a stack of diagnostic cards and shows the guy the image on the face of the first one: two parallel vertical lines. "Oh my God," says the patient. "That's *disgusting*. It's two people and they're kissing and it's, it's disgusting." Hmm, thinks the shrink; he jots himself a few notes and shows the guy a second image: two parallel horizontal lines.

"Oh, Jesus," says the patient. "That's two people and they're having sexual . . . sexual intercourse and it's just . . . just disgusting." Hmm. The shrink jots some more notes and shows a third card: two crossed lines. "Oh God, oh Jesus, yuuuk, that is *so* disgusting. . . ." Wait a second, interrupts the shrink, we don't even have to go on with this test, I can tell you right now what your problem is: you've got a pathologically dirty mind. "*I've* got a dirty mind?" stammers the patient, his voice rising. "*You're the one showing me the dirty pictures!*"

And with Polanski, it's the same thing, only the exact opposite. It's as if in being confronted with one pruriently clammy, manifestly obvious association after another, he simply counters mildly, "Oh, that's just two parallel horizontal lines, that's two parallel vertical lines," and so forth. As he considers—or, as is more usually the case, is *brought* to consider—the often horrifying particulars of his past life, it's as if he were possessed of a pathologically *clean* mind. And yet that very obliviousness—the relentlessly willed, sunny breeziness of his resolve—may be the very capacity that repeatedly has allowed him to move on and to keep functioning at all.

"You can have no idea how liberating an experience *Knife in the Water* was for the rest of us in the Polish cinema when it first came out in 1962."

Before visiting Polanski in Paris, I'd been doing some traveling in Poland, and one evening I'd arranged to talk with Andrzej Wajda, the grand old master of the Polish cinema, at a café in Krakow, where he was preparing a stage production of four one-act plays by Yukio Mishima. When our conversation turned to Polanski and, specifically, to *Knife in the Water,* he cited its bracingly new look and way of seeing, its dazzling technical proficiency (virtually the entire film takes place on a cramped sailboat in the middle of a lake, and Polanski and his cinematographer Jerzy Lipman had had continually to be coping with the ever-changing light- and cloudscapes), but in particular he was referring to its revolutionary subject matter. "Because for the first time since the war," he continued, "here was a film that didn't have anything to do with the war." For over fif-

teen years, Polish filmmakers had wallowed in the war—often, as in Wajda's own case, with *Kanal* and *Ashes and Diamonds,* quite brilliantly— and even when they hazarded a more or less contemporary fable (as, a few years earlier, Wajda himself had with *Innocent Sorcerers*), still the charac- ters seemed positively bowed down under the weight of the war's ongoing legacy. "But Roman would have none of that. It wasn't that he had con- tempt exactly for what we were doing; he just had no interest in it. He was all about starting afresh, and this was his answer: a film that truly could have taken place anywhere. I'm sure that that in part accounted for its breakthrough success abroad, the cover of *Time* and so forth." (Everywhere I went in Poland, that *Time* cover kept cropping up in conversation—the September 20, 1963, issue, a torrid still from *Knife in the Water* under the banner "Film as an International Art," promoting an article on the first annual installment of the New York Film Festival. That cover made quite an impression back home. To this day, Poles of a certain generation still refer to Polanski, with a strange mixture of pride and almost resentful sar- casm, as "our *Time* boy.")

"But he was always like that," Wajda went on, "from the very start." Wajda had actually first encountered Polanski many years earlier, even before Roman entered the Lodz Film School, in his incarnation as a child actor. Strikingly small, wiry, and preternaturally baby-faced, Polanski enjoyed quite a career in that capacity (initially over the radio in Krakow, where he was featured in an ongoing dramatic serial alongside the simi- larly juvenile Louis Begley—then Ludwik Bielinski—the eventual interna- tional lawyer and late-blooming author of *Wartime Lies;* then in the theater, where he enjoyed the long-standing lead as the company mascot in *The Son of the Regiment,* an agitprop tearjerker imported from the Soviet Union; and later, in countless films); for years he was able to go on por- traying characters considerably younger than himself, though they were almost invariably versions of his own pugnacious, street-tough gamin per- sona ("the Polish male Shirley Temple" is how one filmmaking veteran recalled him for me). And indeed, as such he'd snared a featured role in Wajda's very first film, *A Generation* (1954). "He was an insatiable presence

on the set back then," Wajda recalled, "voraciously interested in everything technical—lighting, film stock, makeup, camera optics—with no interest whatsoever, on the other hand, in the sorts of thematic concerns which obsessed the rest of us: politics, Poland's place in the world, and especially our recent national past. He saw everything in front of him and nothing behind, his eyes firmly fixed on a future toward which he already seemed to be hurtling at maximum speed. And for him that future was out there, in the world, and especially in Hollywood, which he equated with the world standard in cinema. Already then. And that was absolutely unique among us."

"I agree completely with Andrzej," Polanski's cousin Roma Ligocka commented a few minutes later, after the director had excused himself to return to his theater rehearsals. A painter and cinematic costume designer now based in Munich, she happened to be in Krakow for a retrospective of her own drawings at a local gallery, and she'd joined us at the café. "Only," she went on, "he has it exactly backward. Yes, Roman was hurtling forward, *like a rocket,* but it wasn't so much toward the future as *away from the past.*"

It must have been a singularly horrible past (which is to say, as he'd be the first to insist, not all that different from many, many others of that time, in that place, but still . . .). And, as I say, it's not that he even refused to discuss it with me. It's just that his recollections generally tended to get delivered flatly, and even when not delivered as if by rote, they didn't really vary from the way he rehearsed them in his autobiography.

Occasionally, his stories did tend to sneak up on him and grab him in mid-telling—once or twice, for instance, when he spoke of his mother, who, incidentally, was only half-Jewish. She had been a fairly well-to-do White Russian exile, married and comfortably settled with a daughter, when she first met Roman's father, Ryszard, in Paris, in the early thirties. He was by all accounts a terrifically engaging Polish expatriate with artistic pretensions, if of considerably lesser means. Still, she left her husband for him, and Roman was born a year later, in 1933 (six months after Hitler's ascension to power). (Roman's birthname, incidentally, was Raymond, so

that the punning title of his autobiography, *Roman by Polanski*—"*roman*" being the French word for a novel or a fiction—is doubly apt. In fact, even the "Polanski" is a bit bogus: his father's original last name was Liebling; he'd changed it after leaving a first wife of his own. ("For as far back as I can remember," Polanski reports in the book's first sentence, "the line between fantasy and reality has been hopelessly blurred"—the key word in that sentence being *hopelessly*, and an interesting question arises as to whether he is consciously using it precisely.) Both Ryszard's artistic and his business schemes faltered badly in the midst of the ongoing Parisian Depression, and four years after Roman's birth, in a fatefully wrongheaded move, Ryszard dragged his new family back home with him to Krakow.

In the months after the Nazi invasion, the family was forced to decamp from one apartment after another in a tightening gyre. One day, Roman's recollections broke notably free of their usual monotone when he described for me the sheer horror with which even then, as a nine-year-old, he'd fully and immediately apprehended the significance of what was happening one morning as he leaned out from his second-floor apartment window to see the Nazis walling up the end of the street which he'd been using as access to a nearby square. (Back in Lodz, the Polish film critic Maria Kornatowska made a particularly astute observation, it seemed to me, when she pointed out how, superficial appearances aside, *all* of Polanski's films, especially including *Knife in the Water*, have been about the war, and in particular about the simultaneous combination of claustrophobia and agoraphobia which so characterized that ghetto experience. "In *Knife in the Water*, for instance," she pointed out, "the water is only seemingly an open horizon; in fact, it encloses and entraps absolutely. And that's the quintessential Polanskian universe.")

Most of the time, though, Polanski reverted to his monotone, sometimes spookily so, as when he related the story of how during one of the roundups, early on in the ghetto, he'd watched transfixed as an old lady had trouble keeping up with the marching column, and presently fell out, collapsing to all fours, whereupon she began pleading with a German officer, begging and wailing, until suddenly a pistol appeared in his hands,

there was a loud bang, and blood came gushing out of her back as she col-
lapsed lifeless to the ground. And of course this was only one of several
such incidents Roman witnessed as a child. (Years later, in her review of
Macbeth, Pauline Kael noted how it is not the amount of violence in
Polanski's films that so unsettles the viewer as much as the way that vio-
lence "always [occurs] a shade faster than you expect, so that you're not
prepared." When it comes to the violence in his films, Polanski has always
insisted that, far from being a sensationalist, he's the purest realist, and in
fact he's one of the few directors around who have actually experienced
such sheer amounts and varieties of violence, not in other movies but at
first hand.)

Polanski was utterly unfazed, during our conversation, as he described
being betrayed (one family into whose care his parents had managed to
entrust him early on, smuggling him out of the ghetto, returned him
within days, though they coolly contrived to retain all the money they had
been given along with the suitcase full of his clothes and most intimate
belongings) and being shot at (one afternoon, some months later, in the
countryside, he suddenly found himself becoming random target practice
for a group of passing German soldiers). In fact, his account of life in the
countryside at times verged almost on the pastoral (a city boy on the farm,
lolling in the autumn grass) except for his evocations of the anxious lone-
liness that would sometimes overwhelm him, the almost physical ache of
missing his parents and worrying over how they might be faring.

The one time, strangely, that he lost it completely—his voice tightened,
and when I looked up from my notepad, to my astonishment he was
crying—was when he described an incident back in the ghetto, a time he'd
managed to sneak into the dreaded square where Jews were being herded
for eventual boarding onto the death trains, in search of a younger boy, an
orphan, who'd been staying with him and his father in their little room.
He'd witnessed the monstrous commandant Amon Goeth—the Ralph
Fiennes character in Spielberg's rendition of these events—personally
making the selections, but at length he'd located the boy. Then, attempting
to sneak back out, to his horror he'd found his secret passage blocked.

Their last remaining chance happened to be with a young Polish police officer who was standing guard near another exit. Accompanied by the boy, Roman went up to the officer and began pleading, quietly, desperately, and, after a moment's hesitation, the guard stepped aside. " 'Go,' he hissed at us," Roman recalls. " 'Don't run. Walk.' And we did. And we got out." By now he had utterly dissolved in tears. "I think of that young Polish boy quite often, somebody who really saved my life, and he didn't have to. I can't . . . I can't . . ." His voice trailed off completely. It was strange: the most horrible terrors and violations he seemed to have completely steeled himself to, but he utterly lost it at the memory of a kindness.

Ryszard Horowitz, the son of the family that took young Roman in when he first returned to Krakow after the war, had been similarly savaged by the events of the prior half decade. (Now a noted photographer in New York, Horowitz was one of the youngest survivors liberated from Auschwitz after the war; before that he'd been the one, in Spielberg's version, who'd briefly attained refuge by hiding in a shit-filled latrine; his father had run the Schindler warehouse and his sister was the girl who, representing all the other *Juden,* gave Schindler the cake and the kiss at his birthday party.) Recently, Horowitz told me how years later he asked Roman, "How did we endure it all?" and Roman replied that it hadn't been that difficult. "As children, we adapted and even took it as the norm. It was trying to live a normal life afterward that was difficult."

Cinema itself was one of the things that had helped young Roman survive the war. Even before the Nazi invasion, Roman had evinced an uncanny fascination not just with film but with the sheer wonder of projection itself. He'd only been able to attend two weeks of formal schooling before the war broke out in September 1939 (after that he wouldn't enter another classroom for over six years), but the thing he most vividly recalls from that brief educational exposure was the classroom's epidiascope: not so much the images projected onto the blank screen as the machine itself, which he used to study with awe, and primitive versions of which he

immediately began trying to replicate back home. Some months later, after the ghetto had been sealed, he'd lean out from that second-story window and gaze dreamily out across the wall upon the propaganda exhortations being beamed by the Nazis onto the blank tenement façades beyond: "Jew = Lice = Typhus." Occasionally, he'd sneak out of the ghetto on smuggling runs—he was quick and agile and above all diminutive enough to be able to do so on a fairly regular basis—and often he'd squirrel himself into the cinema houses on the other side, which the occupying authorities were keeping well stocked with propaganda newsreels and Aryan romances. (He taught himself to read deciphering the Polish subtitles.) Such forays were doubly transgressive: not only had he no business being outside the ghetto, but the underground resistance had decreed a blanket boycott of these Nazi offerings under the slogan "Only pigs go to the movies." Still, he couldn't keep away—especially after the ghetto's liquidation, during the months before his evacuation to the countryside, when he was largely on his own on the city streets and such movies provided one of the few measures of solace and consolation. (The queasy transgressive aura that came to pervade so much of Polanski's later filmmaking may thus owe something to the transgressive circumstances of his earliest film*going*.)

And this passion for films continued, of course, after the war. Ryszard Horowitz recalls visiting the projectionists with Roman after various screenings and bribing them for stray single cells from *Snow White* and the pirate flicks that were his special love. Roman's younger cousin Roma Ligocka, whose family likewise shared that crammed postwar apartment with Roman and the Horowitzes (fourteen people in two rooms), recalled how one day Roman escorted her to her first movie ever: "I don't remember what it was—something from MGM, I remember the lion. But of course there was no TV in those days, and you can't imagine what an impression it made. 'What *is* this?' I asked Roman. And he started to explain about the little images strung together on a reel and how I was too young to understand but that someday he was going to be doing it."

Back home, he stripped radios and put them back together, tapped one of them into the phone to see what that might be like (it was like getting in

big trouble), called in false alarms to see how he'd have filmed the resulting commotion, organized local kids into elaborate fantasy productions which he scripted, stage-set, acted in, and directed. "I realize now from looking at photos that he was in fact quite small," Roma recalls, "but to me, then, he was big and powerful and scary. Our favorite game was that we were shooting a picture, he was the director, he'd undress me and paint my body and drape me in other clothes for the role and read me my lines, showing me exactly how he wanted me to repeat them and then becoming furious when I muffed them, sometimes so much so that he'd lift me onto the top of the tall, tall dresser, from which I couldn't get down, and then he'd simply leave the apartment, sometimes for hours. Afterwards I'd do anything he wanted." How did this make her feel? "I adored him."

He was a strange child—high-strung, headstrong, sickly and yet tempestuous. "For a long while, when he first arrived," Roma recalls, "anytime somebody would shout at him he'd break down crying or try to run away. He could never submit to family life."

"He annoyed everybody all the time," Horowitz elaborated, "and yet at the same time people were drawn to him, they were won over by his energy, his zest, his incredible storytelling ability and his uncanny talent for mimicry, and by his charm."

Charming scamp though he was, some of his stunts very nearly proved lethal, particularly to himself. Once he almost blew himself up toying with the pin of a German grenade he'd found in the rubble. Another time, searching the black market for a racing cycle one rainy afternoon, he got himself bludgeoned seven times and left for dead by a shady con artist who, when subsequently apprehended, turned out to be wanted as a triple murderer as well (the man was subsequently executed).

It was several months after Roman had arrived back in Krakow before his father resurfaced, along with his new wife, and almost from the start their relations proved explosively volatile. Everyone I spoke with who'd known Ryszard (he lived until 1984) regarded him with warmth as, variously, witty, funny, charming, a *monsieur très amusant,* and a fabulous bon vivant. "Ryszard and Roman were too much alike," Roma surmises. "They

loved each other but they couldn't stand one another, and the fights they'd get into— Sometimes I was literally afraid they were going to kill each other." Ryszard continually fretted over Roman's erratic academic performance ("I tended to be unruly at school and a poor pupil," Roman acknowledged to me, "in part because I was either bored or else felt myself behind, owing to the huge gaps in my education, which in turn fed an anxious disinterest") and over the boy's various street scandals, all of which tended to reflect badly on him as a father (one who, as a small, struggling independent plastics entrepreneur in an increasingly socializing economy, could ill afford the notoriety). Roman's perennially snotty treatment of Ryszard's new wife, Wanda (and the knotty complex of guilts and mourning and survivor's self-loathing—on both men's part—that underlay such behavior), didn't make matters any easier. Ryszard's decision to establish his barely fourteen-year-old son in digs of his own was regarded by many of his contemporaries at the time, their personal fondness for him notwithstanding, as quite outrageous, although today Roman insists that he himself was quite happy about it. "It was a relief," he told me. "When you're twelve, thirteen, it's too late to have parents. You don't need them anymore."

This last comment resonated powerfully for me at the time. I could feel a lot of tumblers falling into place: the sense of Roman as an eternal boyman, or manchild—a thirteen-year-old, on the one hand, who by virtue of his horrendous life experiences was already aged well, well beyond his years as he entered adolescence (who in fact, in a certain sense, could be said never to have enjoyed any proper childhood at all), who in turn grew into an adult who in all kinds of ways, both for good and ill, never really outgrew his adolescence (or, at any rate, never did until just recently). His looks, his cockiness, his precocity, his vitality, his sexuality, his self-absorption, his braggadocio, his perversity—they all seemed arrested at a certain pitch. "Roman's a child," Robert Towne told me, although he assured me he didn't mean this in a bad way—"a mature mind with a sophisticated, *ancient* sensibility, but he's a child."

Across his mid- and late adolescence, Roman began steadying himself

somewhat, initially thanks to his at last having fallen into an educational venue that allowed him to thrive, Krakow's superb School of Fine Arts (where, in addition to being encouraged to develop a remarkable innate talent for draftsmanship he was exposed to such otherwise forbidden fruit, in the context of increasingly Stalinist Poland, as Bruno Schultz and Franz Kafka), but also thanks to his sporadic, if tantalizing, theatrical and acting career. (His father was dubious on all counts and regularly let him know it.)

"God, was he a nuisance," Andrzej Wajda recalled for me that evening in the Krakow café, breaking into a laugh. "On the set, he was probing everywhere, trying to teach himself everything—and succeeding. He was in motion all the time—you couldn't focus. In those days, we had to use a tape measure from the camera lens to the actor's face in order to be able to adjust the focus, and we couldn't keep him still long enough to do this. It took hours. Finally, the actors had to physically tackle him, they started beating him up so hard he cried out—and for a moment I could leap up, measure the distances, focus the camera, and immediately cry out 'Action!' "

He paused, and then went on wistfully. "He looked and acted like a child, but his intellectual range and his ambitions were hardly those of a child."

Roman's ambitions, increasingly, were to direct, though the administrators at the prestigious Lodz Film School were decidedly dubious. Acting, maybe—but they couldn't imagine this kid, this little boy, commanding the authority necessary to lead a film crew. (Nor did the fact of Roman's father's stubborn persistence as an independent small entrepreneur help his son's prospects at the elite communist school, or, for that matter, the fact of their both being Jewish in these waning days of the Stalinist hegemony.) But at length, and through sheer strength of will and surfeit of chutzpah, Roman did succeed in barging his way into the director's program, in the fall of 1954.

"For us, film is the most important art," Lenin had famously declared,

and Poland's new Communist rulers early on took the injunction to heart, lavishing considerable amounts of their meager postwar resources on the establishment of a world-class institute for the propagation of future propagandists. With Warsaw itself still largely in ruins, they decided to locate the school a couple of hours' train ride west, in the notoriously bleak industrial city of Lodz ("a dump," as Roman would subsequently characterize it), where, it was further thought, the overwhelmingly proletarian surround might temper any bohemian tendencies among the budding filmmakers. (No such luck.) The regime requisitioned a former textile magnate's palace for the purpose, though the grounds quickly reverted to a sort of standardized communist mono-drab (and, indeed, visiting the legendary school today, the overwhelming first impression is of its shabbiness). They equipped it as best they could, which is to say several notches below the world standard (typical Lodz joke: Why do Polish filmmakers so favor those expressionist vantages with the camera aimed from the ground up? Because if they tried to shoot from the ceiling down, or even just head-on, the lenses would fall off their cameras). The faculty, however, was superb—notably including Roman's mentor Andrzej Munk—and the program they administered, blending wide-scale permissiveness with the most rigorous technical and academic standards, was already spawning one of the most distinguished national cinemas in the world.

From the beginning, Roman stood out. "There were many talented people there," one of the most talented of them, Agnieszka Osiecka, a contemporary of Roman's at the film school who went on to become the country's most beloved lyricist and popular poet, told me one day. She cited such other contemporaries as Jerzy Kosinski, Jerzy Skolimowski, Janusz Majewski, and later, Krystof Zanussi. "But Roman seemed a rung above. Everybody knew he was a genius. He was the only one of us—and I include our professors, and for that matter all the other artists and writers in the country at that time—who was not provincial. Somehow all the rest of us, coming from this poor, stooped, war-leveled, communist backwater—we felt ourselves somehow parochial or peripheral, not fully entitled. But there was none of that in Roman. His was the voice of a *free* man who from the

start felt himself equal to all the world. It was remarkable. And he was an absolutely optimistic creature. He was always full of good spirits. I never saw him melancholy."

I asked her if he ever mentioned his experiences during the war.

"Never," she replied emphatically. "Perhaps there was a bit of that syndrome to him, you know: 'Well, that's over; now let's be happy.' It's a strange talent, you know, to be happy. Many don't have it."

"He was an unavoidable presence—the motor behind countless parties at which he himself did not drink," Jakub Morgenstern, a Lodz directing alumnus several classes ahead of Polanski's, told me. "The acting students would tell jokes, for example, but he would *enact* them—long, elaborate stories in which he'd perform all the roles—or else he'd *perpetrate* them. He often engaged in practical jokes which weren't so much intended to inflict cruelty as to allow him to study people's reactions." (Once, for instance, he suddenly splashed a cup of hot tea onto Jerzy Kosinski's suit simply to gauge how someone as "well-organized" as Kosinski would respond.)

But mainly he concentrated on studying and making films. "Others of us there were painters, journalists, songwriters," Osiecka recalls, "but Roman was *all* film. There's a story about him years later, when he was serving on the jury at the Cannes Film Festival and as such had to sit through eight films a day—how, during a break, he stomped out onto the promenade and buttonholed the first stranger he came to: 'Excuse me, sir,' he asked, 'you don't happen to know where they might be showing a movie?' He was avid for a film. And he was already like that back then." In particular, he devoured Hollywood studio films, whose high degree of technical polish he was already trying to emulate, but he also told me how he was bowled over by such classics as *Citizen Kane* and *Roshomon* and would screen them again and again (the latter was once more very much on his mind just recently, he told me, as he prepared to shoot *Death and the Maiden*).

His own student films have since become required viewing for each new class of students at Lodz, and elsewhere—they immediately sounded

themes that were to reverberate through the rest of his career. In one of the first, a two-minute exercise titled *Crime,* a fat, bespectacled man in a trench coat crept into a room in which another man was sleeping, floated up to the sleeper and tenderly stroked his gently heaving chest before suddenly plunging a small pocketknife into it up to the hilt, at which point he simply walked away, closing the door gingerly behind him. (Polanski has favored knives over guns in virtually every film he's made since.) In response to an assignment to compose a film around a character's smile, Roman produced a three-minute short, *Toothy Grin,* in which a young man, shown hurrying down some interior stairs, momentarily glimpses a naked woman drying her hair through a bathroom window; he strains on tiptoe to get a better view, eventually moves on but then doubles back for one last peek, at which point the woman in the bathroom has been replaced by an ugly man brushing his teeth who now looks up and gives the protagonist (and us) a lewd, foamy grimace. Barbara Leaming, who subtitled her 1981 biography of Polanski *The Filmmaker as Voyeur,* insists that Polanski has never been so much interested in portraying violence as in exploring the queasy fascination violence exerts upon us as viewers. He is the master of the bated, expectant gaze, though he's not just interested in what it's like to look but also, perhaps even more so, in what it's like to be caught looking, and as such he's continually implicating and subverting the audience's moralizing gaze. (Of course, he's also replicating his own primordial autobiographical situation, the spellbound ten-year-old's gazing upon horrors from his hiding place, for whom the prospect of being caught looking could at any moment have held the most dire of consequences.) Polanski's favorite contemporary film during those years, Michael Powell's *Peeping Tom,* blended all of these elements in its story of a systematically abused boy who grows into a homicidal maniac compulsively drawn to filming the look of terror spreading across the faces of the women he has seduced as he kills them.

For what was to become his most famous student film, *Two Men and a Wardrobe*—a surreal pastiche concocted under the thrall of Samuel Beckett, in which two men emerge from the sea clumsily lugging a huge mir-

rored wardrobe and traipse absurdly about town, suffering all manner of indignities before finally returning to the sea—Roman cast himself as a frightfully menacing if diminutive young street tough who senselessly beats one of the protagonists senseless (an early version of his cameo in *Chinatown*). That film went on to snare a major prize at the following year's Brussels short-film festival, just as, cockily, Polanski had assured everybody it would.

His graduation exercise, *When Angels Fall*, depicted the dreamy reminiscences of one of those decrepit old hags who monitor the comings and goings in underground public lavatories. For the film's flashback sequences, Polanski launched another leitmotif of his career by casting his own flame of the moment, in this instance a ravishing young starlet named Barbara Kwiatkowska. When Roman first laid eyes on Basia, as she was known, she was already a full-fledged star, a country girl who the previous year, at age seventeen, had landed a featured role by winning a picture magazine's competition to "Get Beautiful Girls on the Screen!" Her face was pert, porcelain fresh, gaminelike, with high Slavic cheekbones and sparkling eyes; her body was incredibly sultry; she was, in short, the perfect girlwoman for Polanski's manchild. Although Roman was still relatively shy and awkward in his dealings with women, he made an antic, wildly flamboyant run at her and won her over, even marrying her a year later, in 1959, though their relations deteriorated into a lacerating power struggle almost from the start. Part of the problem was that in a sense she was farther along in her career than he was in his, as became increasingly evident as he undertook to manage her semi-successful entry into Western cinema (under the name Barbara Lass), during a period when he himself was largely floundering in similar efforts on his own behalf. But a bigger problem was his own extravagantly hypocritical expectations: he was having affairs all the while though he flew into violent, jealous rages whenever he suspected her of following suit (which, at length, she began doing). In fact, in the end, she gave as good as she got, ditching Roman for the handsome young German actor Karl Heinz Boehm (son, incidentally, of the conductor), who a few years earlier had played the lead in Roman's favorite film, *Peeping Tom*. The debacle proved gallingly

humiliating for the young director, and years later friends couldn't help but note Sharon Tate's startling physical resemblance to Basia (or, for that matter, later on, Nastassia Kinski's uncanny resemblance to Sharon Tate).

It was while still in the midst of this relationship with Basia that Polanski, having graduated from Lodz and joined his mentor Andrzej Munk's film collective KAMERA, began developing the screenplay for *Knife in the Water*, in collaboration with Jerzy Skolimowski, the other boy wonder of the Polish cinema at the time. For many months the project was sidetracked by censors and bureaucrats anxious over what to make of its disturbing story line about a smug, well-heeled, middle-aged journalist, his shapely young wife, and the surly, seemingly rootless hitchhiker they pick up on the way out for a sailing weekend (note, straight off, the plot similarities to *Death and the Maiden*): outright political opposition the bureaucrats would have known how to deal with (they did so all the time, that was part of the game); but this script seemed utterly oblivious to political considerations of any sort, and as such was, paradoxically, for them all the more disquieting. While waiting out their decision, Polanski pulled off something completely unprecedented: he went outside the system altogether to obtain backing for a new surrealist short subject, *Mammals* (the money came from his friend and sidekick Wojtek Frykowski's father, who was said to be the king of the Polish black-market currency exchanges). "At that moment, in that place, where the state controlled everything and all students and filmmakers and artists got all their funds from that single source," Osiecka told me, "to even think about venturing outside that system was for the rest of us literally *unimaginable,* but that's what Polanski simply went and did."

Meanwhile, Polanski's sponsors at KAMERA lobbied hard till they were finally able to jar loose a go-ahead on the *Knife* production, but they then immediately surrounded it with protecting angels who, for example, would not allow Roman to take on the starring role of the hitchhiker on top of all the other daunting technical and political challenges he was set-

ting himself (Roman, furious, finally acceded, but in the end he dubbed his own voice over that of his actor stand-in's). Once the film was complete, the censors again hesitated for several months before finally releasing it, to a sensational reception. It went on to win the Critics Prize at the 1962 Venice Film Festival, and the following year was nominated for an Academy Award as best foreign film.

Roman, meanwhile, was back in France. For several years, starting already during his student days in Lodz, Roman had been setting out on threadbare junkets to Paris (first to visit his older half sister, his mother's daughter from her first marriage; later to manage Basia's attempts at a Continental career breakout; and all the while attempting to gain a foothold of his own). In the fall of 1961, after having traveled to Tours, where *Mammals* had been awarded a prize at another short-film festival, he received word that Basia had filed for divorce, and he decided not to go back. "I met up with him there in Paris around that time," Wajda recalled for me. "His situation was incredibly difficult. He was living in complete poverty, unemployed, his hopes suspended on the most enigmatic and tentative of promises from dubious would-be producers. But he was adamant: this was where he was going to build his future. I'd have understood such resolve if *Knife in the Water* had been a failure, but it was a success; he could have returned to Warsaw and launched a new production at any time. Such a prospect, though, held absolutely no interest for him."

He'd teamed up with a young would-be screenwriter, Gerard Brach, who at the time was living a life only marginally superior to that of a *clochard,* a street bum (subsisting, for example, on a steady diet of bread dipped in vinegar). Brach shared with Roman the experiences of a fairly harrowing childhood (in his case, an extended bout with TB), and, more recently, a miserable divorce, and the two found consolation in each other's company. They also began collaborating on the screenplay for the claustrophobic little comedy of cuckoldry and desperation that would eventually become *Cul de Sac.*

As Polanski's reputation finally began to swell, in the wake of *Knife's* Venice triumph, he and Brach were invited to England to work up a genre

horror-thriller for a low-budget start-up production company. This was London on the eve of its swinging revival, the coming days of the Beatles, the Rolling Stones, acid, free love, and the Playboy Club, and Polanski strode into the burgeoning scene as if, at last, into his own true element— the very liberated West he'd fled Poland to achieve.

He taught himself English with astonishing speed, the better to go courting English girls, whom he found "much more straightforward and less calculating than any I'd known." Indeed, as he would subsequently report, "For the first time in my life, I began to feel truly at ease with the opposite sex." Which is to say, he found the voice that would characterize (if not caricature) his casual relations with women for decades to come. "He'd be hitting on girls constantly," as Thom Mount, a longtime friend (and the producer now of *Death and the Maiden*), would describe a slightly later phase, "in this way that was somehow incredibly vulgar and deeply charming at the same time." The crowd he fell in with—particularly a group of American Hollywood types, including Warren Beatty and Robert Towne—was deeply into scoring ("Roman treated women like so many scouting badges," as one female acquaintance put it), and if Roman was perhaps unusually successful (the producer Robert Evans insists that "Roman was more attractive to many women than many leading men"), his behavior was still probably not all that unusual for that place and time. "What you have to remember about the sixties and the seventies," Towne sought to remind me, "is how up until the advent of AIDS, there was a sense that one had an affirmative obligation to experience as much of the world as one could. And it was fun. The Playboy Club was like Disneyland for adolescents, and Roman was no worse, no more outrageous, than many of the rest of us in that group."

Except that he was the one who then turned around and made *Repulsion,* his startling reinvention and reinvigoration of the entire horror genre, a film almost protofeminist in the intensity of its identification with the inner experience of a beautiful young woman gradually going mad under the only partly imagined sense that everybody is constantly hitting on her. Walking down the street, the porcelain-tense Catherine Deneuve

character is regularly subjected to variously vulgar and charming cat-calls and come-ons ("Men," complains one of her colleagues at the hair salon where she works, "they're so filthy, I thought this one would be different . . . ," to which a customer of Deneuve's subsequently concurs, "They're all the same, after only one thing, and I don't know why they bother, they're like little children, only want to be spanked and then given a sweet"). To be sure, the Deneuve character harbors the seeds of deep psychosis even before she ventures out upon her daily gauntlet (the credits open with a patent allusion to Buñuel and Dalí's surrealist masterpiece *Un Chien Andalou* as Polanski's director credit goes slicing across a screen-filling eyeball, but the film's plot more conspicuously summons up the title of another Dalí creation, his painting *Woman Autosodomized by Her Own Chastity*). Still, Polanski weaves that particular instance of individual extremity into a strikingly observed social context.

Nor would this prove a unique case: *Rosemary's Baby, The Tenant, Tess,* and now *Death and the Maiden*. . . . "Throughout his career," Ariel Dorfman's wife Maria Angelica insisted to a group of us over dinner one evening in Paris, "Roman has shown this incredible understanding of and almost an identification with women in their victimhood." At which point, another of our dinner companions fairly sputtered, "Well, yes, maybe, but he's often the one who's doing the victimizing, in the sense, anyway, of treating them like mere objects. It's not a simple claim." But nor is this last a simple claim. The membrane between victim and victimizer is unusually porous throughout Polanski's filmography (remember, of course, that by the end of *Repulsion*, the Deneuve character transmogrifies into the ghastliest victimizer of them all), as throughout his life, and nowhere is this last point more tellingly evoked than right here near the outset of his career. For the principal expression of Deneuve's onrushing madness is none other than walls—walls lurching, erupting, obtruding, encroaching—and we are right back in the ghetto.

This point about Polanski's uncanny ability to express his seeming identification with the victimhood of the very ones he himself was actually victimizing often applied to the situation on his sets as well. As a director he

was a notorious control freak (his sojourn in Paris during the very period that the breezy, improvisational Nouvelle Vague was first breaking across the city's screens didn't seem to have made any impression on him whatsoever in this regard), and at least in the earlier phases of his career, he harbored barely concealed contempt for the majority of actors, whom at one point he likened to mere props and at another to "monkeys." As a seasoned actor in his own right, he'd probably have preferred, in addition to directing, to have acted out all the roles in his films; short of that possibility, he usually tried to impose his own conception of the performance on his actors rather than allow them to develop interpretations of their own. (Kenneth Tynan, Polanski's collaborator on *Macbeth*, once recalled how the director advised him against even discussing anything of real consequence in the script with the actors: "It might look as if things are open to negotiation," he said, "and they aren't.") His propensity for giving highly specific line readings was notorious (Nicholson would subsequently joke that he had to hold himself back from delivering his *Chinatown* lines with a Polish accent; when taunted as to why he put up with such outrageous overdirecting, he grudgingly replied, "Because the little bastard's a genius").

But it was with many of his female stars, especially those from whom he needed to evoke an aura of fragile vulnerability, that he could be most brutal. In his autobiography, he suggests that Catherine Deneuve was such a brilliant actress that as the filming of *Repulsion* proceeded, she actually seemed to go slightly crazy; others on the scene suggest that it was in fact Polanski himself who was systematically driving her crazy; and he even acknowledges that "she was just too nice, I had to turn her into a bitch." Earlier he'd engaged in relentless tormenting of Jolanta Umecka, his novice female lead in *Knife in the Water*, subjecting her to such a string of practical jokes and cruel public humiliations (including a supposedly passionate affair that was itself an extended practical joke) that her resultant compensatory nervous overeating soon had her almost bursting her tiny bikini. On *Cul de Sac*, where the female lead was Deneuve's sister, Françoise Dorléac, one of the film's final scenes involved an eight-minute tour-de-force single take, at the beginning of which Dorléac, naked, ran down the beach and

into the distant water, where she had to remain virtually invisible on the far horizon (the filming was taking place in late fall and the water was nearly frigid) while all sorts of other intricate effects transpired in the foreground (complicated dialogue, guns firing, a plane swooping in from overhead at precisely the right instant) until finally, at the end of the take, she was to emerge from the water and come running back toward and out of camera range. Astonishingly, the first take went almost without a hitch, but, typically, Polanski, the perennial perfectionist, called for a second, and then a third, in the middle of which Dorléac simply collapsed in a dead faint. (The crew virtually rose up in revolt.) And yet, for all of these instances of almost cavalier disdain (when Faye Dunaway was struggling at one point to gain an understanding of her character's motivation for a particularly tricky scene in *Chinatown,* a plainly exasperated Polanski exploded that the money she was being paid was motivation enough), the performances he extracted, particularly from his female stars, were often among their most terrifyingly indelible (the question still being whether this was in part due to the fact that through much of the shoot he'd in fact had them terrorized).

"I thought she was quite pretty, but I wasn't at that time very impressed," is how Polanski would subsequently characterize his first reaction to Sharon Tate. This was four years later, a few weeks after the disaster, and he was voluntarily submitting himself to an L.A. police polygraph examination in a successful effort to clear himself of any possible suspicion of involvement in the at-that-time still unsolved slaughter of Tate, along with four of their houseguests. "At that time I was really swinging. All I was interested in was to fuck a girl and move on. I had had a very bad marriage, you know. Years before. Not bad, it was beautiful, but my wife dumped me. So I was feeling great, because I was a success with women and I just liked fucking around. I was a swinger, hunh?"

They'd met at a London party given by a visiting Hollywood producer, Marty Ransohoff, heretofore the purveyor of such schlock fare as *The Beverly Hillbillies,* who now seemed intent on somehow branching upward.

And so he'd entered into an agreement to produce Polanski's next film, a spoof on vampire movies ("He seduced me with his talk about art" is how Polanski would later characterize the arrangement, bitterly). Tate was Ransohoff's protégée, a classic American beauty, and presently she was cast as the female lead. Polanski had dated Tate a few times prior to the shoot, inconclusively—she was *not* a swinger. The daughter of an American military family, she had had earlier affairs: she was drawn to strong, dominant men—like her previous boyfriend, Jay Sebring, a charismatic Hollywood hairdresser—but to only one of them at a time, and she did not undertake such relationships lightly. It wasn't until they were well into shooting *The Fearless Vampire Killers* that Roman and she actually became involved.

The film would become something of a fiasco, though Polanski at last got his wish to star as well as direct, reprising his horny little boyman role from countless Polish movies as the assistant to Jack MacGowran's vampire-tracking professor ("the little one," as the professor would constantly refer to him, all decked out in his ostentatiously infantilizing finery). Naturally his character fell hard for the innkeeper's voluptuous girlwoman of a daughter, played by Tate, but, perversely, he himself also became an object for the smarmily aggressive attentions of the Vampire Count's swishy young son (another instance of Polanski's lampooning in his films the very sort of behavior to which he was himself so obsessively given in another part of his life). It's hard to see how anything terribly edifying could ever have emerged from this slapdash material, but Polanski, in any case, completely lost control of the film in postproduction and vehemently disavowed the version Ransohoff subsequently released, based on his own cut.

The relationship with Tate, however, survived the debacle and quickly evolved into the happiest of his life to date. "She was so sweet and so lovely that I didn't believe it," he subsequently told the polygraph examiner. "She was *beautiful*, but without the phoniness. She was fantastic. She loved me. She was ready to do everything, just to be with me." Although this was obviously grief talking, to some extent, others too have testified to Tate's

exceptionally sunny and open disposition, her purity of heart, and her devotion to Polanski. One of the things that Polanski himself most prized in her from the outset, as he boasted even to the polygraph examiner, was her forbearance with regard to his ongoing extracurricular involvements, her insistence that she had no intention of trying to smother his lifestyle. Similarly, early on, she guilelessly acceded to his wishes to photograph her nude for a *Playboy* spread—the Polish kid's dazzling trophy. They were wed a few months later. "She was a *fucking angel.*"

It was at this point that Robert Evans, the young head of production at Paramount Pictures, summoned Polanski to Hollywood to discuss a new project. (This was not Polanski's first venture to California. He'd first visited in 1964, on the occasion of the Academy Awards ceremony. *Knife* lost out that year to *8½*, but Polanski didn't seem to mind: he and Fellini made a magical outing together to Disneyland.) Impressed by his work on *Repulsion,* Evans felt Polanski would be just the man to tackle his latest project, the screen adaptation of a sensational, as-yet-unpublished novel by Ira Levin. It was a canny intuition, for in many ways *Rosemary's Baby* was going to do for pregnancy and fertility what *Repulsion* had done for virginity—that is, to evoke the feverish inner experience of an increasingly isolated young woman who feels herself under a steadily strangulating siege, only whereas Deneuve's experience in *Repulsion* was plainly delusional, Mia Farrow's in *Rosemary's Baby* was to be considerably less obviously so. It was the world itself and not she that appeared to be descending into madness (or was it?). *"This is no dream! This is really happening!"* she would scream in the film's most startling scene, as she came hurtling awake from out of a half-drugged stupor to find herself in the midst of a Satanic séance, being given over to the devil himself. Once again, lines which could well serve as the motto for Polanski's entire filmography could serve as an epigraph for his life as well.

As Polanski undertook the screenwriting and preproduction work for the project, he and Sharon transplanted themselves to Los Angeles. Seven years out of Lodz and Roman had risen bodily into heaven, "doing what I most wanted to do in the film capital of the world." The machinery at his

disposal in the well-oiled Paramount studio was everything he'd envisioned, and he'd been superbly fitted to its use. (Film training at Lodz had been based on a Soviet model which in turn, ironically, owed much to the careful study Soviet directors had made of the Hollywood studio system during their visits there in the twenties and thirties.) When Wajda one day some years later asked Polanski just what it was he loved so much about those studios, he replied, "Over there, when I put my hand out like this, they don't say 'Wha-?' they give me a hammer."

Polanski's adaptation of Levin's novel was relatively straightforward, although he did deliberately heighten those elements that added to the premise's ambiguity. On the one hand, he rendered the palpable reality of the satanic conspiracy disconcertingly plausible, though at the same time he always left an out, the sense that maybe all of this was actually just transpiring inside Farrow's own mind—after all, a suspicion no one experienced more terrifyingly than she did herself. Was she just being hysterical? Of course, this inability to get oneself taken seriously, to make oneself be believed (and even, in the face of such authoritarian resistance, to believe oneself) is another of those tropes of female experience that Polanski consistently limns so brilliantly. (Exactly the same issue, of course, arises in *Death and the Maiden* as well.)

Meanwhile, Polanski once again layered his film with the sorts of autobiographical allusions he himself consistently denies. The more pregnant Farrow grows, the more gaunt and hollow-cheeked her face becomes, an effect rendered all the more unsettling by her abrupt, near-Auschwitzian haircut. At any rate, the image of a pregnant woman being dragged away, struggling and resistant, by beefy male authority figures is, for a man with Polanski's history, by no means a neutral one.

In addition, Polanski interspersed his version with grace notes that seemed positively gleeful in their wickedly immediate self-reference. The entire motor of the story is the overweening ambition of Mia Farrow's husband, a marginal actor who sells his soul to the devil for the prospect of success in Hollywood. Or not his soul exactly: rather, his wife's womb, and his firstborn child. "To 1966, the Year One!" chant the celebrating mem-

bers of the coven at film's end (a sly nod at the year of Polanski's own advent in Hollywood)—and meanwhile, back in the actor's apartment, the phones are already ringing off the wall: "That's Paramount calling right now!" Of course, what might have seemed merely playfully perverse when the film opened to glowing reviews and blockbuster success in 1968, within a year would come to seem darkly premonitory.

And sure enough, no sooner had *Rosemary's Baby* opened, it seemed, than Sharon herself was pregnant. It had not been a planned pregnancy, at least not on Roman's part: wary of marriage in the first place (especially after his experience with Basia), he was doubly wary of the stability required of fatherhood (what with his experiences during the war and after, he had precious little experience upon which to model such a prospect). "Constancy was for him both a great longing and a great threat," Towne has cogently surmised. He was going to be the first in his swinging circle of London boulevardiers to enter into this novel state—not at all what he'd had in mind. But Sharon was ecstatic, and gradually, he insists, he warmed to the notion as well. In February 1969, in anticipation of the coming event, the couple moved to larger quarters, a sprawling, ranch-style estate at the end of a cul-de-sac off Cielo Drive in Benedict Canyon whose immediately prior tenants had been Terry Melcher, the record-producer son of Doris Day, and his girlfriend Candace Bergen.

In his recent autobiography, Robert Evans describes Tate and Polanski as "the only really happily married couple in all of Hollywood," and Roman's accounts of their relationship in his own memoirs, ten years ago, were hardly less effusively rosy. Other sources, however, suggest that the marriage had its share of problems. Sharon was bothered by the coterie of hangers-on, many of them old pals from Poland, whose presence Roman seemed to relish; particularly annoying in this regard was Wojtek Frykowski, the sidekick whose father had independently financed Roman's early film, and who himself now seemed to be largely freeloading off his American coffee-heiress girlfriend, Abigail Folger, while increasingly dabbling in drugs. Furthermore, for all her vaunted forbearance (she used to regale friends with the story of how she'd been walking down the street in

Beverly Hills one day when she was accosted from behind by a wolfishly bantering pickup artist who turned out to be her own husband), it's clear that Roman's philandering was wearing on her. When his polygraph examiner, in search of leads, subsequently asked Roman whether he thought Sharon might have been having an affair, he fairly exploded, "*Not a chance!* I'm the bad one. I always screw around. That was Sharon's hang-up."

During the spring and early summer of 1969, they returned to Europe, Roman back to their London flat, where he was working on the screenplay for a new project, and Sharon to Rome for some final work on a film she was starring in there, after which she rejoined him in London (around this time she was reading Thomas Hardy's *Tess of the d'Urbervilles;* she urged Roman to give it a look, told him it would make a great movie). They were both determined to deliver their child in America, but Roman kept restlessly postponing their departure. By July, Sharon was too pregnant to fly and so they booked passage together on the *QE2,* except that at the last moment he decided to stay behind (he insisted that he still had work to do on the screenplay but that he'd join up with her in New York). He escorted her to the dock at Southampton. "Never having set foot in a big ocean liner before, we explored it like excited children," he'd subsequently report in his autobiography. "Something about this parting made it different from other, more casual leave-takings, and both of us had tears in our eyes. . . . As I held and kissed her, a grotesque thought flashed through my mind: you'll never see her again. . . . While walking off the ship and back to the car, I told myself to snap out of it, forget that I'd ever had such a morbid feeling, call Victor Lownes [his friend, the head of London's *Playboy* operation], have a ball, see some girls."

When he failed to join her in New York—he claimed still to be swamped—he promised he'd nevertheless make it to L.A. before she did. When she returned to Cielo Drive, not only was he not there, but Frykowski and Folger, who'd been house-sitting, still were—and what's more, they were refusing to leave. Tate and Polanski had several furious fights on the subject over the telephone during the next few days (Polanski positively forbade her to expel them till he got back), and in fact he

assumed it was her calling to nag him on the subject one more time when, just before dinner on August 9, he picked up the phone to receive word of the disaster.

Sharon was dead, along with Frykowski, Folger, Sebring (who'd apparently come over to console Tate), and the fully formed, eight-month-old fetus (a boy) in Sharon's belly. They had all perished in an unspeakably savage and gruesome manner, the victims of multiple knife wounds. "No, no, no, no," Polanski recalls himself keening, though he remembers little else. One of his Polish friends, quickly summoned to the flat, recalls how Polanski was banging his head into the wall so violently that he feared he might injure himself. "Did she know how much I loved her?" he kept asking over and over, in Polish. "Did she? Did she?" A doctor presently shot him full of sedatives, and it was thus sedated that he arrived back in Hollywood thirty-six hours later, in time for a funeral which Evans would later recall as being "like a ghastly movie premiere."

Nowadays, these deaths (along with that of another victim, a teenager who just happened to be visiting the caretaker in his cottage elsewhere on the grounds that evening, and then, a few nights later, those of an entirely unrelated older couple, Leno and Rosemary La Bianca) all go by the name of "the Manson murders." But it's worth remembering that it wasn't until mid-November that the L.A. police finally cracked the case (one of Manson's followers, in jail on another charge, began bragging of her exploits to a prostitute cellmate who, with considerable difficulty, finally managed to get her prison guards to relay her improbable report).

In the meantime, a hysterically prurient frenzy seemed to sweep Hollywood and the country at large, fanned by a sensationalist press that, for lack of any solid leads, quickly turned on the victims themselves, "killing them [as Polanski himself came to feel, horrified] all over again a second time." *Newsweek* played up the "drugs, mysticism, and offbeat sex" angle, reporting how some suspected "the group was amusing itself with some sort of black magic rites as well as drugs that night." (While Frykowski did appear to have been involved in a fairly druggy scene, Tate in particular, though having experimented with LSD in the past, had adamantly sworn

off drugs ever since learning she was pregnant and wouldn't even drink wine.) Polanski almost felt himself in a Stalinist time warp, witness to (and subject of) a concerted siege of smear-by-innuendo: "How much of a role drugs played in their world was hard to discern," *Time* reported pseudo-judiciously, adding, "Polanski is known for his macabre movies." This last motif—as Polanski characterized it, the "they made those movies, therefore they must have lived that life, hence they deserved to die that death" refrain—began to permeate public perceptions of the case, especially in Hollywood itself, which, as a community (one of the bitchiest and most insecure anywhere in the world at the best of times) sought to put as much daylight as possible between itself and Polanski, yesterday's box-office hero now suddenly transmogrified into "that evil profligate little dwarf" (his characterization of their characterization). "He was excommunicated by Hollywood," is how his friend Jack Nicholson later characterized the situation, "because his wife had had the bad taste to be murdered in the papers."

Not that Polanski was without his own feelings of guilt. When asked by the polygraph examiner whether he felt any responsibility for the deaths, he replied, "Yes. I feel responsible that I wasn't there," and this (delusional) fantasy, that had he been there he and Frykowski together could have beaten off the invaders, came to obsess him for many months. Cleared early on by the L.A. police of any possible involvement, he in turn put himself at their disposal and even undertook a series of amateur sleuthing initiatives of his own in a kind of obsessive investigatory trance of the sort he'd revisit, several years later, by way of the Jake character in *Chinatown*.

That he survived the horror of those months is remarkable, and that he went on, almost seamlessly, to create some of the greatest works of his career in the immediately ensuing years is even more so, but Robert Towne suggests that "His resilience was rooted in his personal history. What he had already survived prepared him to withstand the shock of this new disaster." But it is also the case that Polanski survived the fresh holocaust much as he had his first—by adopting an ironclad, almost colorless interpretation of the events. In this instance, he convinced himself that Manson, a would-be rock singer and songwriter, had sent his raiding party to that

particular house on Cielo Drive in order to exact vengeance upon Terry Melcher, who, as a record producer, had spurned his offerings, and that the attack on Tate and the others had had nothing to do with him or Tate.

That Manson knew that Melcher no longer lived there (as L.A. district attorney Vincent Bugliosi was able to establish), that he may even have known that Polanski did (and, according to the admittedly tenuous argument of a recent biography of Manson published in England, that he may have specifically targeted the director, out of satanist pique at his portrayal of the One True Deity in *Rosemary's Baby*)—these are the sorts of speculations that Polanski to this day cannot abide, as I learned when I tried to raise some of them in conversation. "But this is bullshit! *Bullshit!*" he insisted, with the most vivid sense of—I guess the word would be *urgency.* "It had nothing to do with any of that. Manson was targeting Melcher—that's all there is to it. He was an artist spurned, and it can be a very, very dangerous thing to spurn a certain kind of artist. Think of Hitler."

Once the case had been cracked, Polanski's own obsession with its particularities instantly evaporated. He immediately returned to England ("There was nothing to keep me in Hollywood. I knew that my own inner survival depended on banishing the past few years from my thoughts. . . ."), and he didn't even follow the subsequent trials. Friends like Gerard Brach were astounded by his capacity for focused regeneration. "He just doesn't dwell," Brach told me. "He never spoke of the child he'd lost along with Sharon, for example. Even more amazingly, he never spoke in an angry fashion regarding the killers. He is a man utterly without the spirit of vengeance. As he'd say, '*A quoi ça sert?*' " (In Polanski's subsequent memoirs, the one exception to this pattern of transcendence would come in his treatment of the press: "What hurt me most, when the media started playing up Manson and his 'family' was their complete lack of remorse for slandering Sharon's memory and spreading such a pack of lies about us all. Once Manson was arrested, they behaved as if they'd known all along about his gang's involvement in the massacre.")

By the spring of the following year (1970), Polanski was already deep at work on a new project, a film adaptation of *Macbeth*. With his characteristic blustery disingenuousness (his propensity for parading about with a chip ostentatiously balanced atop his shoulder which he positively dares you to notice, let alone knock off), he insisted that the choice of material had positively nothing to do with the particulars of his own recent life. On the contrary, he claimed, the reason he'd chosen a classic text such as Shakespeare's was precisely to shield himself from the sort of easy calumnies that would have dogged him had he undertaken any other kind of project (had he attempted a light comedy, he pointed out, he would have been accused of callousness; had he chosen a thriller, etc.). The reason he focused on *Macbeth* in particular out of the entire Shakespearean canon, he said, was that it was the only one of the great Shakespearean tragedies that had thus far not been put to film.

His artistic advisor on the project, the late Kenneth Tynan, the eminent British critic and dramaturge at the National Theatre, subsequently published a wonderfully fond and vivid account of their collaboration. Tynan marveled at the intensity with which a man so recently stricken could bring himself both to work and to play. (Invariably, at the end of a long day on the set, Polanski would "fling himself exhausted into the back of the big Rolls with the smoked glass windows, and murmuring, 'Who shall I gratify tonight?' thumb through a constantly amended list of candidates." The next morning, picking Tynan up for the drive to the studio, Polanski would regale him with tales of the previous night's conquests: "Listen, I screwed a Chinese lawyer last night, a barrister from Hong Kong. Beaudiful!" And then, following a free-flowing torrent of other tales, observations, delineations: "Listen, I'm going to Gstaad this weekend with these two chicks I pulled at the party that Victor gave for Warren. . . . You remember, there was the one with the drastic hot pants. Sure, you know the type, sort of between a starlet and a secretary . . . Or is it the party *which* Victor gave? What's the exact difference between *that* and *which*? . . .")

Not that Sharon's memory never came up. Once, for example, Polanski and Tynan were debating the relative merits of various film-world

posteriors—Natalie Wood's, Jane Fonda's, Polanski's own—when Tynan declared that his own favorite was Marilyn Monroe's. "Oh, well," Polanski countered, "if you're going to talk about dead people, Sharon had a pretty good bottom." In his text, Tynan insisted that far from being callous, this remark constituted "a facing of facts and a candid tribute," continuing, "In order to survive and to function, [Polanski] has to immunize himself against nostalgia; and from time to time he deliberately administers to himself little jabs—booster shots, you might call them—like the remark I have quoted. An apt motto for Polanski would be the enigmatic catchphrase used by the indomitable old Captain in Strindberg's play *The Dance of Death*: 'Cancel, and pass on.' " One time, later on, on the set, Tynan queried Roman's estimate of the amount of blood that would be shed by a small boy stabbed in the back. "You didn't see my house in California," he reports Polanski's having replied blankly. "I know about bleeding." This, Tynan insists, was the only time in their entire work together that the subject ever came up.

And yet, of course, the specter of Cielo Drive permeates the finished film, even from its very first scenes as a coven of naked witches (comely beauties as well as wrinkled hags) huddle around a simmering pot, systematically concocting their brew, tossing in a severed hand, a bloody knife, a noose. . . . (*But that's Shakespeare*, Polanski would subsequently protest, repeatedly and too much.) The scene bore its contemporary viewers straight back into the world (and specifically the ending) of *Rosemary's Baby* and almost dared them *not* to make the connections to that, and to everything that had happened in between, as, for that matter, did one of Tynan and Polanski's most inspired innovations, the reconceiving of both Macbeth and his Lady as *youthful protagonists* (as opposed to the sagging, almost menopausal leads of more traditional stagings)—vivid, virile, ambitious, at the very start of their brilliant careers.

Interestingly, in his own memoirs, while forcefully denying any allusions to Cielo Drive, Polanski acknowledged that he'd based one scene in particular on another set of memories: "This is the moment in Act IV when the murderers dispatched by Macbeth burst in on Lady Macduff and

her small son. I suddenly recalled how the SS officer had searched our room in the ghetto, swishing his riding crop to and fro, toying with my teddy bear, nonchalantly emptying out the hatbox full of forbidden bread. The behavior of Macbeth's henchmen was inspired by that recollection." Tynan, too, recalls that day's shoot in his essay, only he zeroes in on Polanski's delicate direction of the little *girl* cast to play Macduff's other child: "With enormous tact and grace, [Polanski] explained to a shy little four-year-old girl that she must lie down and pretend to be dead while he put 'red paint' on her face. 'What's your name?' he asked, daubing away. 'Sharon,' she unbelievably said."

Is it any wonder, then, that in an uncanny way the fulcrum of dramatic, empathic intensity in Polanski's version gradually shifts from Macbeth and his Lady to Macduff, and particularly the fiercely imagined reality of the latter's experience as he first learns of the murder of his wife and children so far away?

> ROSS: Your castle is surprised; your wife and babes savagely slaughtered.
> [. . .]
> MACDUFF: My children, too?
> ROSS: Wife, children, servants, all that could be found.
> MACDUFF: *And I must be from thence?* My wife killed, too? [. . .] All my
> pretty ones? Did you say all? (italics added)

Barbara Leaming, in her biography, records how Terence Bayler, the actor playing Macduff, differed with Polanski over a fine point of interpretation during the shooting of this scene. "No," Polanski finally concluded at length, when he grew tired of arguing, "you'll do it this way. *I know.*"

In 1974, and not without considerable trepidation, Polanski allowed himself to be lured back to Hollywood by Paramount's Bob Evans, who had a new project for him, a brilliant if impossibly sprawling telephone book of a script by his pal from London days, Robert Towne: *Chinatown.* Towne

and Polanski struggled together for weeks to wrest a coherent shooting script out of Towne's delirious profusion of ideas and material. On the first day of the shoot, a stressed-out Polanski emerged from his car, threw up, and set to work. The days after that were fraught with difficulty—explosive confrontations between Polanski and one lead, Jack Nicholson (quickly patched over), and between Polanski and his other lead, Faye Dunaway (only barely patched over at all), and then, as the shooting approached its climax and Polanski radically altered the ending, between Polanski and Towne (who, at the time, vowed he'd never even consider working with the director again). But from out of this chaotic welter of crossed purposes emerged a film of limpid clarity (speaking with me recently with the benefit of hindsight, Towne himself grudgingly admitted that in this regard Polanski had gotten the ending right after all), a film very much of its moment (somehow Polanski's private wrestlings with the intractability of evil—the way in which Dunaway's death hauntingly echoed both his wife's and his mother's—resonated powerfully with the entire country's in the wake of Vietnam and the Watergate affair) but also one which has stood the test of time ("*Chinatown* has passed into legend," the critic Peter Biskind recently noted in a twenty-year reappraisal, "and is regarded by many as an almost perfect film").

Polanski had hoped to parlay *Chinatown*'s success into a production deal on his favorite project, *Pirates*, an epic adventure saga he and Brach had scripted some years earlier—an homage to the beloved screen swashbucklers of his youth (a boy's film!) but in a certain sense an homage as well to the very camaraderie that constituted one of the core attractions the filmmaking vocation had held for him from the start. One has only to hear Polanski's bracingly vivifying "Guys! Guys!" on the set, prior to any fresh take, to realize how this sense of teamwork, of being in the spirited company of like-visioned collaborators, continuously rescues him from the shattering feelings of isolation and solitude his childhood might otherwise have been expected to engender.

In fact, when funding on the *Pirates* project fell through, Polanski immediately took on a more intimate vehicle, the screen adaptation of Roland

Topor's recent novel *The Tenant,* which in a certain sense allowed him to explore that alternative life. Not for the first time, some other artist's material served as a fertile matrix for Polanski's manifestly autobiographical explorations (though, of course, as usual, such associations were strenuously denied). This time, the story concerned a mousy, anxiety-riddled Polish émigré working as a clerk in a Paris office and in search of fresh lodging. Polanski cast himself, against type, in the lead—or rather, not so much against type as in elaboration, perhaps, of a deeply buried aspect of himself, the timorous, shell-shocked survivor whose quaking self-doubts had only been superseded, day after day, year after year, through a dazzling, ongoing projection of will and determination. The clerk moves into a shabby, fourth-floor apartment which had only just recently been vacated—its prior tenant, a young woman, having mysteriously hurled herself out its window. Gradually, under the progressively strangulating pressures of the contemptuous gaze of the other (the landlord above, the concierge below, neighbors and coworkers all around), the clerk finds himself identifying more and more with the previous tenant, begins donning her clothing and makeup, and presently even replicates her final desperate act.

Several critics at the time wickedly suggested that this new film was simply a remake of *Repulsion,* with Polanski himself in the Deneuve role (though this was only to fail to see how deeply Polanski had *already* identified himself in the earlier film with certain aspects of Deneuve's character). In part, of course, the film probed the guilt attendant on any sort of survivorship, even that of someone you hadn't known at all, let alone someone in Polanski's own situation (which is, of course, what made the spectacle of specifically *his* dressing up in a dead girl's clothing so much the more unnerving). It also explored the roots of the paranoid's experience in the actual malice of the real world. "Shut up, you worm," the clerk, in effect, is continuously being told, "you're being too loud, cut the racket, stop standing out like that, you disgust us, drop dead!" And of course, this theme resonates powerfully when coming from a director who as a child had had to literally cower in terrified silence for fear of being flushed out of his hiding place, like so much vermin, or who, more recently, had endured

the media firestorm attendant on the disaster at Cielo Drive. Furthermore, once again, the thematic arrows radiating out from *The Tenant* pointed in both directions, to the director's past and, uncannily, to his immediately onrushing future.

The shoot itself was the smoothest he'd ever accomplished (only eight months from unscripted novel to final cut). Furthermore, its production on location in Paris allowed him to fall in love with that city all over again. Dispensing with the rootlessness that had been his station for most of the more than a decade and a half since he'd abandoned Poland for good, he moved into the apartment on the Avenue Montaigne that has served as his home base ever since, and applied for French citizenship, on the grounds of his birth. (French audiences were perhaps understandably taken aback, upon the film's release a few months later, by their own portrayal at the hands of this, their newest, most celebrated compatriot, as smug, chauvinist, conformity-enforcing, contemptuous and contemptible bourgeois drones. Some valentine! But then, that was just Polanski, the world-class film director being Romek, the Krakow street tough.)

No sooner had Polanski attained his French citizenship than he allowed himself for the first time to pay an emotional return visit to his homeland. He spent Christmas 1976 back in Krakow with his father and stepmother. Their relations had gradually mellowed and, indeed, in the wake of Sharon's death, Roman had found himself increasingly identifying with his father's experience and outlook, his weary pessimism and Judaic sense of guilt (they'd both lost wives to madmen). Back in Warsaw, he found himself being lionized but in a typically Polish fashion, which is to say one laced with resentment as well. In a famous interview in *Kultura,* the playwright Janusz Glowacki (subsequently to become an émigré himself) pressed him on why he'd left Poland. "Why did Erich von Stroheim leave Germany?" Polanski countered. "Why did Hitchcock leave England? If you were a director, you'd like working in Hollywood, too. Now, go ahead and ask me if I'm still Polish. You people keep asking me this question. You want Polish artists to make it in the world, but when they do you accuse them of treason."

A few moments later, Glowacki abruptly changed the subject: Had Polanski ever loved anyone? "A few women." But normal love, Glowacki pointed out, never seemed to figure in his films. "Because normal love isn't interesting," Polanski replied. "I assure you that it's incredibly boring. And . . . I love spectacles."

It wasn't just that normal love was boring. Ever since Tate's murder, it had for Polanski become barbed as well with aspects both of threat and of betrayal. Far from shrinking from sexual involvements, however, Polanski seemed to immerse himself in them to an unprecedented degree (after all, they provided a measure of solace and release as well). But he generally kept such affairs brief and tended to steer well clear of serious romance.

In part, all of this was merely an aspect of the times, and surely there's something to Polanski's complaint nowadays about the retrospective puritanism that has come to cast all sorts of innocent sixties and seventies behavior as virtually criminal. "Look," Robert Towne reminded me when I asked him whether he thought Roman at all exploitative of the women he courted, "in those days, all of us—men and women—were treating each other as objects, and at the time nobody felt anybody was being exploited. Or anyway, that was the most *willing* group of victims you'll ever see."

He liked his women pretty and young, and as the years passed he seemed to like them younger and younger. Again, this was partly a matter of the times (through the sixties and seventies, girls were routinely becoming sexually active at younger and younger ages) and of the circles within which he moved, whose aging Lotharios enjoyed boasting to each other of their conquests and prized extreme youthfulness as a particularly piquant and exotic delectation. On the other hand, in Polanski's case, more pronounced urgencies seemed at work as well. For many years, he says, he shied away from relations with mature women for fear of betraying Sharon's memory. Younger girls posed less of a risk of commitment and were less likely themselves to be entertaining any untoward fantasies regarding parenthood, before the daunting prospect of which Polanski

now seemed warier than ever. As the years passed, too, they were less likely to have had their preconceptions about him shaped and frozen by the media coverage of the Manson debacle. Finally, though, preternaturally youthful himself, he simply felt more at ease with younger women—they were less jaded, had fewer ulterior motives, he could play with them and when not playing he could teach. ("He has a *gout de didactisme* about him," Brach commented to me, "and there's always more one can teach a younger girl. I was often astonished watching the extreme patience with which he'd endeavor to explain often quite complicated, technical things to girls who clearly had no interest. But he loved it.")

All of these factors came to converge in the relationship he forged a few years later with an astonishing fifteen-year-old beauty whom he first met in Munich during Octoberfest 1976, while he was in town directing a stage production of *Rigoletto:* Nastassia Kinski. The daughter of the spooky German actor Klaus Kinski, Nastassia was herself a strange and complicated girl, but Polanski quickly saw her "star potential," and their sexual affair early on drifted into one of wider patronage, as he arranged acting and English classes for his new protégée. The following month, when he was contacted by the editors at French *Vogue* to guest-edit their Christmas issue, he took Nastassia with him to the Seychelles Islands for a photo shoot around the theme of his dormant *Pirates* project, in which he now said he intended to have her star. The girl's ambitious mother, far from objecting to such whirlwind attentions, endorsed them completely.

Following the success of his *Vogue* layout, Polanski was approached by the magazine's brother publication, *Vogue Hommes,* to produce a layout on the theme of "young girls of the world"—girls, that is, in the thirteen-year-old range. Or so Polanski claims. (The *Vogue Hommes* people subsequently tried to distance themselves as far as they could from the entire scheme.) Precisely what happened a few months later in Los Angeles when Polanski ended up bedding a thirteen-year-old girl he was auditioning for that photography spread has always been a bit difficult to pin down. Certain facts are common to all versions: the girl's leaked statements at the time, and Polanski's rejoinders then and seven years later, in a long chapter of his

autobiography (now suppressed as part of a civil-suit settlement that also keeps him from discussing the case). Having somehow heard of the girl, Polanski did some preliminary shooting at her home and then received her mother's permission to drive the girl elsewhere for some location shots; the two of them ended up at Jack Nicholson's empty house, where, continuing the shoot, Polanski offered the girl champagne as she gradually shed her clothes, specifically for a sequence in Nicholson's hot tub, with Polanski presently joining her in the water. From there, they ended up in the guest bedroom and had extended sexual relations, after which Polanski drove the girl home and went on with his evening as if nothing untoward had happened. The girl subsequently told the Los Angeles police that Polanski had been blatantly predatory from the start, engaging in lewd conversation even on the drive out, and that thereafter he had got her drunk and drugged (on half a quaalude) so as to overcome her protests. For his part, in the version in his autobiography, and according to statements made at the time, Polanski contended that the girl herself began talking, in the car, about her extensive experiences with both sex and drugs, and that all their interactions thereafter were consensual. Even he, though, is hard-pressed, in the book version, to account for the asthma attack the girl suffered in the middle of the proceedings, which she subsequently told police had constituted a desperate ruse to get him to stop.

Who knows exactly what happened? Perhaps the girl, starstruck and flattered and tipsy as well, initially consented to Polanski's flirtations; at some point, however, she apparently tried to get him to stop, and he either didn't hear or wouldn't take heed. In a sense, the question is moot: the entire theory of statutory rape rests on the notion that girls under a certain age are intrinsically incapable of giving morally informed consent in the first place.

At any rate, a disbelieving Polanski was arrested the following day and presently indicted on six counts, including "unlawful sexual intercourse," "rape by use of drugs," committing a "lewd and lascivious act" on a child, and "sodomy." Trial was set for August 9—the eighth anniversary of Tate's murder.

The coincidence was significant, for it was as if two trains of development that had launched out from that moment eight years earlier now proceeded to collide spectacularly: on the one track, Polanski's growing predilection, partly grief-driven, for younger and younger girls; and on the other, the media's lingering embarrassment and perhaps even guilty conscience over how they'd treated him at the time of the murders. But not anymore: Aha, they were now able to exult, as if in unison. They'd been right all along: Polanski *was* an evil profligate little dwarf after all! Nor did Polanski help his cause, during the ensuing media firestorm, with the cockily dismissive air of Continental insouciance with which he routinely parried reporters' queries as to the seriousness of the charges against him. To borrow the jargon of a later era, he never did seem to get it.

For all his bravado and his proclaimed eagerness to present his own version in open court, Polanski was soon facing mounting pressures, not the least of which was terror at the prospect of imprisonment. Physically small, still boyishly fetching, an accused child molester, and a celebrity to boot (and as such, presumably, an even more delectably inviting target)— his fears were probably entirely legitimate, even bracketing out the further psychological depth charge that the prison system into which he'd likely be relegated, if convicted on all charges, already contained the mastermind of his wife's murder, along with his entire gang. The prosecution, for its part, was also facing pressures to cut a deal, including independent confirmation that the girl was neither a sexual nor a pharmacological novice. More to the point, her family was increasingly reluctant to allow her to testify at all in the face of so much ugly publicity.

Thus were the elements arrayed for the plea bargain struck during the last days before the trial was to commence. As the world's media crushed into the chambers of Judge Laurence J. Rittenband, of the Santa Monica Superior Court, they were disappointed to learn there'd be no trial after all. Polanski was pleading guilty to a single charge, the least serious (that of "unlawful sexual intercourse"), the prosecutor having agreed to drop all the others. The lawyer independently representing the girl and her family read a statement endorsing the deal and furthermore declaring that

"incarceration of the defendant" had never been his clients' goal in press-
ing charges (all they'd been after was his admission of guilt and willingness
to engage in a program of rehabilitation).

At which point things really began to turn weird. Judge Rittenband,
who seemed dubious from the start, unexpectedly delayed sentencing
pending reports from two court-appointed psychiatrists and a probation
officer. When, a few months later, these all came back surprisingly sympa-
thetic to Polanski and unanimous in their recommendation against incar-
ceration of any sort, Rittenband angrily threw them out as a "whitewash"
and, in a highly unusual, even an eccentric, move, sentenced the director to
ninety days in a state psychiatric prison in Chino, ostensibly for evalua-
tion; in fact, however, Rittenband expressed the intention of having that
evaluative process, however long it might actually take, serve as Polanski's
entire sentence.

Polanski reported to Chino on December 19; the evaluative process took
forty-two days (he was given a clean bill of psychiatric health), and on Jan-
uary 29, 1978, he was released, badly shaken by the experience but at least
relieved that, having served his time and met the Judge's requirements (or
so he thought), he could begin putting the whole thing behind him. The
Judge, however, had other ideas. His in-camera comments to the lawyers,
as well as his statements to the press, had been getting increasingly vitri-
olic, almost vindictive, and in many instances flagrantly injudicious: he
noted how friends sending him letters and conversing with him at the
Country Club thought he'd been far too lenient; he complained about
being made to appear a fool in the press; he indicated that what he really
wanted to see happen was that the director be deported for good (even
though Polanski's eventual status with federal immigration authorities
was none of this local judge's business); he was annoyed that the people in
Chino had let the guy off after only forty-two days.

On January 30, he informed the lawyers that he had indeed changed
his mind and would now be sending Polanski back to prison for the
remaining forty-eight days, followed by "an indeterminate sentence"—
one that could be cut short at any time, but only if Polanski agreed to be

deported, voluntarily and permanently. On being informed of this development, Polanski could no longer see the point of sticking around. Why go back to prison if he was going to be expelled from the country after his release? Why not just leave? (Getting Polanski to think along these lines may well have been Rittenband's underlying intent all along.) Ignoring his lawyer's advice that he keep calm as they appealed the Judge's upcoming ruling, Polanski drove to the airport and booked the only remaining seat on that evening's last flight to London. Once he arrived there, he didn't tarry long: back in Los Angeles a deputy district attorney, branding Polanski a fugitive felon, had declared, "We've got the dogs out, the hounds are on his trail. . . . We will extradite Polanski from anywhere, as long as there's a treaty." With Britain, there was such an extradition treaty, but in France, where he was a naturalized citizen, he would be safe. Within forty-eight hours, Polanski was in Paris.

In Los Angeles, a furious Judge Rittenband moved to sentence Polanski in absentia, but before he could do so Polanski's lawyers filed a detailed petition to have Rittenband disqualified from the case on the grounds of bias and prejudice. Surprisingly, the prosecutors declined to contest the factual assertions upon which the petition was based, but before the lawyers could obtain a ruling on the matter, Rittenband, while denying any such bias, agreed to permit the case to be assigned to another judge. The new judge declared that he had no intention of revisiting the case in Polanski's absence, and it was removed from the court's active calendar, pending Polanski's return to Los Angeles. The district attorney, however, made it clear that the only way Polanski would ever be allowed to return to Los Angeles would be in handcuffs. And there the matter has stood to this day.

"It was a complete tragedy," Andrzej Wajda told me back in that Krakow café when our discussion turned to the subject of Polanski's exile from Hollywood. "He was the worst possible person this could have happened to. For as I told you, all his life he was heading there. No other European director of his generation understood and loved American filmmaking

so well, or so reveled in the possibilities afforded by the American studio system. And I also happen to think that he did much of his best work there: he's the kind of director who seems to need to buck up against structures and obstacles of the kind you get in a studio. Think of it: he did just two films there—*Rosemary's Baby* and *Chinatown*—but what films! It's a disaster."

Maybe, I said to Roman one day in Paris, the lingering problem with the whole affair was how, owing to his ferocious sense of pride, people never got a sense that he felt any deep remorse for what transpired between himself and the thirteen-year-old girl. Surprisingly, he rose to the bait (he never had before).

"What am I supposed to do?" he challenged me. "Go around, wear a hairshirt? That I feel sorry about it, I said years ago. I did everything—how many times do I have to say this, just to satisfy so-called public opinion? And why do I have to do what public opinion says is right? It's often wrong. Just the other day I was reading how twenty million people don't even believe man ever walked on the moon."

He was silent for a moment, before continuing: "And anyway, she wasn't thirteen. She was two weeks shy of fourteen, and that's an enormous difference. It's not like the difference, say, between forty-one and forty-two."

This last comment reminded me of his performance on *60 Minutes,* a few years after the affair. When Mike Wallace asked him point-blank, "Why did you get involved with that thirteen-year-old girl?" Polanski replied, "Since the girl is anonymous, and I hope for her sake she will [remain so], I would like to describe her for you. She is not a child, she is a young woman. . . ." And so forth.

After the show aired, Polanski began calling friends back in the U.S., such as Jerzy Kosinski (who subsequently recalled the exchange): Hadn't the program been great?

"Romek," Kosinski recalls having said, "why did you talk about that? You said she wasn't a child."

"Well, she wasn't."

"Well, actually, she *was*."

"She wasn't," Polanski insisted. "I know that!"

"No, Romek, when you were fourteen, you were a child."

And so forth, into a situationalist impasse.

But, of course, the point is: when Roman was fourteen, he *wasn't* a child.

Arriving in Paris, angry and broke, Polanski immediately set about trying to rustle up a movie. As in the immediate aftermath of Sharon Tate's murder, he once again had recourse to a classic text—in fact, the very one Tate had recommended to him, during one of their last conversations, only days before her murder: Thomas Hardy's *Tess of the d'Urbervilles*. (The film would subsequently be dedicated "For Sharon.") How strange it must have been for Polanski, returning to that text at that particular moment. Hardy, describing Tess, early on:

> Phases of her childhood lurked in her aspect still. As she walked along today, for all her bouncing handsome womanliness, you could sometimes see her twelfth year in her cheeks, or her ninth sparkling from her eyes; and even her fifth would flit over the curves of her mouth now and then.

Or a bit later: "She had an attribute which amounted to a disadvantage. . . . It was a luxuriance of aspect, a fullness of growth, which made her appear more of a woman than she really was." Claude Berri, the producer whom Polanski approached with the project, was dubious at first (what? a big-budget costume melodrama?), that is, until Polanski introduced him to his Tess: Nastassia Kinski.

And indeed the text—and presently the film—for all its surface splendors and pastoral idylls, positively pullulated with perverse references to Polanski's own situation. For fundamentally, Hardy's was the story of a beautiful young girl systematically seduced by an experienced older man, a libertine, whose ultimate act of mastery is really more of a rape than a

seduction, a violation which, in effect, destroys her life, for which cause she ends up killing him. Nor did the coincidences stop there: it is Tess's mother, for example, who, for her own material reasons, almost forces her daughter on her eventual raptor (not only as Polanski felt the thirteen-year-old's mother had done with him, but as had the mother of the actress playing the role as well!). The rape itself takes place on a drive ("At least let me drive you home"). And on and on. Nor are the queasy reverberations limited to that plane alone. In the film's second climactic scene, when Tess's subsequent true love, Angel Clare, on their wedding night, confesses to her a meaningless prior dalliance of his own, and she, reassured, at long last feels free to unburden herself of her own dreadful, inconsequential secret, he reacts with horrifying puritanical revulsion, shutting down completely. "You are not the woman I loved, but another in her place," Angel spits out at Tess, disconcertingly played by Nastassia Kinski in a film Polanski has dedicated to Sharon Tate. (The passionate phase of Polanski's affair with Kinski had in any case long since subsided.)

Tess was another of Polanski's films in which the notoriously male-chauvinist director seemed to be taking the side of Woman. Pauline Kael was onto something important, though, when she wrote, "The film takes a sympathetic, feminist position toward [Tess]—in a narrow and demeaning sense. She isn't a protagonist: she is merely a hapless, frail creature, buffeted by circumstances." But Nastassia Kinski was onto something important as well, when she told a reporter at the time of the film's release, "I see a lot of Roman in Tess. She's a lot like him." For despite the superficial ways in which Polanski might be suggesting his own identification with Alec Durberville, Tess's raptor (and thus in some way expiating his own sense of transgression through his portrayal of Alec's eventual murder), the more deeply affecting currents of identification coursing through the film are those between Polanski and Tess herself. For as of his arrival in Paris in 1978, Polanski seemed to be conceiving of *himself* as a kind of rape victim—at least in two senses.

In his autobiography, Polanski described Hardy's novel as "a study of innocence betrayed and also a study of causality." As Hardy himself had

written in the novel, "One may indeed admit the possibility of a retribution lurking in the present catastrophe. . . . As Tess's own people down in the retreats are never tired of saying among each other in their fatalistic way, '*It was to be.*' There lay the pity of it." Surely part of what drew Polanski to this text was Hardy's sense of the relentlessness of fate, of coincidences, piling one upon the next, remorselessly, into a tragic destiny. At that moment, too, Polanski was feeling ravaged by fate.

But Polanski may have entertained a more specific sense of identification with Tess's fate as well. For in the novel, implicitly, and in the film somewhat more explicitly, the true villainy isn't so much located in Alec's overreaching lust—which at least expresses a kind of life force—as in Angel's priggish, self-righteous, hypocritical, life-stunting, judgmental Puritanism, with Angel of course standing in for this disfiguringly dominant temper of Victorian society as a whole. It's that temper—more than Alec's act—that winds up destroying Tess's life, and in Polanski's film it seems to stand in, at least as vividly, for the puritanical hypocrisies which he felt had just laid waste his destiny back in California. Hardy subtitled his novel, provocatively, "A Pure Woman." Just below the surface of his film, Polanski could be seen to be tending an apologia for himself as, despite everything, still "A Pure Man."

The actual making of *Tess* proved an arduous, drawn-out affair (for one thing, the crew couldn't shoot in Britain, owing to Polanski's extradition concerns, so that all of Hardy's Wessex backdrops, and Stonehenge as well, had to be painstakingly re-created in Normandy); postproduction seemed to take forever; the film's budget ballooned to the highest ever for any French production up to that point; and there was considerable anxiety as to whether the film would ever be able to recoup any of its investment (did anybody really want to see a nineteenth-century costume melodrama, based on a canonical text, which furthermore—surprising for a Polanski film—featured hardly any overt portrayals of either sex or violence?). In the end, such concerns proved groundless: the film went on to consider-

able worldwide commercial success, picked up three French Cesar Awards (including both movie and director of the year for 1979) and three Oscars, and even got cited by the National Catholic Office of Motion Pictures (which a decade earlier had proscribed *Rosemary's Baby*) as one of the "top ten" features of 1980. None of which much mattered to Polanski: worn down by the entire experience, burned out, tired of still trying to force together a deal for his *Pirates* dream project, he announced he was swearing off filmmaking altogether, at least for a while, and perhaps even for good (it would be five years before he'd again find himself behind the eyepiece of a camera).

Meanwhile, things were suddenly bubbling once again back in his homeland. Returning to Warsaw in March 1981 for the premiere of *Tess,* Polanski was captivated by the surging new spirit of emancipation sweeping the country—these were the high good times of Solidarity's original incarnation—and he eagerly accepted an invitation to return later in the year to mount a stage production of his choice. His choice, typically, was jaw-droppingly apt: he would translate and direct a fresh production of Peter Shaffer's *Amadeus,* in which he would also play the scandalous lead—Mozart, the genius as eternal brat. The production proved a rousing success, one of the true flashpoints of a brilliant cultural season soon to be extinguished with the imposition of martial law.

Returning to Paris, where he reprised his role in *Amadeus* for over two hundred performances during 1982, he seemed to subside into a kind of funk. It was as if the rocket that had come barreling out of Krakow, having taken a few hits too many, might now finally be starting to gutter out. It was against this backdrop that he composed his autobiography, an oddly attenuated piece of work. Perhaps its pervasive sense of remove, for all its surfeit of narrative incident, owed to the fact that it was calling on an aspect of his creative imagination—the overtly introspective—that hardly exists at all. And yet there were some passages that proved startlingly vivid in this regard, and they revealed a cored-out sense of hollowness: "Sharon's death is the only watershed in my life that really matters. Before she died, I sailed a boundless, untroubled sea of expectations and optimism. After-

ward, whenever conscious of enjoying myself, I felt guilty. . . . I still go through the motions of being a professional entertainer, still tell funny stories and act them out to the best effect, still laugh a lot and enjoy the company of people who laugh, but I know in my heart of hearts that the spirit of laughter has deserted me."

Thom Mount was heading Universal Pictures at the time, and one day he picked up the phone. "There are really only ten great directors in the world," he explained to me recently. "You asked around in those days and Polanski was on everybody's list—top five, maybe in the second five, but on virtually every list. And there he was, not doing any work. I called him cold—'What the hell are you doing,' I asked him, 'not making films?' "

As it happened, things were in fact beginning to move once again in that regard, and Mount soon found himself joining (in the capacity of executive producer) a massive international juggernaut intent on finally launching Polanski's *Pirates* extravaganza. (Funding, eventually to the tune of over thirty million dollars, would come from a combine led by Dino de Laurentiis and an Arab financier—the galleon alone would cost eight million dollars.)

While *Pirates* was still in preproduction, Roman's father, who'd joined him for a vacation in Switzerland and had been feeling ill of late, was diagnosed with cancer. Roman brought him back with him to Paris. "Of course, I was not unfamiliar with death and dying," Roman commented to me one afternoon in his office. "I'd seen a lot of it, but always before it had been sudden and dramatic, not this slow diminishing and wasting away. I much prefer the other. But for me, the death of my father was very terrible. It was in a way my last connection with Poland, with that which makes you feel still young. I always had this feeling of still being somehow juvenile until my father died. Afterwards that was somehow no longer the case."

I asked him if his father had lived to meet Emmanuelle.

He thought for a moment. "No," he replied, "no, I met her shortly after his death." Typically, it was as if he'd never made the connection before, and as if, in fact, even making it he still wasn't making it.

Emmanuelle Seigner was eighteen years old when she was introduced

to Roman Polanski by a casting-agent friend. Though she was still in high school, the fact that she was the granddaughter of Louis Seigner, one of the legendary grand masters of the Comédie Française, may have played a part in her already having landed a bit part in Godard's film *Detective* earlier that year. Polanski's name meant nothing to her ("Roman who?" she asked the casting agent)—she'd barely been born at the time of Tate's murder, was only eleven at the time of the rape case. Before actually going to meet him, however, she boned up on his history, so much so that, as she says, she was "scared shitless" going up to his apartment for the casting call. (She didn't touch the drinks or cakes he proffered.) He was immediately taken with her. For one thing, she was strikingly beautiful, though not precisely in his customary Basia-Tate-Kinski mold: her facial features were more peculiarly spread, almost as if smeared, her eyes a startlingly translucent green. Part of what he saw in her then, and continues to see in her, might be summed up by two photos of her he keeps, one atop the other, on a pillar facing his desk. In one, she is a happy, sunny schoolkid, her face aglow with a wholesome smile. In the other, leather-clad and done up for one of her subsequent roles in his films, she is a terrifyingly sultry vamp. So he saw that range and mutability, but clearly he saw something more as well.

His Polish friends the Morgensterns visited him shortly thereafter on location for *Pirates,* off the Tunisian coast. "Listen," Jakub Morgenstern recalls his saying almost as soon as they arrived, "I'm madly in love." Morgenstern's wife elaborates that Emmanuelle wasn't there anymore when they arrived—"She'd just returned to Paris for her graduation exams, we only sensed her perfume. But he was in love and he didn't want to hide it, and this was completely unusual with him. In fact, he seemed unreservedly happy for the first time in his life." Why her? I asked. "Ah, love's a mystery," Kuba Morgenstern opined, "but maybe it's because—I like her very, very much—she's simple, almost childlike, she doesn't try to premeditate. Maybe a bit like Sharon before. He's like an animal who's always tensed up, constantly sensing ulterior motives, evil designs. And he likes to give to someone who doesn't seem to want anything of him."

For all the blossoming in his personal life, however, by 1986 Polanski's

professional career was in considerable jeopardy. *Pirates* was proving a fiasco. Perhaps it had incubated too long, victim of a sort of inspirational sclerosis (it was originally conceived as a vehicle for Jack Nicholson, who had in the meantime priced himself out of the running; Walter Matthau eventually landed the role of Captain Red, "the most treacherous pirate to roam the high seas"); certainly it had grown too ambitious (at a certain stage, Polanski was having to oversee the labors of over two thousand cast and crew members); maybe they spent too much at the outset on the galleon, and ran out of much-needed funds later on. "Everything that could go wrong did go wrong," Polanski told interviewers at the time, as if in preemptive expiation. "Literally every shot of that film was like a fish torn out of the mouth of a shark. I don't know of any other director who would have finished it." His relations with de Laurentiis and his other backers progressively soured. Mount, on the other hand, who had been physically with him through much of the eighteen months of the production, came away more impressed with his directorial gifts and stamina than ever before. With the film's dreaded premiere rapidly approaching, both men realized they'd have to strike quickly—to put together a deal on a new film in advance of the coming fiasco.

Polanski returned to Paris and immediately set to work with Brach on a more conventional genre piece, a straightforward suspense thriller. Given that they'd decided to venture into Hitchcockian territory, the specific plotline they eventually settled upon was again strikingly evocative of issues in Polanski's own life: his past life (man and wife arrive at Paris hotel after a long night's flight, man pops into shower and, emerging, finds his wife has simply disappeared), and his future life as well. Harrison Ford, playing the husband desperately searching for his missing wife, soon falls in with an equally desperate leather-clad chippie, played of course by Emmanuelle. The narrative devolves, in part, into an exploration of issues surrounding marriage and fidelity because the husband, while manfully endeavoring to rescue his bourgeois wife, also finds himself being ineluctably drawn to the bohemian chippie. At the climax, his dilemma gets neatly solved for him when the chippie dies in his newly freed wife's

arms. In real life, shortly after the film's completion, Polanski resolved his own version of the dilemma even more neatly, by simply marrying the chippie!

With his next (and most recent) film, *Bitter Moon,* in which he once again featured Emmanuelle, viewers were given further, if somewhat oblique, access to his evolving views on relationships in general and his own in particular. I emphasize the obliqueness of that access, for if the film enjoyed a decidedly mixed reception, both among critics and filmgoers, this was precisely because of the tonal confusion it seemed to engender. The material was incredibly discomfiting, seemingly confessional but then perhaps only mock so: from moment to moment it was unclear to viewers whether they were squirming and laughing along with Polanski or rather, in derision and embarrassment, *at* him—or, in fact, whether it might be *he* who was laughing at *them.* How in control of the material was he? (I happen to be among those who think he was entirely in control and find his mastery at projecting such tonal vertigo onto the audience one of the most fascinating things about the movie.)

Like *The Tenant* before it, *Bitter Moon,* for all its quasiconfessional intimacy, was in fact entirely based on somebody else's work, in this instance a 1981 novel by the French philosopher Pascal Bruckner (the title *Lunes de Fiel*—literally "Bile Moon"—performs an untranslatable pun on the French phrase for "honeymoon": "*lune de miel*"). The very first scene, in which a couple are seen excitedly exploring an ocean liner, for all its intimations of Polanski's own final moments with Sharon Tate on the QE2, is in fact straight out of the book. The couple in question turn out to be British—uptight, played out, childless—and they have clearly embarked upon this Mediterranean cruise, bound eventually for India, in an attempt to resuscitate their flagging marriage. They are presently befriended by a strange couple, an American expatriate, paralyzed from the waist down, and his lubricious bombshell of a girlfriend, played of course by Emmanuelle, who shunts him about in a wheelchair. The paralyzed American (played by Peter Coyote) gradually ensnares the comically repressed British couple, and especially the husband (Hugh

Grant), in an ever more sordidly engrossing account of his affair with the girl. The more confoundedly appalled the British husband becomes by the American's account ("If only half of what you say is true," he blusters, "you'd be too ashamed to tell it"), the more compulsively he seems drawn to the man's girlfriend, as seems, for some mysterious reason, to be the spidery American's intent all along.

The film's ending is shockingly abrupt, though it departs radically from the book's—much as Polanski upended Towne's denouement in *China-town*, though, oddly, in just the opposite direction, for if anything it's the book this time that features the more conventionally Polanskian wicked ending. In Bruckner's version, the Coyote character lures Grant's to an early-morning tea in his girlfriend's quarters, where she lies across the bed, passed out, drunk and naked; he goads the Brit into finally having his way with her, and when the Brit hesitates, he leans over from his wheelchair perch and pours scalding tea all across her magnificent face, chest and body (she awakens, screaming); when the stewards come barging in in response to her cries, the American accuses the Brit of having been the one who poured the tea—and it turns out that the entire narrative is being related by the Brit from the bowels of the Turkish prison to which he has been remanded (his wife, horrified, decides to stay on the boat, becomes an opium addict and, once in India, a call girl and presently a street prosti-tute; the American and his now hideously disfigured girlfriend return to Paris, where she pushes him pathetically around the city's parks). Polanski instead has the American shoot his girlfriend in her cabin, in full view of the visiting British couple (once again the chippie dies in the bourgeois wife's arms) and then shoot himself, and the film ends with the British couple topside and blown away, in a kind of drained embrace. At which point an angelic Indian child approaches them to offer a kind of blessing.

Far from being the exaggerated Polanskian descent into libidinal excess for which some critics and audiences mistook it, *Bitter Moon* thus plays, if anything, more like a libertine's final swearing off libertinage altogether. While "normal love" might still be "incredibly boring," Polanski had found a roundabout way of celebrating its virtues through the self-immolation of

its opposite. It was as if he, of all people, seemed to be saying that erotic relationships that fail to progress to marriage and childbearing are invariably condemned to degeneration.

And sure enough, no sooner had he and Emmanuelle completed the film than they were themselves expecting, and this time (unlike after *Rosemary's Baby*), the pregnancy was quite intentional.

Rafael Yglesias figures, half seriously, that one of the main reasons he passed muster is that he'd brought his young son with him to Paris for the initial interview (the boy slept on his lap through most of it), and Roman and a visibly pregnant Emmanuelle were charmed. This was July of 1992, and they were clearly excited, as well, about their own coming prospects as parents.

Yglesias, an accomplished young novelist who'd recently been branching into filmwork, had just a few weeks earlier turned in the final shooting script for Peter Weir's production of *Fearless,* based upon his own novel, whereupon his patrons at Warner Bros. asked if he might be interested in collaborating with Polanski in trying to wrest a film script out of Dorfman's play *Death and the Maiden.* Yglesias subsequently recalled for me how he'd "said 'Yes,' with fear," a trepidation that seemed made up of equal parts awe ("I vividly remembered seeing *Rosemary's Baby* when I was twelve—so that for me, this was like stepping into a history book") and anxious misgiving. The latter only increased during the weeks before their actual first meeting ("my audition," as Yglesias puts it), as one Hollywood type after another warned him about how Polanski loved seeing how much of a fool he could make of any new visitor, how he delighted in corrupting people, getting them to drop acid, say, or launch into ill-advised affairs, all sorts of supposed depravities.

And although, once in Paris, to his relief, things seemed to go well, Yglesias's anxieties still persisted, just below the surface, through much of the first week. "And then one afternoon," he recalls, "we were working up in his apartment as usual, we'd really been at it and both of us were starting to

feel a bit tired, and suddenly he announces, 'Maybe we should have something to pick us up.' I immediately told him that coffee would be just fine for me. 'No, no, no, no,' he says. 'Coffee's bad for you. Terrible. No, I'll get us something.' He got up and left the room, and I experienced this moment's panic until he emerged from his kitchen, a broad smile spread across his face, with two Häagen-Dazs ice cream bars. And that became a daily ritual. And he really wasn't drinking coffee—not doing so, he said, had completely changed his life. He was seeing doctors, he was putting nothing unnatural in his body. I came to figure I must have just been meeting him at a different phase of his life."

Early on they agreed on a basic strategy for rejiggering Dorfman's tight little chamber piece about the lawyer husband, his torture-surviving wife, and the Good Samaritan doctor who ends up spending the night: whereas the usual procedure for adapting a stage play to the screen is to open it out with all sorts of exterior location shots and so forth, they intended, if anything, to collapse this play's story in even tighter, to make the atmosphere as claustrophobic as possible ("I've always thought of it as *Knife in the Water II*," Polanski told Yglesias). "It was a great, great experience working with him," Yglesias continued. "Between August and October we went through several drafts, and his notes were always incredibly specific. Why does he make the call now, here, instead of later, there, which might work better for these—one, two, three—reasons? And the only thing I had to prove to him for him to agree was that my way was *real*—not that it was more commercial or sympathetic or less expensive—but that somebody would really do it that way. And we'd act it out, there in his living room. Nothing was left for the set: like Hitchcock, he wanted it all blocked out in advance. Endlessly, repeatedly, we'd read the script out loud, taking on the different roles. I remember one time we got to the point where the gun gets loose and Paulina screams at her husband, 'Get the gun!' And suddenly Roman was wondering, 'Is that right? Would she say that—"Get the gun!"—or would she say, "Get it!"?' I said I didn't know. 'Let's read it,' he said. So I went back a couple pages and started in, and he said, 'No, no, go back to the beginning of the scene'—*fifteen pages!* So we went back, read

the whole scene through, one way, then the other, then back to the first. An hour and a half before we'd finally made up our minds."

I pointed out all the autobiographical resonances in the story and asked whether Polanski had spoken much about his own life. "A bit," he said, "in fact, actually, a lot, but only in a practical context, never just telling stories to be telling stories. I mean, for instance, at one point we got to the sequence in Ariel's version where she knocks out the doctor and he then stays unconscious through the rest of the night. 'That's total bullshit,' Roman suddenly declared. 'It's very hard, you know, to knock someone out. See this? See this here?' He lifted his hair back over his scalp to show me a scar. 'Man tried to knock me out once when I was a kid, big guy, and he had to hit me seven times with a rock—hard—before he finally succeeded in doing so, and even then I was only out for a few moments. It's not that easy to knock someone out.'

"Another time he brought up his life, we were sitting at a restaurant across the street, and I'd been saying that I didn't quite believe Paulina's reaction to the doctor's initial arrival at their house. Always, that was the only issue—*is it believable?* I figured that her first reaction upon hearing that voice again like that would be to bolt, to run away, and only afterward might she have realized that actually, in this situation, *she* was in command, at which point she'd have returned. 'Has anyone ever done anything really horrible to you,' Roman asked, between bites, 'something you could never forgive? Believe me, if such a person from my life were to come walking down that street out there right now, I'd leap from this table and chase right after him.' Yeah, I said, but that was because we were in a restaurant in the middle of the day in the middle of a city. What if it were late at night in a remote cabin? He paused for a few moments, chewing. 'Yeah,' he eventually said, 'you're right: I'd run.'

"But, I mean, the disparity in our life experiences! There he was thinking of Manson, and I was thinking of two kids criticizing my dog. The actual Roman and the casual public perception of him are like polar opposites: I see him as almost entirely the victim of his experiences. And,

frankly, it's difficult to imagine someone who has suffered more in his life and handled it so well."

"Tonino!" Polanski called over to his cinematographer, Tonino Delli Colli, a veteran of some of Fellini's, Pasolini's, and Louis Malle's greatest films—and a man even shorter than Polanski himself. ("That's how Roman likes all of his cameramen," one of his assistants confided.)

I'd come to pay a visit on the set—as it happened, in keeping with Polanski and Yglesias's strategy of constricting the play's dramatic arc as tightly as possible, virtually the film's only set—a clapboard bungalow constructed on a darkened soundstage at the legendary old Boulogne Studios, outside Paris, where everything from Gance's *Napoleon* through Renoir's *Grand Illusion* and on past Carné's *Children of Paradise* had originally been shot. (A certain melancholy air hung over the entire proceedings, inasmuch as the Powers That Be had decreed the end of Boulogne, the whole place was about to be torn down—there were eerie demolition notices scattered all about the lot—and Polanski's would prove just about the final film ever to be shot there.)

"Tonino, what lens is that?" The twenty-two-millimeter, Tonino replied, after giving the camera a quick look. "O.K.," Polanski said, turning to Sigourney Weaver, without bothering to gaze through the eyepiece, "that means the frame will reach out to here, this will be the edge, and over here will be just out of the frame, so I want you to be standing here."

"And you can be sure he's right, to the millimeter," one awestruck crewman commented to me. He was quiet, shaking his head, and then he muttered a single word: "Lodz."

Whether it was the depth of his original training at Lodz or the breadth of his subsequent experience, the extent of Polanski's technical competence on the set was continually startling. At one point, I saw him grab the kit out of his makeup artist's hands to redo the bleeding gash on Kingsley's forehead; a few minutes later, he was reconfiguring the wiring of an

electric-light source on the hidden side of a fake candle; a few minutes after that, he was coaching Sigourney Weaver's double on the proper way to hog-tie an unconscious man ("Loop it like this, not like that"). One got the sense that, lacking a crew, he could have done it all by himself. And yet, at the same time, the full-hearted way he shouted "Guys! Guys!," bringing order to the set, was so exuberantly inclusive as to remind you all over again how vitally fulfilling the sense of collaboration, of being one of a band of fellow troupers, is for this man, who, years ago, really had been all by himself.

The scene the crew happened to be working on that day, from relatively early in the story, would become one of the film's most shocking: The grateful husband has invited the doctor to spend the night, the doctor has sprawled out on the living-room sofa and gone to sleep, and, sometime later, the wife (who had bolted at the sound of the doctor's voice) is returning. She approaches the sofa stealthily, but as she does so, the doctor awakens, and she bashes him senseless. She drags his limp body across the room and starts tying him into a wooden chair.

In the play, the doctor stayed unconscious until he was firmly lashed to the chair, but Polanski and his colleagues had energized the scene considerably: as the doctor is being tied up, he regains consciousness and calls out in fear, threatening to wake his host, asleep in the next room. In a panic, the wife reaches under her skirt, yanks off her panties, and shoves them into his mouth. Then she reaches for a roll of packing tape on a nearby table, hikes up her skirt in order to straddle his lap, wraps tape around his head and mouth—once, twice, three times—and leans close to his cheek to rip the tape from the roll with her teeth.

"Cut!"

The effect was incredibly visceral and perverse, even after five or six rehearsals and ten or twelve takes. The scene was also quite an ordeal for the actors, particularly for Ben Kingsley, who, though his neck and face had been oiled, still suffered, wincing painfully during the tearing off the tape before each new take. Polanski and Kingsley joked between takes about just how many beers one was going to be owing the other when this

was all over, but clearly Polanski was concerned. "Ach!" he cried out at one point. "This is terrible. I should have had them rehearse on me. The director should never put his actor through something he wouldn't be willing to endure himself."

Suddenly, he grabbed the roll and wrapped tape—once, twice, three times—around his own, unoiled, head.

"He has definitely changed," Thom Mount, the film's producer and Polanski's longtime friend, was commenting to me a few hours later, over lunch. "I think when he first started he was in love with film, then for a long time he was in love with the lifestyle that film afforded him, and now it's as if he were coming back to his first love all over again. I kid him—I tell him it's about time, because he may only have another twenty good years in him."

Polanski *has* mellowed noticeably in his attitude toward actors and their role in the creative process. His appreciation of the interaction between actor and director seems far more nuanced. "It's like a dissolve, the original vision meeting material reality," he remarked to me another afternoon during a break in the shooting. "And I'm like a conductor working with a superb orchestra. It's faster, more telegraphic, for me to give a line reading—to hum, as it were, the interpretation I'm trying to achieve— than to spell out the emotional complexities underlying that interpretation. A noncomplexed actor will understand that, and I, for my part, am looking to be surprised by the actor." (This more densely textured sense of working with actors may also derive in part from his own recent work as an actor, in a new film by another strong director, Giuseppe Tornatore, whose earlier work includes *Cinema Paradiso*. In this film, *A Pure Formality,* which was then showing all over Europe, Polanski had been marvelously cast, opposite Gérard Depardieu and against type, as a scrupulous magistrate investigating an apparent murder.)

A few weeks after the *Death and the Maiden* shoot was completed, I telephoned the three actors for their thoughts on what working with Polanski had been like. "I'm glad it wasn't my first film," Sigourney Weaver told me.

"He was tough, and he wasn't there to make us feel better. 'Grow up, get real, be an adult'—that was the continual subtext. On the other hand, by the end I think all of us felt this tremendous loyalty." Had being the only woman been difficult? "No, it was difficult being the tallest," she said, laughing. "But, seriously, I think he may be the best actor's director I've ever worked with. The first day of rehearsals, he sat us down and read us the entire script, taking all the parts. Stuart looked on, horrified. But I tend to agree with Ben, who said that he prefers it when a director gives him a narrow target—he finds it liberating. And, of course, it depends on who's giving the line readings. Most directors won't even try—they're unwilling to put themselves on the spot like that. But Roman does you the high honor of directing, of thinking it through, right in front of your eyes."

Kingsley spoke of Polanski's "actor's love of and delight in acting," and said he felt that Polanski had lavished just the right amount of attention on his players—"neither clamping down too hard nor leaving so much leeway you didn't know where you were." As for the line readings, he echoed Polanski's own metaphor, saying, "A brilliant first violinist would be a fool to ignore a brilliant conductor, and anyway it's symbiotic—his reading is coming in response to my own." Kingsley kept returning to "the extraordinary level of trust" that Polanski inspired on the set; it "allowed Sigourney and me to get closer and closer so that we could in turn become more and more violent with each other during our scenes," he said. "And that's not a paradox. That's what acting is: the more trust, the deeper you can venture into the abyss. A lesser director would have freaked out, seeing us happily conversing off in a corner between takes, but a great director understands such a dynamic, and even nurtures it."

Stuart Wilson had the hardest time: he resisted Polanski's directorial style from the start. At one point early in the filming, Polanski even tried to show him how to shrug, and Wilson exploded. Polanski undercut this outburst by launching into a long joke about a horse that repeatedly winks at a particular bettor at the racetrack. The guy can't believe his eyes, but finally he goes and puts all his money on the horse, the race is run, and the

horse comes in dead last. On its way back to the stable, the horse looks up at the bettor and shrugs. "Couldn't you shrug like that?" Polanski asked. Working with Polanski, Wilson told me, had been both terrifying and strange. "Roman's a curious mixture," he said. "He can make you feel more insecure than you ever have felt in your entire life—but then safer, too." He still seemed confused by the experience. I asked if he would ever consider working with Polanski again. "If the right project came along, I'd grit my teeth and be there in a flash," he said.

In closing, I asked Wilson whether Polanski had spoken with him at all about the Tate murder, particularly during those scenes where his character wonders aloud how he would have behaved if he had been subjected to similar horrors, and where he speaks of his guilt feelings about that and about his subsequent infidelities. "No, no," Wilson replied. "That never came up. Listen, Roman's a deep, deep pool who likes to make like he's a shallow pool."

A few months later, I happened to be in Paris again and was able to pay a few more visits to Polanski, who by then was hard at work on the film's postproduction. On my last day, I dropped by his apartment to join him for a drive out to the editing facility. He had an interesting day ahead of him, for he would be choosing from among five takes of a scene by Ben Kingsley: the film's climactic soliloquy, in which, by the edge of a cliff in the early-morning light, the doctor finally does—or doesn't—authentically confess to the depredations that the wife has been accusing him of. The takes had been shot a few months earlier, on location in Spain, near the very end of the ten-week shoot—the one time the cast and crew had left their dark soundstage outside Paris. The filming had been done at twilight, and the crew had had only forty minutes of light to work with. Kingsley delivered five separate versions of the three-minute soliloquy, one after the other, each of them perfect, yet each different—shaded in subtle ways to entirely transform the moral connotations of what he was saying, and, for

that matter, of everything that had gone before. It was an astonishing performance: a veritable acting clinic. Unfortunately, Polanski wasn't going to be able to use them all, and even at this late stage, he hadn't quite made up his mind.

Watching those takes and then a rough cut of the denouement, I found myself thinking about how Polanski's films have changed in the last several years. Through most of his early work, his films tended to taper relentlessly to a dark joke at the dead end: at the end of *Knife in the Water,* for instance, the husband is damned if he does and damned if he doesn't; *Cul de Sac* ends with the cuckold abandoned on a narrow rocky outcropping with the tide rising around him; in *Chinatown*—well, forget it, Jake, that's Chinatown. Polanski's most recent films have been similarly structured, except that in each of them there has been, at the last moment, the glimmer of an out: the possibility of children, say, in *Bitter Moon,* and, to even more impressive effect, the suggestion in *Death and the Maiden,* after all the pain and torment, of a kind of forgiveness.

That morning at his apartment, I had asked Polanski about his own sense of the future. Did he think he would ever get back to Hollywood? Did he care? Was he doing anything about it?

"Of course I'd like to be able to return," he said. "Not to live—I don't think I could live there again, because the city, those streets, have too many bad associations—but just to be able to work in a normal fashion." It is surely the case that his career has been marginalized by his not being able to be there and to compete for such A-list projects as *Silence of the Lambs.* "It's been seventeen years now," he continued. "And I miss the logic and the efficiencies of the Hollywood system. But, no, nothing in particular is on the horizon, and actually I even surprise myself by how I keep seeming to procrastinate on pursuing the matter."

During our conversation, another possibility for the future seemed to be on Polanski's mind. He said that one of the things he would most like to do was make a film in Poland—one set during the war. (Among other things, he has been looking at his old radio-mate Louis Begley's book

Wartime Lies.) This was startling, given his adamant refusal in the past to deal directly with such material, and his hell-bent flight from it earlier in his career. Perhaps Spielberg's *Schindler's List* opened some floodgates for him, or perhaps *Death and the Maiden* itself had. Or—what was more likely, and was something he himself surmised—simply being with his daughter, Morgane, who is now twenty-two months old, has been taking him back to first things.

Morgane was out in the hallway as we talked, cavorting with her nanny, and Polanski smiled at the racket. He is obviously besotted with her. Whenever she toddles into his office, everything comes to a stop as he melts and becomes her plaything. The same on the set: One day, visiting, she started to play with his eyepiece.

"Ah," Sigourney Weaver said. "Another director."

"No," Polanski answered immediately. "She will be in front of the camera!" He and Emmanuelle have had their huge living-room TV screen wired so that they can push a remote-control button and summon up a view of Morgane asleep in her crib.

We listened to her for a while, and then Polanski gave a long sigh. "But thank God for all those turns in my life, even the bad ones—maybe even especially the bad ones," he said. "Had I missed a single one, I wouldn't have ended up here, with Emmanuelle and Morgane, and to me that is completely unthinkable."

It was getting late, and we had to rush over to the editing studio. We tried to sneak out unnoticed, but Morgane, glimpsing the briefcase in the hallway and realizing that we were leaving, let out an anguished cry— "Papa! Papa!"—and came rushing to intercept us. The nanny grabbed her and held her as we sheepishly boarded the elevator. The child, her arms thrust out, kept pleading frantically, "Papa! Papa!" Roman threw her a kiss, and the elevator door closed, but we could hear her wails all the way down, and Roman was nearly undone. "Of course she's desolated," he said, finally. "She doesn't understand. For her, it's as if I were disappearing forever."

(1994)

POSTSCRIPT

But Polanski did not disappear, and half a decade after the publication of this piece, he did indeed return to his Polish roots for the creation of *The Pianist*, starring Adrien Brody, based on Wladyslaw Szpilman's harrowing account of his own wartime survival. (In one particularly haunting scene, Brody's character, an accomplished young classical pianist herded into the ghetto, witnesses a young kid trying to burrow his way back under the wall with his stash of smuggled goods when he gets caught halfway: the boy struggles desperately, a trapped animal, but a shot rings out and he goes limp. An alternative biography.) The film was rapturously received, capturing the 2002 Palme d'Or at Cannes, six Cesars (including prizes for best film and best director), and an (until then elusive) Academy Award for Best Director, which was awarded in abstentia, for Polanski still could not travel to America (despite his long-ago victim's public plea, delivered on *Larry King Live* in the run-up to the awards ceremony, that he at last be allowed to do so and that the world finally move on from the whole sorry incident, as she insisted she had). Polanski claimed not to mind, his life was in any case quite full: in the meantime, he and Emmanuelle had been gifted with a second child, a son, whom they had given the name Elvis.

THE TROLL'S TALE:
JERZY URBAN

Back in the bleakest days of martial law in Poland, during the early mideighties, one of the most peculiar spectacles greeting the occasional visitor to that benighted country were the weekly news conferences conducted by the regime's notorious press spokesperson, the ex-journalist Jerzy Urban, every Tuesday morning—or rather, the broadcast of extensive, largely uncut swaths of that morning's news conference every Tuesday evening over Polish national television. The press séances were themselves uncanny, for Urban—short, squat, porcine, with ludicrously oversized, radar-dish ears—was at the same time unfailingly dapper, punctilious, clever, usually quite witty and almost always disarmingly candid: this in the middle of Communist Eastern Europe in the very midst of martial law! The evening broadcasts, however, were even more uncanny, for all across the country, in record numbers, families and friends would gather by the light of their television sets, positively crawling with rage and fury at the imperiously smug and self-assured face the regime saw fit to parade before them—or rather, as many surmised, to hide behind. Indeed, the positive contempt coursing in both directions—Urban's for his fellow countrymen and theirs for him—sometimes seemed to take on an almost erotic dimension, as caricatures and figurines of the voluptuously despised press spokesman sprouted up all around the country, many of them of a thoroughly prurient cast, but none too disgusting to qualify for inclusion in the collection which Urban himself was known to be happily amassing all the while.

A common parlor game in those early years of martial law consisted of a furtive enumeration of those of the regime's leaders who might likely

URBAN

... była jego żona... *Karyna
Andrzejewska*

PHILOBIBLON

expect to find themselves dangling by their necks from the light posts along Nowy Swiat, come the inevitable revolution. Candidacies shifted from month to month, depending on the latest social or political outrage, but Urban's name seemed to bob near the top of every such list, at the tip of most every tongue. Even among the less expansively hyperbolic of his critics, few gave Urban much chance of navigating his way clear through any coming transition, at least with his career or social standing intact.

 And yet, in fact, hardly any of the old guard—or, for that matter, any of

the new—have done better for themselves. Urban, who in the old days lived a comfortable though by no means lavish existence, nowadays routinely finds himself near the top of a new set of lists—those of the country's most successful entrepreneurs. Nor does anyone suspect him (as one does with so many others) of having amassed his fortune through surreptitious transitional side-dealings: the stations along the way of his progress toward his current good fortune have all been dismayingly well-lit and openly evident. Indeed, a perverse kind of openness has been their very hallmark.

Within a year of the calamitously abrupt disintegration of Poland's Communist regime during the summer of 1989—in the wake of a semi-free election in which its Solidarity opponents swept virtually every single seat they were permitted to contest (including the one in the Warsaw-Central district for which Urban himself was contending)—Urban managed to steady his own downward spiral by slapping together, in a mere four weeks, a shockingly scandalous memoir, entitled *Urban's Alphabet*, in which the former government press spokesman proceeded to skewer, in alphabetical order, virtually all of the most elite members of both the establishment and the opposition, people whom he'd either had occasion to know personally or whose police files he'd often perused, focusing in particular on the most salacious and inappropriate aspects of their respective careers, marital infidelities, or sexual peccadilloes—the entire package pickled in his own distinctively mean-spirited, cynical style: gutter con brio. And, as it turned out, Poles couldn't get enough of the stuff: during its first twelve days, the slim volume sold 400,000 copies, with over 750,000 copies in circulation by the end of its first month—this in a country of barely forty million people (a proportionally adjusted American best seller would have to sell nearly five million copies in a comparable period).

Urban personally netted over $120,000 from this triumph, at a time in Poland when even a few dollars still went a long, long way, owing to the lingering insubstantiality of the zloty. He in turn poured that money into founding a weekly color tabloid with the quintessentially Urbanesque title *Nie* (*No*)—this at a moment when every fiber in the newly liberated cultural life of Poland (not to speak of the rest of Eastern Europe) seemed to

be straining to at last proclaim "Yes! Yes! Yes!" Under Urban's canny direc-
tion and editorship, *Nie* became a sort of cross between the French *Canard
Enchaîné* (or the British *Private Eye*) and Al Goldstein's *Screw* magazine, an
often smutty, scandal-mongering rag, replete with grotesquely obscene
drawings of a not-even-sophomoric subtlety (penises variously rampant
or flagging, female crotches by turns dripping and dentate), which also
happened to be the only journal for a long while willing to take on such
otherwise sacred cows as the country's newly all-powerful Catholic Church
(many of those penises were dangling lewdly from out of priestly robes).
And once again, Urban's instincts proved startlingly lucrative. "The Polish
nation has gotten exactly what it wanted," the filmmaker Andrzej Wajda
recently commented to me regarding Urban and his tabloid. "The man's
real pornography is his cynicism."

Over the years, I've tried to make it a regular point, during my various
reporting trips to Poland, of checking in with Urban—he's always good for
a laugh and sometimes for a good deal more. One of those trips happened
to fall shortly after the publication of his *Alphabet*, and I visited him in the
still fairly dingy offices of the magazine he'd only just launched. I remem-
ber asking him about the stunning dimensions of the still recent electoral
repudiation of the regime for which he'd so long fronted. "Ach," he said,
with an insouciant shrug, "you know how it can be with girls who spend
year after year cooped up with the nuns: inevitably they end up making the
easiest lays." It was an echt Urban remark: concise, disgusting, sexist, sacri-
legious (and specifically anti-Catholic)—but not altogether off the mark.
He predicted that following this first whiff of permissive liberty, things
would stabilize and the electorate would come to reflect a more normal
and widely scattered array of interests and ideologies—a prediction which
has in the meantime been largely borne out. But nor did he attempt—
again typically—to gloss over the extent of the debacle. "My own Warsaw-
Central district happened to provide a catchment as well for all the ballots
of our diplomats abroad, and—I saw the figures—I couldn't even eke out
a majority from among our regime's own envoys in Pyongyang or Ulan
Bator or Tirana." He seemed more bemused than abashed.

Our conversation turned toward his *Alphabet* book and, specifically, toward what I took to be one of the most mystifying things about it: across a text that took virtually no prisoners, routinely savaging friends and foes alike, one person in particular emerged unscathed. Urban had had nothing but kind words for his former boss, the rigidly dour General Wojciech Jaruzelski; indeed, he could barely contain his superlatives ("my greatest and only incurable love," "the greatest mind I have ever encountered, at least among humans," etc.). I commented that I knew it was useless trying to ask an ironist if he was being ironical, but, still, with regard to the general, was he being for real? Was all that stuff on the level? "Oh, absolutely," Urban immediately shot back, whereupon his entire demeanor abruptly changed: he became all soft and maudlin, almost teary-eyed. "No, absolutely—this is a great, great man." After a few more minutes along these lines, I remarked that the general was at any rate a fascinating historical figure, and that I'd long felt that were Shakespeare alive today and inclined to turn his attentions to the Polish drama, I could imagine no more layered and historically complicated or ambiguous a figure than General Jaruzelski, this son of the landed gentry, whose parents had been directly crushed by Stalin and who had yet grown up to become perhaps the most crucial defender of that totalitarian imperial system— what could possibly have been his deep motives?

Urban nodded wary if somewhat indifferent assent to my fanciful conjecture. Emboldened, I pressed on. "For that matter, Mr. Urban," I said, "I've often thought of *you* as a perfectly Shakespearean character. I don't know, something of a cross maybe between Richard III and Lear's fool. . . ."

"Ach, nonsense," Urban interrupted me again, now clearly having lost patience. "And anyway," he continued, "what's all this about Shakespeare? *I've always thought it would be Harold Pinter who would tell my story.*"

Urban's comment has repeatedly come to mind as, in the five years since, I've pondered his ability not only to survive but, time and again, to tri-

umph. The remark showed a veritable rapture of self-knowledge—for, indeed, who but a Pinter could do justice to such a prickly and ominously disquieting personality? Then again, who but Urban would ever have hankered to have his portrait painted by Pinter?

Most conversations seeking to probe the essence of the Urban phenomenon—and in Poland one finds oneself drifting into such conversations all the time—eventually turn on his being Jewish, or, more precisely, on his being a Jew among Poles. A lot of people are convinced that this fact constitutes the very center of his being, though whether that center consists of a dark, throbbing muscle or a cold, dead core varies from one telling to the next. For example, during martial law many people surmised that Urban's evident contempt for the Polish masses, and in particular for the way they had suddenly taken to preening themselves as history's noblest, most selfless agents, had its basis in a deeply ingrained awareness of their obverse potential. As a child living through the Holocaust in Poland, he had no doubt witnessed a lot of behavior that was less than saintly. He knew what the church-besotted Poles were capable of, and he was not above reminding them.

Not that Poland's martial-law rulers seemed especially bothered by Urban's blunt provocations. Indeed, they seemed to have reverted to historic Middle European form, promoting a Jew to a high level of visibility precisely as a means of diverting attention and anger away from themselves. Michael Kaufman, the *New York Times* correspondent on the scene during the mid-eighties and hence one of Urban's most frequent foils at those televised news conferences, tells the story of how one day an old lady on the street pulled him aside and congratulated him on the tenacity of his own performance at those weekly events. "As for *him*," she continued confidentially, her face curling in disgust, "how we despise those Jewish answers of his." ("And what," Kaufman says he retorted, "do you make of those Jewish questions of mine?") Kaufman points out how as a typical court Jew (and hence a political eunuch by definition, of no real threat to any of those above him), Urban was ideally suited to serve the role of

lightning rod, channeling the public's ire away from those who really mattered.

But, at the same time, Kaufman, like many others, realizes it's not as simple as that. For one thing, General Jaruzelski's colleagues' possible predilections notwithstanding, the general personally never seemed to be any kind of an anti-Semite; certainly not as much of one, at any rate, as Urban himself.

Urban could be unnervingly crude on the subject of his own Judaism—"Why should I give a damn what's dangling down there between my legs?"—while at the same time relishing the exposure, in strangely oblique asides, of the putatively secret Jewishness of others. During those martial-law news conferences, he'd frequently deride "the exaggerated philosemitism" of many of the regime's Solidarity opponents.

These intertwined themes—Urban's disdain for both Polish and Jewish exceptionalism—could be seen in one of his most brilliant tactical feints during martial law: his success in getting the otherwise wary Polish authorities to broadcast extended excerpts from Claude Lanzmann's epic Holocaust documentary *Shoah* over Polish State Television. On the one hand, the documentary, which sometimes seemed to focus almost as relentlessly on Polish malevolence during the Holocaust as on German malfeasance, was custom-designed to puncture any Polish pretensions toward national beneficence. On the other hand, in many of these scenes Lanzmann tended to go overboard in making his case, notably in sequences in which he allowed extremely cloddish and backward peasants and villagers to stand for the entire Polish nation—and Urban was thereby able to let the mortified Poles know exactly what other Europeans, whose approval they always seemed to be currying so desperately, *really* thought of them. It was a deliciously cynical and profoundly dispiriting double whammy—precisely what the propaganda doctor ordered. As for his own feelings about Lanzmann's documentary, Urban said to me some years later, "Sure, some Poles did some terrible things during the war, but—what?—we're supposed to take lessons in the proper treatment of a nation's Jews from the *French*?"

The cosmopolitan family into which Jerzy Urban was born, in the summer of 1933, the year of Hitler's ascension to power in Germany, had been assimilated for several generations—so thoroughly so that Jerzy didn't learn that he was Jewish until the middle of the war. (His father had been circumcised, he says, but he was not.) His mother was from a Russian-Jewish family of considerable wealth and—not untypical of such families—considerable revolutionary fervor as well. (One of her sisters had been hanged in 1905 for her role in the attempted assassination of a czarist governor; one of her brothers had been ferried back into Russia by the Germans in 1917 as part of the same sealed train car full of subversives that brought Lenin to the Finland Station; one of her uncles subsequently served briefly as Stalin's finance minister, though most all of the Russian activist members of the clan had been martyred in various purges by 1939.) Jerzy's father was a co-owner and editor of the second-largest newspaper in Poland's second-largest city, Lodz, about one hundred miles west of Warsaw (birthplace, as well, of Artur Rubenstein and, the very same year as Urban, of Jerzy Kosinski, a kind of kindred spirit). His father's newspaper was socialist and, though not communist, it displayed few of the anti-Soviet phobias rampant among most of the other Polish papers of the time (in fact, at one point Urban's father found it necessary to sue the head of a nationalist Catholic daily in Poznan for libeling him as a Russian agent). His paper was fiercely anti-Hitlerian from early on, a circumstance that ironically may have helped to secure his family's survival in subsequent years.

Jerzy, a pampered only child, was said to have been an unusually lovely-looking boy, and I've heard one theory to the effect that his contrarian perversity as an adult might be rooted in resentments engendered by the preposterous incongruity between that childhood sense of grace and entitlement and his subsequent—well, lack of physical splendor. That's doubtlessly too pat. On the other hand, Urban himself told me how, upon being informed of his Jewishness by his parents in the midst of the war—as a precaution: he had to be told so he'd know to keep it a secret—his first

reaction was to rush to a mirror and wail, "Am I then really so ugly as *them?*" (For the urbane little Urban, the category "Jew" had up till that moment connoted only the black-garbed Orthodox believers to the east.) There's probably some kind of knot of causality in there somewhere (Jewishness/ugliness/contrariness). On the other hand, Urban was a perverse little contrarian well before that revelation—or so, anyway, he likes to recall nowadays. His first impulse at the outset of the war was to root for the Germans. And his second reaction upon being informed of his secret Jewishness was to go out and blab it to everyone for the sheer scandalous notoriety of doing so. Clearly, he was not an easy child.

When Hitler's armed forces crossed Poland's western border, on September 1, 1939, the Urban family was already three days out of Lodz, racing east. (Owing to the antifascist line of Jerzy's father's newspaper, his name was prominently featured on a prewar list of the Nazis' principal enemies, and that forced him to consider the advisability of an early escape.) Variously scattered in the ensuing days by bombings, strafings, and the Red Army's invasion from the east, the Urbans were eventually reunited on the Soviet side, in an apartment in the Polish-Ukrainian town of Lvov. Thanks in part to Jerzy's courtyard bragging about the family's former wealth and station, his father was arrested by the Soviet secret police on the ground of having bourgeois tendencies. He was released only when he produced news accounts detailing the Poznan editor's libels against him, accounts which apparently so impressed the Soviet NKVD police agents that, keying on his surname (*and for no other reason*), they installed him as city planner of Lvov. That relatively comfortable arrangement held for a few months— that is, until the Nazi-Soviet pact broke down and Hitler's armies came storming eastward once again. The Urbans fled to the remote countryside, and there, amid primitive peasants and a welter of occupying and resistance forces, they managed to tough out the remainder of the war. To solidify his Aryan credentials, the young Urban was required to attend church every Sunday, and he clearly did not take to the experience.

Urban must have lived through some harrowing events (at one point, he found himself part of a group subjected to a mock execution), but nowadays he tends to downplay such experiences, preferring to highlight his own outrageously inappropriate antics. For example, he recalls being so derisive of the terror shown by the occupants of one basement bomb shelter that they kicked him out permanently. He loves telling such stories. (Perhaps he's not even making them up.) One thing is clear: he cannot abide either playing the role of passive victim or being cast in it.

After the war, the family returned to Lodz. Urban joined the Communist Polish Youth League there and enjoyed a passionate, if brief, romance with Marxism. Of his schooling he now brags, "I was a complete failure. I beat the Polish record in bad marks. I ended up attending seventeen schools before I was finished, or, rather, they were finished with me. I kept getting thrown out." It was one scandal after another. Four times, he applied to join the Party and each time was rejected; for instance, in 1952, he says, he "got called before a student disciplinary tribunal for singing improper songs." Like what? "Oh, 'Hitlerowski'—you know, old Nazi propaganda songs."

After so many rejections, Urban gave up; thus, he was not a Party member even during the period of martial law, when he was serving as the Communist regime's chief spokesman. Indeed, from the regime's point of view his apparent independence constituted a principal element of his cachet. (Actually, Urban did make one last attempt to join the Party—in 1989, when things had collapsed completely. "Not at five minutes to midnight," his friend and fellow-journalist Daniel Passent marvels, "but at ten minutes *past* midnight." Urban was very likely the last Pole ever to apply for Party membership. The Communists could no longer even lay their hands on the requisite application forms.)

Although back in the early fifties Urban lacked the Party's imprimatur, he nevertheless drifted into journalism, where his father still had a little influence. In 1951, he joined the staff of *Nowa Wies* (*New Farmland*). One of his editors there, Irena Rybczyuska (the mother, incidentally, of the

director Agnieszka Hollend), recalls how in those days, "He was a hand-some if shy boy who came advertised as talented, raw, and a bit naughty. But he was also funny, cheerful, exotic—something new, for he didn't seem to bear the imprint of the Holocaust at all. There were other Jews there, older, more somber, but Jerzy was completely different. He was well liked, but he could be mean and terribly hurtful, and he simply didn't know when to stop. There's a Russian expression 'He'd kill his own father for the sake of a joke.' And that was Jerzy. In a photograph album we put together at the time, he scrawled under his own photo, 'Fuck anyone who thinks badly of me.' And that was Jerzy, too."

In a typical journalistic stunt early in his career, Urban placed an ad in a Krakow newspaper, posing as a matchmaker seeking a wife on behalf of a rich Polish émigré living in Britain. Dozens of elegant Krakow women answered the ad and proceeded to spill their most intimate histories to this supposed matchmaker, who then published a scathing account of the adventure, singling out the various candidates by name. (One of them turned out to be another journalist, on the prowl for the other side of the story—a second shameless reporter, shamelessly pretending. Urban was entranced by this woman, his equal in cynicism, and they eventually married.)

After Stalin's death, in 1953, the Soviet imperial system began to thaw, initially along its periphery and particularly among the young. By the fall of 1955, a group of iconoclasts in Poland had seized control of *Po Prostu,* a once ardently Stalinist youth weekly, converting it into the voice of a new generation of socialist reformers. In no time, Urban was heading the paper's domestic desk. The Old Guard, under Soviet pressure, tried to reassert its authority, but all through 1956 *Po Prostu* fought back tena-ciously. It was at the center of the movement that culminated in Poland's celebrated Springtime in October, when Wladyslaw Gomulka, newly re-instated as Party First Secretary, successfully stared down a challenge from Khrushchev. Within a year, however, Gomulka was himself rigidifying, and one of his earliest targets was *Po Prostu.* By October 1957, the paper

had been shut down; Urban was out of a job and, not for the last time in his career, forbidden to publish under his own name.

For three lean years (years rendered all the more anxious by the birth of his only child, a daughter), Urban was forced to publish under pseudonyms or by way of sympathetic fronts. By the early sixties, he had regained a tenuous aboveground respectability, writing for *Polityka,* one of the most sophisticated journals in Eastern Europe, and then he blew it all once more, this time by publishing a savage profile of a prudish antialcohol crusader. (Urban, famously devoted to good drink, had been annoyed, on a trip to the crusader's hometown of Krakow, at not being able to find a single watering hole open past 7 p.m., and his piece constituted an act of righteously sarcastic vengeance.) Trouble was, the antialcohol crusader turned out to be a good friend of the equally prudish Gomulka, who personally ordered Urban's banishment yet again. For three more years, Urban was thrown back upon the forbearance of editors occasionally willing to slip him payments in exchange for pseudonymous articles. (One of these, Dariusz Fikus, was the son of the Poznan editor who had once libeled his father.)

By the late sixties, though, Urban was once again able to publish under his own name, and his signature style was becoming increasingly prized by a widening public: funny, slashing, colloquial, sometimes unspeakably vulgar, but often irresistibly astute. In 1969, Urban rejoined *Polityka.* Its editor-in-chief, Mieczyslaw Rakowski, had gained considerable international prestige in 1968 by resolutely shielding his staff from anti-Semitic purges sweeping much of the country during a top-level Communist Party power struggle. Still, Rakowski wasn't exactly a saint; he steered his weekly along a modestly adventuresome course (reformist, but never *too*), steadfastly supporting his patrons in the Party leadership until just before a shake-up, at which point he would stake out a "reformist" position demanding their ouster. He neatly turned this trick in 1970, when Gomulka was sacked in favor of Edward Gierek, and again in 1980, when the extravagantly corrupt Gierek fell before the Solidarity onslaught. Urban, in turn,

became one of Rakowski's key aides, serving as national editor of *Polityka* during some of its most influential years, in the mid-seventies (and I have heard nothing but glowing accounts of Urban's competence and professionalism in that capacity).

A remarkable photograph survives from that era, a group portrait of the magazine's staff and friends, taken in 1978 at a gathering convened to celebrate Rakowski's twentieth anniversary as editor. In retrospect, it's an eerie image, for over the next several years Poland's journalists—and these were, without doubt, among the country's finest, including Ryszard Kapuscinski, Hanna Krall, Daniel Passent, Wieslaw Gornicki, and Dariusz Fikus—would play an inordinately important role in the country's history, some in opposition to the system (Fikus, for instance, would become head of the Solidarity-aligned Polish Journalists' Association) and others in its defense. In February of 1981, six months into the Solidarity era, the new Prime Minister, General Jaruzelski, appointed Rakowski his Deputy Prime Minister—and Rakowski, in turn, brought Urban along as government press spokesman. Ten months later, Jaruzelski and Rakowski presided over the imposition of martial law, with Urban providing color commentary and rationale. Half the people in that convivial 1978 photograph would in effect end up incarcerating the other half. And yet even today it's possible to wonder why Urban, comfortably if somewhat sinuously ensconced there on a picnic blanket over to the side, right next to Fikus, wound up on the side he did.

"Through 1976, Urban might still have fallen our way," Adam Michnik told me recently. Michnik, one of the foremost theorists of the movement that became Solidarity and one of the martial-law regime's most celebrated and longest-suffering prisoners, today heads the country's leading daily, *Gazeta Wyborcza*. "He had no love for those idiot Communists—he, of all people, could see right through them. In the end, though, I think three factors prevented it. First of all, his extreme contempt for the Church and the tropes of Polish nationalism." (By the late seventies, the Polish secular opposition, led by Michnik himself, had begun to forge a working tac-

tical alliance with the Church.) "Second, his conviction, given geopolitical realities, as we used to call them, that serious resistance was fundamentally futile. And, third, his fear of the loss of his material comforts."

Daniel Passent, like Urban a Holocaust survivor who ended up supporting the martial-law regime, offered an account similar to Michnik's, but with a twist. "The thing you have to understand about Urban is that, like many of the rest of us, he was *defined* by his survival of the Holocaust," Passent said. "He's incredibly courageous in his writing and always has been—much more so than many of his current critics—but he is animated above all by a need for personal security. As a child, he saw the horrible weight of absolute power descending on a defenseless country, and his whole life became devoted to preventing a recurrence of that phenomenon. He—we—felt that Solidarity was taking a terrible risk of provoking just such an outcome all over again. Which is why the weaker the system became—a system whose pathetic limitations he understood as well as, if not better than, anyone else—the more vigorously he rose to its defense. This is what the Holocaust produced, what it honed—a generation of individuals who regularly attempted to lash out at the walls while at the same time holding up the ceiling."

On the other hand, many of Solidarity's strongest supporters—including, notably, Michnik—were also Jews. (Perhaps significantly, they were of a younger generation—the *children* of returning Holocaust survivors.) "For many of us, in the end it was, as our great poet Zbigniew Herbert puts it, just a matter of *taste*," Michnik suggests. "Urban had an iron gut and could stomach all that crap. Others of us simply couldn't."

Many years after the fact, I asked Jerzy Urban how he had felt on December 13, 1981, as martial law was declared. "I felt *wonderful*," he replied, without a moment's hesitation, a mischievous grin spreading across his face. He took a drag on one of the Gitanes *filtres* he likes to smoke, and continued, "Of course I felt wonderful. At last, the battle was engaged. The previous situation had been unbearable, to be continuously under attack like

that, just taking it always, just defending and defending. I'd been dreaming night and day of being able to shift to the attack."

During the sixteen months leading up to martial law, Urban's disgust with the euphoric course of the country's supposed national renewal became increasingly pronounced. For the first time in his career, he became an overtly political polemicist, though in his own distinctive way. One day, he wrote that his second wife (he had divorced his first wife around the time of Gomulka's fall and in 1972 married a woman named Karyna Andrzejewska) had come home ostentatiously sporting a Solidarity button, and naturally—or so he crowed—he had slapped her. When his daughter similarly began championing a Solidarity line, he took to deriding her in his column as "the unaborted." (In earlier contexts, when she'd still been a young teenager, seemingly out of sheer spitefulness he'd occasionally written of her, jokingly, as ugly or fat or—perhaps most cuttingly of all—as looking just like him.) Meanwhile, in addition to his role as government spokesman he began playing a substantial part in state policy-making, especially with regard to the delicate negotiations concerning Solidarity's proposed anticensorship initiative. Much to the surprise of many of his former journalistic colleagues, now ranged across the table from him, Urban, who earlier in his career had often suffered under censorship regulations, now was insisting upon their supposed necessity. (It was one of the ironies of this period that Urban, who as the regime's official spokesperson had now become constrained from perpetrating certain kinds of writing under his own name, would often have recourse to pseudonyms he'd famously first deployed during the days of his own blackballing in order, in effect, to endorse the blackballing of others.)

Dariusz Fikus, Urban's colleague at *Polityka*, told me, "Urban was one of those who really *hated* Solidarity from the very start. For one thing, it ruined his lifestyle—this whole game where he could live in comfort while at the same time appearing to be unconventional and somehow vaguely in opposition. These people were *seriously* in opposition. But, beyond that, Solidarity represented everything he hated with his whole heart—all the superficial trappings of religiosity, the open-air Masses, and the whole

Church-and-nation business, which awoke deep feelings of revulsion in him." (I once asked Urban if he was disgusted by Polish anti-Semitism and, quintessentially urbane, he replied, "Oh, let's not exaggerate—I mean, that's not *all* that disgusts me about that level of society.")

Urban was not directly involved in planning the imposition of martial law (it had been in both his and the regime's interest that the government spokesperson not be burdened with any such explicit prior knowledge), but he was close to those who were (especially Rakowski), so that he knew enough to wander over to Rakowski's command headquarters around midnight as troops fanned out across the country, eventually making thousands of arrests (including many from among the pair's former colleagues). Elsewhere in town, as Urban marvels to this day, his beloved General Jaruzelski was spending virtually the entire night sequestered alone in his office, honing and revising and reshaping the remarks he would be delivering to the nation over State Television a few hours hence, at six in the morning, as if, were he simply capable of stringing together precisely the right sequence of words, delivered in just the right tone of voice, everybody would understand.

Everybody did not understand. Rakowski's son defected, and his wife left him. General Jaruzelski's daughter, in her last year of high school, went to live with her boyfriend, a leader of the student Solidarity group. Urban's daughter, for her part, gave her apartment over to the underground, which is how it came to pass that the first few issues of *Tygodnik Mazowsze*, the weekly newsletter that would become the clandestine opposition's principal public organ, were edited practically under the government press spokesman's nose. (A few years later, Urban's daughter would marry one of the opposition's crack clandestine printers, the wedding invitations bearing the imprimatur of NOWA, the country's foremost underground book publishing house, an event that Urban himself brazenly attended.)

Of such diversions, though, Urban was largely oblivious. He was keeping his eye on the main game, which consisted of a tremendously sophisticated attempt to manage the country's mood. At the outset, that mood seemed implacably hostile, and the best the regime might hope for, it

seemed, was society's acquiescence as the futility of further resistance became clear. Over time, even if the regime could never inspire enthusiasm on behalf of its own programs, it might succeed in sowing significant misgivings about the opposition's competence or effectiveness, or even, finally, relevance. That, anyway, was the hope, that was the plan. As Michael Kaufman, the *Times* correspondent, has pointed out, Urban recognized that for such a strategy to have any chance of succeeding, the regime at least had to become an active player in the battle for people's minds, "by creating a spectacle so compelling that people simply wouldn't be able to stay away or keep themselves from watching." Kaufman adds, "That was the rationale behind those weekly press conferences."

Christopher Bobinski, the *Financial Times*'s veteran Warsaw correspondent, recently told me, "Up until Urban's tenure, the government would never respond at all, to anything, period—never felt it had to. But for a brief period there Urban was really doing something truly astounding. He had created a forum where you could ask a question and he would feel a responsibility to reply." From the start, Urban set ground rules for the weekly sessions: large sections of the session would be broadcast on that evening's television news, and the entire transcript of the session would be printed the next morning in the government daily; no question would be considered off-limits, and the conference wouldn't be considered over until there were no remaining questions. "I mean, that was unheard of," Bobinski continued. "It was like having parliamentary question time in the middle of martial law. Urban's counterparts in East Berlin, Prague, and Moscow—they all looked on aghast, they couldn't believe it, they despised him for it. But he understood that if you just showed up and answered the questions, no matter what, you were already ahead in the propaganda war."

Not that Urban ever made any further attempts, beyond just showing up, to endear himself to the Polish masses. Early in the days of martial law, when he was asked about the probable effects of Western economic sanctions he shrugged and curtly replied, "The authorities will always eat their fill." When he was asked about the status of the interned Lech Walesa, he

would often dismiss him as "the non-head of a non-union, a nonentity."
Asked to respond to the occasional underground broadside, he would usu-
ally demur: "The government takes stands only on matters of public sig-
nificance, and these carpings are of no significance whatever." On the other
hand, whenever the underground called a strike action Urban would be
there the next Tuesday, providing detailed and generally reliable figures on
nationwide compliance with the strike call—figures that initially might
have looked bad from the regime's point of view but began looking better
and better as the years passed and Urban's strategy of demoralization took
hold.

Urban wasn't above baldly facetious gestures: regularly hounded by
questions about the sorry state of Poland's economy, he in turn latched
on to reports of increased homelessness in the United States during the
early Reagan years to announce a campaign to collect blankets for New
York City. He could be shameless: once, Kaufman returned from a report-
ing trip to Krakow where he'd come upon a wooden figurine of Urban cast
as a pig and, knowing Urban's perverse penchant for collecting such things,
he'd jovially arranged to have the object privately delivered to his office; at
the following Tuesday's news conference, Urban angrily denounced the
New York Times correspondent for having had the appalling effrontery
to present such a thing to the government's official press spokesman,
thereby, incidentally, instantaneously rendering the correspondent a kind
of national hero (KAUFMAN GIVES URBAN A PIG! blared the head-
lines), an outcome which Kaufman to this day is convinced was absolutely
intentional on Urban's part (puffing him up, World Wrestling style, so as to
render him a more worthy opponent and thereby to increase their mutual
Tuesday ratings).

"He was incredibly clever and invariably superbly well prepared," Kauf-
man recalls. "He had a great staff and he'd always done his homework."

Not that such cleverness made him any friends. "God was he hated,"
says Kaufman. But not that that seemed to bother him much, either. "He
used to repair for occasional meals and drinks over at Spatif, the actors'
club," Kaufman continues. "He'd take his seat and the place would imme-

diately empty, just clear out—and he loved it. He'd sit there in splendid isolation, serenely nursing his drink. It was really strange."

"The thing you have to understand about Urban," Fikus told me, "is how deeply this business was rooted in his character: it was a pleasure for him: *he loves being hated.*"

"My feelings about him were always mixed," Kaufman concludes, "but in the end maybe the most impressive thing about him was his *courage.* Face it, behind those big floppy protruding ears were hiding all the generals and apparatchiks of Poland. And every week, with an insouciance and a bravery that at times seemed to verge on the psychotic, he'd expose himself to the hatred and the contempt of the entire nation."

On my most recent trip to Poland, I had occasion to talk with the now retired General Jaruzelski; we met in a small, bare office at his publisher's, the general in his civvies (relatively threadbare leisurewear, corsetless, a slight paunch, his perennial dark glasses replaced by lenses of the softest brown). And at one point, apropos of nothing at all (he didn't realize I was thinking about writing a profile of Urban), he asked me, "Do you know the two bravest men I have ever met in my life? And it's embarrassing for me as a soldier to have to admit this, because neither of them is a military man. The one is Michnik—finally, now, I've come to appreciate what kind of man this was—and the other, this may surprise you, is Jerzy Urban."

One of the essential paradoxes about Urban comes when you try to square all these testimonials as to his sheer mad-dog courage (and I heard countless others) with Daniel Passent's equally forceful insight about his having been essentially defined by that post-Holocaust hankering for personal security. (The poet and lyricist Agnieszka Osietska made a similar point, suggesting that Urban had drawn close to totalitarianism over the years out of a kind of essential timorousness.) And yet, somehow, both estimations seem to me to ring equally true.

Urban could be damnably clever, as in the Kuklinski affair, when he took a potential propaganda disaster—the revelation of how one of General Jaruzelski's most trusted aides had been an agent of the Central Intelligence Agency and had defected just a few weeks before martial law—and

managed to turn it around. He did so in part by pointing out that the Reagan administration therefore must have had full knowledge of the timing of the upcoming declaration of martial law—and had decided not to pass the information on to Solidarity, presumably because, according to Urban, it, too, wanted the troublesome Solidarity liquidated, for all the obvious sorts of geopolitical reasons. This was a devastating argument and, typically, not one that lent itself to easy refutation.

But Urban could also be just damnably damnable, as in the prelude to the disastrous Popieluszko affair, in the fall of 1984, when, week after week, from his Tuesday podium, he fired off increasingly scurrilous denunciations aimed at an enormously charismatic opposition priest named Jerzy Popieluszko. Urban claimed that this remarkable and intensely spiritual young priest was indulging in quasi-Orwellian "orgies of hatred" at his ever more popular monthly Masses for the Homeland, "feeding negative emotions" and "heating up political feelings against our warning that such activities *cannot* be tolerated." ("Perhaps everyone in Poland has had an opportunity to convince himself that we do not toss around such phrases lightly," Urban went on ominously.) Then one morning the priest was kidnapped and bludgeoned to death by three renegade agents of the state security services.

Popieluszko's martyrdom stains Urban's reputation to this day; people who (off the record) will forgive him a good deal will not forgive him that, and, uncharacteristically, it is a subject that he himself doesn't particularly enjoy returning to, even though it has now been fairly well established that the assassination plot was in no way promulgated by the regime's leadership but was, if anything, carried out as a provocation against that leadership by some of its internal opponents, intent on polarizing and radicalizing the country's political situation. Still, Urban's inflammatory rhetoric doubtless contributed to the creation of a context within which such a provocation could have been expected to occur. And yet Bobinski, for one, feels that the series of news conferences in the immediate aftermath of Popieluszko's assassination may have constituted the high point of Urban's career as a news manager. "For one thing," as the *Financial Times* corre-

spondent points out, "he didn't simply cancel the news conference which, as I recall, happened to fall on the very next day after the body was found and which would have been an entirely understandable thing to have done. He didn't attempt to deny that the deed had happened or to obfuscate in any way, suggesting that it might have been a C.I.A. plot or some such. On the contrary, from very early on he confirmed that mid-level officers in the regime's own security apparatus were the prime suspects. It was all very impressive."

That incident brought out another salient aspect of Urban's tenure as press spokesman—one that is becoming clearer in hindsight. Not only was he facing off against the nation during many of those news conferences; he and Rakowski and Jaruzelski and their allies, attempting to be moderately reformist, were also continually having to confront dogged opposition among more deeply embedded elements in the Party and in the security services. In effect, they were being played for history's chumps: the preponderance of the apparatus was perfectly content to have them perform the dirty work involved in bringing Solidarity to heel, but they had no intention of allowing the kind of systemic reforms that might have addressed the dire social and economic inadequacies that had led to Solidarity's upsurge in the first place. (Whether Jaruzelski and Rakowski and Urban were deluding themselves all along in imagining that they might be allowed to accomplish anything more than brute repression remains an open historical question.) But the Jaruzelski group's failure to implement any serious and visible reforms or to right the desperately listing economy set the backdrop for the precipitate collapse of their entire project, late in the eighties, and the resurgence of Solidarity (or anyway of something more confusingly amorphous that insisted on calling itself by the same name) in the elections of June 1989.

And yet, as we have seen, Urban himself managed to survive the debacle quite nicely. He published his outrageous *Alphabet* book, and for a while it seemed as if the Poles simply couldn't get enough of their monstrous

troll. (He quickly followed this first book up with a second, whose name, *Jajakobyly,* translates, variously, as *Myself the Ex-* or *Mare's Balls;* it also became a best seller.) Soon thereafter, Karyna Andrzejewska cashed in with her own slim volume, under the breathtakingly heartrending title *Urban . . . I Was His Wife!* (This was Urban's divorced second wife, the one he'd so merrily boasted, back in 1980, of having slapped.) As if her title wasn't enough, Andrzejewksa's book featured, as its cover image, a grotesquely reimagined painting of Urban's head—the greenish-pink visage covered over with scrofulous postules, the ears all hairy and demonically pointed. And yet, when it came to such patently slanderous imagery, there was no point in even trying to compete with the self-images Urban himself seemed intent on projecting. His *Alphabet* book had featured, as its frontispiece, a truly revolting photograph of himself in a ratty, open-collared workshirt, his fleshy mouth obnoxiously agape as he stuffed some tasty morsel into his odious face. And this, in turn, was as nothing compared with the increasingly horrifying caricatures and photomonstrages *Nie*'s editor presently began running alongside his own weekly column. If Urban's signature aesthetic and political style had always been "in your face," it was precisely this business of *his-own-face*-in-your-face that was its very essence.

As for *Nie,* it could have been called *Taboo,* for from the very start Urban reveled in the new era of press freedom—an era free, that is, of the sorts of restrictions that he himself had spent the previous decade enforcing. There was, to begin with, the tabloid's emphasis on the blatantly sexual—sex for its own sake (pinups and crotch shots) but also whatever prurient details could be flushed out of any other sort of story. When President Clinton visited Warsaw during the summer of 1994 and every other Polish paper was focusing on such topics as the likelihood of America's support for the country's earliest possible entry into NATO, *Nie* led with the headline PENIS CLINTONA, over a story based largely on expert analyses by such alleged authorities as Paula Jones and Gennifer Flowers.

Urban gloried in breaking an even more strictly observed taboo against ridiculing the suddenly all-powerful Catholic Church. He published car-

toons skewering the Polish Primate, Jozef Cardinal Glemp—perhaps the only man in Poland with ears bigger than his own. And *Nie* also specialized in exposés of priests having sex with their housekeepers, their wards, their neighbors' livestock, and, especially, one another.

Urban delighted in shattering political taboos as well. He was the first journalist, for example, to attack the country's new President, the sainted Nobel laureate Lech Walesa. He did not have that field to himself for long, but his assaults have remained among the most unsparing and, particularly in the months preceding the recent election, the most damaging. (Urban has for years displayed a personal animus toward Walesa, as if this one man contained a distillation of every oafish thing that Urban despises about the entire Polish nation.) He began running a column that consisted of nothing but verbatim transcripts of the President's often impenetrable impromptu pronouncements. He regularly featured embarrassing exposés of the shenanigans surrounding the President's family and his court. And he published a map revealing the location of Walesa's secret vacation fishing camp, complete with pointers on how to avoid police roadblocks.

It would be unfair, however, to dismiss *Nie*'s coverage as merely a cavalcade of blasphemous gestures. For Urban has cobbled together an often powerfully effective presence on the new democracy's political scene. Several years ago, as Parliament was being stampeded by the Catholic Church into passing the most punitively restrictive antiabortion law in all Europe, for example, *Nie* announced that it would offer fifty million zlotys (about four thousand dollars) to any woman willing to admit to an affair with a member of Parliament which had resulted in an abortion, preferably one paid for by him. "You should have seen the panicky, ashen faces in Parliament the next morning," a legislative staff member told me.

Nie broke financial scandals involving formerly oppositionist parvenus, of which there were a dismaying number. (It seemed to be one of *Nie*'s goals to insinuate, however unfairly, that not a thing had changed, and that the new politicians were every bit as corrupt as the old—a sensible rhetorical ploy, since it would have been futile to try to deny the prodigious extent of corruption in the previous regime.) *Nie* also castigated what it

saw as the neoliberal excesses of the new financial planners, with their desire for a possibly overabrupt transition to capitalism. Urban insists that he generally favors the shift to an open-market system, and claims to have lobbied tirelessly for just such a change during the Jaruzelski years; he simply feels that it was being rushed by Solidarity's initial technocratic team. At one point, *Nie* ran a contest in which old-age pensioners were invited to send in their payment stubs for the current month along with a brief essay on "Why I Even Bother to Go on Living."

One afternoon, a prominent contributor over at *Gazeta Wyborcza*, Poland's leading daily and a direct outgrowth (under Adam Michnik's editorship) of the old clandestine *Tygodnik Mazowsze*, commented to me, "*We* created *Nie* by raising expectations and then refusing to fill them. Not so much now but early on we displayed a decided reluctance to explore our own side's shortcomings as vigorously as we once had those of the old Commies." A surprising number of others expressed grudging respect (alongside their general revulsion) for aspects of what Urban was up to with *Nie*. He was, people said, serving an undeniably useful function. The trouble was that virtually no one would go on the record with such comments. As a reporter, I'm used to situations where people who want to say something bad about somebody else will do so only off the record. This was the first time that sort of thing happened almost every single time anybody wanted to say something *nice*.

On my most recent trip to Poland, I decided, as usual, to visit Jerzy Urban, this time in *Nie*'s new digs, which were considerably more splendid than the ones I had seen before. *Nie* (with a weekly circulation hovering near an astounding seven hundred and fifty thousand) had moved from its dingy third-floor walkup to a spacious and stylish villa along a quiet, tree-lined side street in Warsaw's embassy district. A pair of private security guards (variously referred to as Urban's commandos and his *goryle*) stood watch at the entry gate, probably with good reason.

Urban greeted me, even more incongruously svelte and dapper than

usual, in a large, airy second-floor office and sat down behind a large, neat black circular desk. A breeze wafted in from the awning-shaded balcony behind him. On one wall was a striking framed image of a bright-yellow banana peeled back to reveal the exuberant penis within.

We began by talking about a recent and no doubt pleasant (from his point of view) turn of events: the parliamentary elections, which had seen a general repudiation of Solidarity's slate and a return to prominence of some of his former Communist-aligned allies ("the Velvet Restoration," as Michnik had taken to calling it). A photograph that had been taken the night of the parliamentary elections, and had become famous, showed Urban celebrating with his old cohorts, buoyantly wielding a magnum of champagne, a bottle that was to other bottles what his ears are to other ears, and gleefully sticking out his tongue, which was proportionally huger than either. "Well," he said now, smiling, "I told you so—the girls and their nuns, as you see."

Our conversation turned to his various legal entanglements, including a defamation suit that he had brought against a Catholic right-wing historian from Lublin, named Ryszard Bender, who had had the gall to refer to Urban as "the Goebbels of martial law." The court went with Bender, but the verdict was overturned on appeal. Whether the analogy had genuinely stung or whether Urban was just nursing his sense of grievance for its evident publicity advantages was a bit unclear; he was laughing as he recounted the incident. He seemed decidedly more perturbed by a recent item in a Silesian tabloid called *Panorama,* which alleged that Urban had been spotted in church, *praying,* and claimed that, having suddenly come to his senses, he was about to come out in opposition to abortion after all. "Now, *that* definitely calls for a lawsuit," he said grimly. "I mean, I can't very well be expected to tolerate such a flagrant sullying of my good name."

Then we began talking about *Nie.* I asked him about his favorite stories, and he mentioned the abortion-reward offer, various Walesa debunkings, some of the sexual "public-service interventions," as he calls them. But he went on to say that the thing he really loved doing in *Nie* was what he

called "happenings": semi-staged or *Candid Camera*–style provocations. "For example, the time we went to a little village in the western interior of the country claiming to represent various American joint-venture interests, and got the town leaders there to sell us their entire town, *including the church*," he said. "Once we published supposedly exclusive papers proving how one of our more extreme nationalist anti-Semitic splinter parties was in fact being entirely financed, surreptitiously, by the World Jewish Conspiracy.

"And then there was the time we announced how, in keeping with the new spirit of capitalism, I myself had recently taken my profits from *Nie* and purchased the rights to our country's national anthem, 'March, March Dabrowski!'—you know, this ridiculous piece you keep hearing all the time, ad nauseam. Well, we reported that I'd bought the rights for the equivalent of about one and a half million dollars and from now on anybody wishing to play or perform the piece would have to pay me ten thousand zlotys"—about seventy-five cents. "We gave out an address, and to my astonishment people began sending in their fees. I couldn't believe it. What am I saying, I couldn't believe it? Of course I could believe it—I can believe anything. *That's what I do.*"

Perhaps Urban's favorite "happening," though, was the time he conned the newly reopened luxury Hotel Bristol into getting itself certified kosher. He pulled out an issue of *Nie* and, turning to a photo spread, showed me how an actor—or, rather, a young actress—had been disguised as a hunched, bearded, and bedraggled old rabbi and had been driven to the hotel in Urban's Jaguar; and how the "rabbi" had dragged the hotel's prim-and-proper female business manager all around the establishment, peppering her with arch questions.

"It was great," Urban declared. "We made a complete fool of this business-manager lady." ("Yeah, she's probably committed suicide by now," one of my friends subsequently commented. I asked what she had done to deserve such treatment. "Oh, her just being a woman is generally provocation enough for Urban," my friend replied.) Urban continued, "And here the rabbi is signing the certificate—look at the manager, look

at how tense she is. It's hilarious. And then here we have the rabbi being escorted back to my Jaguar, and then here . . ." Urban was speechless with satisfaction: the last picture showed the "rabbi" back in the Jaguar, a few blocks away, her black coat removed, her white shirt opened, her beard gingerly pulled aside as she breast-feeds her child. The photograph was captioned "*Rabin z dzieciatkiem*," the latter being a word for *child* used almost exclusively in the expression "Madonna and Child." It was a combination of image and caption almost precision-engineered to fry every nationalist circuit in the Polish imagination. Urban smiled broadly and declared his labors good.

"So, it's getting to be time for our editorial-board meeting," he said. "You're welcome to join us." On the way downstairs, he also invited me to have dinner that evening at his villa.

The staff was gathering in the conference room. There were a few recognizable faces, including one of the martial-law regime's most notorious television-news apologists, but mainly there were young, eager, aggressive, and vaguely slaphappy novices. Urban, comfortably ensconced among them, seemed magisterial, a *grand seigneur* in his element—a contented man. He began by announcing that a vodka-tasting would immediately follow the meeting; turning to me, he explained that, just as one company had its Chopin-brand vodka, another was proposing to market Urban vodka, so they were all going to sample the product. Then they launched into a traditional brainstorming session, with, I suppose, a difference.

"I don't really think we should do too many more of those priest-fucking stories," Urban declared. "People are getting tired of priests fucking. What they want nowadays is priests embezzling, priests with dollars. Let's see if we can generate a few more of those. And, anyway, we still seem to have a monopoly on Pope-bashing—nobody so far has dared to join in with us on that."

That evening, on the drive out to Urban's new villa, in the village of Konstancin, an old suburb of sanatoriums and spas nestled in the pinewoods

about half an hour south of Warsaw, I began wondering about Urban at the editorial meeting. Could he really be that contented? The caliber of the staff: eager young hacks, tired old apologists, second- and third-stringers . . . This man used to virtually run *Polityka,* surrounded by the very best of Polish journalism and drawing on some of the biggest names of the Eastern European intelligentsia. Surely he must sense how far he has fallen. And yet . . .

The taxi pulled up to Urban's walled compound. Private armed guards approached the cab from a video-camera-equipped entry shed, examined my papers, and ushered me in.

Urban himself was there to greet me on the other side of the gate, freshly scrubbed and crisply, if casually, dressed in Armani jeans and a capacious olive-green cotton T-shirt. As we ambled up the gravel driveway toward the year-old, California-moderne-style mansion, he genially told me a bit about the neighborhood. Boleslaw Bierut, the Stalinist-era dictator, had had a villa a few lots down the way, he said, whereas this property used to belong to—he broke into one of his wide, mischievous grins—a cousin of the regime's veteran opponent, the late Cardinal Wyszynski. At the head of the driveway, his sleek olive Jaguar XJ6 was snugly slotted into the carport. Along the entire length of the carport's interior wall, just above the Jaguar, stretched a sublime socialist-realist panel depicting Lenin exhorting the workers. Urban's grin grew even wider.

The walls of the villa teemed with conventionally adventurous paintings (Picassoesque nudes, surreal dreamscapes), and there was an amply stocked bar. Urban's third wife, Malgorzata Daniszewska, joined us, an apple-cheeked zaftig young wench (the sort of ironical woman who'd get a kick out of being referred to as a "wench," married to a man who'd doubtless also be pleased to have her thus characterized). Back at the hotel I'd read an adulatory 1991 *Forbes* piece about her and in particular about her editorship of a new magazine entitled *Firma.* The article (cluckingly bylined, "The wife of a former Communist minister in Poland now runs a cheerfully capitalistic business magazine") had been illustrated by a photograph of a cheerfully gawking crowd gazing down upon an early public-

ity stunt on behalf of the magazine: Urban himself smugly leaning back on an outdoor deck chair, having his shoes polished at a public shoe-shine stand by his cheerfully enterprising young wife (under the caption, "In the new Poland, there is nothing wrong with capitalist exploitation"). It was another quintessentially Urban happening. (The magazine had in the meantime gone under, but, undaunted, Mrs. Urban was cheerfully plotting a fresh batch of new entrepreneurial ventures.)

The Urbans escorted me out to their back patio, where a table was laid in a casually elegant style and, in the warm evening, servants floated back and forth with generous servings of wine and gazpacho and Swedish meatballs. A violet-light electric insect trap hung from a rafter, occasionally zapping the stray mosquito. The first time this happened, Urban caught me gazing up, momentarily disconcerted. "Crematoria," he said, smiling.

I asked him about the often mentioned irony of a former official of a Communist regime living in such luxury. "Oh, you know, it doesn't mean that I suddenly became a talented businessman," he said. "It's just that I started making money on what I always knew how to do anyway, which is to edit a newspaper. Before, the profits devolved to the Party; now they come directly to me. That's the only difference."

I asked Mrs. Urban how long they'd been married. "Eight years," she replied. "We met two years before that, in the middle of martial law." (It turns out she's actually a bit older than she looks, somewhere in her early mid-forties.)

How exactly had they met?

"Well, actually," Mrs. Urban recounted, "I'd first encountered Jurek briefly a bit before martial law, in the midst of the first Solidarity period, though we didn't pay much attention to each other, and, anyway, I didn't think much of him. I was a sports journalist at the time and the deputy chair of the Solidarity chapter at our magazine, and he, obviously, was the enemy incarnate. After martial law got declared and we'd watch him on TV, he was just a prick with ears, as far as I was concerned. But then, a few years later, at a cocktail party in 1984, we had occasion to meet once again

and this time, within fifteen minutes, it was clear that everything was obviously different."

How so?

"Well, there was something—how should I say?—the atmosphere between us, it was like . . . like . . ."

At this moment—swear to God—another mosquito happened to stray into the electric mesh around the violet light and began fritzing spasmodically.

"Like *that!*" Mrs. Urban exulted. "Sparks and everything. Absolutely electric. And after that, things moved rather quickly. It turned out he was much better in bed than on TV."

"Though I was quite good on TV," Urban interjected defensively.

"You were slow on TV," pronounced Mrs. Urban, the veteran sports journalist.

The fried mosquito remnant finally disengaged from the deadly mesh and plummeted to earth. The evening proceeded apace. Occasionally, stabs of light pierced the distant woods—the flashlights of guards on patrol. Urban recounted a series of stories from some of his recent trips abroad, including a Manhattan dinner, back in his press-spokesman days, with his childhood chum Jerzy Kosinski (at the time, the only émigré who would deign to sup with him). Generally, he noted, he really didn't enjoy travel. "It's strange for me to be in places where I'm not immediately recognized by everyone," he said. "And, I must say, not an entirely pleasant sensation."

"So," I said to Urban as we sat sipping our after-dinner liqueurs, "would you say you have lived a happy life?"

"*Absolutely,*" he shot back emphatically, without a moment's hesitation. "Are you kidding? I mean, think about it. In the fifties, I was young and deeply embroiled in the opposition, with *Po Prostu,* and I had all that excitement and prestige. In the seventies, I was at the heart of *Polityka,* one of the foremost intellectual journals of its time in Eastern Europe—maybe even anywhere in the world—and I had all that satisfaction. In the eighties, I was in the government, in the middle of history, and I got to have all that

influence. And now, today"—he gestured expansively about him—"I have all this. I mean, what other pleasures could I long for?"

"But those are contradictory pleasures," I pointed out. "You can't very well take satisfaction in having once been in the opposition and then take pleasure in having been part of a government that went and jailed all your old allies from that opposition."

"And why not?" Urban countered. "One wouldn't want to experience just one kind of pleasure in one's life. One wants to sample *all different kinds of pleasure.*"

(1995)

THE SON'S TALE:
ART SPIEGELMAN

A good way to study the many possible furrowings of the human brow is by telling a succession of friends and strangers, as I've taken to doing lately, that the best book you've read in a long time is a comic-strip history of the Holocaust. Brows positively curdle, foreheads arch, faces blanch and stiffen as if to say, "If this is one of your jokes, it's not very funny." Only it's not one of my jokes—it's the truth. The book is the first volume of *Maus*, and its author—the perpetrator of my perplex—is Art Spiegelman.

Actually, the fans of *Maus* have been following its development for some time in installment form. Each new episode has been tucked inside successive issues of *RAW*, the semiannual journal of avant-garde cartooning (The Graphix Magazine of Abstract Depressionism, as its cover once proclaimed) that Spiegelman and his wife, Françoise Mouly, have been editing and publishing out of their SoHo loft, in New York City, since 1980. Jules Feiffer has described *Maus* as "a remarkable work, awesome in its conception and execution," and David Levine has characterized its effect on the reader as "on a par with Kafka" and its mastery of tone as "reminiscent of Balzac."

"A comic-strip history of the Holocaust" isn't quite right: such a characterization is begging for trouble—or for misunderstanding, anyway. This is no Classics Illustrated/Cliffs Notes digest of the despicable schemings of Hitler and Himmler and their whole nefarious crew. Hitler and Himmler hardly appear at all. Rather, *Maus* is at once a novel, a documentary, a memoir, an intimate retelling of the Holocaust story as it was experienced

by a single family—Spiegelman's own. Or rather, as it was experienced by Spiegelman's father, Vladek, who recounts the story to his son, Art, who was born in 1948, after the war was over, after everything was over, including the possibility of any sort of normal upbringing. The conditions of survivorship skew everything: Vladek's first son, a brother Art never knew, was an early victim of the Final Solution; Vladek and his wife, Art's mother, Anja, somehow survived their separate fates in concentration camps, emerging hollowed out and cratered; years later, Anja would take her own life, just as Art was leaving the nest. Art's relationship with his father is a continual torment, a mutual purgatory of disappointment, guilt, and recrimination. This relationship is as much the focus of Art's story as is his father's reminiscence. The elegant back jacket of the Pantheon edition features a map of World War II Poland and, inset, a street map of the Rego Park, Queens, neighborhood where that war continued into the present in the mangled graspings and grapplings of father and son. *Maus* is subtitled *A Survivor's Tale,* but the question of *which* survivor is left to hover.

Maus is all this—and then again, it's just an animal story. For Spiegelman has recast his tale in the eerily familiar visual language of the traditional comic book—animals in human clothing and in a distinctly human environment—thereby playing off all our childhood associations and expectations. Art, Vladek, Anja, Art's stepmother, Mala, and all the other Jews are mice. The Germans are cats, the Poles pigs, the Americans dogs. Spiegelman's draftsmanship is clean and direct, his characterizations are charming and disarming—the imagery leads us on, invitingly, reassuringly, until suddenly the horrible story has us gripped and pinioned. Midway through, we hardly notice how strange it is that we're having such strong reactions to these animal doings.

And then it all stops: the volume is truncated in midtale. Vladek and Anja's desperate progress from prosperity into the ghetto and beyond, from one hiding hovel to the next, ends abruptly with their arrival at Mauschwitz. To learn what happened to them there, how on earth they survived—and whether or not this father and his son ever do achieve a measure of reconciliation—we are invited to await a second volume.

The man greeting me at the entrance to the fourth-floor walk-up apart-ment in SoHo looked far younger than his almost forty years. He also looked considerably more clean-cut and less threatening than the intense, longhaired, mustachioed, scrungy, Zappaesque character he had contrived as his own stand-in in some of the existentialist underground comic strips he'd produced during the seventies.

The apartment, too, was more spacious than I was expecting, and it was bustling. In fact, the Spiegelmans occupy the entire floor, which they've divided in two: the front half consists of the staging area for *RAW*, while the back half provides them with living quarters. After seeing me in, Spiegelman excused himself to go confer with Françoise, a strikingly lovely Frenchwoman with high cheekbones and a luxuriant overflow of wavy brown hair. The next issue of *RAW* was about to go to press, and Françoise was on her way out to consult with the printers. The production values of *RAW* are exceptionally high—"neurotically precious" is how R. Crumb, the legendary underground-comics master and an occasional contributor to the magazine, once described them to me.

Spiegelman and Mouly launched *RAW* with the twin intentions of rais-ing the status of cartoon graphics to an art form and introducing an American audience to the sort of high-level comic-strip art that has thrived for many years in Europe and Japan. Mouly, as the publisher, is famous for the painstaking attention she lavishes on all technical aspects of the production process.

The two of them had a certain amount to discuss before she left, and they stood together for a few moments huddled over the proof sheets, chain-smoking filtered Camels. Meanwhile, several assistants sat hunched over flatbed tables, monkeying with galleys. The room was surrounded on all sides by bookshelves, which were sagging under the weight of the most extensive library of comic books and anthologies anyone could ever imag-ine. After a while, Mouly took off, and Spiegelman invited me into the back half of his loft, the living quarters.

"The whole next issue is ready," Spiegelman confessed anxiously. "Everything's now waiting on me, because I still have to finish the next installment of *Maus*. And it's taking forever." He escorted me to the far back of the loft, to his Maushole, as he calls it, where a worktable was covered with a neat clutter. Notebooks bulging with transcripts and preliminary sketches were piled to one side; dozens of little packets of papers were scattered about on the other—each bundle representing the successive workings and reworkings of a single panel. "Comics offer a very concentrated and efficient medium for telling a story," he said. "And in this case it's like trying to tell an epic novel in telegraph form. In a way, it's a lot more challenging than trying to simply tell a story. In a prose story, I could just write, 'Then they dragged my father through the gate and into the camp.' But here I have to live those words, to assimilate them, to turn them into finished business—so that I end up *seeing* them and am then able to convey that vision. Were there tufts of grass, ruts in the path, puddles in the ruts? How tall were the buildings, how many windows, any bars, any lights in the windows, any people? What time of day was it? What was the horizon like? Every panel requires that I interrogate my material like that over and over again. And it's terribly time-consuming.

"It's strange," he continued. "The parts of my father's story which I've finished drawing are clear to me. The parts I haven't gotten to yet are still a blur—even though I know the story, know the words. I've got everything blocked out in abstract, except the ending. In Part Two, the question of my father's veracity starts coming into play. Not so much whether he was telling the truth, but rather, just what had he actually lived through—what did he understand of what he experienced, what did he tell of what he understood, what did I understand of what he told, and what do I tell? The layers begin to multiply, like pane upon pane of glass.

"I still don't know how I'm going to end it," he said, pointing over at the notebooks. "I don't *see* most of it yet. I'm only just beginning to see Mauschwitz."

I asked him why he'd decided to publish the book version of *Maus* in its current truncated form.

"Funny you should ask," he replied. He suggested we go up on the roof, where he'd installed a rudimentary sundeck. We sat on some garden furniture and surveyed the SoHo skyline, the tar-roof line. He lit up a Camel, took a deep drag, and resumed: "I'd never really had any intention of publishing the book version in two parts. But then, about a year ago, I read in an interview with Steven Spielberg that he was producing an animated feature film entitled *An American Tail,* involving a family of Jewish mice living in Russia a hundred years ago named the Mousekawitzes, who were being persecuted by Katsacks, and how eventually they fled to America for shelter. He was planning to have it out in time for the Statue of Liberty centennial celebrations.

"I was appalled, shattered," Spiegelman continued with a shudder. "For about a month I went into a frenzy. I'd spent my life on this, and now here, along was coming this Goliath, the most powerful man in Hollywood, just casually trampling everything underfoot. I dashed off a letter, which was returned, unopened. I went sleepless for nights on end, and then, when I finally did sleep, I began confusing our names in my dreams: Spiegelberg, Spielman . . . I contacted lawyers. I mean, the similarities were so obvious, right down to the title—their *American Tail* simply being a more blatant, pandering-to-the-mob version of my *Survivor's Tale* subtitle. Their lawyers argued that the idea of anthropomorphizing mice wasn't unique to either of us, and they, of course, cited Mickey Mouse and other Disney creations. But no one was denying that—indeed, I'd self-consciously been playing off Disney all the while. If you wanted to get technical about it, the idea of anthropomorphizing animals goes all the way back to Aesop. No, what I was saying was that the specific use of mice to sympathetically portray Jews combined with the concept of cats as anti-Semitic oppressors in a story that compares life in the Old World of Europe with life in America *was* unique—and it was called *Maus: A Survivor's Tale.*

"I didn't want any money from them—I just wanted them to cease and desist. What made me so angry was that when *Maus* was eventually going to be completed, people were naturally going to see my version as a slightly psychotic recasting of Spielberg's idea instead of the way it was—

Spielberg's being an utter domestication and trivialization of *Maus*. And then there was a further infuriating irony: theirs supposedly took place in 1886, and what with the Statue of Liberty tie-in, they were going to be swathing the story in all this mindless, fashionable, self-congratulatory patriotic fervor—whereas, if you were being true to the initial metaphor, in depicting the way things actually were in 1940, you would have had to strand my mice people off the coast of Cuba, *drowning*, because it is precisely the case that at that point, the time of their greatest need, mice people were being denied entry into the U.S."

Spiegelman started to calm down. His cigarette had gone out; he lit up another. "Well, anyway, it's over for the time being. My lawyers told me that while I have a very strong moral case, my legal one isn't so hot. It'd be hard to prove anything one way or the other, certainly not enough to justify a prior injunction against release of the movie, which is the only thing I really wanted. Some of my friends couldn't understand why I was getting so worked up. One editor told me, 'Look, all the guy stole was your concept, and frankly, it's a terrible concept.'" (The redoubtable R. Crumb was likewise bemused by Spiegelman's desperate churnings. "He's such an egomaniac," Crumb told me, laughing. "I mean, who the hell cares? I've seen some of the previews for Spielberg's film. Those mice are cute." R. Crumb has the most devastatingly prurient way of pronouncing the word *cute*.)

Spiegelman may have been calming down, but he was still obsessing: "I mean, if Samuel Beckett had stolen the idea, I'd be depressed, but I'd be *impressed* as well. But Steven Spielberg! Oy! I just read where they've now licensed off the *doll rights* for the Mousekawitzes to Sears, and McDonald's is going to get the beverage-cup rights!"

So, Spiegelman continued, he decided that if he couldn't stop Spielberg, he might nevertheless beat him to the turnstiles, immediately publishing as much of the story as he'd already completed (he explained how all along he'd seen the arrival at Mauschwitz as the narrative's halfway point) and thereby at least establishing primacy. Pantheon was happy to go along, and Spielberg's production company obliged by running into difficulties and having to delay the film's release until around Thanksgiving. As

Spiegelman observed, "It was actually a great idea. You see, in Europe there's a real tradition, in serious cartooning as well as in high literature, of multivolume projects—just think of that supreme mouse writer, Proust, and all the volumes he was able to generate from that initial whiff of Camembert!"

When Art Spiegelman was about ten years old, in 1958 in Rego Park, Queens, he fell one day while roller-skating with some friends, who then skated on without him. Whimpering, he walked home to his father, who was out in the yard doing some carpentry repairs. Vladek inquired why his Artie was crying, and when Art told him about the fall and his friends, Vladek stopped his sawing, looked down at his son, and said gruffly, "Friends? Your *friends*? If you lock them together in a room with no food for a week, then you could see what it is, friends!"

Spiegelman places this incident as the first episode in the book version of *Maus,* and it serves as a sort of overture, an intimation of one of the book's principal themes. For, at one level, Artie was an all-American boy, roller-skating, out goofing with his gang. Back home, though, life was haunted, darkly freighted and overcharged with parental concern.

Actually, Artie had been born in Stockholm in 1948, three years after his parents' miraculous reunion at the end of their separate camp fates. Two years after Artie's birth, the family was finally permitted to emigrate to America. Back in the old country, in Poland between the wars, Vladek had been a wealthy man, or rather Anja's father had been a wealthy man, and Vladek had married into that wealth. Art seems to leave intentionally ambiguous (although here, as elsewhere in *Maus,* the ambiguity is of an almost crystalline precision) whether or not he thinks Vladek initially married Anja for her money and her station. At any rate, Vladek managed important aspects of her family's textile business and attained substantial financial security for himself, his wife, and their beloved baby son, Richieu—until the war, that is, when both the wealth and the beloved son were snatched away. In America, in New York, Vladek worked in the gar-

ment trade and later in the diamond district, but he never recaptured the security of his earlier life. Though the Spiegelmans were basically middle class, they lived below their means. Raising his first son, Vladek had been a young father with a buoyant sense of his future. Raising his second son— his second "only child"—he was an old man, fretting over his insecure present when he wasn't fixated on his desolate past. Art's parents *were* old. There were really two generations separating them from this American boy; on top of that, they were Old World; and on top of that, they'd aged well beyond their years owing to their experiences during the war. As Artie grew into young adulthood in America of the sixties, he would be facing generation gaps compounded one upon another.

And yet, for all that, Art remembers his childhood as remarkably normal. "I really didn't encounter serious problems," he recalled that afternoon in the back room, "until I went away to college and was able to match my experiences against those of others. I mean, for instance, the fact that my parents used to wake up in the middle of the night screaming didn't seem especially strange to me. I suppose I thought everybody's parents did. Or the fact that in the Spiegelman household, the regular birthday gift for my mother, year in and year out, was some sort of wide bracelet, so that she could cover over the number tattooed on her forearm. Sometimes when neighbor kids would come over and ask her what that stuff on her arm was, she'd say it was a telephone number she was trying not to forget.

"No," he continued, "I was a pretty normal kid, except that I was reading a lot too much Kafka for a fourteen-year-old. I knew I'd grow up to be neurotic, the way today I know I'll soon be losing my hair." He brushed back a thinning, brown wisp, further revealing his precipitously receding hairline. "It didn't, it doesn't bother me.

"By fourteen, too, I knew I'd be a cartoonist: I was obsessed with comics. I spent hours copying from comic books, especially the satirical ones, like *MAD* magazine, which was a terrific influence."

I asked Spiegelman whether any of that bothered his parents. "They encouraged me up to a point," he replied, "up to the point where it became clear that I was serious. A kind of panic set in as I turned fifteen and was

still doing it. They were terribly upset because clearly there was no way one could make a living at cartooning, and my father especially was, perhaps understandably, obsessed about money. They wanted me to become a dentist. For them, dentist was halfway to doctor, I guess. And we'd have these long talks. They'd point out how if I became a dentist, I could always do the drawing on the side, whereas if I became a cartoonist, I couldn't very well pull people's teeth during my off-hours. Their logic was impeccable, just irrelevant. I was hooked."

Young Spiegelman knew he wanted to be a cartoonist, but he wasn't sure what kind, so he tried everything. When he was twelve, he approached the editors of the Long Island *Post,* a local paper, seeking employment as a staff cartoonist. The *Post* ran a story about the incident, headlined, BUDDING ARTIST WANTS ATTENTION. When he was fifteen, he was in fact appointed staff cartoonist of the *Post,* an unpaid position. Meanwhile he commuted by subway to the mid-Manhattan campus of the High School of Art and Design, where he edited the school paper, hung out after (and sometimes during) school at the nearby offices of *MAD* magazine, and, inspired, began turning out his own cartoon digests, one called *Wild,* and another *Blasé,* which "was printed with a process even cheaper than mimeo." He contributed to a Cuban exile paper, and served a stint up in Harlem, disguised to the world as a hip black cartoonist ("Artie X").

In 1966, Art left home for Harpur College, the experimental subcampus of the State University of New York at Binghamton, and there things began to come seriously unmoored. The underlying conflicts with his parents roiled to the surface now that he was no longer in their immediate presence. Furthermore, "Binghamton was one of the early capitals of psychedelics," he says, "and the drug culture definitely accelerated my decomposition beyond any containable point." His intensity became increasingly manic. He was living off campus, in a forest cabin. "And I made a strange discovery," he recalls. "I was just kind of holding court, people were coming out to visit, and I found that if I just said whatever came into my mind, the atmosphere would get incredibly charged—and if I kept it up,

within half an hour, either my guests would run out, screaming, or else we'd approach this druglike high. It was like a primordial sensitivity session. And this was going on for days on end. I wasn't eating, I was laughing a lot, I was beginning to suffer from acute sleep deprivation. I was starting to experience these rampant delusions of grandeur. I was sure I was onto something, and sure enough, I was—a psychotic breakdown."

Eventually, they came to take him away (he informed the school shrink that the top of his head looked like a penis); he was dispatched by ambulance to a local mental ward (exaltedly he wailed in tune with the siren); they sedated him (it took three full-bore shots); and threw him into a padded cell. ("Waking up, my first thought was that I was God alone and that what I really needed to do now was invent me some people . . . Later, I began screaming for a nurse, and when this guy came in, I said, no, I wanted a *nurse*. He said he was a nurse—I'd never heard of such a thing as a male nurse—and I said, 'Gee, how do you people reproduce here on this planet?' ") Gradually, they reeled him back in—or he reeled himself back in; they didn't seem to be of much help. One attendant, a conscientious objector doing alternative service, befriended him and advised him on how to get out. ("He told me to drink less water—they seemed to think I thought my brain was overheating or something—to play Ping-Pong, *lots* of Ping-Pong, and to blame it all on LSD, which was a category they could understand; all of which I did, and within a month I was released.")

He was released on two conditions: first, that he start seeing a psychotherapist on the outside, and second, that he go back to living with his parents. "Living at home was exactly the wrong prescription," Spiegelman said, "since it was home that was driving me crazy. I said this quite emphatically to the shrink one day, and he asked me, 'So why don't you move out?' I told him about the condition. And he said, 'You really think they're going to throw you back in if you don't follow their conditions?' I said, 'Gee, thanks,' and immediately left both home and psychotherapy.

"The wonderful thing about the whole episode, though, is that it cut off all expectations. I'd been locked in a life-and-death struggle with my par-

ents. Anything short of the nut house would have left things insoluble. But now I could venture out on my own terms. Over the years, I have developed a terrific confidence in my own subconscious."

Art was out of the house, but the tormented Spiegelman family drama did not subside, and a few months after his release, his mother committed suicide.

Spiegelman becomes quiet and measured when he talks about this period. "The way she did it, I was the one who was supposed to discover the body, only I was late coming by, as usual, so that by the time I arrived there was already this whole scene . . . Was my commitment to the mental ward the cause of her suicide? No. Was there a relation? Sure. After the war, she'd invested her whole life in me. I was more like a confidant to her than a son. She couldn't handle the separation. I didn't want to hurt her, to hurt them. But I had to break free."

He's silent for a moment, then resumes: "But talk about repression. For a while I had no feelings whatsoever. People would ask me, and I'd just say that she was a suicide, period. Nothing. I moved out to California, submerged myself in the underground-comics scene, which was thriving out there, imagined myself unscathed. And then one day, four years later, it all suddenly came flooding back, all the memories resurging. I threw myself into seclusion for a month, and in the end I emerged with *Prisoner of the Hell Planet*."

That four-page strip, which first appeared in San Francisco as part of the *Short Order Comix* series in 1972 was an astonishment—one of the most lacerating breakthroughs yet in an extraordinarily active scene. The strip opens with a drawn hand holding an actual photograph portraying a swimsuit-clad middle-aged woman and her smiling T-shirted boy; the photo is captioned "Trojan Lake, N.Y., 1958" (the same year as that of the roller-skating incident with which *Maus* opens). In the next frame, the mustachioed narrator peers out, framed by a fierce spotlight and decked out in prison (or is it concentration camp?) garb. "In 1968, my mother killed herself," the narrator declares simply. "She left no note."

There follow four pages of vertiginous, expressionist draftsmanship

and writing—part Caligari, part Munch. The story of the suicide is re-
counted, and the strip concludes with the narrator locked away in a vast
prison vault: "Well, Mom, if you're listening, congratulations! You've com-
mitted the perfect crime. . . . You put me here, shorted my circuits, cut my
nerve endings, and crossed my wires. . . . You murdered me, Mommy, and
you left me here to take the rap." A voice bubble intrudes from out of
frame: "Pipe down, Mac, some of us are trying to sleep."

A few months before *Hell Planet,* Spiegelman had composed an early
version of *Maus,* a three-page rendition that he included as his contribu-
tion to an underground anthology called *Funny Aminals.* In that first ver-
sion, the relationship between father and son is quieter, almost pastoral.
The cozy Father Mouse is telling his little boy Mickey a bedtime story. It's
an adorable, cuddly scene (there's a Mickey Mouse lamp on the bedside
table)—only the story is ghastly. Several of the incidents that were to be
amplified years later in the book-length version appear here in concen-
trated form. But by the strip's end—as Daddy and Mommy in the bedtime
story are being herded into Mauschwitz—Daddy explains that that's all he

can tell for now, he can tell no more, and Mickey has, in any case, already nodded off to sleep.

It's strange: Spiegelman's 1972 take on his parents—a warm, empathetic father and cruelly manipulative mother—was to undergo a complete reversal by the time he returned to these themes in the book version of *Maus*. As if to underscore this transformation, he contrived to include the entire *Hell Planet* strip within the body of the new *Maus*'s text, drawing on a true episode in which his father accidentally comes upon a copy of *Hell Planet* his son never intended for him to see.

The 1972 *Maus* and *Hell Planet* strips were representative of one channel in the distinctly bifurcated artistic program that Spiegelman was pursuing now that he'd launched his underground-cartooning career. On the one hand, he was trying to push the comic-strip medium as far as he could in terms of wrenchingly confessional content. Simultaneously, although usually separately, he was testing the limits of the comic strip's formal requirements. In high deconstructionist style, he was questioning such things as how people read a strip; how many of the usual expectations one might subtract from a strip before it began to resemble an inchoate jumble of images on the page; whether that mattered. By 1977, he managed to unite examples of both his tendencies in a single anthology of his work, which he titled, with considerable punning cleverness, *Breakdowns* (besides its obvious confessional connotation, the word *breakdown* refers to the preliminary sketches that precede and block out a finished comic strip).

"*Breakdowns* came out as I was turning thirty," Spiegelman recalls, lighting up another cigarette, "and with some of the strips there, it was really like I'd taken things, particularly the formal questions, pretty much to the limit. So I was faced with a dilemma, 'Now what?' And after all my experiments, it was as if I finally said, 'All right, I give up, comics are there to tell *a story*.' But what story? Drawing really comes hard to me. I sweat these things out—one or two panels a day, a page maybe a week. And I was damned if I was going to put in all that work for a few chuckles. I hesitated for a while, but finally I decided that I had to go back and confront the thing that in a way I'd known all along I'd eventually have to face—this

presence that had been hanging over my family's life, Auschwitz and what it had done to us."

With the first installment of that second version of *Maus*, which appeared in the December 1980 issue of *RAW,* Mickey, the little pajama-clad mouse boy of the initial version, had grown up. He was now a chain-smoking, somewhat alienated, somewhat disheveled, urban cartoonist mouse named Art. His father, too, had aged, become more stooped and crotchety, and their relationship had become far more complicated. "I went out to see my father in Rego Park," says Art, the narrator mouse, introducing his tale. "I hadn't seen him in a long time—we weren't that close."

"After I'd left home to go to college," Art, the real-life cartoonist, recalls, lighting up another cigarette, "my father and I could hardly get together without fighting, a situation that only worsened after Anja's suicide. Vladek remarried, this time to a kind woman named Mala, another camp survivor who'd been a childhood friend of Anja's back in her old town of Sosnowiec, but it was a sorry mismatch, and that relationship too seemed to devolve into endless kvetching and bickering. It was a classic case of victims victimizing each other—and I couldn't stand being around. And yet now, if I was going to tell the story, I knew I'd have to start visiting my father again, to get him to tell me his tale one more time. I'd heard everything countless times before, but it had all been background noise, part of the ambient blur; precisely because I'd been subjected to all of it so often before, I could barely recall any of it. So now I asked him if he'd allow me to tape-record his stories, and he was willing. So I began heading back out to Rego Park.

"From the book," Spiegelman continues after a pause, "a reader might get the impression that the conversations depicted in the narrative were just one small part, a facet of my relationship with my father. In fact, however, they *were* my relationship with my father. I was doing them *to have a relationship with my father.* Outside of them, we were still continually at loggerheads."

The Vladek portrayed in the present-tense sequences of *Maus* is petty, cheap, maddeningly manipulative, self-pitying, witheringly abusive to his second wife, neurotic as hell. But when he settles in and starts retelling his life story, you realize that, yes, precisely, he is a survivor of hell, a mangled and warped survivor. The present Vladek imbues his former self with life, but that former Vladek illuminates the present one as well. Spiegelman develops this theme overtly but then, too, in the subtlest details. At one point, for example, Vladek is recounting how when he was a Polish soldier in a Nazi POW camp, early on in the war, he and some fellow soldiers were billeted into a filthy stable, which they were ordered to render "spotlessly clean within an hour," a manifestly impossible task, the failure at which cost them their day's soup ration, "you lousy bastards." Suddenly Vladek interrupts his story and the scene shifts to the present, with Artie seated on the floor before his father, taking it all in. "But look, Artie, what you do!" Vladek cries. "Huh?" asks the absorbed Artie. "You're dropping on the carpet. You want it should be like a stable *here*?" Artie apologizes and hurries to pick up the cigarette ashes. "Clean it, yes?" Vladek will not relent. "Otherwise I have to do it. Mala could let it sit like this for a week and never touch it." And so forth: kvetch, kvetch, kvetch. And then, just as suddenly, we're back in Poland: "So, we lived and worked a few weeks in the stable. . . ."

While many of the ways Vladek grates on his son amount to minor foibles and misdemeanors, he is capable of more substantial outrages as well. Perhaps the most mortifying (and unforgivable) of these atrocities emerges only gradually as the story unfolds: the fact that Vladek didn't just misplace the life history that Anja had written out years earlier to be given someday to their son, a folio Artie even remembers having seen somewhere around when he was growing up—that, actually, he destroyed it. "Murderer!" cries a flabbergasted Artie when Vladek finally confesses the callous immolation at the climax of Book 1. "Murderer," he mutters, walking away. Curtain falls.

"The fact that he'd destroyed that autobiographical journal of hers,"

Spiegelman says, "meant that the story forcibly became increasingly *his* story, which at first seemed like a terrible, almost fatal, problem. The absence of my mother left me with—well, not with an antihero, but at any rate not a pure hero. But in retrospect that now seems to me one of the strengths of *Maus*. If only admirable people were shown to have survived, then the implicit moral would have been that only admirable people deserved to survive, as opposed to the fact that people deserved to survive as people. Anyway, I'm left with the story I've got, my shoehorn with which to squeeze myself back into history.

"I've tried to achieve an evenness of tone, a certain objectivity," Spiegelman continued, "because that made the story work better. But it also proved helpful—*is* proving helpful—in my coming to terms with my father. Rereading it, I marvel at how my father comes across, finally, as a sympathetic character—people keep telling me what a sympathetic portrait I've drawn. As I was actually drawing it, let me tell you, I was raging, boiling over with anger. But there must have been a deeper sympathy for him which I wasn't even aware of as I was doing it, an understanding I was getting in contact with. It's as if all his damn cantankerousness finally melted away."

I asked Spiegelman about the mouse metaphor, the very notion of telling the story in this animal-fabulist mode. It seems to me one of the most effective things about the book. There have been hundreds of Holocaust memoirs—horribly, we've become inured to the horror. People being gassed in showers and shoveled into ovens—it's a story we've already heard. But mice? The Mickey Mice of our childhood reveries? Having the story thus retold, with animals as the principals, freshly recaptures its terrible immediacy, its palpable urgency.

I asked Spiegelman how he'd hit upon the idea. "It goes back to that *Funny Aminals* comic anthology I told you about before," he explained. "Along with several of the other underground-comics people out in California, I had been invited to contribute a strip to this anthology of warped, revisionist animal comics. Initially, I was trying to do some sort of Grand

Guignol horror strip, but it wasn't working. Then I remembered some-
thing an avant-garde filmmaker friend, Ken Jacobs, had pointed out back
at Binghamton, how in the early animated cartoons, blacks and mice were
often represented similarly. Early animated cartoon mice had 'darkie'
rhythms and body language, and vice versa. So for a while I thought about
doing an animal strip about the black experience in America—for about
forty minutes. Because what did I know about the black experience in
America? And then suddenly the idea of Jews as mice just hit me full force,
full-blown. Almost as soon as it hit me, I began to recognize the obvious
historical antecedents—how Nazis had spoken of Jews as 'vermin,' for
example, and plotted their 'extermination.' And before that back to Kafka,
whose story 'Josephine the Singer, or the Mouse Folk' was one of my
favorites from back when I was a teenager and has always struck me as a
dark parable and prophecy about the situation of the Jews and Jewishness.

"Having hit upon the metaphor, though, I wanted to subvert it, too,"
continued Spiegelman, the veteran deconstructionist, lighting up again. "I
wanted it to become problematic, to have it confound and implicate the
reader. I include all sorts of paradoxes in the text—for instance, the way in
which Artie, the mouse cartoonist, draws the story of his mother's suicide,
and in his strip (my own *Hell Planet* strip), all the characters are *human*.
Or the moment when the mother and father are shown hiding in a
cramped cellar and the mother shrieks with terror because there are 'Rats!'
All those moments are meant to rupture the metaphor, to render its
absurdity conspicuous, to force a kind of free fall. I always savored that sort
of confusion when I was a child reading comic books: how, for instance,
Donald would go over to Grandma Duck's for Thanksgiving and they'd be
having turkey for dinner!

"But it's funny," Spiegelman continued, "a lot of those subtleties just pass
people by. In fact, I remember how I was over at my father's one evening
soon after I'd published the three-page version of *Maus*. As usual, he had
several of his card-playing buddies over—all fellow camp survivors—and
at one point he passed the strip around. They all read it, and then they

immediately set to trading anecdotes: 'Ah, yes, I remember that, only with me it happened like this,' and so forth. Not one of them seemed the least bit fazed by the mouse metaphor—not one of them even seemed to have noticed it! A few days later, I happened to be making a presentation of some of my work at this magazine. I was sitting out in the art editor's waiting room with a couple other cartoonists, old fellows, and I pulled out *Maus* and showed it to them. They looked it over for a while and began conferring: 'Kid's a good mouse man,' one of them said. 'Yeah, not bad on cats, either,' said the other. Utterly oblivious to the Holocaust subject matter."

I asked Spiegelman what his father had thought of the newer installments of *Maus,* as they began appearing in *RAW.* "He never really saw them," Art replied, snuffing out his cigarette. "Early in 1981 he and Mala moved down to Florida, and within a few months of that he was already beginning to lose it. He was past seventy-five years old, and he was pretty much incoherent throughout the last year before his death. We had to put him in an old-age home. He died on August 18, 1982."

Art paused for a moment, then continued: "I was less affected by his death than I thought I'd be, perhaps because he'd been a long time going, maybe because there was no room for that relationship to change. I went to his funeral, almost like a reporter trying to see how his story was going to end up. But my feelings were more inchoate than anything that would make a good anecdote.

"I'd already finished all my taping sessions with him before he'd begun to go senile, and I had the story pretty well blocked out, chapter by chapter, except for the ending. As I say, I still don't know how I'm going to end it. The last time I saw him, he was sitting there propped up in the nursing home. He may or may not have recognized me. The nurses were trying to stroke any last vestiges of memory in him. They were showing him these *Romper Room* flash cards—you know, 'Dog,' 'Cat,' 'Dog,' 'Cat,' . . . 'Cat.' "

Spiegelman's voice trailed off. It seemed he might have come upon his ending after all.

(1986)

POSTSCRIPT (1988)

As things turned out, Spiegelman need not have worried about Spielberg's film. The film opened to middling reviews and middling success—no one, at any rate, was confusing it with *Maus*, which, for its part, was greeted with overwhelming critical acclaim and proved an unexpected best seller. During its first year and a half, Spiegelman's book sold almost one hundred thousand copies in the United States, and arrangements were under way for no less than twelve foreign editions (including German, French, Hebrew, Finnish, and Japanese translations). Meanwhile, Spiegelman continued to eke out the subsequent chapters, slowly, laboriously . . . And a new character made a brief appearance in the eighth chapter, in a momentary flash-forward to the present: a baby girl mouse named Nadja, Vladek's sudden granddaughter.

POST-POSTSCRIPT (1998)

Nadja was joined, in 1991, by another child, Vladek's first grandson, Dash—and that same year, the first volume of *Maus* was joined by a second and concluding one, which proved, if anything, an even greater critical and commercial success. The following year, the entire *Maus* series was honored with a "Special Pulitzer" (" 'Special' as in Special Olympics," Spiegelman would subsequently quip)—and the books have gone on to sell millions of copies worldwide in now more than twenty languages. (Spiegelman's second volume, incidentally, once again preceded Steven Spielberg's second whack at parallel material, this time, of course, in his much heralded 1993 film *Schindler's List*.)

For its part, Spiegelman's career continued to soar. The *Maus* drawings and documentation were the subject of exhibitions at New York's Museum of Modern Art and in other venues around the world. Art produced an exquisite illustrated edition of Joseph Moncure March's lost flapper-age classic, *The Wild Party,* and even tried his hand at children's books with the instant classic, *Open Me, I'm a Dog* (another tale of animal transformation, in this instance the story of a puppy transformed into a book—in fact this very book in the child reader's lap—by an evil wizard's terrible curse). Spiegelman became a regular contributor to *The New Yorker,* perpetrating many of the magazine's most striking and controversial recent covers, and a consulting editor at *Details* (where he took to unleashing the *RAW* menagerie on a new generation). And by decade's end, he'd even begun designing and composing the libretto for an original opera.

In 1998, Françoise asked Art what he might like for his fiftieth birthday and he replied: her hand in marriage. That is to say, not the grudging city hall green-card ceremony they'd shared twenty years earlier, but a real wedding bash. Which is how over a hundred well-wishers came to converge, one brisk winter night, on a festive Manhattan penthouse—floating in the spangled sky between the Empire State Building and the World Trade Center—where, between riffs of a small band led by R. Crumb, they got to hear Art and Françoise exchange fresh vows and then be celebrated, in turn, by Nadja, who serenaded them with a winning rendition of "When I'm Sixty-Four," and six-year-old Dash, who contributed an original epithalamic offering, a poem extolling first his mom ("When I think of Françoise, I think of *flowers:* They are soft and gentle as she is.") and then his dear papa:

> When I think of Art, I think of *amazing:*
> It is amazing that he could make a book all by himself
> and the book is *Open Me: I'm a Dog.*

Over a half century after the Holocaust, Vladek's line had at last produced a blessedly oblivious survivor.

GRANDFATHERS
AND DAUGHTERS

My Grandfather's Last Tale

Sara's Eyes

A Season with the Borrowers

Why Is the Human on Earth?

A Fathers and Daughters Convergence:
Occasioned by Some Portraits by Tina Barney

My Grandfather's Passover Cantata

MY GRANDFATHER'S LAST TALE

Scheherazade had had enough—or so the story goes. She'd told a thousand tales and had no more to tell. Her sister tried to rally the poor girl: didn't she realize that unless she took up the skein once again that night, not only would the Sultan order her killed on the spot but he'd resume the homicidal binge her tales had so tenuously forestalled, killing yet another maiden each and every night thereafter? Scheherazade, utterly drained, couldn't bring herself to care. For a thousand nights she'd been unspooling her improvisational yarns, anxiously awaiting the promised return of her young lover, Alcazar, who a thousand days earlier had retreated into the backcountry to organize a revolution and her liberation. But by now it was surely clear that he wasn't coming—and, hopeless, she was all told out.

At that very moment Alcazar came bounding over the balcony ledge and rushed to enfold his lover in a passionate embrace. Just one more night, he urged her: if she could keep the Sultan distracted for just one more night, he and his men would launch their insurrection that very eve. But couldn't he see? Couldn't he understand? she pleaded in reply. She simply had no more tales to tell. Think of something! he called as he vaulted back over the balcony ledge and was gone.

Disconsolate, Scheherazade lapsed into a deep, late-afternoon drowse. All her tales seemed to rise up about her, as if in a pell-mell debauch: Aladdin and Sinbad, Ali Baba and the forty thieves, greedy caliphs and crafty viziers, flying carpets and slicing daggers, soaring falcons and chess-playing apes . . .

And already it was nightfall. With a boisterous fanfare the Sultan and his courtiers came barging into Scheherazade's quarters, avid for tales, and yanked the maiden from her storm-tossed dreams. Why, the Sultan boasted, this girl's stories were so enthralling that time and again he'd imagined himself *right there*—in the very thick of the action, shoulder to shoulder with her myriad protagonists. So, Scheherazade, what was it going to be tonight?

For the longest time it seemed that the answer would be nothing. Shaking, silent, Scheherazade strained for inspiration. None came. The Sultan's concern gave way to anger and presently to scalding rage. Still nothing.

Finally, at the end of her tether, Scheherazade burst forth into narrative—her own: the tale of a young girl, hopelessly ensnared, desperately longing for deliverance by a long-lost love. In the distance explosions could be heard, and flames licked the horizon, but seamlessly Scheherazade wove even these into her tale. Messengers came charging into the palace, urgent with bulletins. The Sultan, transfixed, brushed them away: nothing short of miraculous, the way this girl could spin such lifelike tales!

On and on Scheherazade unfurled the story of her own liberation. So rapt had the Sultan become that even as Alcazar and his troops stormed into the royal chambers, even as they clamped the despot in heavy iron coils and dragged him away, delirious, he still seemed to half-believe that he was in the midst of an indescribably marvelous tale.

Alcazar rushed forward to embrace his consort once again, in triumph but in calamity as well. For Scheherazade, having given her all, had indeed told one tale too many: utterly spent, she collapsed, pale and depleted, into his arms, and—opera being opera—proceeded to die.

I.

For years I'd been trying to arrange a premiere for my late grandfather's final opera, *The Last Tale,* and I'd pretty much given up hope.

My grandfather was Ernst Toch (pronounced *Talk,* with a husky-breathy bit of Middle European business tucked away at the very end), and though his is hardly a name to conjure with nowadays, there was a time—oh, there was a time. In Santa Monica, where he spent much of the latter half of his creative life, the émigrés used to regale one another with a story about two dachshunds who meet one evening out on the Palisade. "Here it's true," one assures the other, "I'm a dachshund. But in the old country I was a Saint Bernard."

Back in the old country my grandfather *was* a Saint Bernard—in Weimar Berlin, that is, during the mid- and late twenties and on into the early thirties. Born in 1887, and thus wedged, generationally speaking, between, say, Arnold Schoenberg (b. 1874) and Paul Hindemith (b. 1895), Toch was at the forefront of the modernist Neue Musik revolution that swept Middle Europe in the aftermath of the First World War. His chamber opera *The Princess and the Pea* received its first performance at the Baden Baden Festival in 1927, right alongside Hindemith's *Hin und Zurück,* Kurt Weill's *Mahagonny,* and Darius Milhaud's *L'Enlèvement d'Europe.* His First Piano Concerto was given its premiere by Walter Gieseking, his Cello Concerto by Emanuel Feuermann. His orchestral works were regularly featured under the batons of such eminent conductors as Erich Kleiber, Hermann Scherchen, Otto Klemperer, William Steinberg, and Wilhelm Furtwängler. He collaborated with the theatrical luminaries Max Reinhardt and Berthold Viertel, and with the novelist Alfred Döblin (of *Berlin Alexanderplatz* fame) and the satiric poet Christian Morgenstern. In short, he was at the very center of a vast, energized, and energizing echo chamber—one that was soon to come crashing all about him, and so many countless others, with Adolf Hitler's rise to power, in January of 1933. It was Toch's most recent opera, *The Fan,* that William Steinberg was rehearsing in Cologne when Nazi brownshirts came storming into the hall and literally lifted the baton out of his hand. Not long after that the once-respected German musical monthly *Die Musik* came out with a special anti-Semitic issue featuring portraits and photos of my grandfather alongside the likes

of Mendelssohn, Offenbach, Mahler, Schoenberg, and Weill—their features retouched so as to make their faces appear vaguely sinister, their noses exaggerated, the pupils of their eyes dilated, the entire cavalcade of images framed by dire quotations, in bold Gothic type, from the long-dead German composer Felix Draeseke ("Our sole salvation lies in anti-Semitism") and from the Führer himself ("The Jew possesses no culture-building power whatsoever").

However fortunate in securing refuge in America, Toch was never to recover that lost sense of cultural resonance and buoyancy—not that his reputation exactly amounted to chopped liver in his newfound home, his own late-life estimation of himself as "the world's most forgotten composer" notwithstanding. During his first decade in California his film scores were thrice nominated for Academy Awards. His Third Symphony won the Pulitzer Prize in 1956. But when, in the last years of his life, he composed his Scheherazade opera—a work he grew to consider the summary achievement of his career, and one that would prove to be among his own last tales—no opera company was waiting eagerly in the wings to produce it, as there had always been in Berlin. It remained unproduced at his death, in 1964.

In the next years his widow, Alice (more commonly known as Lilly), alongside her other efforts at stoking the flame of his musical legacy, ceaselessly endeavored to get the opera produced. As I entered my late teen years (I was twelve when my grandfather died), she recruited me in those efforts. When she died, at age eighty, in 1972, her role as executor of the Toch estate fell to me.

It was a role to which I was in many ways singularly ill suited. If Toch was a dachshund who'd been a Saint Bernard in the old country, he was also, musically speaking, a Saint Bernard who had arisen amid a family of dachshunds. Most composers come from families that are in some way already deeply musical. Not Toch: there were no particular musical propensities in any of his antecedents, and there have been virtually none in any of his descendants either. This is particularly dismaying in my case, because not only was my mother's father this singularly accomplished composer

but my father's mother, in the years before the Nazi Anschluss, was the celebrated head of the piano department at the Vienna Conservatory of Music.

None of this seemed to do me any good: the genes must have canceled each other out. For years, along with my younger brother, I labored away at piano lessons, and my grandfather even composed occasional pedagogical exercises to ease us on our way. About three or four years into the process—I must have been about nine at the time—my brother and I mounted a full-court press on a medley of those works, and were brought before the old man to display the results. I did my best to impress him, and he did his best to be encouraging. But after we left, or so I was told years later, he turned to my grandmother and said, "With the younger one, maybe, there's a chance." (Indeed, with time my brother was able to attain a certain amateur proficiency.) "But with the older one—it's amazing; I've never seen anything like it—it's absolutely hopeless." Shortly thereafter, and quite mysteriously to me at the time, though I wasn't about to ask any questions, the pressure to persevere with those dread piano lessons suddenly subsided. I quit, and that was it for any formal musical training in my life.

Nor did I have any particularly vivid memories of Toch himself. As I began making contact with conductors, performers, and academics in my various halting campaigns to propagate his work, I was surprised to find how well known he remained to many of them. He was repeatedly described to me as a "musician's musician"—a master craftsman many of whose most sublime achievements were principally recognized by other musicians. One would hardly have described him, though, as a "grandson's grandfather"—or at least an utterly assimilated, all-American grandson's idea of a grandfather. In fairness,

his last twelve years (my first twelve) were a time of feverish productivity on his part, culminating in two years of labor on that opera. At any rate, he had precious little time for us grandchildren (there were four of us, the offspring of his and Lilly's only child, our mother, Franzi). He was seldom around. In retrospect I realize that it wasn't just that he always happened to be away—at Yaddo, at the Huntington Hartford Foundation, or at the MacDowell Colony; in rented lodgings in Vienna, or Zurich, or above Montreux. What he was specifically away from was *us*—or, rather, all the mundane, quotidian, frivolous responsibilities, and maybe even temptations, we represented.

When he was in town, ensconced in the Santa Monica home Lilly had had designed and built for him on the far slope of the Franklin Street hill, with its magnificent view of the eucalyptus-girdled Brentwood Country Club golf course and the Santa Monica Mountains in the distance, a languorous, da Vinci–like backdrop, our visits were relatively infrequent and invariably quite formal. In particular, extreme quiet was rigorously enforced—quite an ordeal for four children. *Couldn't we see?* The closed draperies behind the bay window of my grandfather's studio would be pointed to, self-evidently: Ernst was *working!*

On those occasions when he did emerge, he was a sweet and even playful, though somewhat distracted, presence. He was inordinately fond of monkeys and could do marvelous simian turns. He loved clowns and clowning and anything associated with the circus (he had even composed a raucous *Circus Overture,* André Kostelanetz's recording of which he would occasionally play for us). But he wasn't any good at the only thing that really mattered to me in those days, which was the Dodgers. He had never even heard of Sandy Koufax, a circumstance that left me almost speechless with stupefaction. And speaking of speechlessness, we could never take him to a restaurant or on any other social outing, because, it was explained to us in reverently hushed tones, he was afflicted with perfect pitch and such sensitive ears that any conversation registered as music. The inevitable racket of intercutting conversations at a restaurant regis-

tered as very, very bad music—an actual torture. We were urged to understand.

So I can't really say I got to know him well. Such knowledge as I do have came flooding in during the last few years of my grandmother Lilly's life, as she labored to fill me with an awareness of the particulars of her husband's life and music and the relentless requirements of the music's propagation. My mother clearly wasn't going to take up the task: widowed by my father's death in a car accident when I, the oldest, was only ten, she obviously had her hands full raising four children. Beyond that, as the late-arriving only child of a couple whose "only *real* child" (as she often put it) had been her father's music, she was always going to have a conflicted relationship to the task at hand.

So I was the chosen one, and during the last two years of my grandmother's life I spent long weekends and vacation weeks at her side, rifling through boxes teeming with scores, manuscripts, tapes, LPs, contracts, and professional and personal correspondence, ordering a lifetime's profusion for eventual transfer to the archive she established at the University of California at Los Angeles and helping her to prepare for the year-long oral-history project to which she had, in conjunction, committed herself.

Scheherazade-like, she kept herself alive that entire last year slogging through those boxes and completing almost thirty taping sessions (which eventually yielded nearly a thousand pages of transcript), telling the tale of this composer husband to whose needs she had subsumed her own life almost completely.

Within a few weeks of the last session Lilly died—or maybe, her duty done, she finally allowed herself to die. The people at the UCLA oral-history program asked if I would check and edit the transcript myself, since by then I was probably the person most familiar with its contents and especially with Lilly's high-Viennese accent. I took six months off from college and threw myself into the project. At times I felt a little like Hart Crane in that wonderful early poem of his about coming upon an attic cache of his grandmother's love letters. Like him, I'd ask myself,

"Are your fingers long enough to play
Old keys that are but echoes:
Is this silence strong enough
To carry back the music to its source
And back to you again
As though to her?"

Yet I would lead my grandmother by the hand
Through much of what she would not understand;
And so I stumble.

 I did a lot of stumbling. At times, my grandmother seemed to be trying to take me by the hand through much of what I literally could not understand. In one taped passage she was getting set to relate the name of the specific site on the Italo-Austrian front where Ernst had spent a particularly dreadful but crucial period in the trenches during the First World War. Since she was the only one left who remembered the name of the place, she made sure to slow down and enunciate the name with extraordinary precision, as if for all posterity. The place, she pronounced ever so distinctly, was "Hot Potato Shit." I must have replayed that bit of tape a hundred times, speeding it up, slowing it down, splitting it off onto different channels. (I dream about it to this day: Hot Potato Shit.) I must have spent twenty hours in the research library poring over ancient, yellowing gazetteers. Haupt Tatra Spitz? Hohe Tauern Spitz? I didn't, and I still don't, have a clue.*
 Nor, in the end, did I have much of a clue about how to promote my

*One of the readers of this piece, when it first appeared in *The Atlantic* in December 1996—a certain George Strauss, of Piscataway, New Jersey (originally from Vienna)—had the wit to reach for a 1913 Baedeker guidebook to the Oesterreich Ungarn region of the old Austro-Hungarian Empire, and there, right where it was supposed to be (in the Krain region between Laibach—now known as Ljubljana, the Slovenian capital—and Trieste), he located a village called (or anyway once called, for who knows what it's called nowadays): Hotederschitz.

grandfather's music, as is evidenced by the fact that you, dear reader, most likely still haven't heard much, if any, of it. In the first few years I replicated Lilly's methods—the excruciating post-concert backstage sieges of visiting conductors and chamber groups, the endless carping at far-flung publishers and courtship of radio programmers and recording czars. I was not entirely without success. I managed to get Toch's 1948 treatise, *The Shaping Forces in Music: An Inquiry Into the Nature of Harmony, Melody, Counterpoint and Form,* reissued in paperback. By way of a preface I included the English translation of a contemporary letter by Thomas Mann, who praised the volume as "beyond any question . . . the most amiable book of instruction and perception in the field of music that has ever come to my knowledge—lucid, clever, . . . cheerful and comforting; endowed with a liberality that dispels superstition and false pomp; broadminded, benevolently progressive, yes, optimistic. . . ." I helped to midwife a few recordings, and during the centennial of Toch's birth, in 1987, I was able to secure a smattering of performances and radio specials. I did what I could to keep the music in print and the archive in good order.

But gradually I resolved to let my grandfather's work fend for itself,

Actually, it occurred to me more recently, as I was putting this book together, I do happen to know somebody who just might be able to ferret out the current Slovenian name for that onetime Austro-Hungarian village: an American expatriate filmmaker pal of mine, Michael Benson, who for reasons of the heart and now happy fatherhood, makes his home in Ljubljana. I wrote him; he got right on it. His reply:

"OK, here's the real hot shit: Hotederschitz is now called 'Hoterderscica' in Slovenian, only there's a little 'v' on top of that *s* and the first *c,* which are thus pronounced *sh* and *its* respectively, producing yes, collectively, a *shits* imbedded in the word. ('Hoterdershitsa' would be the phonetic pronunciation, approx.) It's a tiny village near the mercury mining town of Idrija, southwest of here, about half an hour's drive. And yeah, the Italian-Austro-Hungarian front snaked through that whole area and up into the Alps along the Soca (pronounced *Socha* due to that same 'v' on the second *c*) River, which in Italian is called the Isonzo, thus the Isonzo Front in *A Farewell to Arms.* You wouldn't know that that territory was/is in Slovenia, however, from reading Hemingway: he never once mentions the word in the whole book. (The closest he gets, which is not very, is in referring to the Bosnian Muslim troops on the Hapsburg, i.e., your grandfather's side.)"

confident that in the fullness of time it would find its own level; for the most part I got on with my own life and career as a writer. In this context I might relate something I've often found odd and even a bit unnerving. Although I have no musical aptitude per se, whenever I write, or review my own or other people's writing, almost all my judgments about the process tend to get framed in musical metaphors: questions of pacing, modulation, tone, harmonics, counterpoint. I'll sense that a given passage is out of key, or could use a little more syncopation, or needs to shift from the dominant to the subdominant—and I don't even know exactly what any of those terms mean. I have a profound sense that I am engaged in a compositional enterprise involving the sequential deployment of material across time in a "formful" manner, which is to say within a transparent architectonic (one of my grandfather's favorite words) structure. When teaching writing classes I often assign my grandfather's book. Though I can't fathom a single one of its nearly 400 musical examples, I understand exactly what he was talking about on every page, and subscribe to virtually all of it, feeling I couldn't have parsed the matter better myself. When I'm alone, typing at my keyboard, I often hear music in my head, especially as my pieces approach their climaxes; almost invariably the music in question (when I stop, later, to think about it) turns out to be my grandfather's. In fact, passages of my own turn out, in pacing and melody and formal structure, to be virtual transcriptions of passages from his quartets or symphonies. It can get to be a little spooky.

Anyway, as I say, I got on with my career and resolved to let my grandfather's music proceed on its own. But there was this one painful exception to the rule: his last opera, whose ongoing lack of performance continued to taunt me. Over the years I did what I could. There were various close approaches and one excruciating near-miss, with Seattle's vigorous young opera company. I tried to limit my advances to major opera companies, since such an important work, it seemed to me, deserved a significant debut. But the work itself presented problems, or so I was repeatedly told: the soprano lead was fiendishly demanding, for one, and the length of the

piece was awkward (ninety minutes in a single act). Nearly a third of a century after its composition I was beginning to lose hope.

But then one morning early last year I awoke to find that a single-page note had come spewing out of my fax machine the previous night: a letter from the Deutsch-Sorbisches Volkstheater, in Bautzen, Germany, informing me (not asking my permission or anything, simply informing me) that they were planning to present the opera that coming November and going on to say that although they were somewhat strapped financially, and hence unable to pay for my flight, they would be happy to put me up in a local hotel for a few nights if I could somehow make my own way to Bautzen. The letter concluded by inquiring whether, on that basis, I'd be interested in coming.

Perplexed, I consulted my household atlas. Bautzen turned out to be a small provincial center in the eastern corner of the former East Germany, just north of the Czech border and about thirty miles outside Dresden in the direction of Poland. Its name was also given, in parentheses, as Budysin, and looking again at the fax's letterhead, I saw that the theater was listed also as the Nemsko-Serbske Ludowe Dziwadlo Budysin.

My initial reaction was, well, mixed. I was thrilled that the opera would at last be performed. But in Bautzen—who'd ever heard of Bautzen? And, more to the point, by the *German-Serbian* Folk Theater?

This did not sound altogether good for the Jews.

II.

Lilly Zwack and Ernst Toch were both born in Vienna, though in very different Viennas. Lilly's father was a banker, and she was thus a princess of the highly assimilated Jewish aristocracy—a class whose idolatry of things German and corresponding disdain for things Jewish (specifically Eastern European Jewish) could verge on the anti-Semitic. Ernst's parents were more conventionally Jewish. His father was a processed-leather dealer

whose family had attained relative financial security only with his genera-
tion. The father naturally assumed that Ernst, his only son, would take up
the family business, and was quite discomfited to see him inexplicably
tending toward music instead. He did everything possible to discourage
the tendency, and indeed almost all of Ernst's musical education had to
take place in secret.

Ernst appears to have been some kind of prodigy when it came to the
universe of sounds, and Vienna being Vienna, it was perhaps only natural
that such an aptitude inexorably turned toward music. The brief tenancy
of an amateur violinist in the Toch household afforded the boy his first
exposure to sheet music: within a few nights of rapt attention he had fig-
ured out virtually all the fundamentals of musical notation.

A few years later, when still only age ten, Ernst made the "decisive dis-
covery," as he later put it, of pocket scores—specifically, miniature editions
of ten Mozart string quartets, which he happened to notice propped up in
a music-shop window. He hoarded his pfennigs and bought one of the
booklets, smuggling it home and studying it late at night under the bed-
covers. "I was carried away when reading this score," he wrote much later.
"Perhaps in order to prolong my exaltation, I started to copy it, which gave
me deeper insight." Soon he managed to buy all ten of the scores. After
having copied three or four of them, he began to make out the structure of
the individual movements. When he started to copy the fifth, he decided to
stop at the repeat sign and try his hand at improvising the development.
He compared his efforts with the original. "I felt crushed," he later recalled.
"Was I a flea, a mouse, a little nothing . . . but still I did not give up and
continued my strange method to grope along in this way and to force
Mozart to correct me."

He would never receive any formal compositional training. Though
supplemented as an instructor by Bach and the other masters of the high
tradition, Mozart remained the reigning god in Ernst's pantheon. "If
Mozart was possible," he would sometimes declare, "then the word *impos-
sible* should be eliminated from our vocabulary." Whenever he encoun-

tered anyone complaining about Mozart's dying so young, he'd erupt, "For God's sake, what more did you want from the man?"

By his middle teens Ernst was already composing quartets of his own; he completed six by the age of seventeen. A schoolmate borrowed the last of these and managed to show it to Arnold Rosé, the first violinist of the eminent Rosé Quartet. A few weeks later Ernst received a postcard notifying him that the piece had been accepted for performance—his first.

And yet, for all this early success, he never imagined that he would be able to convert his beloved hobby into any sort of vocation. In 1909 he was well on his way toward a medical degree at the University of Vienna when, seemingly out of nowhere, he received word that he'd won the Mozart Prize—the coveted award of a quadrennial international competition for young composers; which he had entered three years earlier on a lark. The prize came with a stipend for study at the Frankfurt Conservatory. He was elated that at last he'd be getting some formal training. Instead, when he arrived, as he later recalled, the head of the conservatory's composition department, Iwan Knorr, insisted on studying with him. Indeed, the new quartet (op. 18) and other works Toch produced in quick succession showed that he had already attained full maturity as an heir to the late-Romantic tradition of Brahms.

Following his time at Frankfurt, he was appointed professor of composition at the nearby Mannheim Hochschule für Musik. During return visits to Vienna in the ensuing years his courtship of Lilly began—a courtship that took on added urgency with the onset of the war and his drafting into the Austrian army. Over the next five years he fell largely silent, with the exception of an idyllic serenade for string trio composed, improbably, in those mud-choked trenches at Hot Potato Shit. Working frantically behind the scenes, Lilly eventually managed to secure him a cultural deferment (ah, the exquisite exigencies of the late, lamented Hapsburg Empire!), and he was pulled back behind the lines to Galicia for the latter half of the war. Within a week of that pullback virtually the entire squadron with which he'd been stationed was wiped out in a gas attack.

When the war ended, the couple, now married, settled in Germany. As Toch's creative energies resurfaced, it became clear that his five years of silence had veiled a profound inner transformation. His next string quartet (op. 26) scandalized the audience at its Mannheim premiere, in 1919. "The musical revolution did not come about suddenly," he wrote years later, summarizing the dynamics behind the Neue Musik upsurge in which he played so vivid a role. "Gradually, composers began to feel that the old idiom of tonality had exhausted itself and was incapable of utterance without repeating itself, that the once live and effective tensions of its harmonic scope were worn out and had lost their effect. . . . Indeed, [breaking free of that tonality] was refreshing, even an inner need, . . . as refreshing as a plunge into cold water on a tropical summer day."

By 1923, Toch had secured a ten-year contract, complete with a generous monthly stipend, from one of Germany's most prestigious music publishers, B. Schott's Söhne. He showed an increasing predilection for experimentation. For instance, he composed a suite for mechanical player piano that allowed intricate chords of well more than ten notes. And he forged an entirely new genre with his Geographical Fugue for Spoken Chorus, a rigorously patterned sequence of place names ("Trinidad, and the big Mississippi and the town Honolulu and the lake Titicaca / The Popocatepetl is not in Canada rather in Mexico Mexico Mexico") splayed into a strict fugal canon and intended to be spoken, rather than sung, by a traditional four-part chorus: Weimar Rap. Given its premiere at a 1930 music festival in Berlin as a trifle, a sort of musical joke, it was ironically to become perhaps Toch's most famous and influential piece. A young American in the audience, John Cage, was particularly captivated, or so he told me years later, when I met him while researching an article about his and Ernst's dear friend the musical lexicographer Nicolas Slonimsky. "Ah, yes," Cage said, that marvelously sly twinkle in his eye. "Toch—boy, was he onto some good stuff back there in Berlin. And then he went and squandered it all on more string quartets!" Years later, in 1962, Toch revived the genre in his "Valse," arranging the clichés of typical American cocktail-party banter

into three-quarter time—taming all that nerve-racking chatter, that is, into a more rigorous and endurable sort of noise ("My, how super-dooper / Hold your tongue, you strapper / Let's behave, not like babies, but grownups / She is right / She is right!").

Another of Toch's musical divertissements from that bountiful period was a chamber opera composed, as it happens, a third of a century before *The Last Tale* and in many ways its obverse. Based on a charmingly mischievous libretto by Christian Morgenstern, *Egon und Emilie* begins as a dapper contemporary couple enters stage center and the woman energetically begins regaling everyone with how great it is to be singing like this and embarking on an opera. She waits expectantly for her consort's riposte—which doesn't come. Demurely seated, he says nothing. She tries to rouse him again and yet again: nothing. The more frantically she endeavors to provoke him, the more agitated the accompanying music becomes—and still nothing. Finally she flees the stage entirely, a broken woman. Whereupon, twenty minutes into the piece, the man gets up, clears his throat, and announces, in a level if somewhat disdainful voice, that he for one can't stand opera, it's all so completely artificial, and he has no intention of indulging such nonsense any further. Curtain falls: end of opera, end of evening.

As daft as that opera may have seemed at its Berlin premiere in 1928, with the passing months it began to take on a prophetic aura. For there were others, too, who had no intention of indulging this nonsense—this marvelous cosmopolitan capital city with its four year-round top-notch orchestras, its three full-time opera houses, and its dozens upon dozens of theaters, all trafficking in the latest spiky idioms—any further.

Upon Hitler's rise to power, Toch took the measure of the new reality almost immediately, much to Lilly's surprise—he'd always seemed so apolitical. It was time to go. For purposes of escape he took advantage of having long before been selected (along with Richard Strauss) to represent Germany at a musicological convention in Florence in April of 1933. He never returned to Berlin, instead fleeing to France. After he had established

himself in a Paris hotel, he let Lilly, back in Berlin, know that the coast was clear for her and their five-year-old daughter to join him by way of a coded telegraphic message that read simply, "I have my pencil."

As if that was going to be enough: as if that was all he was going to need. He had little else. His publisher had abandoned him. His music was being burned, and the plates broken. Concerts of his work were canceled. The only traces remaining of his once vibrant reputation were doctored photographs in exhibitions of "degenerate music."

It would be several years before he even found a new home. With Paris thronged by refugees, the family moved to London, where Toch managed to secure some film work at the behest of his old Berlin collaborator the director Berthold Viertel. (The scenarist of the film in question, *Little Friend,* was Christopher Isherwood, who later evoked his own experience of the project in his novel *Prater Violet.*) Within a year, Toch was invited by Alvin Johnson, of the New School for Social Research, in New York, to be among the first to join the faculty of Johnson's celebrated University in Exile.

Once in New York, Toch endeavored to repair the shattered music-publishing part of his career by joining up with Schott's longtime American partners, a company called Associated Music Publishers (AMP), which, itself unaffected by Hitler's rise, was only too happy to have him. Because his former performance-royalties collection agency, the German firm GEMA, had expelled him, however, along with all its other Jews, he had no way of collecting royalties from performances of any of his works anywhere in the world. For this reason, AMP urged him to join GEMA's principal American counterpart, the American Society of Composers, Authors, and Publishers (ASCAP). Though there were some technical obstacles to his doing so, these were quickly smoothed over by the intercession of a new friend, George Gershwin. (Gershwin had originally approached Toch, as he did several other émigrés—Stravinsky famously among them—in an attempt to get some formal compositional training. Anxious about the strictly orthodox caliber of his own achievement, Gershwin had become obsessed with the notion of composing a conventional string quartet.

Much to his frustration, however, neither Toch nor any of the other émigrés was willing to tamper with such evident native genius.)

The trouble came a few months later, when AMP was bought out by ASCAP's chief rival, BMI, and the new management summarily decreed that it would no longer publish or promote the work of Toch or any other ASCAP composer. Several decades later, BMI's ownership of AMP (or any other publisher) was suspended owing in part to antitrust allegations, but in the meantime its impact on Toch's career proved devastating. He was now forced into a second sort of exile, his works scattered among an ill assortment of publishers, none of which was ever to show much interest in promoting its own small share.

III.

More problematic yet, for Toch and many of the others, was what his colleague Ernst Krenek referred to as "the echolessness of the vast American expanses." From a world of continuous, almost febrile anticipation, in which their ongoing work had been charged with pressing significance (audiences would not only experience the work almost as soon as it had been written but also spend hours and hours arguing about it), Toch and the others had moved into a cultural scene characterized at best by its "unlimited indifference and passive benevolence toward anything and anybody," in the words of the conductor Henri Temianka, who was referring specifically to the ethos of Southern California. At worst—and, unfortunately, this worst was generally the rule—modernist émigré work met with almost allergic hostility.

From the start, from even before the start, Toch had tried to meet this reaction head-on. In 1932, he had toured the United States as a guest of the Pro Musica Society, playing the piano and lecturing at chamber recitals. At a news conference prior to one such concert he exhorted his interlocutors to open themselves to new sounds. He warned them of the consequences of trying to force those sounds into such preexisting mental compart-

'I DO THE TALK,' DECLARES WIFE OF ERNEST TOCH

Famous German Composer Will Appear at Repertory Theatre Under Sponsorship of Pro Musica

By F. L.

Curly-haired Ernst Toch, famous composer-pianist of the younger radical group in Germany, eats raw meat, but when it comes to talking he lets his wife do it.

She even "gets temperamental" for him. Sometimes, at recitals, when an outburst of some sort is expected from an artist held in such awe as her dark-eyed husband—well, if he doesn't feel up to it she "does the spasm" for him.

They laughed together, this unusual German couple. They arrived in Seattle yesterday morning, he to give a recital tomorrow evening and she to do the talking, supervise his diet and, if necessary, be temperamental.

He was wearing a loose, tweed suit. She was dressed smartly in brown.

"I do not speak the English," Toch said quietly. "My wife, she talks."

Opinions Divided

What about his music?—his strange, startling new music which has set some critics to foaming at the mouth, others to raving and still others to ranting. Ah! his bright-eyed young-looking wife, she could tell all about that.

"My husband," Madame Lilly Toch said, hands fluttering, "he would like to talk, but he cannot. He gets started, so! and into German he goes. Then he must to stop. He gets the—how is it?—shy? Then he has to walk away with his head bowed. So, me, I do the talk, instead!"

The composer—44 years old, though he looks much younger—has been something of a sensation in Europe in the past few seasons. This is his first time in America. Madame Toch believes Europe is quite right, she said, her husband, he is a genius. She loves his music, she smiled. Oh, yes, once in a while, when he played something new for her, some new composition of his, she would be a little bit puzzled. She would have trouble "following."

Plays Strikingly

"But that," and she dismissed it with a wave, "is maybe because I am not a musician. I talk for him, but when he plays I want just only

EATS RAW MEAT.

Dr. Ernest Toch, famous German composer, shown here with his wife, will play the piano in concert tomorrow evening at the Repertory Playhouse under auspices of the Seattle Chapter of Pro Musica. Mrs. Toch, who speaks English fluently and does the talking when her husband is interviewed, admits he sometimes enjoys a raw meat sandwich.

ments as classical, Baroque, or Romantic. "In such a case," he explained, "either the music remains outside of you or else you force it with all of your might into one of those compartments, although it does not fit, and that hurts you, and you blame the music. But in reality it is you who are to blame, because you force it into a compartment into which it does not fit, instead of calmly, passively, quietly, and without opposition helping the music to build a new compartment for itself." The assembled reporters absorbed this lesson impassively and then posed a few mundane questions, such as what was the composer's favorite food, to which Toch heedlessly replied, "Steak tartare." The next morning's paper predictably featured a large photo of Toch at the keyboard under the headline EATS RAW MEAT.

In 1935, again partly thanks to one of Gershwin's interventions, Paramount commissioned Toch to score its new Gary Cooper–Ann Harding vehicle, *Peter Ibbetson,* which won Toch his first Oscar nomination; within the year he moved his family to California. Over the next decade, his services were in considerable demand in Hollywood, where, owing to the perceived eerieness of his modernist idiom, he was quickly typecast as a specialist in chase scenes and horror effects. (Channel surfing across late-night TV, I continually bump up against his distinctive strains: *Dr. Cyclops;* the midnight sleigh chase in Shirley Temple's *Heidi;* Bob Hope's *The Ghost Breakers; Ladies in Retirement,* which earned him another nod from the Academy of Motion Picture Arts and Sciences; the "Hallelujah" sequence in Charles Laughton's *The Hunchback of Notre Dame.*)

In December of 1937, Toch received word of the death of his mother, in Vienna. While attending the ritual prayers for the dead at a local synagogue he conceived the idea of a memorial cantata based on the Passover Haggadah. Having strayed considerably from the more circumscribed orthodoxies of his youth, Toch insisted that he was drawn to the universal implications of this tale of the liberation of the Jews from their Egyptian oppressors. But surely his developing *Cantata of the Bitter Herbs* took on more urgency during the terrible months of its creation. As he was composing a particularly haunting chorus based on the psalmist's text "When

Adonai brought back his sons to Zion, it would be like a dream," Hitler's forces were triumphantly goose-stepping their way into Vienna, sealing off the town of his birth.

The Anschluss initiated a vertiginous period of desolation in Toch's life. Gnawing anxiety about the fate of trapped friends and relatives (he had more than sixty cousins in Austria) was sublimated into time-consuming negotiations with international bureaucracies in desperate and often futile attempts to gain their freedom; more than thirty didn't make it out, and Lilly's sister, too, perished in Theresienstadt. The financial pressures of sponsoring a burgeoning family of dispossessed exiles, and of meeting U.S. affidavit requirements by showing that he could, if necessary, support still others, forced him to channel ever larger portions of his creative time into the most lucrative possible employments—teaching on the one hand (he was appointed to a composition chair at the University of Southern California) and Hollywood on the other. The studios' notorious caprices, such as the blanket elimination of the upper registers from one of his scores as a cost-cutting measure, increasingly grated on him. Furthermore, the loss of any sort of responsive audience rendered the few hours he was able to preserve for his own work increasingly hollow. As he complained to a friend in a 1943 letter, "For quite some time . . . disappointments and sorrows render me frustrated and lonesome. I become somehow reluctant to go on writing if my work remains more or less paper in desks and on shelves."

Underlying all his anxiety was the fear that he had squandered his musical vocation, that he had lost everything—even, in effect, his pencil. Indeed, these years were parched by the most harrowing dry spell of his life. Although from 1919 to 1933 Toch had created more than thirty-five of his own works, from 1933 to 1947 he struggled to create eight.

And yet somehow, perhaps tapping a primal source available only to one brought so low, Toch was on the verge of a stupendous regeneration. In letters at the end of the war he began exploring the image of the rainbow, token of renewal. For his own renewal he returned to first things—that is, to the string quartet. "As for me," he wrote to another friend, "I am in the midst of writing a string quartet, the first of its kind after eighteen

years. Writing a string quartet was a sublime delight before the world knew of the atom bomb, and—in this respect it has not changed—it still is." The quartet (op. 70) bore as a motto lines from a poem by Eduard Mörike: "I do not know what it is I mourn for—it is unknown sorrow; only through my tears can I see the beloved light of the sun." And through the shimmery pizzicato of the third movement the listener can see it too.

Toch was simultaneously completing his book *The Shaping Forces in Music,* a labor born of his frustration as a teacher at the lack of texts capable of integrating modern and classical styles. As for most existing theoretical work, "there seemed to be," he wrote to a friend, "a break all along the line, either discrediting our contemporary work or everything that has been derived from the past. To my amazement, I find that [traditionally based] theories are only false with reference to contemporary music because they are just as false with reference to old music, from which they have been deduced; and that in correcting them to precision, you get the whole immense structure of music into your focus."

Thus Toch's creative regeneration in the late forties recapitulated the apprenticeship of his childhood in this other way as well: once again, through an exploration of the masters, Toch recovered the essential stream of his own vocation.

The years after the war paradoxically proved the most difficult of all, for now extraneous obligations threatened to strangle Toch's reviving vocation. Tormented by these conflicting pressures, he was felled by a major heart attack in the autumn of 1948.

He almost died. Later he would say he'd undergone a "religious epiphany." Pressed to explain what he meant, he noted that the word *religion* derives from the Latin *religare,* meaning "to tie, to tie fast, to tie back." "Tie what to what?" he went on. "Tie man to the oneness of the Universe, to the creation of which he feels himself a part, to the will that willed his existence, to the law he can only barely divine."

As soon as he had recovered sufficiently to travel, Toch returned to Vienna, the city of his childhood, to compose his first symphony. It would be followed, during the remaining fifteen years of his life, by six more.

Such a complete symphonic flowering so late in a composer's life was virtually unprecedented in the history of music.

The first three symphonies, surging once again in his modernist idiom, should be interpreted as a musical triptych—a sustained outpouring from that single epiphanic source.

To his First Symphony, Toch assigned a motto from Luther: "Although the world with devils filled should threaten to undo us, we will not fear, for God has willed his truth to triumph through us." His Second Symphony, dedicated to Albert Schweitzer, a man he revered (he would insist that the symphony had been not only dedicated to Schweitzer but "dictated" by him), carried the biblical motto from Jacob's wrestling with the Angel: "I will not let thee go except thou bless me." For his Third Symphony, in 1955, Toch deployed a quotation from Goethe's *The Sorrows of Young Werther:* "Indeed I am a wanderer, a pilgrim on this earth—but what else are you?" The lines accomplish a harmonic conflation of the German and the (wandering) Jewish traditions, and at the same time transmute intimate autobiography—Toch would often refer to this piece as his musical autobiography—into a microcosm of universal human history.

Toch's productivity continued unabated until his death; he moved through almost thirty opus numbers in fifteen years. But what he was really on the lookout for the entire time, as he told anyone he thought might be able to help, was a good libretto. At one point he felt he'd found an ideal opera subject in Lion Feuchtwanger's late novel *Jephta*—a sort of Hebraic *Iphigenia* in which a great Jewish general is required to sacrifice his daughter for the sake of victory. But he couldn't wait for a writer to adapt the text; the music erupting inside him poured forth instead as his Fifth Symphony.

In 1960, the Hungarian violinist Feri Roth, who had recorded several of Toch's quartets, mentioned to Toch that he'd recently been talking with the noted playwright and scenarist Melchior Lengyel about a dramatic piece Lengyel had composed years before in Budapest but had begun to feel might work better as a libretto. It sometimes seemed that there were almost as many Hungarian émigré artists on the fringes of Hollywood as there were Germans. (Gottfried Reinhardt, in his delightful memoir of his

father, Max, tells a story about visiting the Clover Club, a gambling casino on Sunset Boulevard, one evening in the company of Otto Preminger. As it happened, they were the only two non-Hungarians at the roulette table, and the agglutinative language of their neighbors so grated on Preminger's nerves that finally he "brought his fist down on the baize, shouting, 'Goddammit, guys, you're in America! Speak German!' ") Lengyel, who had collaborated in Budapest with the young Georg Lukacs and had scripted Bartók's ballet *The Miraculous Mandarin,* was also quite successful in Hollywood, providing the stories for both *Ninotchka* and *To Be or Not to Be.* But now he was looking for a composer.

Roth brought the two men together. Lengyel summarized his idea for an opera based on Scheherazade's last tale, and Toch seemed sufficiently intrigued that Lengyel offered to have the text translated. When the translation arrived one morning some weeks later, Toch retreated into his study with the manuscript and, quite unusually, didn't emerge for lunch. When Lilly, concerned, eventually broke in with a snack tray—also quite unusually—she found him radiant with excitement and the manuscript already copiously scrawled over with musical motifs.

It is easy to see in Lengyel's story the themes that so called out to Toch, a man in his seventy-third year whose life had been haunted by motifs of tyranny and deliverance, of exhaustion and renewal, of blockage and release. It is a bit harder to see how a man of his age and relatively fragile constitution could summon the sheer physical stamina required for such an ambitious undertaking. But, almost rapturously possessed, Toch threw himself into the project, composing some of the most intricately layered and subtly modulated music of his entire career. Indeed, so possessed was he during the two years of the work's composition that he managed to remain entirely oblivious of the onset of the cancer that would claim his life not long after its completion.

The end, when it came (or at least his awareness of its approach), was relatively sudden. He was rushed to the hospital, and was dead within a few weeks, of stomach cancer. The sketches left by his bedside were for a new string quartet.

IV.

The German-Serbian Folk Theater, in Bautzen. To begin with, it turned out to be *Sorbian*, not Serbian, as I discovered flipping through a tourist brochure shortly after my arrival at the hotel. The Sorbs, otherwise known as the Wends (and no particular relation to the Balkan Serbs, though they have sometimes displayed a confusing tendency to spell themselves "Serb" as well), apparently constitute a kind of historical hiccup, ethnically speaking—an ancient "Slavonic," which is to say Slavic, people stranded behind the lines deep in Germanic Saxony, with Bautzen as their cultural capital. The brochure detailed all sorts of distinctive folk costumes—exquisitely dentelated lace aprons, collars, and headdresses for the women, stiff black caps or top hats for the men—none of which were in evidence as I gazed out my hotel window onto the town's main square.

Nor, for that matter, was there anything particularly Sorbische about the Deutsch-Sorbisches Volkstheater. Sorbs had been somewhat coddled by the East German regime—that is to say, considerable subsidies had been lavished upon "Sorbische" cultural institutions in exchange for Sorbian political quiescence. But despite the fact that the existence of a distinctive Sorbian "nation" is recognized in the German unification documents of 1990, Sorbian culture has clearly withered considerably over the past several decades, such that at the Volkstheater the staffing and programming—on the musical side, anyway—have virtually nothing distinctively Sorbian about them. One veteran could recall the token programming of at most three or four pieces by Sorbian composers in the entire twenty years he'd been there.

While walking around the neighborhood the afternoon before the premiere (Bautzen is a picturesque town spreading out from a medieval fortified core that commands an escarpment over the swift-flowing river Spree), I happened upon a somewhat more pertinent feature of local history. In the bowels of the judicial building, according to a plaque only

recently set into its outer walls, the East German security police—the regime's dread Stasi—had maintained one of their principal interrogation and incarceration centers for political prisoners; the center itself had been closed since 1992. Indeed, as I learned from a pamphlet I picked up in a nearby kiosk, Bautzen since the beginning of this century had been an internment center for successive regimes. (A vaster complex on the outskirts of town had been used by the Nazis—and was mentioned in the epic *Schindler's List,* under the name Budysin—and then by the Soviets as an internment center for ex-Nazis.)

According to the pamphlet, the interrogation center inside the judicial building must have been a truly dystopian institution. The pamphlet quoted Walter Janka, an East German publisher and a veteran of the Spanish Civil War, who had served time there under both the Nazis and the Stasi. The Stasi forbade him to have any reading or writing materials, and when he complained to his interrogators that not even the Nazis had promulgated such a blanket policy, he received the chilling reply, "Well, we're not in Nazi times anymore." Among the torments favored by the Stasi were extended stints in isolation and standing erect for days at a time in so-called tiger cages. For a while, I learned, the town's two biggest employers had been the various Sorbian associations and the two prisons.

So I was not entirely surprised, when I attended the opera's final rehearsal later that day (the company had decided to dispense with the opera's original title and produce it as *Scheherazade*), to see that the director, Wolfgang Poch, was framing his production at least in part as a political allegory. His casting had a vaguely subversive edge to it, with the role of Scheherazade going to a lovely Dutch soprano, Marieke van der Meer, who provided the focus for the contest between a Russian Sultan (the bass Oleg Ptucha) and an American Alcazar (the tenor Robert Lischetti). More to the point was Poch's inspired shading of the Sultan's court, which was portrayed as foppishly servile to the tyrant's every whim—right up, that is, until a moment near the end, when it seemed to melt into the woodwork, as if it had never played any role in bolstering the despot's terrible rule ("Sultan?" the courtiers seemed to say. "What Sultan?").

Poch, as it turned out, was a West German, a journeyman opera director and a veteran of more than 150 productions and assorted head postings in houses all over Europe, who in 1993 had applied to take over this regional company almost on a whim, and had grown more and more convinced of its potential. A high-strung enthusiast, tall, lanky, and somewhat frail, with a great bobbing Adam's apple as his paramount feature, the sixty-year-old director described his efforts to widen the provincial company's range and heighten its visibility through challenging programming; earlier, for instance, it had tackled the world premiere of Weill's *Der Kuhhandel*. Poch had come to know Toch's music in his university days, in Berlin. The son of a half-Jewish mother who had survived the war by passing as an Aryan, Poch made it something of a mission to resurrect the work of this man who had been so unjustly forgotten. For years, completely unbeknownst to me, Poch had likewise been trying to produce the Scheherazade opera, and he had almost succeeded when he headed the company in Baden Baden, the site of some of Toch's most celebrated triumphs at annual music festivals during the Weimar era. His devotion was touchingly lavish, and the more he talked, the more it seemed that this opera in particular had grown to exert an almost demonic hold over him.

I frankly didn't know what to expect from such a marginal-seeming production. But as the lights dimmed and a hush fell over the first-night crowd, I was more and more pleasantly surprised. The stage set was steeped in a sort of Klimt or Hundertwasser Orientalism, and if the staging was a bit static, the musicianship of the orchestra, under the direction of Dieter Kempe, a veteran Bautzener, was astoundingly competent—a legacy of East German cultural policy, perhaps; I was assured that the East was teeming with such proficient regional ensembles. The singing of the principal players, especially van der Meer, was generally transporting and at moments luminous. (Van der Meer, I learned, had been born exactly two days before Toch died.) The reviews in the next few days were almost uniformly favorable, with several critics calling for further performances in better-established venues. A CD recording session has been slated for 1998 with the Leipzig Gewandhaus orchestra.

I attended two performances in Bautzen, on consecutive nights, and in both cases the audience, made up primarily of local people, seemed authentically taken with the piece, showering the ensemble with repeated ovations. But in neither case did more than a few of the audience members register the blatantly allegorical connotations of Poch's staging—or so it seemed, on the basis of conversations I had with several people afterward in the lobby and near the coat check. Charming, I was told, captivating, wonderfully moving. But apt, relevant, pertinent? My questions met with blank stares.

This would never have been the case in nearby Poland, where the tradition of subversive mass readings of stage and literary works is so entrenched that for years every production of Shakespeare was viewed primarily (and sometimes exclusively) as a barely veiled commentary on Polish reality. From what I could tell during those few days in Bautzen, anyway, the former East Germany may have been different: the capacity for such an ironic reading, the sense of imaginative play or subversive engagement or even simple curiosity about the past, seemed to have all but completely atrophied, like a muscle kept too long in a cast.

The first night in particular, this hollowed-out response rankled. I couldn't help thinking that a similar pusillanimity—a sort of timorous mass thoughtlessness, to cast matters in their best possible light—had abetted not only the Stasi regime but the Nazi dictatorship before that. Seen in that light, this willful obliviousness was as responsible as anything else for the calamitous breakup of my grandfather's career. Yet it was also true that it was Germans, and these provincial Germans in particular, who had gone to the trouble (as performers) to resurrect Toch's languishing last major opus and (as an audience) to open themselves to that act of reclamation. My ambivalent feelings were in some sense an echo of my grandfather's. Shattered as he had been by his repudiation and exile—an exile that had begun when he was almost exactly the age I was now—he had insisted all along on seeing himself first and foremost as an heir to the Austrian-German tradition. He had thus remained within the German-Jewish assimilationist tradition that seemed to treasure the German cultural heritage—that seemed to *need* to treasure that heritage—even more

than did the Germans themselves. How else to account for his return to Vienna, of all places, so shortly after the war—Vienna, the fount of some of the worst anti-Semitism in all the German lands, both before and during the Nazi period—except to say that yes, Vienna was all that, but it was also the very headwaters of his creative vocation? Or, beyond that, to account for his choice of Luther, of all people, as the voice behind his First Symphony, composed there? After all, when Luther spoke of a "world with devils filled," Jews were among the principal villains he had in mind. There were knots upon knots in all this, and, standing a trifle awkwardly amid the champagne glasses and the passing canapés at the post-premiere party, I was reminded of an observation that another knotted and knotty Viennese Jew, Ludwig Wittgenstein, once made—how philosophy unties knots in our thinking, hence its result must be simple, but philosophizing has to be as complicated as the knots it unties.

The next night, though, for some reason things did seem simpler. Maybe I was just being lifted higher by the music itself, as I grew more familiar with it. The vexing political context seemed to fall away, and as Scheherazade struggled through her block and into the transporting narrative, I experienced an overwhelming sense that my grandfather had drawn together all the disparate themes of his own life in one transcendant summary exaltation. Things that had seemed chopped and broken and scattered—the shards of both his life and his music—were retrospectively realigning and resolving themselves. As Scheherazade's last aria reached its lyrical climax, I found myself remembering a letter Toch had written to a young would-be composer not long after his own heart attack—and on the verge of his astonishing regeneration—in 1949. "A composition must grow organically, like a tree," he had urged the young man to understand. "There must be no seams, no gaps, no foreign matter. The sap of the tree must pass through the whole body of it, reach every branch and twig and leaf of it. It must grow, grow, grow, instead of [like a mismatched suit] being patched, patched, patched." I could see that Toch had been talking not only about the composition of a piece of music but also about the composition of a life—and, for that matter, of a family line. And as the audience now rose in

ovation, showering particular kudos on their beloved Poch, who stood there drained and pale, trembling in his triumph (for, as none of us realized at the time, he was already riddled with a cancer that would claim his life within a few months—such that this would be almost his last tale too), I found myself realizing how for Ernst the spiritual challenge was the same in both instances. I suddenly recalled some lines from one of the last notes he ever wrote to Lilly—the one with which, Scheherazade-like, she had chosen to conclude her oral history before herself going on to die. It consisted of a poem in which he acknowledged all the sacrifices she had made in his behalf over the almost fifty years of their life together, assuring her that he was aware of the suffering such sacrifices had often entailed—an awareness that was his despair. Yet he begged her forgiveness: it couldn't be helped, for, as he, and she, and now I concluded by way of explanation,

> *Ich treibe nicht—ich werde getrieben*
> *Ich schreibe nicht, ich werde geschrieben!*

> I do not press, I am pressed—
> I do not write, I am written!

<div align="right">(1996)</div>

POSTSCRIPT

For those of you who may have doubted my claims in this regard earlier in this piece, I simply lifted (or so I subsequently came to realize) the rhythms and the cadences of the outset of this essay from the propulsive launch of my grandfather's First Piano Concerto and those of its ending from the relentlessly ingathering and then all-spangly last bars of his Seventh Symphony.

You could look it up, because, as it happens, both pieces recently became available on CD. Improbably, and frankly owing to hardly any direct effort on my own part, there has been a veritable surge in the Toch discography with something like fifteen fresh recordings, both in Europe and America, in under a decade.

SARA'S EYES

In 1987, one hundred years after Ernst Toch's birth, his first great-grandchild—a girl, Sara Alice—was born in New York City. Thirty minutes after her birth, my daughter was already taking my measure. She lay in my lap, startlingly alert, scanning me as I scanned her, our gazes moving about each other's bodies, limbs, faces, eyes—repeatedly returning to the eyes, returning and then locking. The same thing happened, I soon noticed, as she lay cradled in my wife's embrace, this locking of gaze into gaze. And it was only gradually that the wondrous mystery of that exchange began to impress me—for not even an hour earlier my daughter's eyes had been sheathed in undifferentiated obscurity, and now what seemed most to capture their attention? Other sets of *eyes*. (Not noses, mouths, lights—*eyes!*) How could this be? Of all the possible objects of regard, what is so naturally compelling about two dark pools of returned attention? I could already imagine the scientific explanations—that the newborn infant displays a quantifiably verifiable predilection for certain facelike configurations, for example, or that this predisposition to gazing at eyes is instinctive, a sort of visual sucking reflex—but all such explanations seemed to beg the question. For I already *knew* that she had a predilection for facelike configurations, for dark dots ranged in pairs—the evidence was as obvious as the face before me—and the explanation for this predilection was equally obvious: because "facelike configurations" are *like* faces.

A few hours later, as I was trying out some of these notions on a friend of mine, he concocted an instant hypothesis in the sociobiology mode:

"The ones who gazed up at their parents' noses simply got tossed out of the cave." I kind of liked that explanation. At least, it tapped into the primordial horizon that gazing into my newborn daughter's gaze summoned forth in me. My eyes locked on hers, I'd had a sense that I was gazing into origins, the ur-past—that this gaze of hers was welling up at me from deep beyond the past's past. Of course, that sense of things was all wrong, for, eye to eye, it was *she* who was gazing into the past. I was gazing into the future's future.

(1987)

A SEASON WITH THE BORROWERS

{The transcript that follows tracks the last half of the Father's Day 1998 edition of Ira Glass's This American Life *radio program.}*

IRA GLASS: This is *This American Life,* and I'm Ira Glass. Each week on our program, of course, we choose a theme and invite a variety of writers and performers to tackle that theme. Today's program, for Father's Day, we bring you stories about fathers who do not get close to their kids, and about fathers who do. Lawrence Weschler is an author and journalist, a writer at *The New Yorker,* and this story is about an odd breach of trust between father and child—a breach of trust done without meaning to—and what happened next. He and his eleven-year-old daughter, Sara, went into a radio studio in New York City to tell us this story. It begins simply enough, when she was little and he would read to her.

LAWRENCE WESCHLER: She would get into very active conversations with the characters in the books while we were reading. So for example, when we were reading *Little House on the Prairie,* there would be these moments where she would interrupt my reading and say, "Wait a second. I want to talk to the Indian." And we'd have to look at a picture of the Indian, and she'd say, "Now, look, Indian, in a few pages you're going to meet Laura, but you've got to understand. I know she's taking your land, but it's not her fault. She's just a kid. Now, let me talk to Laura." And we'd go back and talk to Laura. And in these interactions, I would take on the role of the Indian, and I'd say things like, "Who's that talking?" And we'd

have these incredibly elaborate conversations. Do you remember that, Sara?

SARA WESCHLER: Yes.

LW: Anyway, this sort of thing would go on all the time. And at a later point, we began reading the *Borrowers* series, the series of wonderful books by Mary Noble—

SW: Norton.

LW: Excuse me, Mary Norton. That's right. Should Sara describe what those books are about?

IG: Sure. Sara, explain what the Borrowers are like.

SW: Well, the Borrowers, they're these little people who are, I think, four inches tall, and they live under the floorboards in the house. What they do is, they take things from people, little things that they can use around their house.

LW: So what kinds of things would they take?

SW: Well, they take pocket watches to use as clocks and stamps for pictures on the wall.

LW: And part of the thing about the Borrowers is—are they allowed to talk to people?

SW: No.

LW: Want to talk about that a little bit?

SW: Well, they think that people can really hurt them, because according to the book it's happened before.

IG: Right.

LW: So anyway, we were reading this book. And one day I came home and Sara was incredibly excited. Her face was just glowing. She said, "Daddy, you won't believe it! *We have Borrowers here in our own house!*" Maybe you remember this differently, Sara, but my memory is that you went to a particular place in the basement and pointed to this little hole in the wall near the floor and said, "I was coming down the stairs and there was one of them standing right there, a little girl. And she was wearing a pink taffeta skirt." That's what you said. "And I froze, and she froze, and we

looked at each other. And I knew I wasn't supposed to talk to her, that she shouldn't talk to me, so we just looked at each other. After about thirty seconds, she waved her hand just slightly and then she ran away." And Sara took me to the place where all this had happened and pointed, declaring, "And it was right there!"

IG: And Sara, let me just ask you, What do you remember of this?

SW: Well, see, it's sort of strange to say this, because I feel like I'm betraying the Borrowers. But I still believe in them, and if I ever actually got to meet one, I'd never tell anyone. And I do remember having seen something. It wasn't really for thirty seconds. It was like maybe ten seconds, and then it ran away.

IG: And even now, when you think about it, you can picture it.

SW: Yeah, yeah. I didn't imagine it. It was definitely there.

IG: And it was a little girl?

SW: Yeah, I think.

IG: Okay.

LW: And then, over the next few days, Sara began leaving things for this Borrower. The first thing in the morning, she would race downstairs to see if the things had been picked up.

IG: Do you remember what kind of things you would leave?

SW: Sometimes I would leave toothpicks, or pieces of food.

IG: What do they use toothpicks for?

SW: Oh, just to dig with, or as a walking stick, things like that.

IG: So, sort of an all-purpose tool.

SW: Yeah.

LW: Anyway, she would leave these things there, and she would be so disappointed—disappointment verging on desolation—when they hadn't been picked up. And she'd have long conversations with me: "Why aren't they picking them up? Don't they know that I'm giving it to them?" And I'd try to explain that maybe they were scared or nervous or something, because that's how Borrowers are. But she was so sad. I figured this would end after a week, but it went on for weeks.

And I don't know why I did it—because it launched a cascade of

consequences—but one night, I picked up the stuff and put it in my pocket. And the next morning Sara came bounding up the stairs, crying, "Daddy, you won't believe it! There are Borrowers, just like I said! They took the stuff! They took the stuff!" And she was transported with delight.

I figured that would be the end of it, but it wasn't.

IG: What happened next, Sara?

SW: I started writing to them. I started writing letters.

IG: Okay, why don't you pull out one of those letters and let's hear what you wrote for the first one.

SW: Okay.

IG: Now, you were six at the time?

SW: Seven. "Dear Borrowers, I have seen you, but I want to meet you. If I do, I will not tell anyone without your permission. Agreed or not agreed?"

LW: That note, on a little yellow Post-it, lay by the hole for several days, and for several mornings, Sara would be completely devastated that it had not been answered. So I went through several days of not knowing what to do, because she was getting more and more sad about this and more and

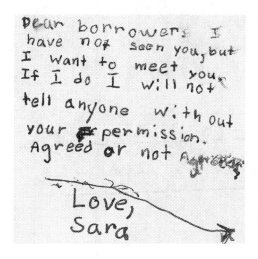

more concerned. So then I figured it wouldn't do any harm to pick up the piece of paper and write a little tiny message back. Which I did.

IG: Do you have that there as well?

SW: Yeah, it's on the back of the same piece of paper.

IG: Okay.

SW: "Dear Sara, Gosh, this is strange. Who are you? How do you know about Borrowers? I thought no human bean ever knew about us." (That's how Borrowers spell the word: "bean.") "My dad says it's too dangerous for Borrowers to meet a human bean, and he even says I mustn't write to you. But maybe at least I can write. Will you write back? I hope so. I'll keep it a secret from my dad. Signed, Annabellie. P.S. I am eleven. How about you?"

IG: And, do you remember getting this letter?

SW: Mmm-hmm.

LW: Do you remember what you said when you came up the stairs?

SW: No.

IG: What did she say?

LW: Oh, she was just over the moon: "I told you! I told you! She answered! And she wants me to write back!" And she wrote back immediately.

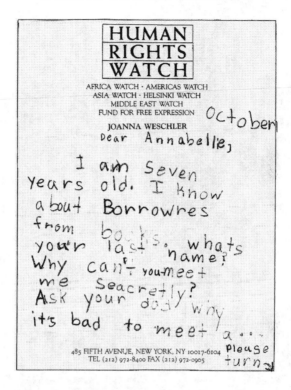

HUMAN RIGHTS WATCH

AFRICA WATCH · AMERICAS WATCH
ASIA WATCH · HELSINKI WATCH
MIDDLE EAST WATCH
FUND FOR FREE EXPRESSION

JOANNA WESCHLER

October

Dear Annabelle,

I am seven years old. I know about Borrowres from your last books, whats your name? Why can't you meet me seacretly? Ask your dad why its bad to meet a ... please turn

485 FIFTH AVENUE, NEW YORK, NY 10017-6104
TEL (212) 972-8400 FAX (212) 972-0905

SW: Yeah.

IG: So, Ren, did you conceive of your Borrowers as being descendants of the Borrowers in the book?

LW: Well, it was unclear. It was a possibility, and it was up to Sara to keep dredging and find out more. A large part of the correspondence is Sara doing genealogical work on the family and asking all kinds of questions.

SW: Yeah, I would ask, like, "What was your grandmother's name?" And it turned out that her grandmother was Arrietty, who was the main character in the book. And she said that she calls her dad "Pea," as in a "peapod," because in the book, the dad is Pod. And she calls her mom "Hommie," because in the book the mother is Homily.

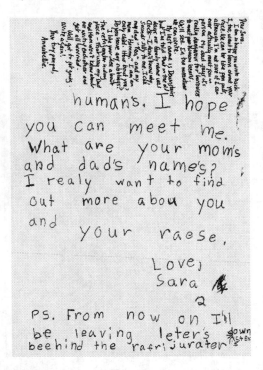

humans. I hope
you can meet me.
What are your mom's
and dad's names?
I realy want to find
out more abou you
and your raese,

Love,
Sara

2

PS. From now on I'll
be leaving leters down stars
beehind the rafrijurater

IG: How long did the letters go back and forth? How many letters were there?

SW: There were over seventeen. I didn't finish counting, but I counted up to seventeen.

LW: And there came to be a crisis in the midst of all this, which was that we were going to be moving to a new house about half a mile, three quarters of a mile away. And as the day drew closer, Sara was getting into a darker and darker mood and was really, again, growing almost desolate. One day she said, "Daddy, we can't move. What about the Borrowers? What's going to happen to them? I've been feeding them for weeks—they're going to starve to death! What are we going to do?"

SW: And so what we ended up doing was, my dad said, "Well, they can

move with us." And then, what I did was, I made a map of how to get to our house.

LW: Sara made this very elaborate map, and she said, "But they're not going to be able to do this all in one day." So what she did was, well, what did you do?

SW: There's this restaurant called Villa Nova in Pelham, and there's this kind of radiator thing on the outside. I don't know exactly what it is, but there's a hole there big enough for a Borrower to get through. And so I put some cloth in there to make it comfortable, and I told them in a letter that they could rest there, because they could probably make the first half of the trip during the first day. And then it was really close to Fifth Avenue, which is our busiest street in Pelham. So that when they had to cross Fifth Avenue to get to the other part of Pelham, they could do it in the middle of the night.

IG: Why would that be important?

SW: Because the cars wouldn't be going back and forth.

IG: Oh, of course.

LW: It was going to take them, like, an hour to get across the street.

SW: Not an hour: like fifteen minutes.

LW: Oh, excuse me. So suddenly the whole project of moving went from being a near disaster to being a delight. And every time we moved boxes over to the new house, Sara would run downstairs to see whether they had, in fact, brought some of their stuff over, too, because they had to do it in several trips, right?

SW: Yeah.

LW: And each time, it would turn out that they had brought some stuff over, right?

SW: Yeah.

LW: Parenthetically, it was fairly easy to know what they had, because it had all been in my pockets as I had been picking it up over the many months of the correspondence. I had a whole shoebox full of stuff that Sara had been leaving for the Borrowers, so I just kind of transported little sprinklings of it each time we moved some of our stuff over.

IG: And Ren, during this time, were you frightened about where this was all going to lead, that at some point you would get found out?

LW: Well, it was getting strange, and actually kind of nerve-racking. I kept on figuring that Sara was going to grow out of this, or that she would make the association that this was kind of like what we used to do when we would read about the Indian and Laura. I kept on thinking that she would just enjoy that, but she was getting more and more into it, and it was becoming more and more convoluted and involved. And the more involved, the more I could see how invested Sara was in it. I mean, it really was the main thing going on in her life during that season. And as she began telling friends about it and so forth, the stories had to get more and more elaborate to include all the stray bits of details that were seeping into things. I didn't quite know where it was going to go. I would send the Borrowers on vacations, I would have them suddenly disappear for a while, and I would hope that by the time, say, the vacation was over, Sara would have forgotten. But if I said they'd be gone for three weeks, three weeks later, on that day, there would be a note for them from Sara. I sent them into the woods—there was a little park nearby, and for them this was a huge national park, and there was a stream, and this was the equivalent of the Mississippi for them—and I would send them off, hoping that Sara would get over it, would move on.

IG: And Sara, did you suspect at that point?

SW: No.

LW: But what was really funny, Sara, is that you would say things sometimes, like, "Daddy, it's really weird, Annabellie uses the same kind of pen as you do." And then you would say, "Yeah, I guess she must have borrowed one of your pens." And one day, I heard her talking to her friend Megan, and she said, "Annabellie's handwriting is just like my dad's, only really tiny." She would say things like that, and yet not put it together.

SW: I really didn't. But the second I started to suspect it, then I was almost sure that it had been him, and I just went up and asked him if it was him.

IG: Why is it that you started to suspect? Do you remember what happened that made you suspect?

sw: I don't think it was the handwriting, actually. I think it was that I would tell my dad, for instance, that I was in the basement, and I stuck my finger into this hole and felt something sort of silky. It was probably just some old piece of cloth that was stuck there, but I felt it and it slipped away from my finger. And I told my dad about it, and then in the next letter, Annabellie would be saying, "Was that you who touched me when I was wearing my silk dress?" And so I started to think, you know, I tell my dad things—and sometimes I'd exaggerate a little bit, sometimes when I was younger, I would make things a little more exciting than they might have really been—and when I read the letter, it had that exaggerated part in it. So I'd say, "Well, that didn't really happen. I was just adding that to my story."

IG: That made you suspicious.

sw: Yeah, and I asked my dad—

LW: So what happened there was that—we had moved into our new house. We had been there for a couple of months at that point, and I was down in the basement moving some boxes around, and Sara came down there—

IG: How old was she at that point?

LW: She's eight at this point in the story. Her lower lip was trembling, and she looked at me very firmly, as she's quite capable of doing. And she said, "Daddy, I'm going to ask you a question now, and you have to tell the truth, because it's a sin for daddies to lie to their daughters." And my heart just sank. And she said, "Daddy, are you the one who's been writing Annabellie's notes?"

I looked at her, and she looked at me, and there was silence for five or six seconds. Then I said, "Umm, you know, it's kind of complicated." And she said, "Daddy, it's not complicated. It's simple. Are you the one?" And I said, "Can we talk about this later?" She said, "No, just tell me. Are you the one?" And I took a breath and said, "Yes, it is me." And she broke into—

sw: I was crying.

LW: Oh, god. She was sobbing. It was easily the most wrenching thing that had happened in my parenthood up to that point. I had totally

blown it. It was a total disaster. I was crying, and she was crying. And we were both kind of clutching each other and holding each other. We were really in a trap there; we were deep down the hole at that point. We were in big trouble. And suddenly this kind of calm came over Sara's face. It was kind of like the sun rising in the morning. Her forehead stopped being furrowed—it became smooth. And she said, "Daddy, don't you realize? You ruined everything! Because there *are* Borrowers, and you were taking the letters before they were able to get them!"

She had solved everything there, because, among other things, that was what she was going to be able to tell her friends and they could all chortle about what kind of a crazy father she had—

SW: [*laughs*]

LW: It was amazing. She found a way of getting us out of this disaster that I suppose I had fashioned for us.

SW: I remember saying, "You should have left it there. Maybe they would have actually written back to me, finally, at some point." Like I said earlier, I still believe in them. I know that might sound really babyish to some kids who might be listening to this, but I still believe in them. When I told Megan, my friend, that it had been my dad, she stopped believing in them. And from then on, whenever I would talk about it, she'd laugh at me and say, "Oh, Sara, stop being such a baby." She's a year older than me, and at that time, she still considered herself superior to me, even though we were best friends.

IG: Yeah.

SW: She said, "Sara, stop being a baby. It's not true." And I said, "But I've *seen* them!" And she said, "No, you haven't. You've just imagined it. It's not true. You should stop telling me about it, because it's not true."

LW: How do you feel about it now when you look at those letters?

SW: I don't know. Sometimes, when I read them, I still wonder why this happened to her, I wonder why that happened to her, I wonder why she would say that—even though I know it was my dad writing to me, I still sometimes think of there being an Annabellie somewhere out there.

LW: Last night, when we pulled out the box of letters, did it give you pleasure?

SW: Actually, I look at it a lot.

IG: You look at it a lot?

SW: Yeah.

IG: And what do you think when you look at it?

SW: Now, looking back, I think it was sort of nice of him to do, because I remember when it was happening, and after I had figured out that it was him, I asked him, "Well, can we still write to each other?" We never actually wrote to each other after that, but I just thought after a while that it was a nice thing, and that even though there was no Borrower writing to me, having my dad make up this whole family was maybe just as special. Or maybe it's almost as special as having actually been writing to a Borrower.

IG: Sara, can I ask you: What do you think the lesson of this story is? That is, if parents hear you and your dad tell this story on the radio, and if another parent gets into this kind of situation, what's your advice for them? Should they go along with it? Should they write letters and pick up stuff?

SW: I don't know, because it was really fun for me to have this kind of experience but when I found out that it was my dad writing, it was really upsetting. I don't know. If I were a parent, and I had that kind of thing, I would not pick it up.

IG: You would not?

SW: No. I would encourage my child to keep on writing to the Borrowers and to try to get them to write back, but I wouldn't pick it up.

LW: What if they keep coming to you *so* sad, every morning, the way you were sad coming to me, and just pleading, "I wish, I wish, I wish they would come." Can you imagine ever picking it up?

SW: No.

LW: Really?

SW: No, because I don't think it's fair to lead someone on like that.

IG: Ren, as far as you're concerned, what's the lesson of this story? If you

had this to do again, if you could go back with the benefit of hindsight, what would you do? Would you have left the letters?

LW: I'd like to say that, had I to live it over again, I wouldn't do it that way, but I'm not sure. It started so naturally; and in the end, by the way, what I'd have to say is that probably the most poignant, closest, amazing moment I've had, the moment I'll remember most vividly from a particular phase of my life, is the holding on to each other in the basement, both of us crying but Sara not running away, and Sara saving us. And that kind of cemented our relationship in a really kind of wonderful way. So I don't—

SW: It might not end that way for everybody.

LW: Yeah, it might not end that way for everybody, that's true. I continue to puzzle about it, and it is unresolved for me, as my answer is indicating, I suppose.

IG: It's interesting to me the way that you view the lesson of the story is that Sara saved the two of you. That as a parent, you got yourself into a moment where you literally didn't know what to do and that she finally said the thing that made everything okay.

LW: Yeah, I absolutely feel that. Has it affected our relationship, do you think, Sara? Do you not trust me in a way that you used to trust me?

SW: No. No, no. I still trust you.

IG: Do you view this as one of the moments when you were closest to your dad?

SW: Well, I'm very close with my dad, so I don't know. Yeah, I guess so, but it's not much closer than I am usually, because I'm very close to my dad, like, all the time. But yeah, it was one of the times when I was closest, I guess. Yeah.

LW: So my heart is in my throat [*laughs*].

IG: Hey Sara, if you still think they exist, have you tried to wait for them and spot them again?

SW: Well, I have seen . . . Well, I'm not sure, because I've seen them in the shadows. The only time I'm absolutely positive I saw one was downstairs in the basement of my old house. But I have seen them since. Sometimes I'll go and I'll sit on the steps and look around. Sometimes I'll be

making, let's say, a cake and I'll leave a little bit of dough wrapped in some paper by the staircase in the basement for them to take.

IG: Do they take it?

SW: Well, I don't know. I don't find it, but, then again, who knows what that might mean? It could be—

IG: Right, it could be bugs.

SW: A mouse . . . or a dad.

LW: A mouse or a dad [*laughs*]. This child is afflicted.

SW: [*laughs*]

IG: [*laughs*] The house is crawling with 'em.

[MUSIC]

IG: Lawrence Weschler is the author of *Mr. Wilson's Cabinet of Wonders* and *Calamities of Exile*. Sara Weschler just graduated from elementary school this week. When we spoke, she said that she would be listening to our radio program this weekend in the car.

SW: I don't want us to listen to it at the house because if there are still Borrowers in our house, I don't want them to hear this and think that they can't trust me, because right now I'm telling their whole story. I feel like I'm sort of betraying them. I just wanted to make sure that they knew that if I *actually* did meet one, I wouldn't tell anyone. I would never tell a single person in the world.

(1998)

WHY IS THE HUMAN ON EARTH?

{The following text originally appeared as an afterword to Michael Benson's collection of space-probe photographs, Beyond: Visions of the Interplanetary Probes *(2003). In that context, it served in part as a rebuttal to the book's preface by Arthur C. Clarke.}*

Pop quiz in seventh-grade English. The teacher has her class address a simple question in the form of an impromptu essay: What is the purpose of human existence on earth? And she gives the kids fifteen minutes.

She gets a variety of responses, and one of them, from an twelve-year-old girl (who, for the purposes of this essay, we will call my daughter, Sara), goes as follows:

WHY IS THE HUMAN ON EARTH?

I believe that there is, despite the fact that we humans have done so much damage to the world, a reason for our existance on this planet. I think we are here because the universe, with all it's wonder and balance and logic, needs to be marveled at, and we are the only species (to our knowledge) that has the ability to do so. We are the one species that does not simply except what is around us, but also asks why it is around us, and how it works. We are here because without us here to study it, the amazing complexity of the world would be wasted. And finally, we are here because the universe needs an entity to ask why it is here.

Which, I think you'll agree, is not at all bad, as such answers go. I mean, it took Kant three thick volumes to get to just about the same place. And the pertinence of such comments (any minor grammatical or ortho- graphic misprisions notwithstanding) to the portfolio of images collected in this volume could hardly be more manifest.

Wonder and balance and logic, indeed—to which one might add beauty and grace. But all of it—and this is Sara's crucial insight—all of it for naught (or at any rate for naught in terms of "wonder" and "balance" and "logic" and "beauty" and "grace") without the necessarily fragile and puny and utterly contingent human gaze.

The thing is, I think Arthur Clarke and the hearty band of futurists whose thinking he echoes in some of the notions he advances in the preface to this volume, get it all wrong. (Gloriously, thrillingly, even inspiringly wrong—but wrong nonetheless.) Not so much in the claim that "the probes that are the subject of this book . . . may well turn out to be our successors," with *Homo sapiens* giving way to *Machina sapiens* (carbon-based life, as I've heard the contention parsed elsewhere, giving way to its silicon-based successor). Could be. Hope not, but I don't know.

No, where Clarke & Company really go wrong is in a somewhat more subtle side claim. "Despite the evidence of these pictures, which surely must constitute some of the greatest landscape photographs ever seen, many," Clarke asserts (referring, I take it, to such Luddite Neanderthals as myself), "will refuse to grant any degree of intelligence or creativity to these robots. But the sooner we acknowledge this," he goes on, "the better. Even now we are developing machines that can learn from experience, profit from their mistakes and—unlike human beings—never repeat them." And then a few sentences further along, clarifying his evolutionary point (and cleverly preempting my first stumbling attempts at a riposte): "It is a little difficult to see how a lifeless planet could progress directly from metal ores and mineral deposits to electronic computers by its own unaided efforts. But though intelligence and creativity can arise only from

life, they may then learn to do without the fragile organic substrate that
they require." And that's where he loses me.

Granted: an entity capable of learning from experience and profiting
from its mistakes may be said to evince a kind of intelligence and maybe
even of creativity. But that sort of intelligence or creativity is not the fun-
damental bedrock of human consciousness. What about awe—surely the
overwhelming experience called forth in the merely human readers of this
book? We are here, in the words of my daughter, because without us here
to study it, the amazing complexity of the world would be wasted. And the
way that amazing, ravishing complexity is experienced among humans is
through the sense of awe—precisely the sense (and perhaps in the end, the
only one) that machines and probes may themselves never prove capable
of replicating.

Sartre, following in the footsteps of Heidegger and Husserl in his 1943
tome *Being and Nothingness,* famously parsed existence between the In-
Itself and the For-Itself, the In-Itself simply being everything, as it were,
that is—all material reality (the world, the oceans, the continents, all the
plants and animals, all the planets and stars, the vacuum between the stars,
all the atoms and the spaces between atoms, the brimming plenitude of
being, and yes, as part of all that, we ourselves in our mode of being as
material objects, subject to all the prods and pressures of material reality).
Of the In-Itself, it could be said that everything that is is the way a rock is a
rock: it just is. The For-Itself, by contrast, was Sartre's way of evoking the
notion of Consciousness: Being, to varying degrees aware of itself with
stirrings, longings, and so forth on its own behalf. Note that Sartre didn't
limit the notion of Consciousness to human beings—all consciousness,
however initially inchoate, partakes of the same existential reality, a reality
notably unlike that of a rock, a reality that never simply is what it is, that as
much as it may aspire to such a state of plenitude and satiety is continually
falling short and falling away. At various points in his argument, Sartre
seems to equate the In-Itself with the Being of his title and the For-Itself
with its Nothingness. And all existence For-Itself is by definition fragile,
mortal, utterly contingent (it never had to be here, it will inevitably pass

away): being, in that sense, hurtling (to varying degrees aware of such) toward death.

In these (admittedly oversimplified) terms, I would suggest that the primordial precondition for the experience of marvel or awe is that very "fragile organic substrate" which Clarke and his conceptual fellow travelers so cavalierly dismiss on their merry conceptual dash toward that *Machina sapiens* nirvana. The planets and the probes as such are alike in partaking exclusively of the domain of the In-Itself. For all its whirring gadgetry, a probe In-Itself is in the end precisely the way a rock is a rock, and nothing more. It can be directed to aim and focus and snap and transmit, it can even be directed over time to direct itself to aim and focus and snap and transmit all the more effectively, but it cannot be directed to experience awe. And awe—marvel, wonder—for surely such is the overriding lesson of the experience of this volume of images—these, in the end, are what matter; these, in the end, are what count.

The story goes that the incomparable Buckminster Fuller was asked one day, near the end of his life, whether he was finally disappointed, having done so much to bring about the era of space travel, that he himself would never be able to experience outer space. To which the old man magisterially replied, "But, Sir, we *are* in outer space."

The artist David Hockney, who's the one who first told me the Fuller story, went on that day to observe how he himself could never seem to get interested in space movies. "They always seem to be about transport and nothing else," he insisted. "Well, transport is not going to be able to take us to the edge of the universe—it's like relying on buses—though a certain awareness in our heads might."

Space probes as entities on their own soaring out there experiencing the universe in all its stupefying splendor? I suppose so: maybe. But in another sense (Hockney's sense), they're merely highly souped-up, hyperelaborated glasses: bifocals at the far end of seemingly endlessly elongating tethers. Interesting in and of themselves (and in fairness, of course,

far more than that: fascinating, astonishing; objects themselves of drop-jawed marvel and awe for the sophistication of their workings, and maybe even more so, the sheer audacity of their conception)—but in the end, simply extensions of something far more astonishing: the fragile human capacity—nay, propensity—to gaze and marvel.

Such that a volume like this current one affords a veritable layer cake of wonder. The splendor of the heavenly bodies themselves, of course. Why is there anything, ask the philosophers, with their very first originary question, rather than simply just nothing at all? To which might now be added: and why—however possibly could there be—anything as stupendously, improbably, and heartrendingly lovely as this? But that last formulation in turn opens out upon a greater wonder still, the shivering, shimmering ghost at the heart of the great machine: given that there is something rather than nothing, how does it come to be (after all, how easily could it never have come to be!) (and how terrifyingly easily could it all yet cease to be) that embedded in its midst there is something capable of becoming aware of, let alone appreciating, all that splendor?

And the fragility, the sheer puny contingency of that second something, as against the vast plodding immensity of the first—the infinite algebra of that relation—that (and here I find myself coming into humble agreement with my little daughter) is the wondrous cosmic chord that keeps getting sounded across the pages of this marvelous volume.

(2003)

A FATHERS AND DAUGHTERS
CONVERGENCE:

Occasioned by Some Portraits by Tina Barney

About three years ago, on an art walk through SoHo, in a gallery off Broadway, I happened upon a large-scale color-saturated photograph that stopped me cold: Tina Barney's double portrait of what were clearly a father and his late-teenaged daughter, staring head-on into the camera. It stopped me cold, and immediately I started to warm to it. As it happened, this was the photo that was featured on the show's announcement postcard, so I was able to take that version of it home with me: I push-pinned it to the wall facing my desk and have, in the months and years since, had frequent occasion to lose myself into it.

Back in college, years ago, I'd had a girlfriend who looked remarkably like the girl in Barney's picture—and who'd look at me in a remarkably similar manner: self-assured, ironical, a drowsy-lidded gaze freighted with entendres and double-entendres. Occasionally we'd go up to visit her parents in San Francisco. I could be wrong, but something about the light and the furnishings makes me sure the bedroom in Barney's photo is also in San Francisco. Anyway, my girlfriend's parents were of a certain class—comfortable haute-bourgeoisie, which is to say a situation slightly higher than my own family's—and every once in a while, she and her father would get themselves lined up, facing me, just like the pair in the photo: she'd be giving me that ironically freighted look, and her father, in turn, who looked remarkably like the guy in the photo, would also be giving me

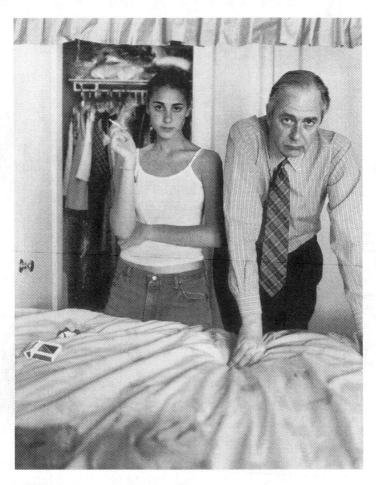

a look just like his: wary, somewhere between begrudged and resigned. Between the two of them, they had me nailed.

And years later, as, daydreamingly, I continued gazing back into the father and daughter in Barney's double portrait over my desk, they still had me nailed: I was back in college, it was as if I hadn't grown a day, I was

still that slightly gawky and yet increasingly assured kid, right on the cusp, eternally on the cusp.

Do any of us ever grow up?

Anyway, as I say, that photo has been staring at me from across my desk for years now, slowly becoming festooned over with other cards and photos and announcements, but still pertinent, still sweetly charged, still capable of drawing me in in the midst of my otherwise busy days.

Days full of this and that, my writing work, my own family responsibilities, and this past year, increasingly, caring for Herb, the dear old man across the street, a ninety-eight-year-old geezer who until just recently had been wry and spry and sharp and funny and astonishingly nimble, an ongoing inspiration to everyone in the neighborhood, including me and my wife and our little daughter. Late some nights—say, three in the morning—our entire block would be dark save for two lights: me in my office, writing away at my desk, and Herb across the street in his front parlor, hunched over, his glasses pushed up onto his bald pate, gazing down, intently reading by the light of a single bulb. I knew that some months hence, when whatever piece I happened to be working on got published, Herb would read it and have me over to kibbitz about it: he'd be my best reader, and I was writing for him.

Though, it has to be said, over the last several months Herb had suddenly started declining precipitously, and—it was tough to face but clearly true: he no longer sat there at night in the front parlor in that puddle of light, reading away. He was largely confined to his bed, which had been moved down into his living room because he could no longer make it up the stairs. A dear, spirited Trinidadian woman named Marjorie had moved into the house to care for him full-time. Herb was on his last legs. He no longer wanted to live: in considerable chronic pain and discomfort, all he wanted anymore was to be let to die.

Very early one morning a few months back, around four—it happened

to be my birthday—I was startled awake by the phone. It was Marjorie, calling to tell me that Herb had just "breathed his last" and asking if I could come over to sit with her, she really didn't want to be alone with the body. My wife happened to be away, traveling, so after I got dressed, I went into my now-thirteen-year-old daughter's room to wake her and tell her what had happened. Sara took it pretty hard: she'd adored Herb, too. I told her where I'd be, how she should go back to sleep but if she wanted she could just look out her window and she'd be able to see me there across the street. I'd keep checking, I said, in any case.

And the morning proceeded like that: sitting by Herb's side, making the necessary calls, commiserating with Marjorie, occasionally peering through the window across the street to check on Sara (she was standing there, framed in her bedroom window, somber, intent, unmoving the entire time). Eventually the sun rose, the police arrived, then the coroners, and I headed back across the street to get Sara ready for school.

Sara came downstairs to greet me: she'd obviously been thinking. "Daddy," she said thoughtfully, "do you realize that Herb died on the very day that you became half his age? And that, for that matter, even though today is the thirteenth and I myself happen to be thirteen, in two days it will be seven days until I become exactly two-sevenths your age. Which is weird because at that point I will be two-times-seven and you are seven-squared and Herb was two-times-seven-squared, which of course also means that I will have become one seventh of Herb's age. And what's really weird, if you think about it"—clearly she'd been dwelling on all this; up there in the window her mind had been racing—"half of seven is 3.5 and you are going to be 3.5 times as old as me, or phrased differently, thirty-five years older than me."

I looked at her for a few long seconds and finally said, "Sara, get a life."

That evening I was back at my desk, working, when I happened to gaze up at the Barney photo. It had undergone a sudden transformation. Wait a second, I found myself thinking, I'm not the one the father and the girl are

looking at—*I'm the father!* That's me, or almost: that's what I'm fast becoming. It was a startling, almost vertiginous shift in vantage.

A few weeks later, during a trip to Chicago, I wandered into another gallery that happened to be staging a Tina Barney retrospective. I got to talking with the gallery owner, described the picture over my desk, and she said, yes, of course, she knew it, and in fact she happened to have a couple earlier pictures from the same series.

"The same series?" I asked.

Oh yes, she said, leading me into her storage vault and riffling among the framed images. Barney photographed the same father and daughter at least three times. Once when the girl was maybe ten or so—this one here (and indeed, there they were, draped on the same bed: the girl roughly the age my own daughter had been the day I happened on the later image at that SoHo gallery)—and then another time, about three years after that, when the girl was thirteen or fourteen: this one . . . here. And indeed, there they were again, the same bedroom, the girl exactly my daughter's age: with exactly her haughty, put-upon self-assurance ("Daaa-aaadie"). The gallery owner then pulled out a Barney book and turned to the last image in the series, the one over my desk. And yes, there they were again, same father, same girl.

Ten years: God, he had aged.

(2002)

MY GRANDFATHER'S
PASSOVER CANTATA

My grandfather, the composer Ernst Toch, had just turned fifty and was in the second year of his Southern California exile, in December 1937, when he received word of the death of his beloved mother, owing to "natural causes," back in his hometown of Vienna. Over those fifty years, as he'd risen to the forefront of the modernist Neue Musik movement in Weimar Germany, he had fallen somewhat away from his own Jewish roots, but in deference to her Orthodoxy, he now sought out the solace of a local synagogue where he could partake in the recitation of the Kaddish, the solemn Hebrew prayer for the dead.

While there, he happened to encounter the eminent local rabbi. Jacob Sonderling (himself likewise of German origin, but veteran of a much earlier emigration), and the two of them got to talking about a fitting and worthy memorial gesture. For some years, Toch told Sonderling, he had been recalling the gemütlich family Passover gatherings of his youth, and he'd recently taken to contemplating the service as possible source material for an oratorio. Rabbi Sonderling enthusiastically endorsed the idea and promised the complete support of his temple in mounting a full-scale production that upcoming Passover. Toch averred that he was entirely unqualified to craft an appropriate text. So Sonderling (presently joined by their mutual friend, the great Weimar émigré theater director and celebrated Hebraicist, Leopold Jessner) poured himself into that task, and Toch set himself to crafting the music.

There could hardly have been a more charged moment in which to be doing so. As Toch and Sonderling labored over their account of the lib-

eration of the ancient Jews from the bondage of the wicked Pharaoh's tyranny, the news out of Europe was itself growing bleaker by the hour. The very week that Toch turned to perhaps the most hauntingly poignant and lyrical passage in the entire piece—that tenor solo derived from Psalm 126, "When Adonai brought back his sons to Zion, it would be like a dream"—word came of the Anschluss, with Hitler's storm troopers triumphantly goose-stepping their way into his achingly beloved Vienna, sealing the nightmare prospect for thousands upon thousands of the city's Jews, including dozens of Toch's own relatives and cousins, newly trapped there behind enemy lines.

For all the urgent immediacy of the piece's composition, however, Toch never conceived of his *Cantata of the Bitter Herbs* as a narrowly Jewish piece. Rather he recognized in the fate of those ancient Jews a universal theme—the yearnings for freedom and liberation experienced by oppressed peoples everywhere. (In this, he was not that unlike his new friend George Gershwin, who just two years earlier had recast similar longtime "Jewish" themes of longing for liberation from oppression and discrimination through the prism of his masterpiece, *Porgy and Bess*.) In an effort to render such convictions all the more universally accessible, in this instance Toch consciously bent his musical idiom to a more tonal range (a range, that is, more in keeping with his newfound Hollywood style).

That Passover, Rabbi Sonderling indeed marshaled an impressive array of forces, including master players from the Paramount studio orchestra under the direction of producer Boris Morros, for the premiere of the Toch Cantata at the Fairfax Synagogue. In addition to the piece's many other elements, it required a children's choir, and there, prominently in the first row was Toch's only child, his daughter Franzi—his recently deceased mother's granddaughter, and the girl who would in turn become my own mother—age eight.

Fifty years following the death of my grandfather's mother, my wife gave birth to his first great-grandchild, our daughter Sara. A year later, my

פ"נ

ירדה לעמק הוד הפארתינו
הו"ו .גזוקר ונגלה נזר ראשינו
סלה הליץ זכותו ב'עד מבעליו
פרש כפיו לינו ולאביון ידיו
הה איש ההלך פורח הי'אל
כל ובי' עסק באמונה מוה וסף
המנוח מוה יצחק הכהן ז"ל
נפטר ונגדה אב עיות תרל"ק
ה.ב.צ.נ.ת

mother (her grandmother) was killed in a pedestrian accident (during the painful days that she lingered on in a coma, Sara was first learning to walk, and one had the uncanny sense of a spirit leapfrogging the generations).

Several years after that, when Sara was eight, we happened to be traipsing through an abandoned and overgrown Jewish cemetery in a lush forest in rural Poland, contemplating the tossed and tumbled ancient headstones, evidence of a once vibrant presence, now palpably absent.

The tombstones featured all sorts of weathered carvings—vases, candles, menorahs, and, most mysteriously, pairs of outstretched hands, their fingers peculiarly spread in a V-formation, the thumb and two adjacent fingers to one side, the pinky and its neighbor to the other.

"Why," my eight-year-old Sara wondered, quite sensibly, "are they all saying 'Live long and prosper'?"

A few months later, while preparing a Talk of the Town piece for *The New Yorker* around the theme of KCRW's recent *Jewish Short Stories* radio series, I got a chance to interview that series's host and moderator, the actor Leonard Nimoy, author, in addition, of *I Am Spock,* a recent memoir of his experiences on the *Star Trek* television series. I mentioned my daughter's query to him and he burst out laughing, for as it turned out, he now told me, she had gotten it "exactly right."

As he had been preparing the Spock character in the early days of the series, Nimoy, who had been raised in Orthodox Jewish surroundings in Boston's West End, had thought of the eternally exiled Vulcan as a sort of cosmically Wandering Jew cast among that otherwise homogeneous crew. Called upon to invent a ritualized greeting gesture for his Vulcan alter ego, Nimoy related how he suddenly recalled one of the most charged moments of the services at his local synagogue when he was a child: how the Kohanim, the representatives of the priestly tribe, approached the raised stage and formed a semicircle, their large shawls draped over their extended arms, and their fingers outspread in that four-fingered-V configuration.

"It was a very loaded moment," Nimoy explained. "You weren't supposed to look as they began chanting, for it was said that at that moment the Shekinah, the holy presence of God, entered the sanctuary, and that

this spirit was so powerful, so beautiful, that if you saw it you'd die. Being an eight-year-old, of course, I peeked, and the sheer theatricality of the occasion indeed made a lasting impression, one that I subsequently summoned forth in creating that 'Live long and prosper' gesture."

I recorded this little morsel of exegesis in that Talk story, entitled "Oy, Spock," a few weeks later, and frankly, as the years passed, allowed the revelation to recede from my memory. Till just the other day. . . .

. . . when I received word that Noleen Green and the L.A. Jewish Symphony were going to be reviving the *Cantata* at one of their concerts. They asked me if I had any ideas for a possible narrator. And I remembered my conversation with Leonard Nimoy. I called him to ask whether he'd be willing. Graciously, he agreed.

And there you have it: Strange. Weird. I myself have just turned fifty— the very age Toch was when he undertook the work's poignant challenge. And this Sunday, I will be attending the concert at the Symphony's regular digs at the Beverly Hills High School Auditorium, accompanied by my own daughter, granddaughter of that little girl who sang in the very first row of that very first concert.

(2002)

THREE L.A. PIECES

An L.A. High School Youth:
Robert Irwin

The L.A. Quake

The Light of L.A.

AN L.A. HIGH SCHOOL YOUTH:
ROBERT IRWIN

And then when I came back"—the artist Robert Irwin was recalling some time he'd spent in Japan about ten years ago, in the early seventies—"I'd taken one of those seventeen-hour flights from the Orient which really wipe you out. Anyway, I got home about midnight and went immediately to bed, thinking I'd probably sleep for two days. But I was so jazzed and hyper that I couldn't fall asleep. So I got in my car and put the top back and put my tape deck on and was just driving along in the middle of nowhere. Actually I first went over to Fatburger and bought a Coke from Jay, and then I set out cruising the freeways. I was driving over Mulholland Pass on the San Diego freeway, you know, middle of nowhere at about two o'clock in the morning, when I just got like these waves—literally, I mean I never had a feeling quite like it—just waves of well-being. Just tingling. It's like I really knew who I was, who I am. Not that you can't change it or whatever. But that's who I am: that's my pleasure and that's my place in life. To ride around in a car in Los Angeles has become like one of my great pleasures. I'd almost rather be doing that than anything else I can think of."

Robert Irwin and I were sitting outside Mè & Mè, talking about him and his life. Mè & Mè is a falafel stand in the middle of the busiest section of Westwood, a fairly new stand, which means it has a fairly new Coke machine, which means it gives slightly better cola than some of its more established competitors. When they were new, Irwin used to frequent them—as it happened, the Coke fountain here was a bit past its prime, and for some days now Irwin had been restless (or as restless as he lets himself get), on the lookout for a new stand.

"In terms of just day-to-day life," he was continuing, "basically I can have a terrific time doing nothing. I'm quite at ease, and always on the plus side. I can come down here and sit on the corner, and, I mean, nothing's happening where I could say I'm having a hilarious time, but I'm feeling real good and the world's fine.

"I don't know how to explain it exactly. I guess I'm as confused by other people's insecurity as they are by my security. And my security is probably no more substantiated than their insecurity!"

Irwin is in his early fifties, but he gives the appearance of someone considerably younger, perhaps because he has something of a baby face—or, more precisely, a baby head, for his head is strikingly large, with soft, benevolent features, and sits perched atop a comparatively thin neck, which in turn opens out onto a solid, almost hefty frame. There is a touch of elfin mischievousness in the delight that is usually transporting him, even in his serious moods. His forehead is high and broad, his hair thinning on top and graying to the sides. His body is still in very good shape; he downs a fistful of vitamins every morning and ritually jogs five miles in the afternoon.

I asked him if he had any notion what that sense of well-being grew out of, and without hesitation he replied, "High school. Or more generally, just the experience of growing up in southwest Los Angeles, which was a fairly unique experience—obviously turns out it must have been a *very* unique experience, because it produced a fairly interesting, rich activity. All of us at Ferus grew up basically with that same background." (He was referring to the extraordinary group of artists who ranged themselves around L.A.'s funky, pioneering, avant-garde Ferus Gallery during the late fifties and the early sixties.) "For example, conversation was a continually running sarcasm; you never gave anybody a straight answer. You played games all the time, and where that comes from, I don't know. But, man, I can talk to somebody in Michigan, and I can spot a Southern California person— West L.A. especially—in Europe or anywhere; I can spot them a mile away. We start a conversation, and it's like I've been talking to this person all my life, and I've never met him! There was just a whole freewheeling attitude

about the world, very footloose, and everybody in southwest Los Angeles had it. From the time you were fifteen, you were just an independent operator, and the world was your oyster. Maybe you didn't have that much, but the world was just always on the upside. And that's what that script is about, or at least I hope it's in there. It was just really a rich place to grow up."

For the past several years, Irwin has been living with Joan Tewkesbury, the celebrated scenarist whose credits include screenplays for Robert Altman's *Nashville* and *Thieves Like Us*. Partly at her instigation, Irwin composed *The Green and the White*, an unproduced screenplay about life at Los Angeles's Dorsey High School during the early forties (the school's team colors account for the title). This wistful memoir abounds with boisterous characters—Spider, Cannonball, Cat, Mole, Blinky, and others—but the protagonist, Eddie Black ("his hair in a pompadour with a slight duck tail"), is none other than Irwin himself. The screenplay's tone is raucously vital throughout, the incessant banter somehow simultaneously glib and heartfelt.

I asked Irwin if he'd be willing to take me on a drive around his old haunts, and he said, "Sure." The sun was shining, a warm breeze rustling through the high palm stalks—a perfect afternoon for a drive. We dispensed with our Cokes and headed back toward his house.

As we were walking the few blocks back into the Westwood hills, out of the bookshop–record store–and–movie house glut of the village, past fraternities and densely packed student apartments, then turning right onto a slightly less frantic side street, Irwin continued speculating on his L.A. youth. "I mean, people talk about growing up Jewish in Brooklyn, know what I mean? And they always dwell on the dark side. I hear all of that, and I grant that it makes for good drama, makes good writing, and it makes good intellects, in a sense. Well, apparently this made for good artists, 'cause we didn't have nothing to do with all of that—no dark side, none of that struggle—everything was just a flow."

We just flowed into his carport and climbed into his car, a sleek, silver 1973 Cadillac Coupe de Ville, one of the few luxuries he allows himself

within an otherwise Spartan lifestyle. In one fluid motion, he selected a cassette from the box on the floor, popped it into the tape deck (Benny Goodman filled the car's interior), slid back the sunroof, slipped the key into the ignition, and the car out of the driveway, and eased us into the midafternoon surge of L.A. traffic.

A few moments later, we were barreling down the San Diego freeway, southbound, toward one of those amorphous, undifferentiated communities that make up the mid–Los Angeles sprawl—not really a suburb, but not the central city either; not really poor, but by no means well-to-do. Bob spent his adolescence on the southeastern edge of Baldwin Hills, just north of Inglewood. (If you were to draw a line between the Hollywood Park Race Track to the south and the present site of the Los Angeles County Museum of Art to the north, Leimert Park, one of the main staging areas of Bob's youth, would constitute the midpoint.)

"I don't remember particularly much about my early childhood," Irwin was saying, "but it was never sad that I can think of. Kind of floating and suspended, maybe, but that's something I still do. The high school period I remember very well, however, and it was an unmitigated joy, even though it was in some ways minimal, because of my parents not having any money or anything. I had a job and worked the entire time, made all my own money. From the time I was very young, my mother had a lot to say about that sort of independence, which was nice for me. At age seven, I was selling *Liberty* magazine door to door, and within a few years I won this little award for being the magazine's top salesman in the county. To this day I'm a sucker for any kid along the street hawking flowers or newspapers or a shine. I had jobs in a movie theater, in coffee shops, at garages. During the summer I'd lifeguard up at Arrowhead or out on Catalina. All those jobs involved a lot of action, a lot of involvement. They were really part of my pleasure. And they were very important, because they gave me total independence from very early on. I never had to ask my parents for anything, and they never in a sense really stopped me from doing anything. They were real open to me in that sense."

As we threaded in and out of traffic, the warm air swirling about us, I flipped through the box of cassettes: Stan Kenton, Artie Shaw, Bing Crosby, Frank Sinatra, Count Basie, Al Hibbler, and Erskine Hawkins. "*That* of course was also a big part of those years," Bob volunteered, anticipating my question, "the incredible music and the dancing. In fact, dancing even became an important part of my financial picture.

"At first, when I was thirteen or so, I just had no sense of rhythm at all. But I taught myself to dance by using the doorknob in the living room as my partner, and I got to be a pretty good dancer, good enough so that I could contest-dance. For a period I was entering contests almost every night of the week. There was a whole circuit: Monday was the Jungle Club in Inglewood, Tuesday was the Dollhouse out in the Valley, Wednesday was in Compton, Thursday in Torrance, Friday in Huntington Park.

"You contest-danced with a partner, of course. So you always had one regular partner and a few maybe that you were building up. Because a good partner was crucial: she could make or break you. Interestingly, you weren't usually romantically involved with your dance partner. That was the thing about dancers, especially in terms of sex: got it all out dancing, that was their whole gig. It was just such a goddamned pleasure.

"Everybody at the school I went to, Dorsey, everybody was really into dancing. We used to dance at lunchtime and then after school. The big step at the time was called the Lindy, which was kind of like the New Yorker, only smoother. The key movement was the shoulder twist, where the girl came directly at you and then you spun each other around and she went on out. When you got it going real smooth, you could literally get to the point where you were almost floating off the ground, acting as counter-weights for each other. It was absolutely like flying, just a natural high.

"At these contests there were maybe a half dozen regular couples who made the circuit, and they'd alternate winning, depending on who the judges were. You'd come out one couple at a time. You'd sort of be standing to the side, and they'd say, 'The next couple is Bob Irwin and Ginger Snap,' or whatever, and you'd take her and throw her in the air, she'd come down,

you'd come boogying out on the side, and then you'd start your routine. And you could make a lot of money doing that. At my peak, I was bringing in upwards of a hundred a week!"

About ten minutes out of Westwood, we swung off the freeway onto Slauson, a wide boulevard that skirts the southern flank of the Baldwin Hills, and proceeded east about two miles.

"By the way, this here was the big drive-in," Bob indicated, turning off Slauson onto Overhill and then pulling into a parking lot. "Used to be called the Wich Stand—still is, I guess." In the broad daylight, the pink thrusting roof, the jagged stone pillars, the dusty palm trees flanking a garish, orange Union 76 signpost in the distance, the virtually empty asphalt lot: it seemed the most commonplace of Los Angeles vistas. But years ago, this had been the hub of teenage nightlife in the region. *The Green and the White* offers a vivid evocation: "A round drive-in set in the center with cars parked three and four deep radial around it: the show and pussy wagons with a few family irons. There is a parking area to the side where the more radical looking rods are neatly parked side by side with walk-around space. A lot of boys stand around eyeballing."

We negotiated a lazy arc around the lot, and just as we were about to ease back onto Overhill, Bob pointed toward one corner of the drive-in and commented offhandedly, "Over there's where I almost got shot once." He paused for effect.

"Yeah, I used to come over here after work most nights when I was working at one of the nearby garages. I'd come over for fries and a Coke, and . . . By the way, this used to be the race-strip right along here." (We were heading south on a wide stretch of Overhill, which indeed was beginning to take a decided downhill dip.) "For a while anyway, that is, until the cops succeeded in stopping us. That signal wasn't there.

"Anyway, I used to go there after work, all greasy and everything, and this real pretty girl started working there. Pretty soon I noticed that she was taking my car every time, and she started playing jokes, like putting roses on my tray, that kind of stuff. So we started having a kind of dialogue. I asked a couple of other drive-in ladies what the story was, and they said

she'd just gotten married, so I didn't make a run on her or anything. But one night she asked if I'd take her home, so I said okay. Had to wait till she got off at two a.m. and then drive her all the way out to Gardena, so I was kind of regretting it. But then she invited me to come in and—all this time I wasn't really thinking. But I went in, and the point is that we began to have this casual love affair. She was sensational, so all that was very great. She told me her husband was a real bad-ass and so forth and that they were getting divorced. He was a bandleader.

"Anyway, so one night I'm sitting in the drive-in with a friend of mine, and she comes up to the car and says, 'Don't say anything, my husband's in the very next car.'

"This, by the way, is Verdun, the street on which I lived in high school, and this here was my house—6221." We'd veered off Overhill down a very steep Sixty-third Street a few hundred yards to the corner of Verdun. The modest stucco house, slightly smaller than its neighbors, was perched atop a slight hill, the carport level with the street, the living room above it, a brick stair path leading up from the driveway to the front porch. The street was lined with trees, and we parked in the shade. Bob killed the engine— and Benny Goodman. "That window on the right was my bedroom. This house was one my parents got. I mean, my mother was the instigator of getting it. That was late in the Depression, so it was a big stretch for them. Boy, it took every cent they had. They had to get $600 together for the down payment. But they made it, and then they lived here for a long time, only moved out about ten years back.

"But anyway, so this guy got out of his car, and he comes over to my car, and he says, 'I know everything. My wife told me everything,' and blah blah blah. I felt like a rat. 'I love her,' he says, and blah blah blah. I said, 'Listen, you know, I'll stay out of it,' because I never wanted to get involved in that sense anyway. So he said, 'God bless you,' which really made me nervous, because those kind of guys are very weird. So that was the end of that, I thought.

"Then I came in the drive-in one night like three months later, and there he was. He comes up to the car—he was real pissed off, just

enraged—and he says that he wants to talk to me. So we walked over to the back of the drive-in, where I showed you. He pulls out a gun and sticks it right up against my forehead and hisses, 'You made her go down on you. She told me how you made her do it.' His eyes were bulging. All I said was, 'I never *made* her do anything.'

"By the way, that slope there was all ivy instead of lawn the way it is now. That was the bane of my existence, having to weed the ivy.

"Anyway, so he was shaking, nervous, sweating, and when I said that I never made her do anything, he broke down and started crying. He was leaning on my shoulder. At the time I didn't get scared, because I guess you just don't have time to put it all together. But he'd had four of Babe Pillsbury's boys in the backseat of that car with him. What he was originally going to do was just pull me off the side of the road and have them stomp me, which they could have done very well, because they were real bad-ass motherfuckers. But anyway, instead he broke down crying and everything, you know, 'God bless you' and all that again, and then he split. A few minutes afterwards I really got shook up, because he really had the gun and he had been dead serious thinking about using it. I mean, he really was shaking and all upset, and those kind of guys can do that sort of thing. So, anyway, that was a bizarre side tale."

He started up the engine again, Benny Goodman resurged, and we rolled out of the shade. We began climbing back toward Slauson, and the neighborhood steadily improved. "Over there's where I used to catch the bus before I had any car. See, our school was kind of schizophrenic. We were like 35 percent black; the blacks lived down in the flatlands, where we're heading now, and they had no money. (By the way, John Altoon, who later became one of the top Ferus artists, he lived down there, too, and also went to Dorsey, just a little bit ahead of me.) Then there were the kids who lived in the hills, and they had some money, although this was still the Depression and nobody had much. But back there where I was living was 'over the hill,' so I always looked like I was coming from the hills, but actually I was from the other side of the tracks, too. I mean, one block further out and we'd have been in Inglewood.

"By the way, the whole stretch here we're driving now"—we had crossed Slauson and were continuing northeast on Angeles Vista, a wide, but lightly traveled thoroughfare flanked on either side by residential streets lined with incongruously tall palms—"this was the distance I'd run home each night after closing up the theater, where I was usher and then assistant manager. It was about a two-, three-mile run each night, leaving there at about one a.m. when the buses had ceased running and traffic was too light to hitchhike. The job was a pleasure, the run was wonderfully invigorating, and the next morning I always had to be up early for school."

I asked Bob about race relations at Dorsey High. "Well, maybe I'm a bad source for that, because, like the black thing, the feminist thing, those were just never issues with me. I never thought of women as being different or blacks as being lesser.

"For instance, girls. I used to chase girls—radically: every night was chasing girls. When I worked in the theater, I always had a girl stashed in the back row all the time I was an usher there. A girl was involved with everything I did. But I used to be amazed: I'd sit down with some of the guys, who were all doing this, just chasing anything that moved, and they'd all be talking about marrying virgins. I'd never particularly thought about it, but even at that time—I was fifteen, sixteen—I remember thinking, that's weird. They were going to marry virgins, and the chicks they were balling were all whores. I never thought like that. When a girl turned on to me, I never thought less of her, I always thought she was terrific, that she was doing something special for me. I mean, their attitude made no sense to me, it was just bare-ass backwards. For starters, it was self-defeating, because if you knock all the girls that put out, then if a chick's smart at all she don't put out. Any girls with any brains just don't put out to that kind of guy."

From the hills we had eased down to the flatlands and into the town center. We passed a skinny wedge of a park—crabgrass, restrooms, asphalt, a dry fountain—across from which loomed an old art deco–style movie house, now recast as a Jehovah's Witnesses Assembly Hall. The letters W-A-T-C-H-T-O-W-E-R streamed down its ornate tower.

"So this here's Leimert Park," Bob continued, "and it was kind of the center of our social life, this and the drive-in. Here's the theater I worked at for several years. Next door there was a little restaurant called Tip's, and I'd work there occasionally, too. That parking lot back there, which they shared, is where me and my buddies used to siphon gas out of unsuspecting vehicles. We'd take out the garbage and shift the hoses and canisters. They were of course rationing in those days."

This was the first time the war had impinged on Bob's recollections. I wondered whether it had had any more significance for him at the time.

"Oh, no," Bob responded immediately. "We were just oblivious. We conducted ourselves like the war wasn't on in any way. Not having gas and all that was simply a challenge. I didn't have any older brothers, and come to think of it, none of my friends in that group did either. Maybe that was part of it. But basically we didn't pay any attention."

I asked him if the obliviousness of the local youth had bothered the older members of the community, whether he and his friends were criticized as irresponsible.

"I don't know. I mean, if I was oblivious to the war, I was certainly oblivious to any criticism!"

Irwin was thirteen at the time of the Japanese attack on Pearl Harbor, just graduating from high school as the war ended. I asked him where he had been December 7, 1941.

"I don't know," he replied.

I asked him about the day the war ended.

"Haven't the slightest idea."

Hiroshima?

"Nope. *Hiroshima Mon Amour* was the story of a fairy tale."

I wondered if part of the reason he and his friends were having such a fiercely good time was because they all realized they were presently going to be shuttled off to the war.

"Oh, no." Bob dismissed the notion with a sweep of his hand. "Look. Look at it here. Look at how it is: calm, sunny, the palm trees. What is there to get all fucking upset about?" He laughed. "This is reality. In other words,

the war was not reality. The war wasn't here. The war was someplace else. So any ideas you had about the war were all things you manufactured in your head from newspapers and that. To me, this was reality; this was my reality right here."

We had in the meantime swung out of the shopping district and were cruising along a pleasant residential street on our way back toward Baldwin Hills. "Right there is where one of my favorite girlfriends lived." He pointed, and then paused. "She was the champion. World Champion. She would get so knocked out, she would literally . . . I could hardly get her out of the car afterwards; she would be absolutely unable to walk. That was my introduction: she was my first real major sexual experience. So what I got was this total fantasy of what it was like, because she would literally pass out cold right in the middle of it. We'd be lying there in the backseat, and she'd be out, like *bang!*"

How old were they?

"Sixteen. *Bang!* I mean, just out cold. No other girl has ever passed out on me since, you know. I used to have to walk her. . . . I'd park over in this alley and walk her up and down the block just to get her legs going so that she could walk into the house!"

Was that where one generally made out, in cars?

"Sure. The car was the key, the pivotal item in the whole ball game. Everything was wrapped around the car. The car was your home away from home. And you put months and months into getting it just right. Everything was thought out in terms of who you were, how you saw yourself, what your identity was."

I asked him how his cars expressed his self, as opposed to how others expressed their owners.

"Well, first of all," he began, "there were three, maybe four categories. One was like 'go.' You built the thing—like the Cat and the Mole, they built things that were just rat-assed, but, boy, they went like a son of a bitch. The body could be almost falling off, you'd be sitting in an egg crate, but everything was in the engine, and *that* was very sanitary. Then there was 'go-and-show,' which was like a car that went real good but wasn't necessarily

going to be in a class with the Cat and the Mole, but it would look fine. It was a question of taking a car that was a classic model and then just doing the few right things with it to accentuate why it was a classic model, building it up to absolutely cherry condition. Then there was 'show,' and then there were like 'pussy wagons,' which were strictly kind of like Chicano cars are now: lowered way down, everything exaggerated, blue lights under the fenders, Angora socks bobbing in the window, seats that tilt back, all that sort of bad taste, which has now achieved almost the level of a profession.

"Well, I was category two, go-and-show. Sort of a little bit of both. I mean, the car had to be real good, because it had to have an edge on it, but on the other hand, it had much more to do with its being an absolute classic model, with everything set up just right. I had a very hard time getting one in that condition, because they cost a lot of money, but that was my ambition."

How many cars had he worked his way through as an adolescent?

"Oh, not that many; about half a dozen. A little '32 roadster, a '34 five-window coupe . . . The first car I wanted was a '32 B roadster. It was Fred Gledhill's car, and he was selling it. I didn't have enough money, and that was the only time I ever asked my father for some money. I asked him for $100, just as a loan, so I could make the down. And he wouldn't or couldn't loan it to me, I don't know which. That was the biggest disappointment of my life up till that point. It may be till this day the biggest disappointment. I don't think I ever had a bigger one. I mean, we won the war and what have you. . . ."

Several plotlines dovetail across the expanse of Irwin's screenplay, but perhaps the most involving concerns the loving devotion with which the protagonist, Bob's stand-in Eddie Black, nurses a beat-up '39 Ford back into "cherry" shape. Throughout the script, Eddie confers with his buddies prior to each decision.

CAT: Hey, Eddie-O, you got the '39 running?
EDDIE [*startled*]: Huh? Oh, yeah. Yeah, it runs good, Cat. I've got it with me. After school I'm going over to get a set of mufflers.
CAT: Yeah, what kind?

[*Mole walks up hearing Cat's conversation.*]

MOLE: Get yourself a set of Sandys for a '39.

EDDIE: I was thinking of a set of 15-inch Porters.

CAT: Mole's right. Sandys have a real bark.

CANNONBALL [*approaching*]: What's up, Eddie-O?

EDDIE: Got the '39 here. I'm getting a set of mufflers.

CANNONBALL: Oh, yeah. Hey, get some fine 18-inch Rileys with those down tips like I got on the '36.

EDDIE: Yeah, they're good.

MOLE: They got no bite.

CANNONBALL: They're real mellow.

CAT: They're for sneaking up on chicks.

EDDIE: I like when you back off the Porters. They have that nice deep throaty roll. No flat and no pop. Too much pop on Sandys.

And so forth. A few scenes later, the Porters installed, the car nearly completed, the script floats into a lyrical reminiscence of the late nights of a Southland youth.

The box office is closed. The theater is semi-dark waiting for the last show to be over. We see Black exiting. He says goodnight to the manager in a black tux. He exits toward us and turns left to his car which is parked almost in front of the theater. The '39 is looking very sharp now. It's sitting at just the right angle, lowered in the rear, the new chrome bright against the grey primer. The car is almost finished. Black sits for a moment letting the '39 idle and dialing the radio until he hits on a station, Bobby Sherwood's "Elks Parade."

He idles away from the curb. The car is driven with more than care. Each time he winds up just so before he shifts; then with a short rev of the engine between gears he gives the mufflers a slight rap. Once in a while, for no seeming reason, except pleasure, Eddie lets the '39 hang longer in first and second. Sometimes he snaps off the shift between the two, letting it back all the way down to a stop at the corner.

We follow Eddie through the now familiar neighborhood. He pauses in front of Susy Stewart's and Anna Grace's houses, each dark, and each time he raps the mufflers lightly.

We idle on to a main street. Crenshaw. It is wide and well lit. There is very little traffic. The radio is playing "I've Got a Crush on You," by Tommy Dorsey and Frank Sinatra. Black has a Coke and idles along. The lights pass in patterns.

We pass down Hollywood Boulevard, also well lit with no traffic. There are a few people walking.

Eddie idles through a drive-in. He does this twice and chips a little rubber as he leaves.

He heads for home. "Skylark" by Earl Hines and Billy Eckstine plays as he idles down the dark tree-lined street letting the mufflers back way down. He pulls into his driveway and the lights go out.

As we wheeled out of Baldwin Hills, back down many of the same streets Eddie Black had often cruised, Bob recalled that particular '39: "Well, I finally got that car finished. I had twenty coats of ruby-red maroon on the dash, and I had this great finish outside. The car was absolutely hunky-dory. Twenty coats of ruby-red maroon, let me tell you, to paint the dash: that means taking everything out, all the instruments and everything, painting it, building up these coats very slowly, spraying the lacquer. It was just a very exaggerated thing. So it took a lot of work, but I finally got it into that condition.

"That was just in time for Easter week in Balboa. Everybody'd go down to Balboa for Easter week. All the girls' sororities and clubs had their houses there, and we used to go down and hang out in various situations there. Maybe you'd do some work for them, but mostly you just played around and slept in your car or out on the beach. My friend Keith went with me one time, and we'd been sleeping on the beach, so we went over to the girls' house the next morning to shower and brush our teeth. I had a fairly good gig going, 'cause the car was in very cherry shape, which of course was very important to the whole scene."

Did girls really respond to the cars?

"Well, you at least thought they did. It gave you a sense of identity, and your identity was what you wanted it to be, sure. I don't know how much, but. . . .

"Anyway, so we'd gone over to this girls' house, and we were just shooting the breeze, and I asked if we could wash up, and they said sure. So I went in and showered, 'cause I had my stuff with me. Then Keith came in the bathroom, and I thought to myself, 'How the hell did he get his stuff?' 'Cause his toothbrush and all were locked in the glove compartment. So I went down immediately and took a look. Instead of coming up and asking me for a key, Keith had just pried the glove compartment open with a screwdriver, which is unbelievable. I still can't believe it to this day. He'd broken the lock and also slipped the screwdriver and put this big gash across the dash right through my twenty coats of ruby-red maroon. Well, I just absolutely came on him. I mean, I just bounded up those stairs, blood in my eyes. He'd locked the door. The girls were yelling, 'Don't, don't!' I was tearing down the door, just kicking it in. And he, realizing that I was really going to tear him limb from limb, he leaped out of that second-story window, broke his ankle on the cement pavement, and still managed to scamper off. I didn't see him for another month after that. By that time I'd slowed down a bit, although I don't think I ever forgave him. Can *you* believe that? I can't."

We had come full circle back to Leimert Park and were idling by the crabgrass. I asked Bob whether his work on cars, more than any particular art classes he subsequently took, might be seen as one origin of his artistic vocation. He concurred.

"Of course, what's going on in such situations is precisely an artistic activity. A lot of art critics, especially New York *Artforum* types, have a lot of trouble seeing the validity of such a contention. I once had a run-in with one of them about this—this was years later, in the middle of the Ferus period. This guy was out here, one of the head honchos, and he was upset—what was it?—oh, yeah—because Billy Al Bengston was racing motorcycles at the time. This critic just dismissed that out of hand as a

superficial, suicidal self-indulgence. And I said you can't do that. We got going and ended up arguing about folk art. He was one of those Marxist critics who like to think they're real involved with the people, making great gestures and so forth, but they're hardly in the world at all. Anyway, he was talking about pot-making and weaving and everything, and my feeling was that that was all historical art but not folk art. As far as I'm concerned, a folk art is when you take a utilitarian object, something you use every day, and you give it overlays of your own personality, what it is you feel and so forth. You enhance it with your life. And a folk art in the current period of time would more appropriately be in the area of something like a motor-cycle. I mean, a motorcycle can be a lot more than just a machine that runs along; it can be a whole description of a personality and an aesthetic.

"Anyway, so I looked in the paper, and I found this ad of a guy who was selling a hot rod and a motorcycle. And I took the critic out to this place. It was really fortunate, because it was exactly what I wanted. We arrived at this place in the Valley, in the middle of nowhere, and here's this kid: he's selling a hot rod and he's got another he's working on. He's selling a '32 coupe, and he's got a '29 roadster in the garage. The '32 he was getting rid of was an absolute cherry. But what was more interesting, and which I was able to show this critic, was that here was this '29, absolutely dismantled, I mean, completely apart, and the kid was making decisions about the frame, whether or not he was going to cad plate certain bolts or whether he was going to buff grind them, or whether he was just going to leave them raw as they were. He was insulating and soundproofing the doors, all kinds of things that no one would ever know or see unless they were truly a sophisticate in the area. But, I mean, real aesthetic decisions, truly aesthetic decisions. Here was a fifteen-year-old kid who wouldn't know art from schmart, but you couldn't talk about a more real aesthetic activity than what he was doing, how he was carefully weighing: what was the attitude of this whole thing? What exactly? How should it look? What was the rela-tionship in terms of its machinery, its social bearing, everything? I mean, all these things were being weighed in terms of the aesthetics of how the thing should *look*. It was a perfect example.

"The critic simply denied it. Simply denied it: not important, unreal, untrue, doesn't happen, doesn't exist. See, he comes from a world in New York where the automobile . . . I mean, automobiles are 'What? Automobile? Nothing.' Right? I mean, no awareness, no sensitivity, no involvement. So he simply denied it: 'It doesn't exist.' Like that: 'Not an issue.' Which we argued about a little on the way back over the Sepulveda pass.

"I said, 'How can you deny it? You may not be interested, but how can you deny it? I mean, there it is, full blown, right in front of you, and it's obviously a folk art!'

"Anyway, he, 'No, no.'

"So I finally just stopped the car and made him get out. I just flat left him there by the road, man, and just drove off. Said, 'See you later, Max.' "

Bob was laughing uproariously by now, relishing the memory of the incident. Calming himself, he continued, "And that was basically the last conversation we two have ever had."

We started moving once again. "Well," Bob sighed, "I suppose all that's left to show you is the high school."

We cruised through a flat business district for several blocks. I observed that for all his tales of teenage life that afternoon, the school itself had cropped up only rarely in his recollections.

"Well," he explained, "from the tenth grade on I didn't even take a notebook. That shows how seriously I took school. If there was an assignment, I'd scribble it on some scrap of paper. School was essentially a place to go and meet. I went to school, and I went every day, because I really was having a good time: that's where all the action was."

Had any particular subjects interested him?

"Well, I took art classes, and I had an art teacher who thought I was very talented; I guess I had a natural facility and it was easy. There were only two required classes that I ever took. My father definitely wanted me to take algebra, and my mother definitely wanted me to take Latin. I flunked them both, which shows you. My father really wanted me to take algebra, for the discipline. So I tried real hard, took it three times, beginning algebra, and flunked all three times."

"Did that matter at all to you, flunking classes?"

"Nope."

"Did it matter to your father?"

"Finally, I guess not."

We rounded a corner and confronted the school's sign, Dorsey High ("Registration, September 11—See you soon!"). Bob was pointing: "Over there, past the main entrance, there's like a large circle, which is where we all danced during lunch and after school. And over here"—we sidled round toward the playing field, where squadrons of green-and-white-jerseyed jocks (most of them black) were friskily sacking each other in the late-afternoon sun—"this was the football field, scene of my many . . . whatever. I played end. We had a very good team, made the city finals. I was a good, solid participant, but hardly the star or anything."

I wondered how on earth Bob had time for all of this; it sounded like he had lived eighteen adolescences, rather than one. "Well," he explained, "we are talking about *three years* of high school," as if that explained anything. He went on to describe how he'd been a floater. "I wasn't really a member of any particular clique, although I floated between several. There were the guys who were into cars, others who were into girls, others into dancing, others into gambling—I just drifted between them, partaking of everything."

I asked him about the gambling. "Well, as you know, Hollywood Park Race Track is just a few miles back that way. And there was one group of guys—they hung out over at this pool hall on Adams—and they were into dressing up, wearing suits and porkpie hats, the whole dude routine. They were heavily into gambling, and I hovered around them. Starting around tenth grade, we began going to the ninth race each day, because after the eighth race they just opened the gates and let you in free (otherwise, we couldn't have gotten tickets, because we were still too young). But all day we'd be listening to the races, getting to know the horses, trying to pick 'em."

Was he making any money?

"Well, in the very beginning I wasn't making much. It was like two-dollar bets. I didn't really begin to make money gambling until I turned professional, which was years later. No, I'd win sometimes, lose sometimes. I don't know whether in the long run I came out ahead or behind, because I didn't keep track. If I came out behind, it was not very far behind, because (*a*) I could not afford to lose and (*b*) I never liked losing. I mean, losing is something I never took kindly to at all.

"It's funny. You know the theory about gamblers really being in it for the losing? Well, that's something that never entered my psyche. Losing, forgetting the money, just was no fun. To me, losing was not interesting. So if I'm losing, I don't play. That's why I never gamble in Las Vegas. I mean, I love to shoot craps. It's a great game, one of the great gambling games of all time, but basically you can't win. You're playing against the house, and it's strictly percentages, strictly mathematics. You can be a better gambler, have a few winning streaks, but basically you can't beat mathematics.

"You *can* beat other people, by playing better than they do. So any game where it's man-on-man, me-against-you, or me-against-the-crowd-at-the-racetrack: that's my kind of gambling game. It's my skill and your skill, and if I'm better than you are, I'll beat you. Over the long run, you might beat me here, you might beat me there. In fact, in small nickel-and-dime games, I'd be inclined to let you win, but to play loosely enough so that it makes no difference, on the basis that you may eventually end up in a real game with me, at which point the investment will have proven worthwhile.

"But back in high school, this was still embryonic, just nickel-and-diming around. It was more just part of the pleasure."

The sun was low in the sky now, and we were meandering lazily toward it, back toward the freeway and home. Our conversation was drifting casually—curious associations. One thing led to another, gambling to . . . birth control. I asked Bob if kids in his circle worried much about pregnancy.

"Well, we thought about it," Bob reflected, "but not a hell of a lot. You did one thing or another. Sometimes you just kept your fingers crossed. It just depended what the occasion was, who you were with. Got very lucky, I

guess. Just plain lucky. Joan sometimes talks about all the girls at her high school, how half of them got knocked up and had to get married before they even graduated. In my high school I don't remember anybody getting married . . . or knocked up. No abortions that I can remember. So sure, it was a concern, but not one that stopped you. Everybody was just lucky or something. We lived a sainted life or whatever you call it—a charmed life."

We had passed his junior high, and I asked him if that had been a similarly blessed time for him. He said not especially. "I have just a total blank in terms of memories before high school. Since that's come up a few times, I've wondered why. And part of it, I think, is that I never delve into it. I mean, people like Joan, with whom there are traumas in their youth, one thing about why there are traumas is that they dwell on them a little, they remember them and think back on them and use them as reference. I never think about that stuff at all, and I never go back. It's not so much a question of not having a memory as not having an interest in going back to think about those things. . . ."

(1982)

THE L.A. QUAKE

*Early on the morning of January 17, 1994—at 4:30:55, to be precise—
Los Angeles was struck by a massive blind thrust quake, with a Richter
reading of 6.7. I happened to have flown into town just the night
before. This was my report:*

When last month's quake knocked a sleeping friend of mine right
out of the bed in her Hollywood flatlands home, she stumbled
through the dark to her shuttered living-room window and tweaked a
crack open in the Venetian blinds, only to witness, at that very moment, a
shooting star streaking across the sky. Subsequently she recalled for me
how she was thereupon visited by two immediate thoughts, one riding fast
upon the other: the first (deeply primordial), that this must indeed be the
Apocalypse; the second (preternaturally rational), that if she was even
capable of seeing the stars at all, well, then, the quake must have knocked
out the electricity all over town. As, indeed, it had.

The quake knocked me out of a bed in a house on a Santa Monica hill-
side, and as I stumbled outside, the cityscape spread out below me was ink-
black in every direction—blacker than the sky. I momentarily imagined
what it would have been like to have been a passenger in a jetliner making
its final approach to LAX a few moments earlier, to be dreamily gazing out
upon the spangled carpet of lights below, when suddenly they all went out.
Imagine being the plane's pilot! (In fact, as we subsequently learned, the
lights even went out in Reno, Nevada, some four hundred miles away,
though not as a direct result of the quake: rather, in a sort of electric-grid

version of acupuncture, the very fact of all that electricity's suddenly no longer having the L.A. megalopolis to power meant that the energy went rebounding throughout the rest of the system, randomly frying out circuits everywhere it surged. I envisioned some relentless old lady, insomniac at her slot machine, methodically feeding in the quarters, when suddenly all the stray power of the San Fernando Valley came whamming through her predawn casino.) Back in Santa Monica, it was pitch-black and eerily noisy: dogs baying, glass splinters tinkling, car and burglar alarms wailing plaintively. All that, and underneath it all, some other sound, at first indecipherable: lulling, calming, pastoral . . . gurgling. A mountain stream, perhaps. And in fact a mountain stream, precisely: going out to the front yard I now realized that the underground reservoir which ordinarily supplies all of Santa Monica from the top of the hill must have sprung a leak, and the downsloping roadway had become a flowing watercourse.

Noise, actually, had been my primary experience of the quake itself a few moments earlier, even more so than the shaking—or rather maybe they were both the same. Everything was reverberation, as I came jolting to wakefulness—wildly various resonance, and my entire body one great throbbing ear. You know how you can be walking along some street absentmindedly, not even noticing how you've come to be passing under some railway overpass, when all of a sudden a train will come barreling by overhead, and you're stunned to consciousness (the boundary between your body and the world momentarily dematerializing in the adrenaline rush). Well, that's kind of what it was like to be woken in midquake: only, to make the analogy more precise, you'd have to imagine what it would sound like having your head not a sedate five yards under the track but more like, say, five inches. The noise is the sound of the earth itself wracking (the rockplates inside the ground crashing up against one another); it's the sound of the walls and joints throughout your house slamming; it's the sound of every unattached book and plate and couch and table in the house clattering about; it's the sound of your heart leaping into your skull in sheer terror. (Because then, too, there's the shoving: the world seems to hit you, to hit you hard, and then again, and then another time, *really* hard,

and then once more.) And on top of all that there's the incredible noise—
an ungodly, curious roar, unlike anything you've ever heard; it even takes a
few moments to identify what it could possibly be—the sound, of course,
of yourself screaming.

Or anyway, that's how it all seemed to me. And I had it easy. As I say, I
was on a hill, which is to say on the first floor of a house anchored in solid
bedrock. For people down below, in the loose-soiled sedimentary flood-
plain, or else high atop skyscrapers, it was a whole lot scarier. Later that day
I heard the story of a guy who was in town visiting from New York, staying
with friends in their penthouse apartment, twenty stories up a tower nes-
tled on the rim of the palisade overlooking the ocean. They'd lent him the
best bed in the house—facing the glass wall gazing out over the bay, mir-
rored walls on either side recapitulating the glorious view. He woke to the
sound of an explosion, which, as it happened, was the glass wall bursting
onto his lap. Luckily it was safety glass and it shattered into tiny jewel-like
cubes, which presently buried him inches deep in his sheets. The building
had begun swaying dramatically, as it was designed to do in such circum-
stances (better that it whip about like that than that it fracture): only,
at that height, the sway was on the order of several yards in each direc-
tion. That torque in turn quickly compromised the perpendicularity of
the walls, and the floor-to-ceiling mirrors began shattering convulsively.
(They were *not* safety glass.) All of this in the pitch-dark. The earth's shak-
ing was by now communicating itself through to the top stories, and next,
most horrifying of all, the building itself began shuddering in harmonic
resonance. Those superfast vibrations in turn began to impel the bed,
slowly but inexorably, toward the suddenly looming abyss. The quake only
lasted fifteen seconds, which was lucky, because by the time it stopped, the
bed had already shimmied more than halfway across the room.

All of which was remarkable in that Santa Monica was a good fifteen
miles from the quake's epicenter, in Northridge, on the far side of the next
valley over, and there were a lot of communities in between that didn't
seem to have been hit anywhere near as hard. For that matter, within Santa
Monica (as within the San Fernando Valley), there were some streets that

seemed decimated while the ones immediately adjacent seemed to have weathered the quake just fine. We all received a crash education in geology and seismology in the days immediately thereafter, and gradually some of this began to make a sort of sense.

The initial rupture in any earthquake might be likened to an atomic explosion—a sudden release of titanic amounts of energy at a single point which thereupon gets conveyed across space in the form of waves. But whereas in an atomic explosion the energy radiates out more or less evenly through atmosphere (much like the wavelets rippling out across the surface of a previously placid pond in the wake of a dropped pebble), with a quake, the waves are moving through earth of radically varying densities, slowing down or speeding up, expanding or constricting, depending on the consistency of the soils through which they pass. (Thus, the house I was staying in on the rock face of the hill was less affected than those in the sandy floodplain down below.) More disconcertingly, the transition from one sort of surface to another often sets off counter-reverberations: you get the initial wave moving one direction and a counterwave moving off the face of the underground "wall" echoing back the other, redoubling the quake's intensity. In Santa Monica, waves that had traveled fifteen miles hit the edge of the palisade facing the ocean and then bounded back. (The damage in Santa Monica was most severe in the twenty blocks closest to the coast.) On any given street, one wave might be at its crest while the counterwave was at its trough and they'd in effect cancel each other out: relatively calm sailing for those on the surface. But just a few streets over, both waves could be cresting at the same place, and those people were in for quite a ride.

And in fact, it wasn't just the intensity of the ground's shaking that determined the extent of the damage. As in the case of that poor guy in the penthouse, every structure has its own unique and inherent harmonic pitch, a frequency at which it will begin to vibrate on its own in response to any outside stimulus. (Think, for instance, about how you can get a champagne glass to start moaning merely by circling its rim with your wettened finger: too fast or too slow and the hum dissipates, but just right and the

vibrations can get so strong as to shatter the glass.) Thus, ironically, some buildings (or freeway overpasses) may have been destroyed because the underlying ground vibrations were *too slow*. This, too, helps explain why one house might have buckled while its immediate neighbor emerged largely unscathed. It was a wonderfully educational week to be in L.A.: fun with science!

Although, in fairness, the residents of L.A. have really had enough education for a while, thank you: for the past five or so years, they seem to have become unwitting subjects for every sort of social and natural scientific experiment. Remember, L.A. used to be the Promised Land, and California the Golden State—terminus for an unending flow of dreamers seeking their fortunes. In the immediate wake of January's quake, even the *Los Angeles Times*, long the town's most enthusiastic booster, was having to ask, in a banner headline, HAVE WE BECOME THE CITY FROM HELL? Things probably began souring for L.A. about a decade ago, when the city's principal high-paying manufacturing plants began shutting down—cars, tires, rubber, steel—as management sought out cheaper labor platforms, mostly abroad. Then came the fall of the Berlin Wall, an unmitigated disaster for Southern California, long the diadem of America's military-industrial complex. For all the vaunted superiority of the region's intelligence-gathering and -generating capabilities, no one, it seemed, had ever conceived the possibility of a prospect as dire as total victory—and now wave after wave of layoffs hit the previously sacrosanct aerospace and weapons industries. Regional unemployment soared to over 10 percent, the nation's highest; real-estate values plummeted. And all of that before the (not unrelated) race riots of two years back, the worst in the country's history. On top of which there was a lingering drought, progressively strangulating agriculture (the state's number one industry) and parching the hills surrounding the city. The drought was occasionally punctuated by torrential tropical downpours, "storms of the century" which flooded the urban basin, burying whole neighborhoods in mud flows, and incidentally

provoking an astonishing proliferation of chaparral undergrowth in the hills surrounding the city, foliage which, once the rains ended and the drought resumed, quickly dried to tinder, setting the stage for last fall's fires, the most explosive in decades. And now this.

FEMA, the Federal Emergency Management Administration, which set up temporary offices in town in the wake of the riots and then had to keep them open for the fires, was just starting to wind down its operations when the quakes struck. A friend told me about a computer recording he'd encountered when trying to reach another government agency. "Due to the recent . . ." droned the metallic voice, and then there was a moment's hesitation while the computer seemed to seek out the appropriate module—". . . earthquake . . ."—another pause, reversion to core message: "these offices will be closed for" and so forth. "I mean," my friend commented, "it's like they're ready for everything, 'cause they know it's all coming. What else have they got programmed in there—'Pestilence'?" Another friend of mine commented, "That does it, I've just about had it now. I mean, if locusts come, okay, maybe I'll still stick it out. But frogs—if I see a single frog, even the tiniest, most innocuous little green garden toad sunning itself out there on my front porch, that's it, I'm gonna be outta here. Because I'm a firstborn, and after the plague of frogs comes the slaying of the firstborn, and I'm sure as hell not hanging around to watch."

And yet Los Angeles's tribulations are most likely not the Vengeance of an Angry God: if anything, a more pantheist eschatology seems called for. "Look," the director of the permanent disaster-coordinating office in the basement of city hall was already commenting several years back, well before the latest cycle of disasters, "the thing you have to understand about this place is that it's a desert, there isn't supposed to be any city of several million people here. Every square inch of Los Angeles has been wrested from nature, and—fire, floods, drought, quakes—*Nature wants L.A. back.*"

A hurricane, no matter how vicious, eventually blows by; a fire gutters out; a flood subsides. One is left in peace with one's desolation: the labor of

cleaning up can begin. It's not like that with large quakes, which invariably cast a steady staccato of so-called aftershocks in their wake. Over fifteen hundred such temblors followed the Northridge quake in the first week alone—most of them inconsequential, but a good two or three a day strong enough to give everyone pause—strong enough, in fact, that they'd probably have rated mention on international wire services in their own right if they hadn't followed the initial one. And their damage wasn't just to people's already badly frayed nerves, though that was bad enough. (And not just people's: I was visiting a friend when a 5.1 struck one afternoon, a few days after the original 6.7. My friend has a beautiful Rhodesian ridgeback, a sleek, sinewy, eighty-pound dog, and with the aftershock's first rumble that dog was already in midair, leaping onto my lap, all four legs scrunched under its chest: a trembling kitten.) Structures, too, were further undermined. New fissures emerged on overpasses, and fresh landslides closed highways that were being used as alternative routes for other, already closed highways. Inspectors had to go back and revisit dwellings that had only barely passed muster a few hours earlier, and many of these now had to be condemned and evacuated: by the first week's end, over fifteen thousand such housing units had been "red-tagged," their denizens cast out onto the street, and that number steadily swelled with each new aftershock. The proprietor of one bookstore I visited told me how he'd rushed over to his store the morning after the original quake to find all his shelves toppled and the floors over three feet deep in scattered books: it took him and dozens of his friends two days to set everything right, painstakingly realphabetizing his entire inventory, at which point an aftershock toppled half of the shelves all over again.

In many instances the very prospect of further aftershocks prevented even the most minimal of salvage operations—most famously in the case of a prominent medical office building at a busy corner in West L.A. The seven-story building housed the offices of many of the city's most eminent psychiatrists ("the shrinks to the stars," as the papers quickly took to noting), and the morning after the first quake, with the building already sagging precariously (the whole busy intersection had had to be cordoned off

in anticipation of its impending collapse), the doctors could be seen pleading with police to be allowed just a few moments' entry to retrieve a professional lifetime's worth of records, notes, manuscripts, rolodexes, and so forth. All to no avail: it was just too dangerous, no one was let in (one fellow proposed bringing some death-row inmates down from San Quentin to comb the premises; it wasn't clear whether he was being serious or not), and after a few nights, the building, still unbreached, finally succumbed to the wrecker's ball.

The aftershocks were scary enough as aftershocks, but, of course, everybody's secret fear was that they, and the original quake that had preceded them, were in fact all merely *fore*shocks of the coming Big One. There are various ways of trying to conceptualize the ferocity of that inevitably approaching megaquake. During that Monday morning's 6.7, the ground shook, depending on where you were, for between fifteen and thirty seconds; in an 8.3 the ground will be lurching, nonstop, for well over two minutes. That guy in the penthouse would have been long gone. The scale on which these things get measured compounds geometrically, not arithmetically, so that a 6.0, say, is in fact ten times stronger than a 5.0. The *Times* tried to help its readers to visualize this progression by printing a timeline of the aftershocks along the bottom of one page. A 5.2 provided the tallest bar, about three inches high. I remembered that one: that was a scary one. Meanwhile, off to the side, a bar representing the original 6.7 quake coursed up the entire length of the page, over two feet, and a box at the top informed us that in order to truly represent that quake's actual relative force, the bar would have to continue on for another four feet! It was probably not lost on anyone that pretty much the same proportional disjunction would apply to the difference between our plenty-horrendous-enough 6.7 and any eventual 8.0.

There were countervailing theories. Each successive temblor, some surmised, was tending to dissipate the pressures otherwise building along the major fault lines, thereby at least forestalling the Big One's inevitable advent. On the contrary, others hypothesized, each successive lurch was only further adding toward those very pressures. Following each jolt the

entire city seemed to race for its radios and TVs, anxiously awaiting the almost instantaneous readings from the scientists over at the Cal Tech seismology lab (there was something reassuringly validating about the numbers themselves: yes, that indeed was a 4.9, or a 5.3) but especially so as to listen, once again, as the reporters grilled the scientists on the significance of those numbers. There was something unfailingly comic about the disjunction between their two modes of discourse. "Based on prior aftershock patterns," the scientist would intone carefully, "our models now tell us that there's a 50 percent chance that there will be another quake measuring at least 5.0 within the next two to three days." Invariably, at this point, the first question out of the reporters' mouths would be something on the order of, "Does that mean it's going to happen?"

By that first week's end, a sort of normality was already reasserting itself. It's incredible what you can learn to live with, sheer human adaptability being a natural wonder almost as awe-inspiring as any earthquake. Crime was reported to be way down (arrests for all the first ten days after the quake were said to total less than for any single one of the ten days preceding it). Certain previously depressed sectors of the city's economy were suddenly booming once again: for example, of course, construction. (An artist friend of mine went to pick up some supplies at a local paint store and overheard the conversation of two housepainters. "It was like they'd died and gone to heaven," she reported to me. " 'Can you believe this?' the one guy says to the other, to which the second replies, 'We're going to be into overtime for the next five years!' ") Prior to the quake, the city was laboring under a terrible commercial-real-estate glut, and there was something like a 12 percent vacancy rate on apartments in the Valley. Not anymore.

And even the transportation debacle was forcing some of the kinds of innovative solutions that reformers have been advocating, forlornly, for years. Thus, for example, the authorities established two sorts of detours around the collapsed overpasses on the Santa Monica Freeway, previously

the nation's busiest stretch of highway: there was a relatively short bypass, but that was open only to buses and carpools; everybody else had to get off the freeway much earlier and negotiate a far more elaborate and time-consuming series of deviations. Predictably, a lot more people took to driving in carpools. And meanwhile it wasn't an entirely bad thing that many of the city's suburbanites were being forced onto surface streets in neighborhoods whose very existence they'd successfully managed to oc-clude through years of freeway commuting. (The poorest congressional district in the country straddles the Long Beach Freeway south of L.A., just a few miles from the district with the country's highest property valuations—a socioeconomic replication, as it were, of the geoplate tec-tonics which, just a few hours outside of L.A., have the country's highest peak, Mt. Whitney, rising almost directly up from out of its deepest depression, Death Valley. The very geophysics which caused that anomaly were now shaking up a lot of other things as well.)

The utility crews were working heroically, and astonishingly effectively, to patch the rampant damage to the city's infrastructure—electricity, transportation, water. . . . Even so, in whole sections of town, by week's end, people were still being advised to boil their water for at least five min-utes prior to drinking it. Still, as I say, in the meantime, people were muddling through. I went out for dinner Saturday night. (Everybody, it seemed, went out to dinner or to the movies Saturday night; it was like a vast communal sigh-heaving: Enough is enough!) The waitress recited the evening's specials with the inimitable singsongy cadences of the classic L.A. actress-in-waiting—"Tonight we have a lovely veal picatta served with a side of sun-dried tomatoes fried in fresh garlic butter, a delicious fresh fillet of tuna seared and served on a bed of fresh-picked spinach" and so forth, and then, without missing a singsongy beat: "And tonight none of our dishes has been prepared in water!"

The first weekend after the quake was incredibly beautiful. They'd pre-dicted an incoming storm, which would have complicated matters consid-

erably, but it was holding off, and instead the offshore breezes were wafting in glorious high cumulus clouds, the air was soft and balmy, the violet mountains in the distance were startlingly clear, the bay heartrendingly blue, the light (that wonderful, wondrous L.A. light) as graciously limpid as I could ever remember.

I sat on the Santa Monica palisade, reading the papers—specifically about the incredible, record-setting cold snap that still had most of the rest of the country in its scary grip (in fact, that week far more people died of the cold back east than as a result of the Northridge quake). I was also reading a perceptive op-ed piece by the L.A. writer Carolyn See. "A lot of people are saying that the quake was ennobling," she was telling the readers of the *New York Times*. "I think it's the sourest of disasters. Nature shakes you cruelly, meanly: it makes it clear that you count for nothing. And then it makes you clean up your room."

There was a lot to that, only you could take it even further. California lavishes you with ease and comfort and light one day, only to beat you senseless the next, and then pleasure you all over again the day after that. Hell, it indulges and savages you *at the same time*! Back in the sixties, we used to have a term for that kind of parenting. We called it crazy-making.

(1994)

THE LIGHT OF L.A.

The day of O.J.'s infamous slow-motion Bronco chase—actually, it was already past sundown here in New York as I sat before the glowing little TV monitor in our darkening kitchen, utterly transfixed by the steadily unfurling stream of bob-and-wafting helicopter images, hot tears streaming down my cheeks—my then-eight-year-old daughter happened upon the scene, gazed for a while at the screen and then over at me, at which point, baffled and concerned, she inquired, "What's wrong, Daddy? Did you know that guy?"

"What guy?" I stammered, surfacing from my trance, momentarily disoriented. "Oh, no, no. I didn't know the guy. I don't give a damn about the guy. It's that *light*! That's the light I keep telling you girls about." You girls: her mother and her. That light: the late-afternoon light of Los Angeles—golden pink off the bay through the smog and onto the palm fronds. A light I've found myself pining for every day of the nearly two decades since I left Southern California.

Months passed, and on sporadic returns to L.A., for one project or another, I occasionally recounted my Bronco-chase experience to friends and acquaintances, and everybody knew exactly what I was talking about. The light of the place is a subject that Angelenos are endlessly voluble about—only, it turns out, people bring all sorts of different, and sometimes even diametrically opposite, associations to the subject.

For example, David Hockney maintains that the extravagant light of Los

Angeles was one of the strongest lures drawing him to Southern California in the first place, more than thirty years ago—and, in fact, long before that. "As a child, growing up in Bradford, in the North of England, across the gothic gloom of those endless winters," he recalls, "I remember how my father used to take me along with him to see the Laurel and Hardy movies. And one of the things I noticed right away, long before I could even articulate it exactly, was how Stan and Ollie, bundled in their winter overcoats, were casting these wonderfully strong, crisp shadows. We never got shadows of any sort in winter. And already I knew that someday I wanted to settle in a place with winter shadows like that. In fact, years later, when I staged *The Magic Flute*, it's that aspect of the story that I keyed onto—this journey from darkness toward the light, how the light pulls and pulls you. It certainly did me, anyway: the light and those strong, crisp shadows."

Robert Irwin, one of the presiding masters of L.A.'s Light and Space artistic movement of the late sixties and early seventies, and a native Angeleno, concurred that there's something extraordinary about the light of L.A., though he said that it was sometimes hard to characterize it exactly.

"The thing is it's so radically different from day to day," he explained, "and then so incredibly specific on any given day.

"One of its most common features, however," he suggested, "is the haze that fractures the light, scattering it in such a way that on many days the world almost has *no* shadows. Broad daylight—and, in fact, lots and lots of light—and no shadows. Really peculiar, almost dreamlike.

"It's a high light, as opposed to the kind of deep light you might get, say, in the Swiss Alps, where your eye keeps getting drawn to the object—say, to that snow-capped peak on the far end of the valley. Here, instead, you're likely to find your eye becoming suspended somewhere in the middle distance, and it can almost get to be as if the world were made up of energy rather than matter.

"I love walking down the street when the light gets all reverberant, bouncing around like that, and everything's just humming in your face."

A few days after my conversation with Irwin, I happened to be talking with John Bailey, the cinematographer, most recently of *As Good As It Gets*,

and he energetically confirmed Irwin's observation: "I have a sophisticated light meter, which in my work I'm always consulting. Most places in the world when it's overcast enough so that you get no shadows, the meter lets you know you have to set your aperture a stop to a stop and a half below full sun. Here in L.A. the same kind of diffuse light, no shadows—I could hardly believe the first time I encountered this—and my meter will read almost the same as for full sunlight. Other days, though, you'll be getting open sun, which, of course, here means open desert sun—a harshly contrasting light. After all, for all its human settlement, the Southland is still this freak of nature—a desert abutting the sea. And open desert light is very harsh—you get these deep, deep shadows. Your eye subjectively makes these incredibly sophisticated adjustments so that you're able to see into the shadows, but filmstock tends to be incapable of such subtleties: you get the sunlit area and what's in shadow just reads as black, unless you compensate with fill-light aimed into the dark patches. Cinematographers from elsewhere, from foreign countries and the like: the first time out they know that they have to compensate, but it's never enough, and they're invariably dumbfounded by their first morning's dailies."

I mentioned the Laurel and Hardy shadows of Hockney's youth. "Exactly," Bailey said. "Shadows and no shadows—that's the duality of L.A. light, isn't it? And how appropriate for a place where the sun rises in the desert and sets in the ocean.

"But for all that, the main thing about the light here is its *consistency*," Bailey continued. "Of course, the early independent producers originally made their way out here, toward the end of the first decade of this century, so as to get out from under the thumb of the Edison Trust." There are all sorts of fascinating accounts of that original exodus—Neal Gabler's, Lewis Jacob's, Eileen Howser's—how back in New York and New Jersey, Thomas Edison initially attempted to enforce a dubiously broad patent hegemony through the creation of a trust which deployed lawyers, detectives, thugs, and even sharpshooters to upend the efforts of any mavericks who refused to fork over the arbitrarily mandated licensing fees. In their attempts to elude the Trust's grasp, the independents in turn spread throughout the

land—to Florida (too warm and humid) and Cuba (too disease-ridden), to the Southwest and to San Francisco and presently to L.A. In fact, one of the main things that L.A. had going for it at the outset in those earliest days was its geographical location, "only a hop, skip, and a jump," as Lewis Jacob points out, "from the Mexican border and escape from any injunctions and subpoenas."

"But what they really stumbled upon here," Bailey went on, "was the consistency of the light. So much light, and so many days of it. Back east they'd have to cease production throughout the winter: all those gray cold days when even if the cameras didn't freeze up, they'd barely be able to register anything on film without the use of banks and banks of these incredibly expensive klieg lights." (According to Gabler, such light banks became even more prohibitively expensive during the ensuing decade, when war-inspired shortages seriously constricted the supplies of coal necessary to power them.) "And the same in the summer: afternoon thunderheads would regularly kick up, and they'd have to call it a day. But here there were hardly any clouds and the light on any given day stayed consistent pretty much the whole day through.

"And it's still the case. For instance, you can be doing a three-page sequence: eighteen camera setups shot over twelve hours. In the final movie the whole thing is going to get edited down to two or three minutes of supposedly continuous time. Of course, you have to jimmy the camera angles and so forth, but you can do that here. Try doing it, say, in the high desert of New Mexico, as I had to when we were doing *Silverado*, where light conditions are incredibly variable, cloud banks massing and dispersing over and over all through the day—it can drive you crazy, especially if you've been spoiled by the light of L.A. That's why films thrive here in spite of everything—all the social and political pressures, the offers from everybody else's film boards trying to lure us away—and why they likely always will."

Another day (somewhere in there I began making it a bit of a side-hobby on my various L.A. junkets, calling on people out of the blue to ask for

their take on the light of L.A.), I called Hal Zirin, out at Caltech—the man who founded and until recently ran the solar observatory up at Big Bear Lake. I suppose I was wondering how the sun itself looked in the light of L.A. "Ah, Southern California," Zirin responded, with improbable enthusiasm. "God's gift to astronomy!" I laughed, figuring he was joking. "Oh no," he assured me. "I'm completely serious. Mount Wilson, Mount Palomar, the Griffith Observatory, our solar observatory out at Big Bear . . . It's not for nothing that during the first two-thirds of this century a good three-quarters of the most significant discoveries in astronomy were made here in Southern California."

So wherefore was it?

"Well, it's all thanks to the incredible stability, the uncanny stillness, of the air around L.A. It goes back to that business people are always talking about—a desert thrusting up against the ocean, and, specifically, against the eastern shore of a northern ocean, with its cold, clockwise, southward-moving current. Because, owing to the rotation of the earth, the prevailing currents in the northern hemisphere run clockwise: eastwardly along the equator, in this instance, till they hit Asia, at which point warm tropical currents arch northward, skirting Japan, until they eventually curve back beneath Alaska, where they cool before running southward along the California coast. Hence, the cold California current. And the other crucial element in the mix is these high mountain ranges girdling the basin—so that what happens here is that ocean-cooled air drifts in over the coastal plain and gets trapped beneath the warmer desert air floating in over the mountains to the east. That's the famous thermal inversion, and the opposite of the usual arrangement, where warm surface air progressively cools as it rises. There's a relative lack of clouds—clouds of course being a big problem if you're trying to observe the heavens—because there's relatively little evaporation out over the cool water. And the atmosphere below the inversion layer is incredibly stable. You must have noticed, for instance, how, if you're on a transcontinental jet coming in for a landing at LAX, once you pass over the mountains on your final approach, no matter how turbulent the flight may have been prior to that, suddenly the plane becomes com-

pletely silent and steady and still." (Actually, I had noticed and wondered about it.) "That's the stable air of L.A."

And why was such stability so important to astronomy?

"Well," Zirin explained, "have you noticed, for instance, how if you go out to the Arizona desert, say, it may be incredibly clear but the road off in the distance is shimmering? That's the heat rising in waves off the surface of the ground. On the other hand, go out to the Santa Monica palisade and gaze out over the cool water. It's completely clear and distinct, clean out to the horizon. The heat rising from the ground in most places—or, rather, the resultant interplay of pockets of hot and cold air, acting like distorting lenses in the atmosphere up above—is in turn what makes stars shimmer and twinkle in the night sky. A twinkling star can be very pretty and romantic, but twinkling is distortion, by definition, and if you're an astronomer you want your star—or, for that matter, your sun, if that's what you're looking at—to be distortion-free: solid as a rock. And that's what you get here. The stars don't twinkle in L.A."

And, it occurred to me, that might also account for the preternatural clarity of the encircling mountains, off in the distance—that hushed sense you sometimes get that you could just reach out and touch them—on those smog-free days, that is, when you're able to see them at all.

Angelenos tend to take perverse credit for the uncanny light of the place, as if they themselves were the ones who made it all happen; and, in fact, according to at least one way of looking at things, they may have a point. I broached the subject of the light of L.A. one day with John Walsh, the director of the Getty Museum and an East Coast transplant, and he responded, "Yeah, I know what you mean. I too have often had this sense of the special and peculiar quality of light in this place; I know everybody talks about it, and I've thought about it a lot. At times, though, I'm of two minds on the subject, figuring, I mean, that either it's autosuggestion, or else . . . it's auto pollution."

Someone told me that if it was air pollution I wanted to consider I

should go talk to Glen Cass, at Caltech, a jovial, rotund, clear-eyed, and short-cropped professor of environmental engineering with a very specific interest in smog: he could care less about its carcinogenic implications, or its contribution to everything from emphysema to the thinning of the ozone layer; what obsesses him is the effect of air pollution on visibility— in other words, exactly why it is that some afternoons he can go up on the roof of the Millikan Library there at Caltech, gaze out toward the towering San Gabriel Mountains, less than five miles to the north, and not make out a thing through the bright, white (shadow-obliterating) atmospheric haze.

"My objections to smog," he explains, "are principally aesthetic. I hate how it looks and more specifically everything it prevents me from seeing. I grew up here in Pasadena, and when I was a kid the mountains were a marvelous everyday presence, as indeed they remained until the fifties and sixties when smog really began to get out of hand. It may be that the experience of smog—and for that matter of light generally—is so pronounced here in L.A. as opposed to elsewhere because the uninterrupted visual range is so potentially vast. We live on a flat expanse, sloping gently toward the ocean and backed up against these really huge mountains." Mount Wilson is almost a mile high, Mount Baldy, 10,080 feet, and San Gorgonio Mountain, 11,502, all of them rising straight up from sea level. "Maybe people elsewhere aren't so aware of the reduced visual range caused by their own air pollution because, living in a forest of buildings, or else a forest of trees, they can't ordinarily see that far horizontally in any case, and looking straight up, the sky is always blue anyway, as it is here, since the band of pollution tends to be relatively narrow, vertically speaking." (Cass's observation paralleled the comment of a New York friend of mine who once interrupted one of my L.A. light rhapsodies to insist, somewhat defensively, that Manhattan, too, often gets incredible sunsets; it's just that you have to happen to be looking straight up, at just the right moment, if you've ever going to notice them.)

So, I asked Cass, what, exactly, was all that white stuff choking the view of his beloved mountains?

"Well, it turns out that there are all sorts of different sizes of particles floating in the air—from absolutely minuscule to relatively large and coarse," he explained. "Some of those—and especially the larger ones—simply get in the way of the line of vision between you and, say, that mountain over there. They blot out or defract the beams of reflected sunlight emanating from the mountain that would otherwise be conveying visual detail to your eyes. Contrary to what you might think, though, it's not so much the large, coarse particles that pose the biggest problem. Instead, it's those of a specific intermediate size—about half a micrometer, to be exact—that constitute the jokers in the deck when it comes to visibility.

"And the thing about particles of that size is that they happen to have about the same diameter as the wavelength of natural sunlight. So that, when the sunlight from over my shoulder, say, hits one of those particles floating between me and the mountain that I'm trying to make out, the light bounces off the particle and right into my eye. On some days there can be billions of such particles in the line of sight between me and the mountain—each of them with the mirrorlike potential to bounce white sunlight directly back into my eye. It can get to be like having a billion tiny suns between you and the thing you're trying to see. That's what the white stuff is. And we have a technical term for it."

I hunkered down over my notebook, preparing to take down complex technological dictation.

"We call it *airlight*."

The next morning, I happened to be jogging on the beach in Santa Monica, heading north, in the direction of Malibu, as the sun was rising behind me. The sky was already bright, though the sun was still occluded behind a low-clinging fog bank over LAX. The Malibu mountains up ahead were dark and clear and distinct, and seemed as if freshly minted. Presently, the sun must have broken out from behind the fog bank—I realized this because suddenly the sand around me turned pale purplish pink and my own long shadow shot out before me. I looked up at the mountains, and they were *gone:* lost in the airlight.

Later, as I was describing the experience to a poet friend, Dennis Phillips, and trying to explain the business about the billion tiny suns, he interrupted, correcting me. "No, no," he said. "You mean a billion tiny moons."

Actually, the air-pollution situation in L.A. has been improving markedly over the past fifteen years, as Glen Cass is only too happy to affirm.

There are fewer and fewer days of sheer airlight whiteout, more and more days when you can see the mountains from almost all corners of the basin. The last several years, as I've been paying my occasional calls on my old hometown, I'd been imagining that I was just having an extraordinarily vivid run of good luck—hardly any truly atrocious days—but the fact is that, owing to a singularly effective coordinated interagency governmental campaign, there simply are fewer and fewer such horrible days (and this despite a marked increase in population since the peak smog years of the late seventies).

In the early seventies, for example, according to Cass, Los Angeles was pumping 530 tons of sulfur dioxide into the air every day. Without a stiff regime of automotive and industrial controls, that figure might well have ballooned to somewhere between two and three thousand tons per day today (such were the projections at the time). Instead, such emissions have been clipped to 100 tons per day or less. "We've starved the atmosphere for sulfur dioxide," Cass explains, "and as a result we can see better." Back in 1980, according to Joe Caffmaffi, the senior meteorologist at the Air Quality Management District, the L.A. basin breached federal atmospheric standards almost half the time, a total of 167 days; by 1997, that figure had been cut to sixty-eight days. In 1980, 101 Stage One health alerts had to be called; in 1997, only one.

Nevertheless, the light seems more uncanny than ever—or, rather, it may simply be reverting to its original splendor. What with the thermal inversion, even as the smog has subsided a softer version of the airlight phe-

nomenon has persisted—one that Juan Cabrillo, the first European to ven-
ture into these parts, back in 1542, already appears to have noted, gazing
from his ship upon the gently dispersing columns of smoke rising from the
Indian campfires (he famously labeled the curve of shore "The Bay of
Smokes"). Back in 1946, Carey McWilliams, the poet laureate of California
historians, recorded how, the region's aridity notwithstanding, "the charm
of Southern California is largely to be found in the air and the light. Light
and air are really one element: indivisible, mutually interacting, thor-
oughly interpenetrated." Continuing, he noted how

> When the sunlight is not screened and filtered by the moisture laden air,
> the land is revealed in all its semiarid poverty. The bald, sculptured
> mountains stand forth in a harsh and glaring light. But let the light turn
> soft with ocean mist, and miraculous changes occur. The bare mountain
> ranges, appallingly harsh in contour, suddenly become wrapped in an
> entrancing ever-changing loveliness of light and shadow [...] and the
> land itself becomes a thing of beauty.

McWilliams went on to point out how, typically, desert light "brings out
the sharpness of points, angles, and forms. But," he continued, "this is not
a desert light nor is it tropical for it has neutral tones." (Elsewhere he sug-
gests that "the color of the land is in the light.") "It is Southern California
light and it has no counterpart in the world."

I was recalling McWilliams's comments one morning while breakfast-
ing with the architect Coy Howard, a true student of the light, and he con-
curred. "It's an incredibly loaded subject—this diaphanous soup we live
in," he said. "It feels primeval—there's a sense of the undifferentiated, the
nonhierarchical. It's not exactly a dramatic light. In fact, 'dramatic' is
exactly what it's not. If anything, it's meditative. And there's something
really peculiar about it. In places where you get a crisp, sharp light with
deep, clean shadows—which we do get here sometimes—you get con-
fronted with a strong contrasting duality: illumination and opacity. But
when you have the kind of veiled light we get here more regularly you

become aware of a sort of multiplicity—not illumination so much as luminosity. Southern California glows, not just all day but at night as well, and the opacity melts away into translucency, and even transparency."

I wasn't quite getting it, so Howard tried again.

"Things in the light here have a kind of threeness instead of the usual twoness. There's the thing—the object—and its shadow, but then a sense of reflection as well. You know how you can be walking along the beach, let's say, and you'll see a seagull walking along ahead of you, and a wave comes in, splashing its feet. At that moment, you'll see the bird, its shadow, and its reflection. Well, there's something about the environment here— the air, the atmosphere, the light—that makes *everything* shimmer like that. There's a kind of glowing thickness to the world—the diaphanous soup I was talking about—which, in turn, grounds a magic-meditative sense of presence."

The poet Paul Vangelisti knew exactly what Coy Howard was getting at when I related our conversation to him. In fact, he was blown away, for he insisted he'd been trying to frame almost that same point earlier that day, in the latest of a series of daily poems he'd been working on, based on the view across the neighboring arroyo from the window of his Echo Park studio, celebrating, in this instance:

> . . . the pigeon flock
> soaring and tumbling every noon
> silver then white then sunlight
> against the weight of air at the window.

"Coy Howard's associations run to seagulls," Vangelisti pointed out, "and mine run to pigeons—maybe not that surprising a convergence after all, since birds are the true citizens of light. But I know just what he means about the sense of threeness—silver then white then sunlight—and about the meditative, as opposed to the dramatic, quality of the light here."

The light is a constantly recurring theme among the poets of L.A., but I

can think of few whose work is as light-saturated, as light-blasted, as Van-gelisti's. He entitled his first collection, back in 1973, simply *Air*.

"For one thing," he elaborated, "I think the light of L.A. is the whitest light I've ever seen, and the sky is one of the highest. You really notice it if you're playing baseball and you're in the outfield. You're always losing the ball in that high white sky. That may be one reason why the Dodgers decided to put their stadium in a ravine. And then, too, there's a strange thing that happens with the sense of distance and of expanse. Because from here in Echo Park the ocean off in the distance is oceanic, but so is the intervening land, and indeed so is the sky. It's that even, undifferenti-ated, nonhierarchical quality Coy Howard is talking about. And a weird thing is how that light yields a simultaneous sense of distance and of flat-ness: things seem very sharp up close and far away, with nothing in between. And the uncanny result is that you lose yourself—somehow not outwardly but, rather, inwardly. Here the light draws you *inward*."

Anne Ayres, the gallery director at the Otis Institute, told me that some days the light of L.A. can drive her into a state of "egoless bliss." And John Bailey described to me his own occasional bouts with "rapture." But there were others I got in touch with who were having none of it.

"You're talking to the wrong guy," the director Peter Bogdanovich warned me when I reached him. "See, I'm a New Yorker, and though I've lived in L.A. for thirty years, I really haven't been that happy here the last fifteen. I miss seasons, and I hate the way the light of the place throws you into such a trance that you fail to realize how time is passing. It's like what Orson Welles once told me. 'The terrible thing about L.A.,' he said, 'is that you sit down, you're twenty-five, and when you get up you're sixty-two.' "

"But light is *over*!" Paul Schimmel, the chief curator at MOCA, the Museum of Contemporary Art, exclaimed when I broached my pet subject to him. "There hasn't been light in this city for more than ten years now." Schimmel was the creator of "Helter Skelter," a seminal show at MOCA,

which endeavored to prove precisely that point back in 1992. On first arriv-
ing in L.A., in 1981, Schimmel had half expected to encounter some third-
or fourth-generation version of the Light and Space orthodoxies that had
come to be so closely identified with the L.A. art scene during the sixties
and the early seventies—through the hegemony of masters ranging from
Robert Irwin to Richard Diebenkorn. Instead, he found a younger gen-
eration of artists—exemplified by the likes of Mike Kelley and Nancy
Rubins—who seemed to have rejected the light aesthetic entirely, opting
instead for a decidedly darker, seedier, more grimly unsettling and
dystopian view of the L.A. reality. "Partly," Schimmel speculated, "this was
because by the late seventies and early eighties light in L.A. had been so
academicized that it had really become little more than a commercial
cliché. There was nowhere else to go with it. In part, too, long before a lot of
other people, these artists were onto some of the bleak social transforma-
tions that were eroding the city itself. 'Helter Skelter' closed on a Sunday,
and the worst riots in the city's history erupted the following Wednesday."

　　Of course, in its very title the "Helter Skelter" show acknowledged the
fact that its countervision of the L.A. reality was itself rooted in a long
countertradition—one that wended back from the Manson murders into
the noir world of the great crime novelists and filmmakers of the thirties
and forties. It's interesting how those noir novelists and filmmakers almost
completely inoculated themselves against the blandishments of the light of
L.A., in part by setting most of their scenes either at night or indoors—in
fact, usually both. One of the distinct charms of such seventies reworkings
of the genre as Polanski's *Chinatown* and, even more notably, Altman's *The
Long Goodbye* was the way the filmmakers forced their hardened protago-
nists out into the light of day. (Altman's Marlowe spent the entire film in a
perpetual squint, scuttling about like a naked crab summarily wrested
from the dark, nestling comfort of its shell.)

Generally speaking, people I spoke with about the light of L.A. tended to
fall on one side or the other: heedlessly abashed worshippers (the vast

majority) or righteously impervious debunkers. There were a few, however, whose responses were decidedly more nuanced.

One such was Don Waldie, whose remarkable book *Holy Land: A Suburban Memoir* I'd been reading on one of my flights out to Los Angeles. Born and raised in Lakewood (a sort of blue-collar, West Coast Levittown, row upon row of near-identical frame-and-stucco tract houses laid out in a meticulously even grid just north of Long Beach), Waldie still lives in the community—indeed, in the very house—in which he was reared. In fact, his day job is public-information officer for Lakewood. Waldie doesn't drive, so he has to walk to and from city hall each day—twenty-five minutes across an unvaryingly regular pattern of perpendicular zigs and zags. It was during such walks that he began composing—one at a time—the hauntingly lyrical, startlingly brief chapters that make up his book.

I resolved to include him in my survey, so as soon as I'd landed in L.A. I placed a call to Lakewood City Hall—he was out—and left a message on his machine. That evening, I got my own personal whiff of his method.

"Ah, yes," he said cheerfully when I reached him at home. "The light around here is quite remarkable, isn't it? In fact, I gave the matter some thought on my walk home this evening. And it seems to me, actually, that there are four—or, anyway, at least four—lights in L.A. To begin with, there's the cruel, actinic light of late July. Its glare cuts piteously through the general shabbiness of Los Angeles. Second comes the nostalgic, golden light of late October. It turns Los Angeles into El Dorado, a city of fool's gold. It's the light William Faulkner—in his story 'Golden Land'—called 'treacherous unbrightness.' It's the light the tourists come for—the light, to be more specific, of unearned nostalgia. Third, there's the gunmetal-gray light of the months between December and July. Summer in Los Angeles doesn't begin until mid-July. In the months before, the light can be as monotonous as Seattle's. Finally comes the light, clear as stone-dry champagne, after a full day of rain. Everything in this light is somehow simultaneously particularized and idealized: each perfect, specific, ideal little tract house, one beside the next. And that's the light that breaks hearts in L.A."

That and other lights. One evening, out on the palisade, I was watching the sunset in the company of a theatrical-lighting designer. Actually, we had our backs to the sea—the blush of sky and air and land is somehow even more glorious to the east in L.A. when the sun is setting. "Incredible," my designer friend marveled, "the effects He gets with just one unit."

Incredible, too, the effects Vin Scully gets with just one unit—in his case, his voice. As the legendary radio announcer for the L.A. Dodgers, Scully has spent his life in that light, broadcasting the sunset itself between pitches night after night. (Indeed, it may be thanks to those broadcasts that many Angelenos, including me, first became truly sensitized to the light—and to the light of language as well.) When I reached him by phone, it didn't take much more than the word *light* to get him launched, rhapsodizing, for instance, about how "come late July, with the sun setting off third base, the air actually turns purple tinged with gold, an awesome sight to behold, the Master Painter at work once again, and, owing to the orientation of the stadium, out beyond center field, you're staring at the mountains, and mountains beyond mountains, indeed, the purple mountains' majesty spread out there for everyone to see. And on evenings like that it can get to be like a Frederic Remington or a Charles Russell painting, the dust billowing up from the passing cars on the freeway. If you squint your eyes and only let your imagination soar, it's as if a herd of wild horses were kicking by."

As I write, I'm back in New York, exiled from that light. Sixty years ago, it occurs to me, my maternal grandfather, the Austrian Jewish modernist composer Ernst Toch, found himself exiled into that light. He and my grandmother lived on the Franklin Street hill, at the very edge of Santa Monica and Brentwood, north of Wilshire, in a house facing out toward the Santa Monica mountains. The view from their house, and particularly from the bay window of his composing studio, under the knotty branches

of a spreading coral tree and out over the Brentwood Golf Course, was incredibly lovely, especially at the golden hour. (Come to think of it, maybe *that's* where I first became smitten with this thing about the light of Southern California.) Occasionally, my grandparents would entertain guests up there. They'd meander around the grounds and through the house and eventually into his studio, approaching his desk—wedged up against that magnificent bay window, with its enthralling light-filled view—and invariably somebody would crack wise, saying something along the lines of "Well, no wonder you can compose, with a view like that!"

At which point, invariably, my grandfather would respond, "Well, actually, no. When I compose, I have to close the curtains."

(1998)

THREE
PORTRAITS
OF ARTISTS

True to Life:
David Hockney's Photocollages

The Past Affixed Also:
The Kienholz Spokane Series

A Parkinsonian Passion:
Ed Weinberger

Noya & Bill Brandt with self portrait (although they were watchi...

TRUE TO LIFE: DAVID HOCKNEY'S PHOTOCOLLAGES

Back in 1981, the painter David Hockney agreed to participate in a program at the National Gallery in London entitled "The Artist's Eye," in which he was invited to select a group of Master paintings from the museum's bounteous collections and, serving as guest curator, explain in a brief catalogue essay why those particular paintings mattered so much to him. He chose a Piero della Francesca, a Vermeer, a van Gogh, and a Degas. In the course of his essay, he celebrated the richness of the experience of looking at such paintings—especially when compared with the poverty of the experience of looking at most ordinary photographs. With a certain irony, he suggested that the only thing photography was much good at conveying—or, at any rate, conveying truthfully—was another flat surface, as in the reproduction of a fine painting. "About sixty years ago, most educated people could draw in a quite skillful way," he concluded. "Which meant they could tell other people about certain experiences in a certain way. Their visual delights could be expressed. . . . Today people don't draw very much. They use the camera. My point is, they're not truly, perhaps, expressing what it was they were looking at—what it was about it that delighted them—and how that delight forced them to make something of it, to share the experience, to make it vivid to somebody else. If the few skills that are needed in drawing are not treated seriously by everybody, eventually it will die. And then all that will be left is the photographic ideal which we believe too highly of."

Many New Yorkers will find these comments surprising, because—having in the meantime seen not just one but two highly successful gallery exhibitions of the results—they will realize that about the only thing Hockney has been doing since he wrote that manifesto is taking photographs. In fact, over the past three years Hockney has taken tens of thousands of photographs and deployed them in increasingly intricate collages. This fall, Knopf will release a book surveying the results of that passion. During the past year, as Hockney has been supervising the production of that book, I've had several occasions to talk with him about this curious detour in his career.

The first time we met, I was calling on him at his home and studio in the Hollywood Hills, just off Mulholland Drive, overlooking Los Angeles, and the first thing I asked him was what, given his previously documented prejudices, he was doing taking photographs at all. "Ah, well," he replied impishly, "you mustn't overinterpret those comments." Hockney is only forty-eight years old—disarmingly young for an artist who has maintained a world-level following for nearly twenty-five years. His mild Yorkshire accent betrays his English origins, although he sports a yellow-and-red-checkered cap across which is emblazoned the word CALIFORNIA—in homage to the state that has been his adopted home for almost twenty years. His face is genial, his round features emphasized by round glasses (the left frame gold, the right one black). Blond hair shags out from beneath the cap. Every time I met with him, his socks were mismatched (now purple and green, now yellow and red), always with a casual but seemingly self-evident authority. He is of medium height, but it takes a while to realize this, because he usually lumbers about with the comfortable slouch of a tall man. "It's not that I despised photography *ever*," he continued. "It's just that I've always distrusted the claims that were made on its behalf—claims as to its greater reality or authenticity. Actually, I've taken photographs for years. Snaps I'd call them—pictures of friends and of places we'd visit. When I'd get back here, I'd put the pictures in albums. Since the mid-sixties, I've managed to fill several each year. During some periods, I was more involved than others. I mean, clearly, all along I've had

an *ambivalent* relationship to photography. But as to whether I thought it an art form, or a craft, or a technique—well, I've always been taken with my curator friend Henry Geldzahler's answer to that question when he said, 'I thought it was a *hobby*.' "

Beginning in 1968, Hockney often used photography as an *aide-mémoire* in his painting. Several of his most famous portraits—for example, that of Ossie Clark and Celia Birtwell—were preceded by dozens of photographic studies, along with many pen-and-ink sketches. He'd photograph the furniture, the walls, the way light fell across the room at different times of the day; details of faces, hands, limbs; impressions of stances and postures. Photo-realism had come very much into vogue around that time, but Hockney wasn't interested in achieving a photographic likeness—a painting that would look "as real as a photograph." (Many photo-realist paintings were, in fact, slavishly traced onto the canvas from the projected slide of a photograph.) Rather, he was using the photographs to jog his memory; the confluence of dozens of discrete recollections and observations would form the eventual painting, which would in turn achieve a sort of distillation of the essence of all the studies that had preceded it. If anything, by using photographs in this manner he came to distrust their purported reality all the more.

"I mean, for instance, wide-angle lenses!" Hockney exclaimed that first afternoon. "After a while, I bought a better camera and tried using a wide-angle lens, because I wanted to record a whole room or an entire standing figure. But I hated the pictures I got. They seemed extremely untrue. They depicted something you never actually saw. It wasn't just the lines bending in ways they never do when you look at the world. Rather, it was the falsification—your eye doesn't ever see that much in one glance. It's not true to life."

To get around this problem, Hockney began making "joiners." For example, when he needed a photograph of his friend Peter Schlesinger standing, gazing downward, as a study for his *Portrait of an Artist (Pool with Two Figures)*, in 1972, he took five separate shots of Peter's body—head and shoulders, torso, waist, knees, feet—and spliced the prints together, effect-

ing the closest possible overlap. "At first, I was just going through all this because the result—the depiction of the particular subject—came out looking clearer and more true to life than a single wide-angle version of the same subject," Hockney explained. "However, fairly early on I noticed that these joiners also had more presence than ordinary photographs. With five photos, for instance, you were forced to look five times. You couldn't help looking more carefully."

Throughout the seventies, Hockney continued to take photographs as studies or mementos but with little interest in the medium itself. Dutifully, he'd have his assistants enter the prints in his ever-expanding shelf of albums (by the early eighties these numbered over a hundred and twenty volumes), but he was utterly careless with the negatives, tossing them unsorted into boxes. His apathy notwithstanding, other people were becoming quite interested. "The Pompidou Center in Paris kept nattering away at me for years to do a show of the photos, and I kept putting them off," he recalled. "I wasn't interested: most photo shows are boring— always the same scale, the same texture. But they kept insisting. They said they wanted to do it *because* I was a painter, and so forth. Finally, in 1981, I gave in, but I told them they'd have to come and make the selection themselves, because I didn't have a clue. So, early in 1982, the curator Alain Sayag arrived here in L.A. and spent four days looking through the albums, making his selection, and for four nights we sat here arguing about whether photography was a good medium for the artist. My main argument was that a photograph could not be looked at for a long time. Have you noticed that? You can't look at most photos for more than, say, thirty seconds. It has nothing to do with the subject matter. I first noticed this with erotic photographs, trying to find them lively: you can't. Life is precisely what they don't have. Or, rather, time—lived time. All you can do with most ordinary photographs is stare at them—they stare back, blankly—and presently your concentration begins to fade. They stare you down. I mean, photography is all right if you don't mind looking at the world from the point of view of a paralyzed cyclops—*for a split second.*

But that's not what it's like to live in the world, or to convey the experience of living in the world.

"During the last few years, I've come to realize that it has something to do with the amount of time that's been put into the image. I mean, Rembrandt spent days, weeks painting a portrait. You can go to a museum and look at a Rembrandt for hours and you're not going to spend as much time looking as he spent painting—observing, layering his observations, layering the time. Now, the camera was actually invented long before the chemical process of photography. It was being used by artists in Italy in the sixteenth century in the form of a camera obscura, which is Latin for 'a dark room.' The device consisted of a dark box with a hole in it and a lens in the hole which projected an image of the outside world onto a flat surface at the far side of the box. Canaletto used one in his paintings of Venice. His students would trace the complicated perspectives of the Grand Canal onto the canvas, and then he'd paint the outline in, and the result would appear to confirm the theory of one-point perspective. But, in terms of what we've been talking about, it didn't really matter, because the entire process still took time, the hand took time, and though a 'camera' was used there's no mistaking the layered time. At a museum, you can easily spend half an hour looking at a Canaletto and you won't blank out.

"No, the flaw in the camera comes with the invention of the chemical processes in the nineteenth century. It wasn't that noticeable at first. In the early days, the exposure would last for several seconds, or even longer, so that the photographs were either of people, concentrated and still, like Nadar's, or of *still* lifes or empty street scenes, as in Atget's Paris. You can look at those a bit longer before you blank out. But, as the technology improved, the exposure time was compressed to a split second. And the reason you can't look at a photograph for a long time is because there's virtually no time *in it*—the imbalance between the two experiences, the first and second lookings, is too extreme.

"Anyway," Hockney concluded, "Sayag and I spent four nights having these arguments, and in the daytime he made his selection." The trouble

came when it was time to find the negatives amid the many boxes, so that proper reproductions could be made. "There was no way they were going to find them in four days, so instead we went down to a store and bought several cases of Polaroid SX-70 film and came back up here and photographed the prints Sayag had selected, so that he could go back to Paris and prepare the show." The curator left, the negatives were eventually ferreted out, and by the summer of 1982 the Pompidou Center was indeed running a highly successful show entitled "David Hockney, Photographer."

Meanwhile, back in Los Angeles, Hockney was left with several dozen packs of unused Polaroid film. The morning after Sayag departed, Hockney loaded his Polaroid and started on a tour of his house, snapping details. Beginning in the living room—the very room we were now talking in—he cast three views of the floor, moving left to right, then three views of the middle distance, and then three views of the ceiling, with its lovely

skylight. There was no attempt to effect the sort of exact matching which had characterized his joiners. (Chairs and tables were repeated from shot to shot, from slightly different vantages.) The third middle-distance view included a sliding glass door and, through it, the blue of a deck. He now went out onto the deck, repositioned himself, and shot another series of images, with new perspectives but similar repetitions. In the corner of the right-most of these middle-distance images could be seen the top of a blue staircase leading downward. Repositioning himself once again, leaning out over the edge of the balustrade, he shot still another series—this time of the blue steps and the garden and pool toward which they led. Already, as he was shooting the individual Polaroids, he was arranging them into a composition, laying the square SX-70 prints side by side, reshooting perspectives where the images didn't quite meld or where the articulation of space became confused. By the time he was through, he'd created a rectan-

gular panel consisting of thirty individual square images arranged in a grid—three squares high and ten wide—which uniquely conveyed the experience of walking through that house from the living room onto the deck, down the stairs, and toward the pool. And yet this movement was not conveyed in traditional comic-book style or in the staccato-cinematic mode of Eadweard Muybridge, where each new frame implies a new episode or another staggered step. The entire panel read as an integrated whole—as a house, a home, through which the viewer was invited to move from inside to outside and then back.

Indeed, what this collage finally looked most like was the very experience of looking as it occurs across time. Hockney glued the thirty Polaroids onto the panel and then inscribed across the white borders of the bottom ten squares, "My House, Montcalm Avenue, Los Angeles, Friday, February 26th, 1982." And he was off: during the next three months he would compose more than a hundred and forty Polaroid collages. By the summer, they would be the focus of three separate exhibitions—in New York, Los Angeles, and London. A couple of them would even be included in the show at the Pompidou Center.

"From that first day, I was exhilarated," Hockney recalled as he showed me a reproduction of the house collage. "First of all, I immediately realized I'd conquered my problem with time in photography. It takes time to see these pictures—you can look at them for a long time, they invite that sort of looking. But, more important, I realized that this sort of picture came closer to how we actually see—which is to say, not all at once but in discrete, separate glimpses, which we then build up into our continuous experience of the world. Looking at you now, my eye doesn't capture you in your entirety. I see you quickly, in nervous little glances. I look at your shoulder, and then your ear, your eyes (maybe, for a moment, if I know you well and have come to trust you—but even then only for a moment), your cheek, your shirt button, your shoes, your hair, your eyes again, your nose and mouth. There are a hundred separate looks across time from which I synthesize my living impression of you. And this is wonderful. If, instead, I caught all of you in one frozen look, the experience would be

dead. It would be like—it would be like looking at an ordinary photograph."

No sooner had Hockney achieved his breakthrough with his tour-of-the-house collage than he began training his Polaroid on people. By the end of his first week of voracious experimentation, he had achieved what would prove one of the most fully realized collages in the entire series—a warmly congenial portrait of his friends the writer Christopher Isherwood and the artist Don Bachardy. The two emerge from a grid of sixty-three Polaroids (seven squares by nine). Isherwood, the aging master, is seated; there is a wineglass in his hand and a cheerful gleam in his eye, which is trained upon the camera. The younger Bachardy stands, leaning against the wall and looking down affectionately at his longtime friend. Isherwood's head is basically captured in one square still, but Bachardy's hovers, a play of movement, fanned out into six separate squares—that is, six separate vantages, six separate tilts of the head, six separate moments of friendly concentration. Bachardy's six heads give the impression of a buzzing bee bobbing about Isherwood's still flower of a face. And yet the six vantages read, immediately, as one head. And, indeed, a head no larger than Isherwood's. If anything, Isherwood's face is the center of attention, the fulcrum of the image.

"In this case, at first they were both looking at me," Hockney explained as we examined a reproduction of the collage. "But as the minutes passed I noticed that Don spent more and more time gazing down at Christopher with that fond, caring look that so characterizes their relationship. So the piece changed as I was making it."

By way of contrast, back in 1975 Hockney had snapped a photo of his friend Henry Geldzahler, cigar in hand, making a point in conversation with Andy Warhol. The two were seated, facing each other, and a Great Dane stood guard at Warhol's side, facing the camera. Behind them was a mirror, in which you can see Hockney standing, taking the picture. Behind him was another mirror, where, again, you can see the conversationalists and the dog. Strangely, it's only in the second reflection that you notice that the dog isn't real: it's stuffed. And, looking back at the figures of

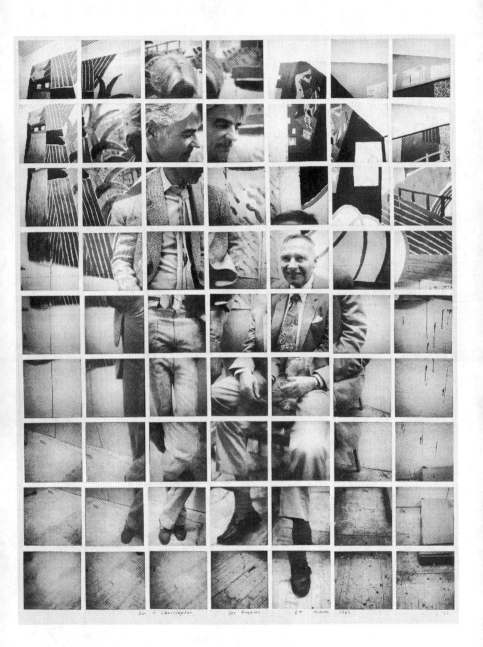

Gui + Christopher Los Angeles 6th March 1982

Geldzahler and Warhol, you can't really tell the difference. "That's the whole point," Hockney told me. "In ordinary photographs, *everybody's* stuffed." In this new portrait, however, Isherwood and Bachardy are anything but stuffed. Theirs is a living relationship: it's living right there before your eyes.

"It took me over two hours to make that collage," Hockney continued. "I'd snap my details, spread them out on the floor while they developed, and go back for more. Christopher said I was behaving like a mad scientist, and there *was* something mad about the whole enterprise. When you look back at the completed grid, it looks as if each shot were taken from one vantage point—there is, as it were, a general vantage—but if you look more closely you can see that I was moving about all over. The lens on a Polaroid camera is fixed: you can't add close-up or zoom lenses, or anything. So to get a close-up of the floor I had to get *close up* to the floor. In this other one here, of Stephen Spender"—Hockney pulled out a reproduction of a remarkable composite portrait with the writer seated in the foreground and Hockney's living room receding into the background—"I spent so much time in the back of the room, *behind* Stephen's chair, that finally he exclaimed, 'Are you still taking *my* picture, David?' "

The three exhibitions of these Polaroid collages, when they were mounted a few months later, would go under the rubric *Drawing with a Camera*—assay and correction, approximation and refinement, venture and return. "The camera is a *medium* is what I suddenly realized," Hockney told me. "It's not an art, a technique, a craft, or a hobby—it's a tool. It's an extraordinary drawing tool. It's as if I, like most ordinary photographers, had previously been taking part in some long-established culture in which pencils were used only for making dots—there's an obvious sense of liberation that comes when you realize you can make lines!" And, for all their beauty as color-saturated objects (Hockney, as ever, is an extraordinary colorist: he somehow manages to coax colors out of Polaroid film you'd never have imagined were in there), these collages are principally about line. An inner sleeve crease, for example, aligns in the next frame with the outer sleeve contour, and contours generally jag from one frame

to the next—a series of locally abrupt disjunctions merging to wider coherence. But there is also, in some of these collages, as in some of Hockney's finest pencil drawings, a remarkable psychological acuity at work. In the Spender combine, for example, the face itself develops out of six squares—three tall and two wide. Those aspects to the left are alert, inquisitive, probing; those to the right are weary, resigned. Spender, Hockney seems to be suggesting, is both. Around the same time, Hockney contrived a poignant study of his housekeeper, Elsa, with her four children grouped around the kitchen table. Little Diana peers out at the camera, adorably, from her mother's lap. Her mother meanwhile is looking over to the side at her second-oldest son, who is looking back benignly at her. Her youngest son is looking calmly out into space, with a hint of a smile. Each of the faces exists serenely whole, centered in its square: a great, soft, uncomplicated calm circulates lovingly among them. Only the oldest son, standing in the middle, his lean body taut and his hands shoved in his pockets, seems to exist apart: his face is divided between two squares, and his gaze seems more complex, anxious, intent—as if in growing he were growing out of this simple household. He seems as divided as his face.

For a while, Hockney's collages got bigger and bigger. (The biggest—consisting of some hundred and eighty-five squares—took more than three hours to complete and involved seven models.) By the end of the Polaroid series, however, Hockney had so mastered his technique that he could radically reduce the scale of the collages while sustaining the complexity of the images at a level he'd attained in the largest works. The masterpiece of the series is arguably one of the last collages, a forty-nine-square composite of the late British photographer Bill Brandt and his wife, Noya, who are portrayed seated as they gaze down at the floor before them, where their own composite is slowly coming into being (though at the outset, Hockney had scattered a splay of hastily snapped self-portraits as a sort of space saver). The piece becomes an intimate celebration of their intense concentration.

"I think some of the most effective collages in both the Polaroids and my more recent series involve the theme of looking—of looking at peo-

ple looking," Hockney commented as we examined the Brandt collage. "There's a kind of doubling, an intensification of the experience. For that matter, looking itself has been the central subject of all these collages. Ordinary photography, it seems to me, is obsessed with subject matter, whereas these photographs are not principally about their subjects. Or, rather, they aren't so much about things as they are about the way things catch your eye. I don't believe I've ever thought as much about vision— about how we see—as I have during the last few years." And Hockney's collages are, in turn, a school for vision. In ordinary photographs, a whole is presented from which details can be elicited. Hockney seems to suggest that this is the opposite of how we actually see the world. For him, vision consists of a continuous accumulation of details perceived across time and synthesized into a larger, continuously metamorphosing whole. "Working on these collages, I realized how much thinking goes into seeing—into ordering and reordering the endless sequence of details which our eyes deliver to our mind," he explains. "Each of these squares assumes a different perspective, a different focal point around which the surroundings recede to background. The general perspective is built up from hundreds of micro-perspectives. Which is to say, memory plays a crucial role in perception."

Looking, for Hockney, is interesting: it is the continual projection of interest. "These collages work only because there is something interesting in every single square, something to catch your eye," he told me. "Helmut Newton, the photographer, visited me up here the other day, and I said, 'Everywhere I look is interesting.' 'Not me,' he replied. 'I bore easily.' Imagine! I've always loved that phrase of Constable's, 'I never saw an ugly thing.' Doing these collages, I think I've come to better understand what he means: it's the very process of looking at something that makes it beautiful."

Hockney paused, suddenly very tired. "Of course," he said, "thinking intensively about looking forced me to think more carefully about Cubism, because looking—perception—was the great theme of Cubism. But let's talk about that some other time. I'm afraid I'm getting sleepy. My friends have been amused at my pace these past several months—they say I've

become like a child, playing for hours on end and then just suddenly conking out. The truth is, I'm not sleeping very well: I keep waking myself up with ideas!"

When I came over again a few days later, the front door was open, and I walked into the living room, where I found Hockney hunched over a proof sheet, peering intently. For a long while, he didn't even notice my presence. "Ah," he said finally, looking up, "hallo." He set the proof sheet aside. "Have you ever noticed," he asked, as if there hadn't been the slightest interval since our last conversation, "how when you look at things close up, you sometimes shut one eye—that is, you make yourself like a camera? Otherwise, things start to swim. It becomes difficult to hold them in visual space. The Cubists, you know, didn't shut their eyes. People complained about Picasso, for instance—how he distorted the human face. I don't think there are any distortions at all. For instance, those marvelous portraits of his lover Marie-Thérèse Walter which he made during the thirties—he must have spent hours with her in bed, very close, looking at her face. A face looked at like that *does* look different from one seen at five or six feet. Strange things begin to happen to the eyes, the cheeks, the nose—wonderful inversions and repetitions. Certain 'distortions' appear, but they can't be distortions, because they're reality. Those paintings are about that kind of intimate seeing."

Among Hockney's Polaroid collages, there's an especially luscious portrait of his friend and frequent model Celia Birtwell, which seems intended as an homage to those Picasso portraits of Marie-Thérèse. Celia is wearing a white, lacy blouse, and one arm is thrown languorously behind her head. Her cheek rests calmly against the other hand. Her eyes seem to float—there are three of them. Two mouths. Two noses. A frond of curls drifts away from her forehead into the dark surround—a smoky wisp, a whisper of desire.

"Analytic Cubism in particular was about perception—about the difficulty of perception," Hockney continued, referring to the work Picasso

and Braque undertook between 1909 and 1912: paintings characterized by especially dense visual composition, usually in monochrome grays or browns. "I've recently been reading a lot of books about Cubism, and I keep coming upon discussions of intersecting planes, and so forth, as if Cubism were about the structure of the object. But really it's rather about the structure of *seeing* the object. If there are three noses, that is not because the face has three noses or the nose has three aspects but because it has been seen three times and that is what seeing is like. And, yes, it's hard, but it's also tremendously rewarding. I mean, no Cubist painting jumps off the wall at you—you have to go to it. There was recently a remarkable 'Essential Cubism' show at the Tate, and I spent hours and hours there during my last trip to London. That show *forced* you to slow down. If you just glanced quickly, you didn't see anything. But, when you did slow down, the paintings just grew and grew. Your eyes darted in and out, forward and back, just like in the real world. At times, you almost forgot you were looking at pictures on a wall! Coming out of those galleries, it just happened that I was confronted with my own painting of Ossie and Celia and, right near it, a Francis Bacon triptych. The Cubist paintings had

been mainly still lifes, and here these ones of Bacon's and mine were fairly dramatic paintings of people. You'd have thought they would have stood up. But, on the contrary, following the intensity of the experience of the Cubist studies, those two paintings—based as they were on a pretty standard one-point perspective—seemed strangely distant, flat, and one-dimensional."

Hockney's love of Picasso is long-standing, although only recently has it taken on this sort of urgency. On several occasions in the last year, he has delivered a lecture he calls "Major Painting of the Sixties." Audiences are invariably surprised when he starts out by proclaiming that the most important art of the sixties did not occur in New York or California or London, nor was it a part of any Abstract Expressionist, Minimalist, or Pop movement; rather, it came into existence over a period of just over a week in March 1965 in the South of France, in an eruption of creativity during which Pablo Picasso created thirty-three variations on the theme of the artist and his model. (Hockney himself owns one of these pieces; he discovered the others while researching his own in an exhaustive Picasso catalogue raisonné.) The claim is doubly heretical: not only are other artists usually considered to have been doing much more interesting work during the sixties but Picasso himself is thought to have been doing much more important work earlier in his career. "The sophisticated art world tends to act as if Picasso died about 1955, whereas he lived for almost twenty years after that," Hockney argues. "Common sense tells you that an artist of that caliber (the only people you can compare him to are Rembrandt, Titian, Goya, Velázquez)—that an artist of that caliber does not spend the last twenty years of his life repeating himself. It's harder to see what he's doing, perhaps. But he remains to the end far and away the greatest draftsman of the twentieth century—the artist with the most sensitive and inquiring eye and the most supple and inventive hand. Those thirty-three paintings are simply richer and more engrossing than anything else that was being done at the time. Still, at that age—at eighty-four!—Picasso was finding new ways to see, new ways to express his vision."

Hockney's Polaroid collages came into being very much in the thrall of

Picasso. The portrait of Celia is but one example. Another portrait—this one of Henry Geldzahler seated on a rickety stool, his legs outspread, as he cleans his glasses—echoes Picasso's 1910 portrait of the art dealer Ambroise Vollard. There are allusions to *Les Demoiselles d'Avignon* in other collages, and there are even two still lifes—witty riffs on the old Cubist themes of guitar, tobacco can, wine bottle, and daily journal (in this case, the *Los Angeles Times*).

By mid-May of 1982, however, Hockney had stopped producing his Polaroid collages. This was partly, perhaps, because the passion had simply spent itself. It was partly, no doubt, because he now needed to redirect his energies from making collages to preparing them for exhibition—the three "Drawing with a Camera" shows were on the verge of opening. But there was an additional factor: Hockney was beginning to sense an interior flaw in the Polaroid medium. Just as cubes were not the point of Cubism, squares were not the point of Hockney's activity. But the square matrix-grid seemed an insurmountable requirement in making these collages: one cannot cut the white border from a Polaroid picture the way one might cut the crust from a slice of bread. (With Polaroids, if you cut into the tile the picture literally comes apart in your hands: the various layers of chemical pigment come unfixed.) While the vision evoked in these grids seemed more true to life than ordinary photography, the white grid itself was constrictive of that burgeoning life. It wasn't just that people began focusing on the grid (seeing Hockney's as yet another in a series of modernist variations on the grid theme—Eva Hesse, Sol LeWitt, Agnes Martin, and so forth). Rather, it was that the rectangular grid remained trapped in the window aesthetic that had been one of the principal targets of the Cubist movement.

"It can't just be a coincidence that Cubism arose within a few years of the popularization of photography," Hockney surmises. "Picasso and Braque saw the flaw in photography—all the sorts of things about time and perception which I've only recently begun to appreciate: the flaw in the camera. But in doing so they also recognized the flaw in photography's precursor, the camera obscura. Now, the camera obscura essentially *was* a

dark room. It had a hole in it, and the hole was a window. You're looking out a window—that was the idea. In fact, that's why you get easel painting, which arose around the same time: the canvas was meant to be a kind of window you could slot back into your own wall. This idea of looking out a window dominated the European aesthetic for four hundred years. Interestingly, by the way, Oriental art never knew the camera obscura, and their art instead looks out of *doors*. Many important works of Oriental art take the form of a screen, which, like a door, stands on the floor. The difference between a window and a door is that you can walk through a door toward what you are seeing. You cannot do that with a window: a window implies a wall—something between you and what you're looking at. A lot's been written about the influence of Oriental art during the last half of the nineteenth century—Manet's appropriation of Japanese motifs, van Gogh's use of the bold solid colors, Monet's gleanings of atmospheric perspective, and so forth—but I suspect the Oriental alternative was especially important for the Cubists. Because what they were up to, in a word, was shattering that window. Cézanne was getting there: in his still lifes he observed that the closer things are to us the harder it is for us to place them—they seem to shift. But he still looked through a window at those cardplayers grouped around that café table. Whereas, as has often been said, Picasso and Braque wanted to break down that window and shove the café table right up to our waist, to make us part of the game."

For all that the Polaroids had taught Hockney about time and vision, they weren't going to be able to help him break down that window: on the contrary, the quaint white grid made the collages look even more window-like than most paintings.

For a time, it seemed Hockney had sworn off photography altogether—or, at any rate, had reverted to a decidedly off-again mode. In mid-May, he drove up to San Francisco. On the way, he veered briefly into Yosemite Valley, where, using a 35-millimeter camera, he took one sequence of nine shots of Yosemite Falls—not nine separate shots of the entire waterfall but

nine segmented sections in vertical sequence, starting with the sky, trailing down the falls through the far valley, across a river, up the near shore, all the way down to his own foot (clad in a tennis shoe). Coming back to the car, he threw the camera into his pack, and he didn't even bother to have the film developed until the fall. During the summer, he visited England, and then, returning to the United States in early September, he traveled by car through the Southwest, to Zion and Bryce Canyons and the Grand Canyon, where he resumed taking pictures. They weren't Polaroids (Polaroids are notoriously inadequate for capturing distant vistas), although, as in the Polaroid collages, he was compiling dozens of details rather than any single wide-angle swaths. He wasn't sure what, if anything, he was up to, and he wouldn't have an inkling, really, until he returned to Los Angeles and had the film developed. Once he'd got the prints back, however, he quickly assembled a few collages and realized, with a great new surge of excitement, that he was on the verge of another breakthrough.

These new pieces were different from the Polaroids in many ways: with the Polaroids, Hockney had established a general perspective but in fact had had to move all over the room to compile the details. With the new collages, he could stay in one spot, using the camera's lens to zoom in for details at various distances. (He now alternated between a Nikon 35-millimeter camera and a much simpler Pentax 110 camera. He preferred the Pentax—a machine not much larger than a cigarette pack, which nevertheless has remarkable optical sophistication, and which he could slip into his pocket and carry around all the time, pulling it out whenever the fancy took him.) The Polaroids took hours to make, but when he'd finished shooting he'd also finished the collage. With the new pictures, the actual shooting could be completed in a few minutes (as fast as he could reload the camera), but the assembly of the collage didn't occur until he got the prints back, days or weeks later, and began building the piece on the worktable in his living room. This second stage of the process could take hours. With the Polaroids, he had had to deal with those white borders, whereas the new photographs were printed flush, with no borders, and hence no white window grid.

"I took dozens of pictures at any given site," Hockney explained, the afternoon we got around to reviewing this more recent series. "And then I just took the exposed rolls to one of the local places here, down in the flatlands, to have them developed—usually I'd go to this Speed Cleaning and One-Hour Processing place. It took me a long time to convince them that I truly wanted them to 'Print Regardless,' and I still get these wonderful standardized notices back with my batches of prints, patiently explaining what I am doing wrong—how I should try to center the camera on the subject, focus on the foreground, and so forth. Once I got the prints, I'd start building the collages, keeping to one strict rule: I'd never crop the prints. Somehow that seemed important to the integrity of the enterprise: things would get all messed up whenever I trimmed them. The evenness of time seemed to be tied up with a regularity in the print size. This, in turn, forced me to be aware of how I was framing the shots as I took them. In effect, I ended up 'drawing' the collages twice."

Given the dissimilarity of the two processes, it is striking how similar the earliest of these new photocollages were to their Polaroid antecedents. (For the sake of convenience, I will refer to all the collages in this later series as "photocollages," as opposed to the "Polaroid collages," of the ear-

lier phase.) Indeed, they seemed to come as close as one could imagine to the original rectangular grid of the Polaroids: only the white borders were missing. There was very little overlap of prints. (Later, it would be rare not to find overlaps.) It seemed that, given a vista—say, the Grand Canyon, looking north—Hockney had simply framed a detail, taken a shot, moved the viewfinder over to the side of the previous detail, refocused, taken a new one, and again, and again, and then down, zigzagging in rows, back and forth. The collage formed a perfect rectangle and, still, a sort of window.

"It's incredible how deeply imprinted we are with these damn rectangles," Hockney commented as we looked at one of the early Grand Canyon collages on its cardboard panel. "Everything in our culture seems to reinforce the instinct to see rectangularly—books, streets, buildings, rooms, windows. Sam Francis once told me how odd American Indians initially found the white settlers—'these people who insist on living in rectangular-shaped buildings.' The Indians, you see, lived in a circular world.

"But these early collages were really more like studies. You did them, just as you do a drawing sometimes, to teach yourself something. It doesn't matter what it looks like when you're finished—that's not why it was made. In this case, in retrospect, I realize I was training my visual memory, and this took a lot of time." Since these prints weren't developing right before his eyes, like the Polaroids, Hockney had to be aware of which areas he'd already covered and which ones he hadn't. Even in a rectangular format, this exercise required intense concentration. Tilting the camera and anticipating intricate overlaps would require still greater skill.

Within a few days of putting together the first of the new collages and realizing he was on to something, Hockney was on the road again, back to Utah and the Grand Canyon. He took thousands of pictures during the next three or four days—enough to compose twenty-five collages. (It would take over a month to do the actual assembling once he got home.) Most of the collages from this trip concerned wider vistas, portrayed with astonishing clarity. Ordinarily, the photographer of such an expanse has to choose one point of focus, with the result that things closer or farther or to

the sides are progressively more out of focus. This, according to Hockney, is another way in which photography falsifies the experience of looking. "Everything we look at is in focus as we look at it," he explains. "Now, the actual size of the zone the eye can hold in focus at any given moment is relatively small in relation to the wider visual field, but the eye is always moving through that field, and the focal point of view, though moving, is always clear." The experience of this kind of looking is preserved in collages where each frame of distant butte or nearby outcropping is in focus and comprises just about as much of the field as the eye itself could hold in focus at any one moment in the real world.

The pictorial rigor and clarity of these panels are reminiscent of the treatment of space in paintings by van Eyck, say, or Piero della Francesca—two of Hockney's favorites. Those artists, too, went to great lengths to record each "object" at its moment of clearest focus—every object on the canvas, "near" or "far," can bear the weight of focused attention, just like the real world, and precisely unlike the world as it is portrayed in conventional photography. "I've always loved the depiction of space in early Renaissance pictures," Hockney told me. "It's so *clear*. I think that clarity is something that has to exist in all good pictures. The definition of a bad picture for me is that it's woolly—those paintings aren't ever woolly, no matter what's portrayed. If it's a mist, it's a clear mist, and not a woolly mist. There has to be this clarity, which is the clarity of the artist who did it—the clarity of his vision, his sense of being."

The major innovation in the new photocollages had to do less with the early Renaissance, however, than with high Cubism. For the first time, on this return to the Southwest, Hockney was beginning to break down the window. Looking at the set of collages from his earlier trip, he had quickly realized what was wrong: there was an arbitrariness to the edge—particularly the bottom edge. To a great extent, conventional photography is about edges—about how to frame the object of vision. Indeed, that is the ordinary photographer's principal contribution to the moment of seeing: his sense of composition, how he chooses to frame the world within four perpendicular edges. "But I wasn't interested in that," Hockney told

me. "Already, with the Polaroids, that sort of composition wasn't an issue. I could have added a strip of squares to the left or the right, or removed one, without really affecting the experience of seeing those collages. The Cubists had a lot of problems with their edges—sometimes they tried to solve them by creating circular paintings—and it's easy to see why: there are no edges to vision, and certainly no rectangular edges." For Hockney to stop at some arbitrary middle distance was alien to the kind of vision he was now attempting. Looking at those first collages of the Grand Canyon, he immediately realized that he had to bring the picture right up to the viewer, that he had to bring the distance right up to his own feet and include the ground right in front of him as well as the canyon beyond.

"Cubism, I realized during those few days, is about our own bodily presence in the world," Hockney continued. "It's about the world, yes. But ultimately it's about where we are in it, how we are in it. It's about the kind of perception a human being can have in the midst of living." (A few months before this conversation, *Vanity Fair* had highlighted some of these collages, suggesting that they somehow blended "NASA spaceship photography with cubism." And there was a certain similarity: just as Jackson Pollock's lush optical fields of the forties and fifties might be seen as having been influenced by the telescopic photographs of distant nebulae which were just then becoming popularly reproduced, so Hockney's work can be seen as having come into existence under the sign of NASA—the sequential shutter-streams of overlapping photographs recording lunar or Martian landscapes or Saturnian rings. But it's precisely the connection with Cubism which upends this false analogy. Hockney's collages, like Cubism, are a record of *human* looking. It's exactly the point that an automatic machine could not have generated them.) From this time on, Hockney usually included photographs of his own feet in the collages. In effect, his feet stood in for him; they planted him as they plant the presence of any subsequent viewer. Indeed, standing there, facing forward into the world before them, the world of vision, the feet seem transposed figures for the eyes themselves.

Several of the Grand Canyon collages are huge and spectacular, long

banners of looking, made up of hundreds of prints. But one of the most noteworthy collages of this period was taken along the Merced River, in Yosemite Valley, which Hockney visited on his return drive. In this one, Hockney has managed to convey how the sound of a rushing stream *looks*. The rectangular grid of the earliest photocollages seems to shake apart before our eyes amid the onrush of cold, tumbling mountain water. The effect is bracing. For Hockney, it was liberating. Thereafter, his collage patterning was free to dash and dart, to arch and overlap, in a celebration of fresh vision.

Over the next several months, Hockney continued to record occasional landscapes. But increasingly, here again, his attention was turning back to people, and one of his preferred subjects proved to be his mother. In a particularly moving portrait, taken during a November trip to England, he portrays her in a blue-green raincoat on a slate-gray afternoon in the cemetery outside Bolton Abbey, in Yorkshire. The grass in the foreground is wet and marvelously described—a rich pelt of individual green blades. In the background rise ancient gravestones; his mother sits leaning against one of them. There is a blank rectangle, a lacuna in the middle of the collage, immediately above her head—an empty plot. Her consciousness, perhaps, of her own mortality? This is at any rate a portrait brimming with remembrance. Bolton Abbey, Hockney explains, is one of the places that she and his late father used to come to sixty years ago when they were first courting.

There were countless other portraits during the fall, the middle period of Hockney's photocollage passion—all the subjects from the Polaroid days, it seemed, were now being recast in Pentax. Throughout, his approach remained consistent: these middle photocollages constitute an exploration of how people are couched in space and how space is couched in time, the time of looking. The viewer, looking, experiences a living relationship in time, but it's strangely unreciprocated: the people in the picture, suspended—sitting, standing, staring, "posing"—don't quite live back at us. It was this fixity which Hockney, by mid-December, was seeking to shatter.

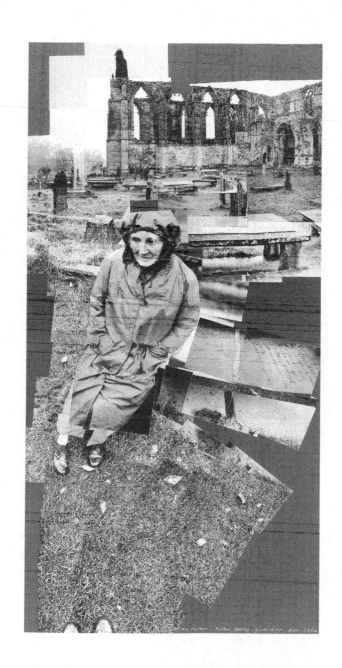

A poster commission for the 1984 Winter Olympics proved the occasion for one of his first efforts in the new direction. "I decided to do a study of an ice skater, and I invited a skater friend to join me at a rink out in New York City," he recalled. "I watched him for some time, and I noticed something very odd: you never see the blur. The convention of the blur comes from photography. It's what happens when motion is compressed onto a chemical plate. We've seen so many photos of blurs that we now think we actually see them in the world. But look sometime: you don't. At every instant, the rapidly spinning skater is distinct. And I wanted somehow to convey this combination of speed and clarity." The resultant collage has a lot of spin—legs flying, skates scraping, shirt billowing, head turning, arms rising, everything converging on and moving out from the focused center, the waist—but no blur. A series of studies Hockney undertook a few days later, back home in Los Angeles during a particularly gemütlich dinner with the film director Billy Wilder proved both simpler and more successful. At one point, following dessert, Hockney noticed that Billy Wilder was fixing to light his cigar, and he immediately reached for his Pentax. In the ensuing collage—a flourish consisting of a mere six overlapping prints (and the bottom one doesn't really count, since it simply describes two elegant wineglasses on the table in the foreground)—he shows Wilder striking his match; bringing it up to his face; inhaling, momentarily distracted from the conversation, which he already seems bent on rejoining; and, in the last print, looking up, puffing contentedly, obviously framing some repartee. The prints fan out, one on top of another: the entire piece reads as one carefree, casual gesture—a toss-off.

On the first day of the new year, Hockney, his mother, and his friend Ann Upton sat down at the wooden table in his living room to play a game of Scrabble, with their friend David Graves keeping score. The occasion constituted both a culmination and a new breakthrough. "The game lasted two hours, I was clicking away the whole time, and I still came in second," Hockney boasted as he showed me the result. "Naturally, my mother won." And, looking at the picture, you can see she's going to: her face appears a

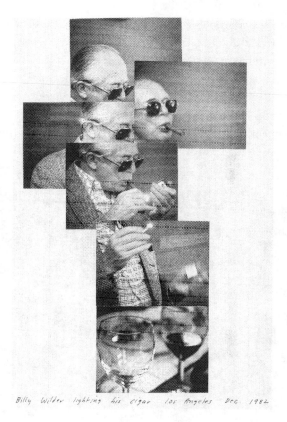

Billy Wilder lighting his cigar Los Angeles Dec. 1982

half-dozen times, in different degrees of close-up, and every shot captures
the visage of a shrewd, veteran contender. *Boss hen,* reads the bottom file
of words as the board faces Hockney. (The words *scowls, sobs,* and *pool*
are also floating in there.) The plastic board is mounted on a spindle, so
that it can be rotated from one player to the next. Hockney has taken
details of the board at various moments and cleverly interwoven them in
the center of the collage so that it's possible, with a little study, for the
viewer to reconstruct the game, or at least its key moments. We watch as

Mrs. Hockney concentrates and then scores a handsome windfall by centering *vex* over a double-word square—a neat twenty-six points. The board comes round to Ann, affording her access to a triple-word corner slot—she ponders, and ponders (five separate faces), and finally ventures the truly pathetic *net*. (Three lower-scoring letters could not have been found.) David Graves, keeping score, looks over her shoulder, considers her predicament, and then breaks into a grin at her solution: three times one times three—nine points. A cat on the side of the table looks up, rum-

mages around, and falls back to sleep. Hockney's own tiles are arrayed on their stand before him: "LQUIREU."

"He was trying for *liquor,*" one cognoscente hypothesized the day in May 1983, when this and the other collages in this series were first exhibited in New York. "Only he kept his 'Q' way too long into the game. You can't just hold on to those big letters endlessly waiting for the right vowels to come along."

"I don't know about that," replied a friend. "What about *liqueur?* That would have given him a fifty-point bonus for using all his letters if he could have attached it to an 'S.' "

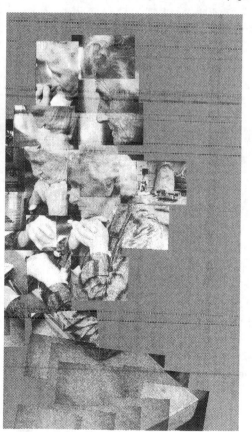

And the extraordinary thing about this collage is that it lends itself to that kind of second-guessing—it opens out onto that kind of storytelling. Indeed, it simultaneously tells a story and presents a group portrait. Dozens of hands, eyes, faces, a spinning board at countless angles: and yet at all times a recognizable picture of a group of three—implicitly four—individuals (five if you count the cat) engaged in an immediately recognizable activity.

In *The Scrabble Game,* Hockney had achieved a level that he was able to sustain for several weeks—notably through a series of supple and elegant pieces that he composed on a February trip to Japan. But toward the end of that visit he began to press the terms of the challenge even further. With these

late collages, he was becoming increasingly interested in the depiction of movement through space—not just the movement of people's heads and limbs as they sat talking but their movement as they walked, the movement of cars and trains, and his own movement, walking or driving through the field of vision. In a collage taken from a bridge over a narrow canal in Kyoto, for example, he preserves the linear integrity of the various vertical posts and trees that recede into the distance between the canal and a parallel street to its right. The result is that the traffic on the street is minced into dozens of narrow, clipped details—car windows, fenders, hoods, headlights. This noisy jumble of traffic plays off against the imperturbable verticals, and details from the same cars seem to move forward in a sort of stutter-progression from one frame to the next. Similarly, in another collage, as his traveling companion Gregory Evans looks out the window of a train moving through suburban Kyoto he seems to be surveying a sprawling city: it takes a moment to realize that most of this "city" is made up of the same house seen over and over again, at different distances, as the train rolls by, and that this sleight-of-collage is one of the things that gives the piece its internal sense of movement.

The increasingly complex depiction of movement through space becomes important in some of the most recent collages, in which Hockney has been endeavoring to compress a three-dimensional narrative into a two-dimensional plane. "At the time I did *The Scrabble Game*," Hockney recalls, "Ann said, 'It's better than a movie.' And in a way it was. You see, I think we overrate the cinema in much the same way we do photography. The increasing popularization of movies may have been one of the reasons for the lapse in the progress of Cubism after the First World War. The movie must have appeared to be the most vivid and accurate depiction of reality possible—it seemed to address many of the same concerns as Cubism (the need to include time, for instance), so that many artists just gave up the terrain of depiction and took off on this journey toward greater and greater abstraction. The problem is that the movie, too, is flawed. For one thing, we're back with the camera obscura—now all of us literally sit inside the dark room, staring through the rectangular hole in

the wall. Furthermore, a movie must traffic in literal time and can only go forward. Even when it pretends to go back, the spool is moving forward, forcing us to keep to an established, dictated pace. There's no time for looking, as there always is in the world. I'm not saying that it's not a good medium—only that it's not what we think or thought it was. So I've recently been trying to figure out ways of telling stories in which the viewer can set his own pace, moving forward and back, in and out, at his own discretion."

As the occasion for one of these "line narratives" Hockney decided to photograph the noted photographer Annie Leibovitz, who had come out to California, on assignment from *Vanity Fair,* to photograph him. "She's a lovely, bright woman," he told me. "And we had some wonderful conversations about the issues I was grappling with. When it came time for her to take my portrait, she told me, 'I just want it to be natural. I don't want to lay anything on it.' Whereupon she packed me and her assistant into a station wagon and drove for two hours into the high desert: she wanted a plain, flat horizon. It turned out there was snow on the desert when we got there, but that didn't seem to matter. So we parked, and she and her assistant unloaded all these lamps and cables, opened the car's hood to attach the wires to the battery, dragged the equipment a few dozen yards into the desert, where they established this elaborate setup, and then finally took their supposedly spontaneous, natural pictures. Well, all the while I was snapping my snaps, and a few days later I put together this collage." He produced a board depicting the entire production—the parked station wagon, Leibovitz and her assistant deploying their paraphernalia, the open hood, the cables, the dirty footprints in the slushy snow, the huge arc lamps. And then, off to the right of the collage, Hockney included Leibovitz's portrait of him in his red pants, green smock, blue striped shirt, red polka-dot tie, and purple-and-black cap, his right hand extended, wielding the tiny Pentax. Click: Counterclick! "I asked Annie if I could insert her photo of me in my collage, and she agreed. She came over a few days later to look at the result and said, 'Yeah, I had a feeling *you* got the picture that day.' "

While Hockney has exhibited all his Cubist innovations in the making of these recent narrative pieces, the collages seem to draw even more directly on a much earlier source—the tradition of medieval painting in which one character moves through several incidents in his life across a single continuous landscape. Christ thus appears, for example, overturning the tables in the Temple, sharing the Last Supper with his disciples, being tried before Pontius Pilate, scourged in the streets, and then crucified outside the walls of Jerusalem—all on a single panel. In effect, Hockney is blending a narrative mode in common use before the invention of the camera obscura with a visual grammar developed some five hundred years later, one of whose principal ambitions was to break the hegemony of the camera obscura which had risen up in the meantime.

Some weeks later, Hockney and I met once again, this time in New York, where he was calling on his dealer, André Emmerich. The two of them continued speaking for a few minutes, but presently Hockney walked over to me and asked if I'd like to join him for a brief visit to the Museum of Modern Art—he was going to be taking a midnight flight back to Los Angeles, and there were a few paintings he wanted to look at again before leaving town.

On our way to the museum, walking the few blocks, Hockney spoke about some of the larger issues raised by his photocollages. "What's at stake for me in this sort of work is the revitalization of depiction," he insisted. "The great misinterpretation of twentieth-century art is the claim advanced by many people, especially critics, that Cubism of necessity led to abstraction—that Cubism's only true heritage was this increasing tendency toward a more and more insular abstraction. But, on the contrary, Cubism was about the real world. It was an attempt to reclaim a territory for figuration, for depiction. Faced with the claim that photography had made figurative painting obsolete, the Cubists performed an exquisite critique of photography. They showed that there were certain aspects of looking—basically the *human* reality of perception—that photography

couldn't convey, and that you still needed the painter's hand and eye to convey them. I mean, several paths led out from those initial discoveries of Picasso and Braque, and abstraction was no doubt one of them. In that sense, it's a legitimate heir. I've always felt that what was wrong with Tom Wolfe's polemic against the American Abstract Expressionist movement in *The Painted Word* was that he never did understand that those people were *sincere*. But still you have to ask yourself, 'Why didn't Picasso and Braque, who invented Cubism, ever follow that path?' And I suspect that it's because, sitting there in Paris back in the early nineteen hundreds, playing out the various possibilities in their minds, they could already see that abstraction led into a cul-de-sac, and they didn't need to do it to find out.

"I mean, the urge to depict and to see depictions is very strong and very deep within us. It's a ten-thousand-year-old longing—you see it all the way back to the cave paintings, this need to render the real world. We don't create the world. It's God's world. He made it. We depict it, we try to understand it. And a longing like that doesn't just disappear in one generation. Art is about correspondences—making connections with the world and to each other. It's about love in that sense—that is the basis of the truly erotic quality of art. We love to study images of the world, and especially images of people, our fellow-creatures. And the problem with abstraction, finally, is that it goes too far inward, the links become tenuous, or dissolve, and it becomes too hard to make those connections. You end up getting these claims by some of the formalist critics of the last few decades that art just isn't for everybody—but that's ridiculous.

"The revival of the figure with many of the young painters today testifies to the enduring longing for depiction, although the crude character of much of this so-called neo-expressionist drawing testifies to the deterioration in basic training which we've seen during the last couple of generations. I mean, training people to draw is basically training them to look. I'm convinced you can teach people to draw as well as Augustus John, although admittedly you can't teach them to draw as well as Picasso or Matisse. If you don't know how to draw, you end up drawing anxious-looking Expressionist faces. The original Expressionists knew how to draw,

and what they chose to draw was anxiety and anguish. Hence the drawing had an authority, a lasting power that is often missing in the work you see currently. The other trouble with not knowing how to draw is that you can draw yourself into certain highly mannered corners that you can't then draw yourself out of. I think a lot of work you see currently has drawn itself into those kinds of corners.

"The strange thing about the legacy of Cubism is that it did exert an influence on abstract artists during the thirties and forties and fifties but was virtually ignored by the realists. Its lessons are very hard: few people besides its originators—Picasso, Braque, Gris, Léger—have been able to deal with them successfully. Most mid-century realists went on as if Cubism had never happened. I mean, I don't mind things looking as though something never happened. In fact, there's a certain perversity in that which I sort of like. I just think that now—as the cul-de-sac of abstraction has become increasingly self-evident—for painting to go forward we have to go back to Cubism. It still has very important lessons left to teach us."

Hockney's passionate monologue had spirited us from the elevator at the gallery, across several bustling city blocks, all the way into an elevator at the Museum of Modern Art, whose doors now opened, delivering us into the temporary exhibition space in the museum's basement. Immediately before us were some Cézanne landscapes, and to the side a Picasso and a Braque. Hockney was suddenly struck speechless.

"Oh dear," he said finally, taking a deep breath. "I truly *must* get back to painting."

(1984)

THE PAST AFFIXED ALSO:
THE KIENHOLZ SPOKANE SERIES

{This text originally appeared in the catalog of the "Edward and Nancy Reddin Kienholz: Human Scale" show at the San Francisco Museum of Modern Art, 1984.}

I.

M y car was going fifty when I fell asleep," the soldier was telling me as we pulled out of the Spokane Airport, "but it must have been topping eighty-five when it hit the tree." It had taken us a few minutes to figure out how to wedge his thickly cast leg into the front passenger compartment of my rented car, but now he was comfortably ensconced and regaling me with the tale. I'd first laid eyes on him a few minutes earlier at the luggage carousel, an awkward, lanky figure in a trim, neat, dark green military uniform, tottering clumsily on his crutch as he tried to feed coins into a pay phone (nobody'd been home). Like most of the people waiting there at the baggage claim, I suspect, I'd first imagined he might be a Marine freshly returned from Lebanon—the terrorist explosion at the barracks had just occurred the week before. He had asked me to help fetch his duffel bag off the carousel—it weighed a ton and a half—and then he'd shyly asked, smiling, whether I was heading out past Coeur d'Alene. His smile revealed a complete lack of front teeth and further accentuated the hareliplike scar coursing from the center of his upper lip into his left cheek.

I had told him that I was indeed heading that way, so here we now were, cruising out of Spokane on a dim, gray afternoon, trading tales.

"Yeah," he said, "I was out cold. I remember the beginning of this dream, and then I don't remember a thing for the next six weeks. They say I was delirious part of the time at the hospital, cussed up a storm, but as far as I was a party to any of it, I wasn't even there. I was *no*where." He was silent for a moment. "I near died." More silence, as the windshield wipers slapped time. "Jesus," he exhaled at length, "thing like that can really shake you up." I asked how old he was. He was silent for another few moments, as if he were trying to remember. "Oh . . . twenty."

We were heading east on Interstate 90. Flat, fallow farm country was giving way to rolling hillocks, and in the intermediate distance loomed the evergreen foothills of the Rockies. To the right, a low wet mist obstructed my gaze, so there was no way I could make out the little farming village of Fairfield, some twenty miles to the south, where Ed Kienholz, the subject and the destination of this little trip of mine, had been born some fifty-six years ago, or the wheat farm on which he'd spent his first seventeen years.

The soldier was telling me about his own mother and father and how surprised they were going to be when we pulled up. They'd heard about the accident—or at least he was pretty sure they had, but you knew how it was, they didn't have a telephone, and he wasn't much good at writing, nor were they, and everybody'd kinda lost touch. His grandpa in Santa Barbara had visited him at the hospital in California (actually, it turned out, he was just in the Army Reserve doing his week's stint, and he'd crashed up the car on the way to the base—lucky thing: it meant he was covered by military insurance); his grandpa had come by once, but they hadn't had much to say to each other, and he didn't know if his grandpa had written his parents or not. His parents hadn't ever even seen his kids—"*Kids?!?*"—oh yeah, he had two, a three-year-old and one that was born while he was in the hospital. He and his wife weren't getting along very well, and he hadn't seen that second one either, actually.

Shortly after crossing the Idaho border, we veered north onto United States 95, and the road now sliced a clean line through evenly dense forest

lands with road signs monitoring the relentless approach of the Canadian border. "I learned something, though," the soldier was now telling me. "And it's that you've got to take charge. You've got to be responsible. You've got to take responsibility for your life and for the world you live in. God spared me this one time, but I reckon it's so as I can be more serious, quit being such as jerk. So I'm starting fresh." I asked him about his wife and the kids. "That was the *old* me," he assured me. "That was when I was being unconscious. Forget that. From here on in, I'm taking responsibility for my life."

We presently pulled off the main highway onto a lumber road which penetrated the forest, and then onto another. Arteries became capillaries; pavement became gravel became mud. Big pothole puddles pocked the road, and little spindly driveways peeled off to either side. It turned out there was a whole subculture in this forest which had seemed so evenly dense from the highways: shacks with smoking chimneys and rusty junk cars piled outside. We presently pulled into one of these driveways, and I was helping the soldier out of the car just as his parents opened their cabin's front door, surprised, I suppose, but not too—indeed, for all the world acting as if their son had just hitched a ride back from the grocery store.

"Yeah," Ed Kienholz told me a few hours later, after I'd reached his house some twenty miles further on, just outside the hamlet of Hope, Idaho, on the shores of Lake Pend Oreille. "That story doesn't surprise me one bit. There are a lot of kids like that, families like that, up here. In fact you should include that story if you ever get around to writing the essay for this show, because it has a lot to do with the kind of people and places these pieces are about."

II.

"From my childhood I mostly remember isolation, being separate and apart. . . . I used to sit in the barn and milk the cows and look out through

the barn doors and see the aura of the lights above Spokane, which was
some forty miles distant, and know that people were not milking cows in
Spokane."

—ED KIENHOLZ
Oral History (UCLA), 1976

A good place to start is with Kienholz's *Portrait of a Mother With Past*
Affixed Also (1980–81), which, although not technically one of the Spokane
series, has been included in this little show. It was produced during the
same period as the four other pieces which do make up the Spokane series

and casts the glow of its interpretive possibilities upon them, like an aura. Indeed, it is as if the force field of significance from Kienholz's youth—the sense of something happening *over there*—has reversed polarities, and today Spokane basks in the glow of that slight light, that weak bulb radiating from Kienholz's farm childhood. Never has this been clearer than in Kienholz's portrait of his mother, an intensely personal work which for many months Kienholz had been loath to show publicly, just as he'd once hesitated for several months before showing that other intimate masterpiece, *The Illegal Operation* (1962). The earlier piece had dealt with abortion, this one deals with motherhood—the earlier piece had been a gut-wrenching howl, this one something more like an expiring sigh. And yet both draw their power and their universal resonances from their intimate, personal particularities.

This one deals with motherhood, but the son is nowhere to be seen, at least not at first glance. Indeed, as we walk up to the foreshortened sheet-metal cabin and open the screen door (the exterior is a meticulous rendition of the entry to the house where Ed's eighty-year-old mother currently lives about a mile from his compound on the shores of Lake Pend Oreille, the view from her kitchen being "reflected" in the outdoor window), what is most immediately striking is her isolation, her solitude, indeed her self-absorption. She stands gazing down at the large photograph in an oval frame which she holds in her hands before her: it is a picture of herself as a little girl, and baby-doll arms extend three-dimensionally out from the flat oval of the portrait, like a child reaching up for her mother. The mother's face is in turn represented by a photograph enclosed in an oval frame of its own which has been wedged into the plaster-cast shoulders of the standing figure. The mother's photo frame is densely mottled, afire with reminiscence. Her memories, we say, are consuming her. And the pulsing, throbbing circuit of that initial force field of remembrance—an old lady yearning melancholically for the child she once was, an infant reaching out eagerly toward the adult she would become—now begins to cast sparks all about the room. For the window behind her looks out not onto Lake Pend Oreille, but rather onto the wheat fields of the farm outside Fairfield where

this mother spent most of her life rearing a family now long scattered. The wooden washbasin below that window is a meticulous re-creation of the sink Ed had helped his father build years ago as a child, when they were extending the farmhouse where he had been born. Upon some little wooden shelves to the side rest the mother's own baby cup, and then Ed's baby cup, and then a little vase Ed painted as a child. From out of an oval frame to the other side of the interior beams a picture of Ed's father, her husband, as a virile young man. And then, if you lean further in, right up close to the transparent Plexiglas plane that separates viewers from this aquarium of reminiscence, you can see to the far right a mirror which presently becomes—no, a Fresnel screen, and through it, the image of her husband as an old man, felled by a stroke, confined to a wheelchair and waiting to die.

These memories, then, spread out from the center of the composition— old woman, little girl—like a jangling necklace of particular instances, indeed, like the bottle necklace in Kienholz's earlier evocation of this same theme, *The Wait* (1964–65), now at the Whitney Museum of American Art in New York. In that piece, a lonely old woman (fashioned out of cow bones) sits waiting for her death, her memories swathed around her neck, jugged in jars like so many pickled preserves. There, though, the old lady is gazing vacantly out, watching, waiting for death. Here, the mother is gazing down, fixated on her life and the stupefying passage of time.

The energy of this piece derives perhaps from its composition as a series of self-enclosed dualities, polarities which in turn implicate each other, like interconnected loops. There is, as we have noted, the mother doubled, the old lady hooped to the young girl, an almost solipsistically self-contained image. And, as we have noted, what is missing from that image is precisely her child, Ed—she is alone at the end of the day. And yet, of course, Ed is everywhere, and everywhere in two ways—as son (the product of the transit of this woman from childhood to old age) but also as artist. She made him, and now he is making her. By including the wooden washbasin, Ed was refashioning something he'd once helped make years before—the first

time he drove the nails in he was his father's apprentice, and he was making a washbasin, a place to wash things; this time, driving the nails in, he is his father's survivor, and he is making art, a way to honor the memory of things. His relationship to this entire piece—the way his hands hold and mold it—is thus surprisingly like the relationship of his mother to the oval frame she is holding.

But there is a third looped duality, and that one is generated by the mirrored back wall of the piece. At first we are so absorbed in the exploration of the abundance of specific details in the cabin's interior that we fail to notice it. If anything, we are charmed by the way the mirror completes the halved chairs, table, and plates, rendering the stunted space whole. It takes a while before we notice the real subject of the mirror which is, of course, we, us, ourselves. This last polarity—ourselves as viewers, and ourselves as viewed by ourselves—immediately introjects and implodes the principal theme of the piece. For we are not here merely gazing upon the aging process of another person—"Oh, look how that old lady aged from that little girl." Rather, we are gazing at something that is happening to us right now, as we watch, as we dally.

The point is driven home by the framed, faded poem which Kienholz has slotted into the mirrored far wall, precisely at eye level, so that in the place of our faces, we see it. It is entitled "Resignation," and it was composed and typed out years ago by Ed's mother herself:

> When the trials of life assail us
> And the storm clouds gather low,
> In the blinding tears of heartache
> The flowers of understanding grow.
>
> For nothing is forever,
> And life is but a day.
> Though great the sorrow of the heart,
> Even this shall pass away.

Even this shall pass away: Ella Kienholz, in writing these lines, was presumably drawing on her spiritual reserves pointing toward her transcendent faith; she was a Sunday school teacher and remains a devout, Bible-quoting Christian. But Ed takes her verses literally, stripping them of their transcendent possibility. A spiral of ancient flypaper unfurls from the ceiling above the washbasin; for flies, life *is* but a day. All of his mother's life—from her four-year-old babyhood to her eighty-year-old widowhood—has been compressed into this present instant, this single moment of realization. Nothing is forever: the fiery, mottled picture frame surrounding her face is the only halo Ed seems to feel his mother will ever attain. The poem speaks of a long, tired, sometimes arduous life passage; but if from the loam of that particular life, a "flower of understanding" does somehow manage to grow, Ed insists that it is an earthbound flower: *Nothing is forever.*

And that goes for us, too, gawking there in the mirror.

III.

Returning to the central image of *Portrait of a Mother With Past Affixed Also*, an old lady holding a photograph of her younger self, we can see that Ed stands in a similar relationship to Spokane in the four other pieces from the cycle included in this show. Or rather, it's as if the Spokane of his childhood—the aura of distant lights connoting a wide world of possibilities—now appears, from the vantage of middle age, a sorrier and more constricted place. Or phrased still another way, it's as if Ed is holding up a mirror and gazing at other lives he might have lived, at other paths he might have traversed, other places he might have ended up.

Throughout his career, Kienholz has displayed an astonishing empathy for the solitude of others, and in particular that of fairly lowlife outcasts whose exterior circumstances would seem to have little to do with his own material success. True, at the time he was creating *The Beanery* (1965), his devilishly inspired re-creation of Barney's Beanery in Los Angeles, he was

often sharing the counter with the bar denizens he was portraying. But they were killing time—that was the whole point of his substitution of sad, stuck clocks for their faces in his version—while Ed's career was racing forward. And even though he has long since become one of the most successful artists in both the United States and Europe (he spends half the year in Hope and the other half in Berlin), he keeps returning to these losers, as if to a first source. For him, they are a fundamental other—but also fundamentally an aspect, a dark mirror of himself. *Mon frère, mon semblable.* And the wonder of his art is how he helps us to recognize that they are *our* brother selves, too.

You have to wedge your body in real tight if you're going to see into the sad room which forms the centerpiece of *Sollie 17* (1979–80): the door only opens partway and a thick sheet of Plexiglas obstructs your vantage. What you see is a haunting triple exposure, three views of a tired old man dressed in baggy underpants, occupying a spare, dilapidated room, killing time. First he is lying on the bed, reading a paperback Western, his hand slipped under the waistband of his underpants, absentmindedly toying with his crotch (in a typical Kienholz touch, the book is entitled *A Handful of Men*). In the second exposure, he is sitting at the side of the bed playing solitaire, a haggard profile. In the third exposure, he is standing, his back to you, looking out the window at a nondescript cityscape, thinking perhaps about the nothing he's made of his life. But Kienholz's art is subversive— just as you're beginning to feel superior, you notice, almost unconsciously, how because of the way the door is blocked and angled, you are looking at him while standing in exactly his hunched posture. Kienholz has managed the trick of transmuting his own empathy onto you. He's hot-wired us with his own compassion.

A similar thing happens at *The Pedicord Apts.* (1982–83). You enter through a small lobby and then proceed down an empty hall with three doors on each side. It's been cleverly foreshortened, and it feels a bit like one of those mystery houses where the perspective's been all skewed up, and people on one side of the room appear ten times taller than people on the other. Here, though, it's time that gets all bollixed. As you step by each door, you activate a tape behind the door, and you find yourself listening in to the ghostly goings-on inside. The effect is arresting: you stop and become absorbed. A conjugal fight is transpiring behind one door; a TV show is unfolding behind another; the clatter of dishes and dinner conversation wells up from behind a third; a woman is sobbing behind a fourth; nobody's home behind the fifth; and—surprise—an angry dog rushes up to growl at you from behind the sixth. That dog brings you back to yourself, back to real time. Just as you're leaving, back up the hall on the far wall of the lobby, there's a mirror, and inside the mirror, there's you. It pegs you flat: you feel strangely implicated, a bit clammy, prurient, something of a

voyeur. Whatever superiority you've contrived to feel over the inhabitants of this two-bit apartment hotel dribbles away in a surge of recognition.

The other two tableaux in this show from the Spokane series are more strictly pieces of urban archaeology—found pieces—environments happened upon, prized, pried out, and recast in permanent form. *Night Clerk at the Young Hotel* (1982–83), for example, was pretty much found as is in the bowels of a building in the same block as *The Pedicord Apts.* The piece is spooky, almost death-intoxicated: it suggests the foyer to purgatory. The clerk himself stands slouched over the counter, reading an article in a tattered detective magazine: *The Killer Who Made Love to a Corpse.* All about the piece there's a virtual mosaic of shrill injunctions—101 Thou Shalt Nots, a down-and-out Calvinism run amok. And yet there's whimsy, too. Kienholz actually excavated the piece on November 30, 1981. Two days later, on December 2, according to Kienholz, "Some bums got into the building, and they were cold, so they started up a little fire, you know, to keep warm, and they ended up burning the whole place down." The calendar on the side wall reads "Dec. 3," and Kienholz has scribbled in a little memo: "Fire inspection today." Humor, but then, resurging, pathos. Above the office door are clustered some photos of wrestlers, men frozen in mock macho poses. One of them is Chief Thundercloud, an Indian on horseback reduced to a wrestling strut. There's a dark time mirror here, too. I remember several years ago Kienholz's telling me about his own childhood, how Indians still ranged the land around his wheat farm when he was a kid, how once one of them had even made him a pair of moccasins after which he'd spent the night out in a field with a makeshift bow and arrow, fancying himself a young brave out on the hunt. The land around Spokane was once Indian country—pretty much the end of the long march of several persecuted tribes, their last stand. I asked Kienholz at the time whether he was ever going to do a tableau about the Indians and what America had done to them. (Some of his strongest compositions, notably his *Five Car Stud* from 1971, have dealt with the scandalous treatment of blacks in America.) He'd said no, he wasn't planning anything in particular. But there's a strange, poignant way in which he's accomplished such a witness

with this piece, even if only tangentially: Indians who once ranged these lands and fished these streams are now reduced to mocking their own heritage as washed-up wrestlers on the walls of some SRO hotel.

Finally, there's *The Jesus Corner* (1983), perhaps Kienholz's most self-effacing and transparent evocation of fellow-feeling. The other works might be subjected to the criticism that even in empathizing with his subjects, Kienholz is somehow cannibalizing their situation, patronizing them, turning them into "art." With this piece, however, Kienholz looks in the mirror and finds not just a fellow human being, but an equal, a fellow artist—a man driven by the same passions, albeit expressed on a more modest scale, that have animated his own life. For several years, Kienholz had been observing the gradual transformations inside the dilapidated display window of an abandoned, boarded-up storefront at the diagonal far side of the same Spokane city block as the Pedicord Apts. and the Young Hotel. Some old guy had turned the vitrine into a devotional altar and was continually stocking it with his own miniature tableaux celebrating Jesus and the redemptive power of prayer. Kienholz, who spent a lot of time trying to track the guy down, was able to find out his name (Roland Thurman) and something of his history: he was a retired boxer, deaf from his years in the ring, and he worked as a janitor at the Crescent department store, which is how he managed to squirrel away a lot of the cellophane and wire hangers and Popsicle sticks and used cloth sashes and thrown-out cosmetics ads ("Helena Rubenstein: The Science of Beauty") which he then redeployed in his prayer displays. Kienholz repeatedly left notes for Thurman, but to no avail—he never heard from him. Finally, one day when he heard that the whole block was about to be demolished in a fit of urban renewal, Kienholz moved quickly, drove a crew into Spokane, and salvaged the entire window display, taking it back to his Hope studio where he recast it as a tableau. It's not just Thurman's style of operation that is evocative of Kienholz—the passion for taking all that excess junk tossed out daily by American consumer culture and redeeming it, granting it a second life as art. It's the very theme of the piece—a Jesus window—which echoes the origins of Kienholz's vocation. As a child Ed started out making

crèches with his mother, and little dioramas celebrating all the standard Christian precepts. Later on, as an adult artist, one of his first full-scale tableaux was *The Nativity* (1961), a junk sculpture collage in which Baby Jesus was represented by a flashing light (the sort ordinarily used in street barricades), Mother Mary had "a compartment in the back reserved for the Immaculate Conception," while Joseph sat astride a child's stick horse "silently playing out his role as cuckold." (If this version of the Nativity seems perversely profane, that is partly because it was initially conceived as a companion piece to *Roxy's,* 1960–63, Kienholz's very first tableau of a Nevada brothel in which the young artist managed to glimpse aspects of the sacred in the sorry, martyred situations of the girls.) With *The Jesus Corner,* Kienholz has included a few ironic touches (the mock apocalyptic can of Bed Bug Doom wedged into a corner of one of the overbrimming shelves seen through the side door), but generally he plays it straight. He intends no ridicule of this fellow artist's work. "I totally disagree with Thurman's belief, the God, putting your faith in a Second Coming, all that crap," Kienholz told me one afternoon as we sat in his studio, looking at *The Jesus Corner.* "But I respect the primitive perseverance, the seeing-it-through. And I think there's a lot more to be said for a punch-drunk, deaf ex-boxer who devotes himself to the humble task of offering this prayer to his neighbors than for the businessman who's continually quoting the Bible while he's screwing over his competitors." There's a sense in which all five of these pieces in the show are redemptive devotions—prayer offerings and witness bearings.

IV.

Driving back toward the Spokane airport a few days later, past the soldier's turnoff, I took to wondering at the overarching unity of Kienholz's career. These days he works with his wife, Nancy Reddin, and her contributions over the past decades have been enormous, so much so that he's even acknowledged the fact by signing all the work since 1972 with both of their

names. Someday perhaps an art historian may wish to study the changes in Kienholz's work since he began working with her. But at that moment, as I was driving past Coeur d'Alene, I was most struck by the thematic consistency of Kienholz's entire life production. The almost delirious variety of his materials, his protean capacity for redeeming all manner of junk and bric-a-brac—at first this sheer clutter of surface variety disguises that underlying unity. But really, for almost three decades now, Kienholz has been returning, again and again, to the same few themes. The difficulty, the woe that is in marriage: while I was up there in Hope, Nancy had shown me some photos of *Bout Round Eleven* (1982), another recent piece. The desperate impasse of the couple in that tableau was simply a reworking of the same theme from *The Middle Islands* (1972–73), and before that *Visions of Sugar Plums* (1964). The television set in *The Eleventh Hour Final* (1968), with its horrifying intimation of Vietnam, subsequently became the radio sets in Kienholz's Berlin series, the *Volksempfangers* (1975–77), with their chilling confluence of Wagner and Nazism. *The Nativity,* as we have seen, courses into *The Jesus Corner. The Wait* becomes *The Tiptoe Widow* (1975), and then reappears as *Portrait of a Mother With Past Affixed Also.* The beery denizens of *The Beanery* finally get up and leave the bar, years later, and head home past the *Night Clerk at the Young Hotel* and up to *Sollie 17.* For all the profusion of his work, Kienholz is in many ways as focused and spare and self-constrained as the late Piet Mondrian. Over and over again, finally, he is exploring that moment when the despair of absolute solitude is momentarily punctured by the grace of intersubjectivity.

(1984)

A PARKINSONIAN PASSION:
ED WEINBERGER

One fine morning in the autumn of 1982, Ed Weinberger simply couldn't bring himself to climb out of bed. Forty years old, an enormously accomplished venture capitalist (a vice president at Allen & Co.) and a vivid outdoorsman (veteran, some years earlier, of the last kayaking expedition down the white-water rapids of British Columbia's remote Peace River before that torrent got dammed up once and for all)—it was as if he'd forgotten *how*. Not that he didn't want to or that he didn't have plenty of things to be doing that he was eager to be getting on with. Rather, it was as if he'd lost the *will* to rise out of bed—or, more precisely, the *ability* to will movement of any sort at all. For an hour, maybe two, in rising confusion and panic, he kept trying to will himself to will—to no avail. At length, finally, haltingly, he succeeded: he managed to dress himself, fumbled out into the world, hailed a passing cab, and immediately reported to his doctor, who, almost first thing, had him write out a sentence on a pad of blank paper. Weinberger's writing, which seemed normal to him, had in fact deteriorated dramatically: it was crumpled, crushed, concertinaed—*minuscule*. The doctor ordered a battery of tests but already surmised (correctly, as things would turn out) that Ed was presenting with an exceptionally ferocious onset of Parkinson's disease.

Ed was quite young to have been thus visited (the average age for the onset of Parkinson's disease is around sixty) though not all *that* young (onset below age fifty occurs in roughly 15 percent of cases). Particularly

impressive in Ed's instance was the virulence of the disease's onslaught (and perhaps, as well, the alertness, perspicacity, and uncanny articulateness of its victim). Despite the fact that Weinberger was immediately put on a steady dosage of Sinemet (Parkinsonism appears to attack the basal ganglia, globus pallidus, and corpus striatum bunched around the lower brain stem, drastically disrupting the production of biochemicals such as dopamine essential to the proper regulation of communication between nerve cells, a situation for which the various drug therapies attempt to compensate, with varying degrees of effectiveness), his condition inexorably worsened—with the rigidity and the tremors, the alternating bouts of frozenness and festination, growing more and more pronounced as the months went by—until, by the end of the decade, when the actor Robert De Niro was looking for someone to study with in preparation for his role as the desperately ravaged postencephalitic Parkinsonian in the film version of Oliver Sacks's *Awakenings,* Sacks, who had by then been working with Weinberger for some time, suggested to the actor that Ed Weinberger be his man. ("I actually experience seven distinct types of stuckedness," Ed had launched out early on in their tutorials, at which point De Niro had interrupted him. "No, no, not like that, instead just let me hang around and observe you, that's how I learn: I observe behavior.") On the set of the film, which I'd happened to be frequenting at the time for other reasons altogether, several of the principals spoke with awe of the uncanny precision with which De Niro's performance had managed to capture and incorporate the infernal welter of Weinberger's symptoms; but De Niro himself and several of the others spoke in even more marveling tones about Weinberger and the remarkable body of work he himself appeared to be in the process of forging, in utter defiance of his plight.

Some months later, intrigued, I telephoned Weinberger to see if we could meet, and he cordially invited me up to his apartment on West End Avenue in the neighborhood behind Zabar's. The man greeting me at the door was somewhat short, though perhaps, rather, on second glance, merely stooped and scrunched over. He was vaguely pudgy, though also, as I quickly realized when he extended his hand to shake mine, incredibly

strong: *taut* pudge. In one of its aspects, as I came to understand, Parkinsonism tends to set the body against itself, such that every impulse is met by an immediate counterimpulse, every push out by a simultaneous pull back in, so that the Parkinsonian lives, as it were, in a perpetual, unrelieved isometric clench, seemingly slack and undefined while in fact growing stronger and stronger all the while. Or, anyway, such seemed to be the case with Ed's version of the disease. (His grip, indeed, grew so powerful that some years later, shaking my hand in greeting, he literally managed to crack one of my knuckles, and then, a few months later, when upon another meeting I unthinkingly offered my hand once more, he did it all over again.)

His clean-shaven, boyish face, topped with short-cropped, perpetually tousled dark curls, was pudgy and slack as well, largely pithed of animation, his mouth for the most part downturned in a generalized expression of dulled dismay, though his eyes, behind smudged glasses, gleamed with an intelligence and engagement belying his slurred voice and otherwise slurried demeanor, and he often laughed, clenchedly. His hands trembled, perpetually; he moved about in minced and shuffling ministeps, sometimes quite quickly (as if being propelled down a steep incline), other times slowly and yet more slowly still; sometimes, in mid-gesture, in mid-sentence, he'd freeze up altogether, for minutes on end, before somehow jump-starting himself back into the world and resuming wherever he'd happened to leave off. Seated at his dining-room table, his body would occasionally (especially as he grew more intellectually excited) give itself over to a veritable tempest of tics and tremors, the wooden chair under him creaking so violently you expected it to come shattering apart at any moment (several had), and he'd pop the lid off a plastic container of variously shaped and colored pills, shakingly spearing a precise one or two after the downing of which he'd gradually proceed to calm down, at least for a while. All of which he took in stride, utterly unself-consciously, not so much resigned as resolutely, obliviously sovereign.

The shelves and glass cabinets flanking his apartment teemed with a gleaming collection of antique mechanical objects, evidence of a mar-

velously consuming passion which, he explained, had long predated his ill-
ness: gold-plated galvanometers, cylindrical calculators, metal cameras,
brass surveyor's plumbs, compasses and cigarette lighters and stopwatches
and meticulously miniaturized steam engines, sinuous sheep-shearing
scissors, exquisitely tapered knives couched in superbly notched and mot-
tled ivory handles. . . . "They all have a strange sort of architectural qual-
ity," he explained, trying to parse the collection's organizing principle,
"something odd about the scale." Oldenburg *avant la lettre*. The apart-
ment's coffee tables were festooned with books on all manner of topics:
pre-Columbian Indian masks from the Pacific Northwest, luxury roadsters
of the twenties, hollow-box concrete bridge construction, medieval armor
and frontier gunsmithery, early modern furniture design, Japanese histor-
ical novels about Mongol Central Asia. . . .

The walls, in turn, featured a medley of assemblages and abstract geo-
metric paintings, all of which, it turned out, were his own, and all of
which had come into existence in the wake of his illness—in fact, only
over the preceding five years. There was, for example, an elegant wall
piece, fashioned out of a faceted array of pale aqua architect's rulers: to
one side, the rulers rose up along a straight line, a steadily discrete arith-
metic progression, each ruler a precise centimeter and a half higher than
the one to its left; to the other side, however, the rulers' progression was
more algebraic, an initially steep though steadily flattening asymptotic
curve. "That's Euclid to one side, the world I used to live in, regular and
steady," Ed explained, "Leibnitz, Einstein to the other—the difference of a
difference, a world of inexorably compressing gradations, increasingly
reductive—the world I live in now."

There were, as well, triptychs of paintings—clean, tight rectangular
planes crafted out of smaller adjoining rectangular panels and slathered
over with layer upon layer of variously thick pigments, variously scratched
and scored and scoured away, as if in archeological layers of excavation.
"Order out of chaos," Weinberger commented simply, following my gaze.
"Order imposed atop chaos."

Along a side shelf were arranged a series of intricately compact three-

dimensional constructions, variously painted rods and planes, vised tightly together by a variety of tiny clamps.

"The thing about Parkinsonism," Weinberger said, in a sudden staccato of phrases (it was as if his fluency was breaking up, and he reached automatically for some pills), "is that it can get to be infinitely absorbing, like a black hole, an incredible gravitational pull collapsing in on itself, I collapse in on myself, am lost to the world—but then the drugs (everything in Parkinsonism being paradox and contradiction) have this tendency to blow me outwards, pell-mell, infinite scatter, inability to focus at all, complete loss of sense of self. And the art, these things, helped me in two ways—I would work on them late at night when I could not sleep—since now I could *focus* on something *outside* myself."

And then there was—and this is what the people on the *Awakenings* set had been raving about—the *furniture,* product of his last few years of focused concentration, and these pieces were indeed astonishing.

For example, there was a side table—a nightstand, I suppose—a set of drawers, fashioned out of the most sensuously smoothed and lovingly varnished dark wood (tropical wenge, as it happened), strangely familiar (early modern in idiom) but then unlike anything I'd ever seen before. It

took me a moment to grasp the piece's precise oddness—for one thing, it was curiously top-heavy and awkward, as if it couldn't possibly remain standing: and yet at the same time, manifestly grounded and serene—but then I suddenly figured out what accounted for its real strangeness: it had no skin, no casement, it was utterly transparent. Entirely crafted out of perpendicularly aligned long rods and flat rectangular planes, the piece's two drawers seemed to hover in mid-air, and when you opened them (for the piece cried out to be handled, buffed, manipulated, the drawers nudged open), they slid out noiselessly from beneath their fixed

lids, and you could watch the entire rectangular solid as it floated silently on an almost invisible railing, the negative space behind it ballooning out in perfect proportion as the drawer itself emerged. "Incredibly challenging to build," Ed was now saying. "Ruthless. Eighteen rods, which means 108 sides, every one of them having to be absolutely straight along its edge and flat across its surface, and every joint—all seventy-six of them—having to be absolutely right, perfectly perpendicular. The slightest variance at any single joint would ramify all about the piece, a mistake of a fraction of a degree here would compound around the piece to several degrees over there."

He reached for a notebook from amid a stack of such notebooks piled atop a nearby shelf—hundreds, thousands of pages scrawled over with his urgent pencil sketches—quickly flipped toward a particular page scrawled over with slashed designs and scrumbled files of calculations. He grabbed a pencil, his hand trembling violently, but as it approached the page, uncannily, his gestures became steady, emphatic, the pencil slicing clean across the page. "See," he was explaining, "each joint meant there was less and less tolerance for error at the next one. Ordinarily, carpenters, cabinet-makers work in tolerances of, say, a thirty-second of an inch or a sixty-fourth. Here we had to achieve machined tolerances, *aerospace* tolerances, treat wood as if it were steel, five one-thousandths of an inch. Necessary, unavoidable extravagance." It was as if at the same time that his body was slackening and losing its definition, his mind had taken to straining after greater and greater precision, toward an almost infinite perfection.

" 'Impossible,' people said. 'Can't be done.' And it almost can't. There's only one person I know who can do it, and it took me a long time to find him. Young guy up in New Hampshire. Scott Schmidt. And luckily I could afford to pay him for his time, to completely retool his workshop. Thanks to my earlier career, money, time was no object."

I commented on the piece's early-modern look. "Well, yes," Weinberger concurred. "In fact, it's part of what I call my Cubist-Constructivist series. Malevich, Mondrian. But especially Rietveld, with his marvelously colorful geometric pieces. Chair, table, all those clean planes and exposed over-lapping joints, his so-called Cartesian nodes. I became fascinated with the

origins of Modernism. In fact, it was a doubly originary time for me: I was launching out myself, just starting out with my own passion for building, and at the same time I was studying, recapitulating the starting-out of Modernism. And yet these pieces are neither nostalgic reversion nor ghostly homage." The drugs seemed to be kicking in; his sentences were resuming their easy fluency. "Rather, I wanted to experience what it must have been like for them, the early Modernists, to play unrehearsed in the formative grounds of their discoveries, when everything that had been taken for granted up to that point was suddenly being rendered strange and new and up for grabs. I wanted to reexperience that moment, without preconceptions or *post*conceptions, to do it forgetfully, as it were, without privileged anticipation as to where things were going, how they would gel. I wanted to explore some of the unpursued possibilities that never took place but could have, from within the imaginative horizon of that moment before claims started getting staked and orthodoxies imposed."

He reached over and gave the nightstand an abrupt and vigorous shake. "And the thing is, with Rietveld's furniture—for all its strict rules, the Rietveld joint is in fact incredibly weak, and his pieces rack like crazy. A Rietveld appears stable but isn't, whereas a Weinberger"—he gave it another shake—"appears not to be but is."

On the other side of the room stood a more recent and even more mysterious piece, a tension-rod credenza, as Ed was calling it. This time, great, luxuriantly soft pinkish-blond horizontal planes (pear veneer over Swiss pear) seemed to levitate in midair, sustained for the most part by an elegant system of vertical silvered-brass turnbuckles, another of Weinberger's intricately calibrated construction innovations. "Ordinarily," he was explaining, "when you want to sustain a table's perpendicular rigidity, you use one of those flattened L-joints, a piece of bent metal with which you stabilize the piece where the horizontal and vertical planes meet. But here we wanted to do something different, and we developed this system of clips and turnbuckles." Each turnbuckle consisted of a long, elegantly sculpted, hollowed-out shaft, with separate threaded rods emerging from each end, which in

turn attached to the clips grasping the horizontal planes. If you rotated the turnbuckles one way, the threaded rods extended out; turned the other way, they contracted. "Last thing before this piece comes together," Ed was explaining, "it's all slack, like a boat's sail, the stays all wobbly. But then you tighten the turnbuckles just right and suddenly the thing tautens up, perfectly stiff and tuned. And it's the damnedest thing, drives architects crazy, because the thing that's holding the planes up at the same time is pulling them apart. Complete contradiction: simultaneous push and pull."

Suddenly, from one moment to the next, the drugs seemed to be wearing off again and Ed, stiffening, had once more taken to trembling violently. "And the thing of it is," he was saying, slowing precipitately as he leaned down toward one of the turnbuckles, struggling to get the words out and

his pointing arm extended, "although this piece is completely solid . . . stable . . . exists in perfect tension . . . if you somehow managed . . . to snip it . . . right here . . . the whole thing . . . would *explode.*"

That first meeting was about ten years ago now, and since then Weinberger and Schmidt have persisted in their remarkable collaboration, a journey of almost pure inquiry, as Ed sometimes points out, largely stripped of ulterior motives or ambitions, an almost secret passion. Or anyway, I sometimes felt, visiting Ed's apartment over the years as one by one the new pieces emerged, my *own* sweet secret, mine and that of maybe a few dozen others. Occasionally I'd bring along additional visitors—museum people, critics, design aficionados—and they'd all leave, shaking their heads in astonishment (New York is such an amazing city, the things that go on behind closed doors!). Occasionally, Ed would quietly park one of his pieces in a Midtown gallery (Edward Merrin's antiquities showroom, for example), though he seemed hesitant about hazarding any full-scale retrospective, or rather, maybe, ambivalent: equal parts eager and anxious and then (at times) authentically indifferent. But this coming November, Ed and Scott (they've taken to signing the pieces together) will indeed finally be mounting such a career-embracing survey show at the Barry Friedman Gallery, and I decided to take advantage of the fact to join Ed for a trip up to Scott's Portsmouth workshop, where they were racing to complete some of the show's last pieces.

On the flight up to Boston, I asked Ed about his childhood background (it occurred to me I'd never really inquired). The drugs seemed to be humming along, and conversation was relatively easy. Ed recounted how he'd been the second child of a Jewish furrier and his wife, a couple of generations out of Austro-Hungary. Until Ed was nine, they'd lived up at 107th and Broadway, J.D. Salinger country, but thereafter they'd moved to Eighty-first and Riverside, not that far from where he lives today. (He'd attended P.S. 9, right around the corner.) "The Museum of Natural History was my main hangout," he recalled. "I loved the canoes, would spend hours

studying how they were made. Tomahawks, knives, guns. The Eskimo stuff. And over at the Met, the arms and armor. Flintlock rifles. Black powder: the firing mechanisms. Fantasies of King Arthur and Daniel Boone, I suppose. But mainly how those things all *looked,* and how they *worked.* I mean, for instance, I had no particular interest in envisioning the *trajectory* of the bullets, where they might be headed once they were fired.

"There was this wonderful place called Robert Abel's Magic Shop: Antique Firearms and Edged Weapons, and still in elementary school, nine years old, I used to hop the crosstown bus by myself and spend hours over there, wandering among the scimitars and swords and battle-axes and pikes and maces. The craftsmanship on those things was just so incredible." Several years later, in college, Ed apprenticed himself to a master knife-maker and crafted a knife of his own, and he still spoke of the experience with abiding tenderness. "The thing about a well-made knife," he said, "is its elegant density of form, its perfect weightfulness in your hand, the tapered lines, the faceted blade, the way the blade in turn slots into the handle just so." His clenched smile softened.

From high school (Stuyvesant), following a year in a Paris on the cusp of the Nouvelle Vague, Ed went on to St. John's College in Annapolis, easily the most transformative experience in his life, he now insisted: "A classic Great Books education. Four years: entirely required program. No electives. Lab sciences: Aristotle, Harvey, Newton. Astronomy: Galileo, Copernicus. Philosophy: Plato, Descartes, Kant, Hegel. And then, maybe most importantly, mathematics with a teacher named Eva Brann: Apollonius on conic sections. The Pythagorean generation: how a point moved through space becomes a line, a line moved through space becomes a plane, a plane moved through space becomes a solid—all of which would come back to me years later as I began working on my constructions and my furniture. Harmonic proportions with Euclid. The fascination of working out the details—an overpowering aesthetic experience, and what's more, demonstrably true. The golden section—you know, how when you divide a line"—he reached for a pad, drew a straight line segment which he then divided into two sections, a longer one which he labeled A and the shorter

which he labeled B—"such that the smaller part B is to the larger part A what the larger part A is to the entire segment AB. Turns out there's only one way it can be done and the ratio remains constant, it approaches 1.618, and that ratio in turn shows up everywhere: the Parthenon, the distribution of seeds in a sunflower pod, the spiraling form of a seashell, Cycladic clay figurines. It's just a deeply satisfying ratio and a hankering after it almost seems inbred in us. And later, I too kept deploying it, for instance in the dimensions of the drawers in my Cubist-Constructivist pieces"—on the pad, he extended his line into a rectangle and then a box—"and especially the negative space behind the drawers as you slid them out, which in turn negotiated a series of golden ratios in relation to the various vertical rods beyond which the empty space progressively expanded. Although not exactly, and never slavishly. I mean, I'd allude to the ratio but then intentionally violate it, for example, falling just short of it, as if to call attention to it by its absence, thereby adding to the strange, somehow unidentifiable awkwardness of the piece. Creating something at odds with its promise. And yet ultimately harmonious, because the perfection was still latent, shimmering there just beyond all the imperfection." Ed's pencil trembled in his hand, hovering just over the pad.

From college, Ed had gone on to teach for a few years, elementary school math, but eventually he decided to return to graduate school, international business at Wharton (this was the late sixties and he was, he says, interested in gestating practical solutions to problems of underdevelopment). One thing led to another, and a few years out of graduate school he found himself managing a turnaround venture for a company whose principal shareholder was Allen & Co., a role in which he so excelled that by 1976 he'd joined the parent company as one of its fifteen directors—his venture specialty turning out to be West Virginia oil exploration and development, a penchant for which he clearly had a knack, racking up a modest fortune over the next several years. (He'd married in the meantime, had a son, and amicably divorced.) He'd always intended to amass a decent-sized nest egg and then retire early so as to devote the rest of his life to he wasn't yet quite sure what. But not *that* early: and not like that.

He looked down on the paper pad, began sketching out the night table around the floating rectangle of the drawer, his mind seemingly adrift in reminiscence. "Early on in my work with Scott," he now recalled, "he'd built an initial mock-up of the Cubist-Constructivist nightstand for me, and I had it in my living room, and I'd stare at it for hours. In fact, feeling myself starting to freeze up, I'd arrange to crumple slowly onto the floor, falling onto my side right there beside the nightstand, my arm extended toward the back of the drawer. Frozen, I'd gaze fixedly up at the drawer, referencing the perpendicular, trying, as it were, to gain conceptual leverage, a sense of uprightness. I would follow a plane and shift to the next plane—the intersection of planes with one another, the distribution of weight, tension across space, fulcrum and transparency: these were all classically Modernist themes, but what for them had been metaphor, for me was *experience*.

"I'd barely be able to move at all; at most, with great effort, I could just barely tap the back of the drawer, nudging it along in the tiniest, most infinitesimal increments. And I'd study them: those little spaces became like the whole world for me. I'd notice how the smallest physical change could have just this huge impact on the piece's overall physical presence. For example, I'd think about the overhang of the horizontal lid above the drawer. Should it be flush to the drawer, or maybe proud, and if so, how proud? Cabinetmakers have such a wonderful vocabulary: if one plane juts out over another, it's said to be proud, and the other one, the one jutted out over, is said to be shy. And that's one of the great things about making furniture, because in the end it all has to be resolved. A given plane can't be both proud and shy in relation to another, you're forced to decide, and it's got to make sense." He paused before continuing (somehow himself, it occurred to me, radically unlike a piece of furniture, both proud and shy at the same time). "But anyway, I'd lie there for hours sometimes, by myself, the evening coming on, nudging the back of the drawer, and then eventually, because with Parkinsonians it's often movement itself which can summon us back to movement, the movement of the drawer was suddenly enough to get me moving again, and I'd come unstuck."

Ed looked out the plane's window, the vast expanse of the blue Atlantic falling away toward the horizon (the pilot had just announced we were commencing our descent into Logan), and then back at his drawing, his trembling hand absently tapping the page. He reached into his pocket, downed another pill. "It's funny," he said, "how early on, especially before I joined up with Scott, I'd draw up detailed plans for structures that turned out to be utterly impossible to build. Going after what your mind can conceive or project but turns out to be physically impossible—that's an echt-Parkinsonian way of proceeding. That's maybe why Parkinsonians so often recognize their situations in Escher's paradoxical drawings: you know, the square tower with its endlessly rising perimeter staircase, up and up and up, inexorably bringing you back to where you started. Physically impossible, but exactly what it can get to feeling like. Later on, with the series of desks Scott and I embarked upon after the tension-rod pieces, I consciously tried to flip that conundrum, to create a desk that was manifestly, physically, and, indeed, massively *there*, but which somehow didn't add up conceptually, didn't seem like it could be holding up at all."

He was speaking of their "wingèd tripèd desks," a series of indeed quite imposing and massively confounding pieces which Scott and he had taken to producing during the early nineties. As their titles implied, these huge desks were characterized by the three burnished brass legs that sustained them—one each to either side of the front and a third more or less in the middle of the far side, facing the sitter. Not only were there no legs under the far corners diagonally opposite the sitter, but the corners themselves seemed to vault away, stretching out beyond the conventionally expected square edge, winging off, as it were, out over the abyss, impossibly cantilevered.

"From almost any angle," Ed was continuing, "the geometry on those desks seemed awry; they seemed inherently unstable, as if they'd collapse under their own weight at any moment, shake loose at their joints, rack hopelessly from side to side, or flip over entirely if you so much as placed the slightest load atop one of those overhanging corners. But far from it: they were completely stable. A man can sit on the overhanging ledge and

the desk won't even register a shudder. I know: I made that claim once when we had some visitors up to the workshop, and they didn't believe me. I could walk out onto it, I assured them. How did I know? they challenged me. 'Because Scott built it,' I replied, 'and I trust Scott.' Whereupon I took off my shoes, clambered up onto the desktop—it must have been quite a scene, I was ticcing and shaking pretty wildly that afternoon—and proceeded to inch out over toward the corner, finally curling my toes out over the ledge in triumph."

Ed laughed, savoring the memory. "Honeycomb internal construction, like an advanced airplane wing," he explained. "In a way just the opposite of the Cubist-Constructivist pieces, where everything was transparent. Here the whole structure was hidden, secret. And also opposite from the Cubist-Constructivist pieces where everything was perpendicular, here almost nothing was. The ledge of the desk immediately abutting the sitter's belly was a conventional 90 degree drop, but almost all the others were just off square, usually by a mere 2.5 degrees. The perimeter of the desk, meanwhile, as seen from above, was likewise skewed off the orthogonal, all sorts of corners you expected to be square which in fact weren't. One of the results of all these minuscule marginal discrepancies, as they compounded one atop the next all about the piece, was that, from the point of view of the piece's manufacture, the tolerances had to be even tighter than ever, still less than five one-thousandths of an inch! Meanwhile, from the point of view of how the piece was experienced by the sitter—and the sitter's placement was fairly rigidly defined, since we'd inlaid a lovely vellum parchment writing panel at the place where he or she was intended to sit—there were all sorts of compounding conundra: angles that looked acute but were in fact square, and angles that you could swear were square but in fact registered 92.5 degrees. Not that any of this was necessarily meant to be grasped right away—on the contrary, it would only be in living with the piece that these discrepancies would gradually dawn on you, one by one, a sequence of dilemmas—disturbing in part but resolved in whole— provoked not by deception, by presenting what is false as true, but if anything by its very opposite: by contriving to convey what is real such that

it appears momentarily doubtful, the conventional taken-for-granted suddenly getting called deliciously into question."

Ed smiled again, as if to say, Welcome to my life. And we were landing.

Scott was there to meet us as we came off the plane—about fifteen years Ed's junior, a well-tanned fellow of medium build, with short-cropped, curly dark hair glinting strawberry-blond highlights and framing a clean-shaven, squarish face, which, with its flattened nose, vaguely resembled that of one of Dürer's or Holbein's northern Renaissance burghers. (As it happened, Schmidt's family lineage featured a rich confluence of German, Scottish, and French bloodlines, laced with a trace of Mohawk.) We loaded into his car for the hour's drive north to Portsmouth, on the banks of the Piscataqua River, where New Hampshire's narrow Atlantic shore presses up against Maine's—the colony's original capital, later home of some of the young nation's foremost breweries and nowadays a summer tourist haven and home base for an improbably large community of artists and artisans.

Ed seemed to grow noticeably more subdued as his drugs now wore off, and he hunched largely silent in the front passenger seat during our drive as Scott filled me in a bit on his own background. Born in the late fifties in Rockford, Illinois, into an ardently fundamentalist Seventh-Day Adventist family from whose strict constraints he'd progressively fallen away, Scott attended the Montserrat School of Art in Massachusetts, where, like most of his fellow students, he says, he was too impatient to acquire any basic skills. Sometime after graduation, he encountered a master furniture maker named Bill Taylor; although Scott had never given such a vocation much thought, he'd always been fascinated by the way things slot together (insect joints, feathers, seashells, machined mechanisms) and, pursuant to that interest, he now decided to apprentice himself to the master. Taylor himself, as it turned out, had originally attended the North Bennet Street School in Boston, one of the country's premier cabinetry institutes, and so, presently, Schmidt, too, enrolled in its two-

year program. Instruction at North Bennet, quite the opposite of Mont-serrat's, was pure skills-oriented, with little concern for design or aesthetics (evenings and weekends, compensating, Schmidt would haunt the city's museums).

"The funny thing," he said, "is that neither Ed nor I particularly love furniture per se—correct me if I'm wrong, Ed. We see it as an excuse for exploring other things. Something one can create that tells you what to do—sit here, put something on this, pull that open—that gives you, as it were, an entry point, a point of access, a door through which to begin exploring the experience, as opposed to an art object whose very essence can stand as a sort of barrier: 'Is it art or what?' I mean, sometimes Ed will say—for instance, regarding one of our more recent experiments—'It's just a chair'; whereas clearly it's more than that. Somehow, I don't know, it's more like the *experience* of a chair."

"But it's *not* art," Ed interjected emphatically, if a bit slurredly, at this point. "It's not art furniture, which I find precious and prissy, and it's not furniture masquerading as art, like one of Scott Burden's benches, which seem to question their own sufficiency as furniture by relying on the crutch of that label 'Art.' It *is* just a chair, but a chair taken seriously as such—a chair truly interrogated, a chair raised to the level of a question."

Resuming his narrative, Scott related how, his old impatience notwith-standing, he'd in fact turned out to be quite proficient, skillwise, and grad-uating from North Bennet, he'd moved up to Portsmouth to launch his own woodworking business. (A few years thereafter, he married his wife Jane, a flutist turned arts administrator.) As a business proposition, it was decidedly touch-and-go. Once, despairing, he'd had a job consultant do a workup on his predicament, and after reviewing things for several hours, the guy had said, "Tell you what, if all hell were about to break loose, there's no question, you're the fellow I'd want to have by my side. Short of that, however, have you given any thought about going back to school?"

Instead, Ed wandered into his life.

We were pulling into Portsmouth now, and Ed seemed completely depleted, so we decided to check him into the hotel for a few hours' nap

(he often collapsed like this for a few hours in the afternoon) before heading out to Scott's workshop on our own. On the way out, Scott recalled how he'd first begun hearing about Ed, this strange guy trawling around for furniture-building assistance, through a mutual friend, a New York gallery owner for whom he'd been doing some work. Momentarily too busy himself, he'd put Ed in touch with the guy with whom he happened to be sharing his studio. But that match hadn't taken. "The guy was constantly complaining about these entirely impossible and amateurish design sketches. Ed would come up and they'd get into these horrendous shouting matches: 'This just can't be done!' 'You're simply not trying hard enough!' I'd overhear all of this, and occasionally, I'd wander over and rifle through the sketches. They *were* strange. For instance, Ed was having a hard time depicting three-dimensional space: he'd represent different layers of planes by way of differently colored inks. And his sense of scale could get, well, uneven. Some of the sketches were hard to read, and others were indeed impossible to make. But there was obviously something going on there, and increasingly I found myself talking with the guy, and presently my workshop-mate departed and I was left with Ed."

We pulled into the parking lot fronting a hulking nineteenth-century, dark brick-faced industrial building, an abandoned Civil War–era Button Factory (as a sign above the entrance still attested), converted into a veritable bevy of artists' and artisans' spaces: photographers, sculptors, jewelers, potters, lithographers, woodworkers. Off to the side of the entrance, a small gallery featured efforts by some of the building's denizens. Just beyond the entryway, on the ground floor, was Scott's studio—two large rooms, the first a combination design and wood-storage space, and the second (roughly the dimensions of a full-size basketball court) stuffed to the rafters with heavy-duty machinery: two table saws, two band saws, a milling machine, a drill press, a planer, a huge jointer. . . . "State of the art," Scott commented, "which is to say, *old*. You can't get equipment this exacting anymore: 1958, 1969, 1949—a lot of it Northfield Industrial, out of Northfield, Minnesota. Still family-run: you call them up to ask about tol-

erances, say, and you're talking to the grandson of the guy who designed and built the machine."

Scott paused, seeming to return to the early days of their collaboration. "Ed would come up here, and we'd work and work, completely focused on the problem at hand, and then, taking a break, we'd go out for lunch. Working by ourselves like that, I could almost forget his condition, and in fact often entirely did, but out there in the world: we'd be sitting at the restaurant table, he still completely engaged by whatever problem we'd been working on back in the shop, growing more and more excited, his mind exploding; only, the more excited he got, the more he'd be throwing his food all over the place, uncontrollably, making more and more of a spectacle of himself, everybody in the room becoming increasingly uncomfortable at this *scene*. I remember once looking past his shoulder at this little kid who was just staring, literally drop-jawed. And yet Ed seemed oblivious to it all, acting as if not the slightest thing was amiss."

Seemed? Acting as if? I asked Scott whether he didn't imagine that at some level Ed was thoroughly mortified with embarrassment.

"No, you know," he said, "I really don't. He just had, he *has* this incredible strength of character—I don't know how else to describe it—this powerful sense that no matter what, he was going to go on, that he wasn't going to allow himself to become trapped by this thing. For example, I never heard him cursing his fate or anything like that; never caught him wallowing in self-pity, which would have been entirely understandable. To the extent possible, he insisted on rising clean outside of his condition: that was what the work was for; it made it possible for him to go on as if there weren't any condition. And yet there were times . . .

"I remember once, down in New York, we were working on a Cubist-Constructivist table, arguing back and forth over an eighth of an inch—him tapping the drawer forward just slightly: was it right this way, or instead should it be this other way? Incredibly intense—*for hours!* Finally, he said, Let's take a break, let's go out. We took the elevator downstairs, continued talking as we walked up toward Broadway, he was slowing down

a bit as we started crossing the street, and suddenly he wasn't there. I turned around and to my horror he'd frozen, back in the middle of the street, in mid-traffic! I rushed back, tried to grasp him, but he was like a block of solid muscle: clenched, planted, immovable. 'No,' he hissed, 'don't touch me, just walk a few inches out in front of me, and I'll be able—there, like that.' And indeed, that did the trick. He was able to move again, and we got out of the street. But suddenly I realized that this talk of inches, of planes one in relation to the other, this wasn't simply furniture with him.

"His focus, of course, was remarkable. I'd leave a working model with him there in New York and return up here to work on the next version, and he'd telephone with his comments. I remember once I was in here working and I had a visitor, had the speakerphone on, and Ed was going over the piece we were working on, for well over an hour. After he'd rung off, my friend commented, dumbfounded, 'That was amazing: it was like you were talking to an ant as he slowly made his way over every surface of the piece.' And that was it exactly. He was treating every surface, every facet, visible or not, as if it were the focus, the fulcrum of the entire piece, dead center on the very top. Early on I had to retool my entire way of thinking about what we were doing. These were never going to be prototypes toward some eventual semi–mass-market. This was a different sort of passion altogether."

One that carried down to the smallest details. "The bolt heads on those Cubist-Constructivist pieces!" Scott now exclaimed. "Did he ever describe the work on those to you? It was easily a year's labor. He had a particular look in mind, unlike anything then commercially available. 'I want them to look new off the shelf,' he'd say, 'but as if the box they're coming out of had been on the shelf for a hundred years.' We went through dozens of designs. Often we'd communicate by way of analogy—that's where his incredible collections of books and objects would come in so handy: we had a huge vocabulary to draw on. Eventually, he based a particular repeating notch along the edge of the bolt head on the eyelet from a Tlingit mask—Pacific Northwest Indian. Something hardly anyone was going to notice, let alone even see, but it was essential that it be just right. Cost us literally tens of

thousands of dollars to manufacture those bolts from scratch. People thought we'd lost our minds.

"And then we had to figure out how to finish them—that was a whole other production. He had a particular look in mind, a particular sheen, particular patina. He was intrigued by the surfaces of guns, especially the blueing, as it's called, on eighteenth-century Kentucky long rifles, which almost no one any longer knows how to accomplish. I was eventually able to track down this one gunsmith in Virginia who seemed to know, but he wasn't telling. Turns out it's a very protected art: I mean, it was his bread and butter that he was the one person who knew how to burnish those rifles. I talked to that guy for two hours, tried to assure him, Look, we're not trying to steal your art, we just need it for some furniture we're building. Two hours: nothing. Finally, as I was getting set to hang up, the guy says, Well, okay, you seem like a nice guy, I'll tell you the secret: it's roadkill. Whereupon he hung up.

"I thought about that for a while, and suddenly I realized he was talking about wrapping animal remains around the barrel of the gun as you fired it, how somehow the resulting smoke and boiling organic mist would result in the remarkable effervescence, the opalescence that characterized the blued barrel's sheen. I began calling around to undertakers and places with pizza ovens, sounding them out as to whether. . . . But luckily, in the midst of all this, Ed's squeamishness kicked in—he's a very squeamish guy—and he eased up slightly on the precise sheen. And we made do with almost-perfect.

"But that kind of thing happened a lot. Once we'd contrived the idea of turnbuckles on those tension-rod pieces, for instance, turns out there was only one person who seemed to have any idea how we might go about making them. Wonderful old guy up in Maine. I went up there and tried to commission him into making them for us, and he said, no, he wouldn't do that, but that he would teach *me* how to, and over a two-week period—I moved in with him—he did. Amazing old man: he's the one who taught me what a thousandth of an inch *feels* like."

There were times, Scott now confessed, when working at such a level of

intensity, he'd started to have his doubts. "I mean, I'd occasionally ask some of my colleagues, Is this crazy? I'd be working on a desk, they'd go off for three months and build a whole house, they'd come back and I'd still be working on the same desk—*the same drawer!* And they'd give me a look. But then sometimes, three in the morning, the phone would ring, and it would be Ed under the desk, exultant, having just noticed some tiny little detail that had taken me days to accomplish and that I'd put there just for him. And the crazy thing is that, at moments like that, it all *did* make sense."

By 1993, Ed and Scott's collaboration was in full flower. The project immediately following the winged tripèd series, their so-called "hollow-box split-arch bridge desk," was perhaps their most ambitious, and to my own eye, their most sumptuous yet, as I was now reminded when Scott took me next door to the Button Factory's little in-house gallery, where one of the bridge desks was in featured residence. Ed's inspiration for this desk had been one of his favorite pieces of Modernist architecture anywhere in the world, Robert Maillart's revolutionary reinforced concrete bridge spanning the precipitous Salgina Gorge, outside Schiers in the eastern Swiss Alps. (Ed had once almost gotten himself killed, ticcing away as he craned out over the looming, forested abyss in an attempt to photograph Maillart's masterpiece.) For the first time in his own work, Ed included an other-than-straight line, a wide, gracefully arced and elegantly ribbed vault, under which the sitter could slide his legs (or, just as likely, as the desk all but cried out to have him do, his entire body: Ed was given to rhapsodizing on Gaston Bachelard's penchant for seductively inviting spaces—nests, nooks, closets, and crannies—whenever he spoke about this piece). The desk had required another of Scott's engineering tours de force, for the weight from the two massive sides of the desk manifestly converged on the narrow center which itself had been all but hollowed out by a wide front-to-back drawer. And yet, with its luminous pear-on-Swiss-

pear construction, the final product almost seemed to levitate, a weightless dream.

The piece's grace, however, belied the urgency of its fabrication, for Ed's own condition was now deteriorating rapidly, the disease proving less and less susceptible to the drugs his doctors were continuing to throw at it (this pattern of declining pharmacological effectiveness is often encountered with Parkinsonism). Ed's swings from frozenness to frenzied festination were growing more extreme, his rigidity more rackingly (and painfully) pervasive, and it was by no means clear how much longer he'd be able to go on working at all. In the midst of this desperately foreshortening horizon, disaster struck.

One Friday afternoon, a week after the birth of Scott's first daughter—"a week, obviously, of high octane excitement and anxiety," as he was now recalling—Scott was pushing himself through a backlog of work. "Actually, this wasn't work I was doing for Ed," Scott explained, as we returned now to his studio, "but for somebody else. All through these years I was working on other projects as well. And this one involved a complicated cut on this Cuisinart-like, high-r.p.m. contraption called a shaper, for which I'd constructed an elaborate jig into which to wedge the piece of wood so as to be able to guide it through the machine. That thing over there. Anyway, there were a series of such pieces that had to be sawn, and in my exhaustion I apparently picked up one I'd already done, something I realized almost immediately—there was this explosion of sound as the saw grabbed the wood—but too late. The machine climbed up the wood, as we say, and pulled me in, there was another explosion, this one more muffled, the sound of blade ripping into flesh and bone, a red mist spraying all over the place. I jerked my hand away, and three of my fingers were dangling, almost completely sliced off, barely hanging by a skein of mangled flesh.

"Independent of the pain, I was immediately overwhelmed by wave upon wave of sadness mixed with anger, waves that just got worse and worse, the realization that something had just happened that was going to profoundly change my life forever, and obviously not for the better. I was

thinking of my wife, my daughter, my future livelihood . . . and, of course, of Ed."

A friend in the building helped him swath his hand in a sweater (his left hand: up till then, he'd been proudly and almost necessarily ambidextrous), and they hurried off to the hospital, where a surgeon quickly surveyed the damage and cut to the chase. They weren't sure what they were going to be able to salvage, he told Scott, but no matter what, first thing they were going to have to do was stabilize things so that he'd have time to grow some more flesh. " 'So,' the guy says," as Scott now recalled, " 'I'm going to be sewing your hand either into your chest or onto your thigh, where it'll have to remain for six months. Listen, I'm going to go get something to eat, back in half an hour. You decide which you want and tell me then.' The anesthesiologist, meanwhile, was lacing me with sedatives and painkillers; I was almost completely zonked out when the surgeon returned, chomping on a muffin and thrusting a medical journal in my face. 'Hmm,' he says, 'look at this,' and he shows me this article about a novel procedure called a Reverse Arterial Digital Island Flap. 'Maybe we'll try that,' he says, by which time it no longer mattered: I was out."

And that's indeed what they did try, taking flesh from the pad of his hand and reversing the artery's orientation in the first of what would eventually prove to be eight operations over the next couple of years. During several of the other procedures, Scott would be awake and watching, as, for instance, the surgeon drilled a thin metal rod down the length of one of his reconstructed fingers, missed, tried again, and missed again, by which time Scott offered helpfully that it might make more sense to first build a jig to help guide the drill, which the surgeon in turn found to be a downright clever suggestion. Most excruciating by far (even more so than the operations in which they extracted bone fragments from his hips to grind into a putty which they then refashioned into new knuckles for slotting into his fingers) were the hours and hours of physical therapy. "It turns out that a huge chunk of your brain and nervous system are taken up with the operations of your hand," Scott explained, "and having to force my hand like that into positions which it manifestly did not want to assume, for months

and months on end—you can have no idea how painful and exhausting that got to be."

Scott gazed over at one of his band saws and shook his head, laughing grimly. "One Christmas Eve," he recalled, "working here in the studio, I accidentally broke one of those reconstituted fingers. I didn't want to go to the doctor and have him redrill one of those rods, and anyway I figured I could do a better job of it myself. So I realigned the finger, and in fact gave it a little extra added crook which I figured might prove useful someday, workwise, and then I used some of this remarkable thermal plastic casting material I had around the workshop. Only, a few hours later, I realized I'd done it wrong; so I called my brother and he came over and helped me, and we went over to that bandsaw and carefully sliced off the cast—a tricky procedure, I realize, but that's where knowing what a thousandth of an inch feels like really comes in handy. After which I reset it, and it eventually got better, and the hand got better: it's six years ago now and I can honestly say that in time I regained the use of most of it."

I asked Scott how Ed had taken the accident. (I remembered how aghast the rest of us friends of his had been for him.)

"He was of course horrified, naturally deeply concerned and supportive, but then almost in denial: it was as if he couldn't stand to hear about it. And anyway, somehow, through the whole thing, I managed to keep working: I contrived a series of makeshift tools, like that vise-mount over there based on a dentist's chair, minus the chair, and I kept working."

Almost on cue, Ed now walked into the workshop, refreshed from his nap. We mentioned how we'd been talking about Scott's accident, and he palpably cringed. "Awck, no," he said, "no. I can't stand it. You know how squeamish I am."

"And anyway," Scott pointed out, "within a few months, Ed was being consumed by a medical drama of his own."

Cruising the Internet with increasing desperation, during the narrowing number of hours available to him each day when he was managing to

retain any physical dexterity at all, Ed first happened to start gleaning references to a daring new Parkinsonian procedure being attempted in Sweden within a few months of Scott's catastrophe. Developed under the auspices of a Finnish neurosurgeon named Dr. Lauri Laitinen, who was working in Stockholm, the procedure was being referred to as a posteroventral pallidotomy, and claims regarding its effectiveness were indeed quite startling. Ed began corresponding with Dr. Laitinen, traveled to Stockholm to tour his clinic in May 1994, and then, that Thanksgiving, reported back for the operation itself.

And about *that* operation, Ed wasn't the slightest bit hesitant to talk. "Essentially," he now explained, "the operation involved inserting a long, narrow probe through the skull, locating a particular clump of hyperactive neurons at the base of the brain in a region called the pallidum, and burning them out—all this while you the patient were quite awake." No one was sure why this procedure worked to the extent that it did, but according to one theory, it appeared to interrupt the brain patterns that induced rigidities and tremors.

The trick, of course, was locating precisely the right clump of neurons— a slippery needle in a very wet haystack.

"Anyway," Ed recounted, "they expected you at nine a.m., and greeted you when you arrived, with extreme graciousness and friendliness, like a host receiving you at a party. They took you into this room and fitted a stereotactic cage over your head, a sort of round latticed framework which in fact reminded me of some of my own early constructions, and then proceeded to record some measurements, mark various coordinates, and take about five minutes of M.R.I. readings, whereupon they disengaged the lattice helmet and cheerfully announced, Fine, that was it, they'd see you the next morning.

"The next morning, Dr. Laitinen himself came into the pre-op room to personally shave my head. He administered an intravenous sedative which made me feel all light-headed and very gay, and then two of his very friendly and encouraging nurses escorted me into the operating theater, where they placed me in a special chair angled at about fifty degrees. They

injected local anesthetic at four places round my head and now reattached the lattice helmet, this time really screwing it tightly into my skull. And that really hurt: I was no longer quite such a happy camper. Laitinen now appeared behind me, made a few soothing comments and began drilling into a spot near the top of my skull, a hole about the size of a dime, which felt very strange, like being at the dentist's: I could hear the bore and feel the vibrations but there was no pain. This went on for about twenty minutes and then I could feel him boring through to airspace. Now he changed instruments and began threading his probe through the brain itself, the tissue of which, as you may know, registers no pain in any case. The entire time he was asking me questions, 'Tell me if you see any flashes of light; that would mean we're brushing up against the optical nerve and we wouldn't want to be doing that,' and so forth, having me move parts of my body, while observing the progress of the probe on the M.R.I. screen by his side. The probe was also emitting different pitches of tone, depending on the density of the tissue through which it was traveling, and he seemed to be using those as well to guide himself to his target.

"This went on for a while, and as he was getting closer he began asking me to cycle my legs and arms, which, given my rigidity was quite difficult, and then suddenly, at a certain point, it was like the blanket of God lifting, like a choir of angels singing Hallelujah, I don't know how else to describe it, the rigidity on my right side disappeared completely and even my left side seemed to ease. He asked me to gaze up at the ceiling, and what had seemed like a blotch suddenly swam into focus—the image of a horse—and that, too, was a good sign, since a sudden surge in visual acuity was an indication that he'd hit the right spot. He said, Okay, he fired the laser for a few seconds, carefully extracted the probe, unscrewed the lattice helmet, spent about five minutes plugging up the hole in my skull with some kind of epoxy mixture or something, and then said, Okay, that's it, you can go now. And I got up and *walked away,* all giggly and slaphappy. It was a *miracle.*"

Ed walked back to his room—celebration all around—eventually drifted off to sleep for a couple of hours, woke up, ravenously hungry,

downed several sandwiches, and went back to sleep, slept soundly and peacefully through the night for the first time in over ten years, woke up entirely refreshed, got out of bed, got dressed, and launched out on a walking tour of Stockholm—among other places, to the museum of arms and armor.

"Which is where you called me from," Scott interjected at this point, beaming. "And it's true: you were completely transformed."

A couple of years later, as per the procedure's protocol, Ed returned to Stockholm once again for the same operation on the other side, and the procedures did indeed signal a remarkable change in the quality of his life. Over time, as with all Parkinsonian interventions, seemingly, the initial burst of well-being tended to subside, several of his symptoms began returning (though nowhere near as badly as immediately before the operation), and he had to contend with a few unpleasant side effects (for example, a certain dulling, he felt, of his verbal and conceptual acuity). Still, for a few years there he experienced an unparalleled resurgence of vitality.

"For one thing," Scott now reported, "he was *driving*. He was tooling all over in this British touring coupe, a metallic blue 1960 Bristol, itself no mean feat of engineering. . . ."

"And a car," Ed interjected, "which, incidentally, I'd purchased several months before the operation. 'But, Eddie,' people kept saying at the time, 'you can't drive.' To which I'd replied, 'I think I'm going to be able to again someday.' And I was."

"It was the strangest reversal," Scott elaborated, "because before that I'd always been the one to drive Ed around, and what with all the disorientations of scale and perspective characteristic of his condition, it wasn't all that surprising that he was a nervous wreck, constantly lunging, cringing, and slamming his foot into the floorboard. And now, here he was the one driving and I was the passenger, and this sweet, meek, hesitant invalid turned out to be a veritable demon, this quite aggressive New York City driver, cutting off cabbies, speeding between stoplights, screeching at

turns, an experience rendered all the more terrifying in that with that car the driver was on the right and as his passenger I was out there on the left, thrust straight into the face of all that oncoming traffic."

Ed smiled, a happy demonic gleam in his eye. "Six o'clock, some mornings, I'd wake up and take the Bristol out for a few laps around Central Park, my own private rally course." His demeanor darkened slightly. "On the other hand, later, sometimes, as the Parkinsonism came flowing back in, if I happened to be out driving empty roads in the countryside, where there wasn't any oncoming traffic to keep me engaged, I'd find myself slowing and slowing, and occasionally I'd even have to pull over as I ground to a halt."

This last comment of Ed's reverberated for me as the afternoon progressed and I watched the two of them engaged in the serious dance of collaboration, for it was obvious that Scott's role was more than that of a simple facilitator—the fabricator to Ed's designer, the realizer of his inspirations—although he was clearly that. "Ed makes them pretty," Scott had boasted at one point, "and I make them last." Elaborating, he'd explained that early on he'd tried to impress on Ed how his own rigor as to design integrity was going to have to be matched by every bit as rigorous a commitment to structural integrity—and indeed, through all the changes of season, humidity, and environment, their pieces have never seemed to warp or buckle or loosen. (They *breathe*.)

But Scott's contribution was more subtle as well, for, in addition, he was continually providing Ed with a necessary traction, the sense of oncoming traffic, as it were, that helped to keep him engaged and in creative motion. The precise way in which he did this was remarkable to behold, for Scott's style was characterized by an extraordinary negative capability and forbearance. They were working on the top and legs of a tall mahogany standing desk that afternoon, and the shapes were still fairly raw. Ed would rake his pencil over the tabletop—"This line," he'd say, "wants to be here"—and Scott would nod sagely. "And this other one instead over here." ("Over the years," Scott had commented earlier, "it's gotten so that I can read Ed's lines. He'll say, 'Cut along that line there,' and in his festinating way he'll

have laid down eighteen overlapping lines. But I know which one he means, and in addition I can compensate for his perceptual and perspectival distortions.") In some instances, Ed's reconsiderations might portend hours and hours of extra labor, but Scott would withhold judgment, except with regard to what was manifestly impossible, and even then his interventions would be characterized by the lightest touch. ("The thing about Scott," Ed had once told me, "is that he never summarily dismisses an idea as wrong. He deflects attention away from its particular wrongness and toward its implied intention, which we can then explore—carefully, *carefreely*—play with, really—sometimes thereby emerging with an unexpectedly interesting right result.")

Their interaction was one of utmost collegiality and mutual regard, and if Scott initially seemed to defer to Ed, Ed was as likely to defer to Scott by the end. Most of their interactions were virtually wordless—a pointed finger, a single syllable, a nod, a grunt, a laugh—and when there were words, they often fed off that vast trove of common metaphors: "like one of your straight-edge razor handles," "that Samurai bow you love so much," "the Mauri war club over there."

"This haunch here."

Ed was pointing to where the piece's long leg jutted up against the underbelly of the tabletop mass. And it did indeed exude a certain haunchiness, a word which would never have percolated to mind in the face of any of their initial creations. For indeed, Ed's style seemed to have undergone a complete metamorphosis in the wake of his operation—or rather, perhaps, themes subdued and barely latent in the earlier work had now blossomed fully to the fore. In speaking of the strange (and strangely estranged) sense of familiarity in which those early works sometimes tended to bask, Ed used to invoke a sense of doubleness: "a fresh past still much in the present and easily recognized as such, conjoined to a more remote one, acknowledged but more indistinct." Which is to say that shimmering just beyond the early Modernist subtext was an early *early* one—a sense of the archaic and the primitive—as in those subliminal Tlingit

mask eyelet references folded into the Cubist-Constructivist bolts. "I'm trying to imagine what it would have been like for a primitive to encounter the modern," Ed had commented to me one afternoon early in our friendship. And of course the fantasy was not entirely without basis, for the early Modernists themselves had been transfixed by the primitive and the archaic (think of the mask-faces in *Les Demoiselles d'Avignon*).

With his more recent work, on the other hand, the work from the far side of his operation, it was as if Ed had broken through to the other side of that analogy, trying to imagine what it might be like for a sophisticated modern to encounter the authentically primitive. The rhymes, at any rate, were no longer to Rietveld or the Bauhaus or Mondrian, but rather to Cycladic statuettes, Easter Island totems, Ming dynasty horse figurines. The pieces were less geometric (concerned with angularity, perpendicularity, golden sections, and so forth) and more organic (in fact, there were hardly any straight lines at all anymore: all the surfaces now bowed and swelled, if ever so subtly). "The trick," Ed commented at one point, "is not to make it too organic—if so, it begins to look like you're trying to make it look like an animal and it becomes kitschy. On the other hand, too geometric and it ends up far too cold. The goal is to maintain yourself right there on the knife-edge between the curvilinear and the rectilinear, just as that edge begins to move."

"Fundamentally, a lyrical piece," Ed recently wrote, describing his and Scott's Monolithic Stand-up Desk, the work immediately prior to the one they were now developing. "Chinese in proportion, stonelike in surface, it evokes an archaic, artifactual presence, while its springy collected stance suggests a purposeful but mysterious animus." Scott offered a more succinct characterization: "Lascaux," he declared flatly. "First thing I thought when Ed showed me the initial drawings was that one of those cave drawings had somehow climbed off the wall and taken on a life of its own."

So, anyway, they were having this problem with the piece's haunch. (My own associations, actually, were to the pad of muscles at the base of the thumb, and I wondered if Scott's weren't as well.) Ed was clearly drawn to

the sinewyness of the table leg's upper thigh, its sheer sensuous muscularity (indeed, pulling the leg out from under the table and tucking it, violin-like, under the crook of his chin, stroking its surface absentmindedly, Ed's own afternoon stiffness seemed momentarily to melt away). But at the same time, something about the swell bulked wrong, too heavy for that juncture. Ed and Scott agreed to scale it back a bit, Scott walked over to the band saw and without the slightest hesitation, carved out a slice. ("I suppose I could have built a proper jig first, the better to secure it," he subsequently commented, "but I prefer the freedom of direct access. It's like shaving: you know where your hand is, you know where the blade is." Which was all well and good: still, it was a bit terrifying to watch.) A half hour later, he carved out another tranche, and an hour after that another one still. And by evening the haunch was all but gone.

Scott laughed: "Five years ago, it would have taken us a month to achieve what we just did in a mere afternoon. We're getting better."

"It happens like that sometimes," Ed said, sighing. "You have to give up the thing you love the most because it just doesn't belong in that piece."

"Yeah," Scott agreed, "but you can always save it for the next one."

And indeed, one of Ed's deepest sources of inspiration for his next piece often turns out to be the refuse pile from the ones he's working on now. Between decisions—while Scott was off implementing whatever gesture they'd just agreed upon—Ed would rummage through the pile of shards, experimentally sliding one fragment atop another and then interleafing a third, all but lost to the world, adrift in a material daydream.

"All along," Ed commented one afternoon, "this has been for me an attempt to create for myself a life of my own, to assert that life, to safeguard it in the face of an otherwise overpowering condition. It's been about achieving an emotional state connected to the beautiful, the graceful, the sublime—though not the precious—as a sort of countervailing passion, countervailing, that is, to a Parkinsonism whose principal characteristics are its harshness and, above all, its smothering *indifference*."

For Ed, I realized, in the most primordial meaning of the phrase, this had all been about *making a difference.*

It was a story that had relied on the confluence of three factors: a vigorous young man 1) felled by Parkinsonism, who 2) just happened to be a

millionaire and 3) just happened to be some kind of genius. Any two of those factors by themselves would not have been enough to have fostered such a remarkable body of work.

And this was a bittersweet realization, for with the current series of pieces, after a fifteen-years' lavish passion, Ed's money was finally on the verge of running out. He was no longer going to be able to afford the sorts of blithe expenditure—on exotic woods, on eccentric bolts, on Scott's exquisite time—that had thus far underwritten this adventure of pure inquiry.

This was one of the reasons for the upcoming show. Scott and Ed were planning to sell the pieces as a way of financing whatever future work they might still be able to undertake.

In preparation for the show, Ed had been scribbling some notes. On the plane ride up, he'd handed me a folder filled with such jottings—journal entries, topical broadsides, imaginary lectures, computer readouts. With evening coming on and Scott and Ed still hunched over their evolving table, I retired to a corner of the studio and opened the folder. The first sentence of the first page declared, simply, "The furniture designs presented here were developed under exceptionally favorable circumstances."

(1999)

A FINAL
VERMEER
CONVERGENCE

A Girl Intent:
Wislawa Szymborska and the Lacemaker

Maybe All This

BY WISLAWA SZYMBORSKA

Maybe all this
is happening in some lab?
Under one lamp by day
and billions by night?

Maybe we're experimental generations?
Poured from one vial to the next,
shaken in test tubes,
not scrutinized by eyes alone,
each of us separately
plucked up by tweezers in the end?

Or maybe it's more like this:
No interference?
The changes occur on their own
according to plan?
The graph's needle slowly etches
its predictable zigzags?

Maybe thus far we aren't of much interest?
The control monitors aren't usually plugged in?
Only for wars, preferably large ones,
for the odd ascent above our clump of Earth,
for major migrations from point A to B?

Maybe just the opposite:
They've got a taste for trivia up there?
Look! on the big screen a little girl
is sewing a button on her sleeve.
The radar shrieks,
the staff comes at a run.
What a darling little being
with its tiny heart beating inside it!
How sweet, its solemn
threading of the needle!
Someone cries enraptured:
Get the Boss,
tell him he's got to see this for himself!

<div align="right">translated by Stanislaw Baranczak
and Claire Cavanagh</div>

A GIRL INTENT:
WISLAWA SZYMBORSKA
AND THE LACEMAKER

"I n my dream," Wislawa Szymborska had written in a slightly earlier poem ("In Praise of Dreams," 1986), "I paint like Vermeer of Delft." And in this poem she paints like him as well. Surely, at any rate, the image splayed across the cosmic screen in the last stanza of "Maybe All This" (1993), the picture Szymborska's words have in mind must be something very like Vermeer's *Lacemaker*. How marvelously, at any rate, the poem helps elucidate the painting, and vice versa.

Start, perhaps, with the painting (created in Delft, around 1669): how everything in it is slightly out of focus, either too close or too far, except for the very thing the girl herself is focusing upon, the two strands of thread pulled taut in her hands, the locus of all her labors. This painting is all about concentration: gradually, spiralingly, we come to concentrate on the very thing the girl herself is concentrating on (everything else receding to the periphery of our awareness), like nothing so much as a painter lavishing his entire attention on his subject (or else, perhaps, like what happens as we ourselves subsequently pause, dumbstruck, before his canvas in the midst of our museum walk).

Are we perhaps exaggerating here? Look more closely at the threads themselves, how they arrange themselves into a crisp, tight V, couched in the M-like cast of shade and light playing upon the hand and fingers behind them. The girl, godlike, momentarily focuses all her attention onto VM, the very author of her existence.

And hence back to the poem. For the girl threading her needle, "the

darling little being with its tiny beating heart inside," is of course none other than the poet herself, intent over her page, laboring toward the perfected line (or else, subsequently perhaps, we, her readers, hunched over her completed poem). Though, as creator of the poem, Szymborska is of course simultaneously the Boss (as do we, too, the poem's readers, momentarily get to be, re-creating, recapitulating her epiphanic insight, seeing it clean for ourselves).

Indeed, Szymborska gets it just right; how in the perfected work of art (be it a poem or a painting), across that endlessly extended split second of concentrated attention, artist and audience alike partake of a doubled awareness: the expansive vantage (lucidly equipoised) of God, the concentrated experience (meltingly empathic) of his most humble subject.

(2000)

ACKNOWLEDGMENTS

As will be seen from the checklist that follows, the plurality of these pieces originally appeared in *The New Yorker*, which is to say William Shawn's *New Yorker*, whether under his own auspices or those of his successors—Bob Gottlieb, Tina Brown, and David Remnick. All of them provided me with an incomparable writerly home for more than two decades, enriched all the more by an altogether dazzling editorial surround, including my own wry, endlessly put-upon editors John Bennet, Pat Crow, and Jeffrey Frank; such fact-checking wizards as Peter Canby, John Dorfman, Amy Davidson, Liesl Schillinger, Blake Eskin, Sarah Smith, and Ben McGrath; and such doyennes of stylistic felicity as Liz Macklin, Mary Norris, Elizabeth Pearson-Griffiths, Mary Hawthorne, Ann Goldstein, and, of course, the irreplaceable Miss Gould. They tried, believe me, they all tried, and where they succeeded they invariably salvaged and polished and rescued me; sometimes, alas, I proved just too stubborn.

Other pieces appeared elsewhere, a circumstance that affords me occasion to celebrate the blithe and vivifying touches, variously, of Bill Whitworth, Toby Lester, Corby Kummer and Cullen Murphy at *The Atlantic Monthly;* Wendy Lesser at *The Threepenny Review;* Dave Eggers at *McSweeney's;* Ira Glass at *This American Life;* and Helena Luczywo and Adam Michnik at *Gazeta Wyborcza* in Warsaw.

It often seems to me that a foreign correspondent can only be as good as his fixers, and over the years, I have been exceptionally gifted and well served by mine—sounding boards, interpreters (of much more than just language), ballasts, and presently, dear friends. In terms of the pieces collected in this book, I

want in particular to highlight the collegial contributions of Piotr Bikont in Poland, and Dusko Tubic and Julia Bogoeva in the former Yugoslavia.

A career as tumblingly various and scattershot as the one limned in this collection cannot have been easy to manage, and yet my agents over the years— Flip Brophy, Deborah Karl, and now Chris Calhoun—never let on and never held me back: on the contrary, they encouraged my wildest flights, lavishing assurance and unfailingly competent good sense all the while.

And what an easy and heartening pleasure, these past several months, to be working once again with my editor Dan Frank and designer Kristen Bearse here at Pantheon, veterans—can it be coming on ten years ago already?—of those happy Mr. Wilson campaigns.

But if we are going to start talking about veterans, how even to begin crediting the contributions and enswathing succor provided by my loving and lovely bride Joasia, the first reader of all these pieces, and by our fiercely sly daughter (talk about tumblingly various and scattershot!) Sara, who may one day be their last. This book was always and will always be principally theirs.

SOURCES AND CREDITS

In Lieu of a Preface: "WHY I CAN'T WRITE FICTION" is excerpted from a Comment ("A young reporter we know writes") in the August 26, 1985, issue of *The New Yorker*.

"THE DIKES OF HOLLAND" is excerpted from the introduction to *Crimes of War: What the Public Should Know*. Edited by Roy Gutman and David Rieff (Norton, 1999).

"VERMEER IN BOSNIA" expands on "Inventing Peace," a Reflections piece in the November 20, 1995, issue of *The New Yorker*. Vermeer's "Head of a Young Girl," from the Mauritshuis collection in The Hague, courtesy of Erich Lessing/ Art Resource, N.Y. The image of Dusko Tadic, is drawn from the live video-feed of his trial before the International Criminal Court for the Former Yugoslavia (ICTY), which in turn was used in a BBC documentary, *Judging Vermeer* (1996), which was based on the original *New Yorker* piece.

"HENRY V AT SREBRENICA" expands on an Arts piece ("Take No Prisoners") in the June 17, 1996, issue of *The New Yorker*.

"ARISTOTLE IN BELGRADE" expands on a Letter from Serbia of the same name in the February 10, 1997, issue of *The New Yorker*.

"THE MARKET ON THE TUZLA/BRCKO ROAD" is excerpted from a Letter from Republika Srpska ("High Noon at Twin Peaks") in the August 18, 1997, issue of *The New Yorker*.

"THE BRAT'S TALE: ROMAN POLANSKI" expands on a Profile ("Artist in Exile") in the December 5, 1994, issue of *The New Yorker*, which also featured the portrait of Polanski by Richard Avedon, reproduced by permission of the artist.

"THE TROLL'S TALE: JERZY URBAN" expands on the Profile "Urban Blight" first published in the December 11, 1995, issue of *The New Yorker*, and is illustrated with the cover of his ex-wife Karyna Andrzejewska's memoir, *Urban: I Was His Wife* (Gdansk: Philobiblon, 1993).

"THE SON'S TALE: ART SPIEGELMAN" is drawn from a piece that originally appeared in the November 20, 1986, issue of *Rolling Stone* and was subsequently featured in Weschler's North Point Press collection *Shapinsky's Karma, Boggs's Bills and Other True-Life Tales* (1988), and, after that went out of print, in his subsequent Ruminator Books collection *A Wanderer in the Perfect City* (1999). The Spiegelman images derive, respectively, from the original *Maus* strip (1972), reproduced in Spiegelman's *Breakdowns* collection (Nostalgia Press, 1977), and from a limited edition lithograph, *The Past Hangs over the Future*, published in 1992 at the time of the completion of the second volume of *Maus*. Both reproduced here by permission of the artist.

"MY GRANDFATHER'S LAST TALE" originally appeared in *The Atlantic Monthly*, in December 1996. The photo of Ernst Toch cradling his baby grandson, and the "Eats Raw Meat" clipping, are courtesy of the Ernst Toch Archive at UCLA, whose website (www.library.ucla.edu/libraries/music/mlsc/toch) features a full inventory of things Tochian.

"SARA'S EYES" originally ran as a Talk piece ("A young friend of ours, suddenly a father, writes") in the March 9, 1987, issue of *The New Yorker*. Photograph courtesy Joanna Weschler.

"A SEASON WITH THE BORROWERS" comprises a transcript of the latter half of the Father's Day 1998 episode of Ira Glass's *This American Life* radio program out of WBEZ, Chicago, and Public Radio International, and is reproduced here with their permission. The notes are reproduced courtesy of Sara Weschler. (Further notes and documentation of the affair can be found at the thislife.org website, where the episode itself can also be heard.)

"WHY IS THE HUMAN ON EARTH?" originally ran as the afterword to Michael Benson's *Beyond: Visions of the Interplanetary Space Probes* (Abrams, 2003), from which the image of Jupiter's moon Europa orbiting above the planet's Great Red Spot (taken on March 3, 1979, by the *Voyager 1* spacecraft) is drawn.

"A FATHERS AND DAUGHTERS CONVERGENCE: OCCASIONED BY SOME PORTRAITS BY TINA BARNEY" originally ran in *McSweeney's No. 8* (2002).

Black-and-white versions of Barney's color photos of Peter and Marina (in 1997, 1987, and 1990, respectively) are reproduced by permission of Ms. Barney; color versions can be seen in her book, *Photographs: Theater of Manners* (Scalo, 1997).

"MY GRANDFATHER'S PASSOVER CANTATA" appeared under the title "Toch's Bitter Herbs Cantata: A Kaddish for Our Time" in the March 8, 2002, edition of *The Forward*. The photograph of the Polish Jewish tombstone is by Monika Krajewska, from her book *Czas Kamieni* [Time of Stones] (Warsaw: Interpress, 1982) and is reproduced with her permission. The photo of Toch and his young daughter Franzi is courtesy of the Toch Archive at UCLA.

"AN L.A. HIGH SCHOOL YOUTH" was the first chapter of *Seeing Is Forgetting the Name of the Thing One Sees: A Life of Contemporary Artist Robert Irwin* (University of California Press, 1982).

"THE L.A. QUAKE" originally ran (in Polish) in *Gazeta Magazyn* (Warsaw) on February 11, 1994, and was then reprinted (in English) in the June 1994 number of the *Threepenny Review*.

"THE LIGHT OF L.A." first appeared as a Far-flung Correspondents piece ("L.A. Glows") in the February 23, 1998, issue of *The New Yorker*.

"TRUE TO LIFE: DAVID HOCKNEY'S PHOTOCOLLAGES" expands on an Art World piece that first ran in the July 9, 1984, issue of *The New Yorker*, which in turn formed the basis for a yet further expanded introduction to *David Hockney Cameraworks* (Knopf, 1984). Black-and-white renditions of a detail from *Noya and Bill Brandt with Self-Portrait (although they were looking at their picture being made), Pembroke Studios, 8th May 1982*; and the full swaths of *My house, Montcalm Avenue, Los Angeles, Friday, February 26th, 1982; Don and Christopher, Los Angeles, 6th March 1982; Celia, Los Angeles, April 10th, 1982; The Grand Canyon from the North Rim Lodge, Arizona, Sept. 1982; My mother, Bolton Abbey, Yorkshire, Nov. 1982; Billy Wilder lighting his cigar, Los Angeles, Dec. 1982;* and *The Scrabble Game, Los Angeles, Jan. 1st, 1983* are all reproduced courtesy of the artist. (Larger-scale color versions can be found in the *Cameraworks* volume.)

"THE PAST AFFIXED ALSO: THE KIENHOLZ SPOKANE SERIES" originally appeared as an essay in the catalog to the "Edward and Nancy Reddin Kienholz: Human Scale" exhibition at the San Francisco Museum of Modern Art in the summer of 1984. The photographs of the *Portrait of a Mother with Past Affixed Also* (1980–81) and the interior of *Sollie 17* (1980–81) tableau appear courtesy of the L.A. Louver Gallery and Nancy Reddin Kienholz.

"A PARKINSONIAN PASSION: ED WEINBERGER" first ran as a Profile ("The Furniture Philosopher") in the November 8, 1999, issue of *The New Yorker*. The images of Weinberger and Scott Schmidt and their pieces appear courtesy of the photographer, Jason Schmidt (no relation).

The final Vermeer Convergence, "A GIRL INTENT," first appeared in *McSweeney's No. 4* (2000) and then, in Polish translation, in *Gazeta Wyborcza*. The detail from Vermeer's *Lacemaker*, from out of the Louvre Museum in Paris, is courtesy of Scala/Art Resource, N.Y. Wislawa Szymborska's poem "Maybe All This," as translated by Stanislaw Baranczak and Claire Cavanagh, from Ms. Szymborska's *View with a Grain of Sand: Selected Poems* (Harcourt Brace & Co., 1993), is reprinted by permission of the poet and the publisher.